DATE DUE

An Introduction to Visual Culture

"An original, well-researched and engaging text that makes a unique contribution to the analysis and understanding of visual culture. Mirzoeff's masterful handling of his material makes for a timely work that will have an immediate and direct appeal to many readers and students."

John Di Stefano, The School of the Art Institute of Chicago

"Mirzoeff's careful attention to issues ranging from Renaissance perspective to popular media culture makes this book a valuable starting point for readers interested in sampling the range of topics covered in visual culture studies."

Lisa Cartwright, University of Rochester, New York

An Introduction to Visual Culture provides a comprehensive introduction to the exciting new interdisciplinary field of visual culture.

Tracing the history and theory of visual culture from painting to the World Wide Web, *An Introduction to Visual Culture* asks how and why visual media have become so central to contemporary everyday life. Mirzoeff suggests that our primary way of understanding the world is now increasingly visual, and not textual.

In this innovative introductory text, Nicholas Mirzoeff explores:

- What is visual culture?
- Elements of the visual, including perspectives, color, line, and vision.
- A wide range of visual media, including painting, sculpture, photography, television, cinema, Virtual Reality, and the Internet.
- The importance of "race" and ethnicity, gender and sexuality, and the body in visual culture.
- The international media event which followed the death of Princess Diana, as marking the coming of age of a global visual culture.

Nicholas Mirzoeff is Associate Professor of Art at the State University of New York, Stony Brook. He is the author of *Bodyscape: Art, Modernity and the Ideal Figure* (1995) and editor of *The Visual Culture Reader* (1998) and *Diaspora and Visual Culture: Representing Africans and Jews* (1999).

An Introduction to Visual Culture

Nicholas Mirzoeff

London and New York

First published 1999
by Routledge
11 New Fetter Lane, London EC4P 4EE

Simultaneously published in the USA and Canada
by Routledge
29 West 35th Street, New York, NY 10001

Routledge is an imprint of the Taylor & Francis Group

© 1999 Nicholas Mirzoeff

Typeset in Perpetua by
J&L Composition Ltd, Filey, North Yorkshire
Printed and bound in Great Britain by
Butler and Tanner Ltd, Frome and London

British Library Cataloguing in Publication Data
A catalogue record for this book is available from the British Library

Library of Congress Cataloguing in Publication Data
A catalogue record for this book has been requested

ISBN 0–415–15875–3 (hbk)
ISBN 0–415–15876–1 (pbk)

CONTENTS

ILLUSTRATIONS

All illustrations are by the author with the exception of the following. We are indebted to the people and archives below for permission to reproduce these photographs. Every effort has been made to trace copyright holders, but in a few cases this has not been possible. Any omissions brought to our attention will be remedied in future editions.

ACKNOWLEDGMENTS

I am grateful to the University of Wisconsin Graduate School and the Humanities Institute at SUNY Stony Brook for funding that enabled the writing of this book to get off the drawing board. For providing a vital audience for, and first critique of, my ideas, my thanks to all in the visual culture seminars at Stony Brook and Madison, as well as my undergraduate students in 1997–98. Thanks to Lisa Parks for her insights on science fiction. The suggestions made by readers for Routledge of both the initial proposal and finished manuscript were very helpful indeed. Special thanks to Rebecca Barden for being an editor who actually edits and much more. Thanks also to Chris Cudmore, Alistair Daniel, Katherine Hodkinson, Matt Papa and everyone else at Routledge. Kathleen Wilson was as ever the indispensable critic, editor, partner and very much more. This book is for Hannah on her second birthday.

INTRODUCTION
What is visual culture?

MODERN LIFE TAKES place onscreen. Life in industrialized countries is increasingly lived under constant video surveillance from cameras in buses and shopping malls, on highways and bridges, and next to ATM cash machines. More and more people look back, using devices ranging from traditional cameras to camcorders and Webcams. At the same time, work and leisure are increasingly centered on visual media, from computers to Digital Video Disks. Human experience is now more visual and visualized than ever before from the satellite picture to medical images of the interior of the human body. In the era of the visual screen, your viewpoint is crucial. For most people in the United States, life is mediated through television and, to a lesser extent, film. The average American 18 year old sees only eight movies a year but watches four hours of television a day. These forms of visualization are now being challenged by interactive visual media like the Internet and virtual reality applications. Twenty-three million Americans were online in 1998, with many more joining in daily. In this swirl of imagery, seeing is much more than believing. It is not just a part of everyday life, it is everyday life.

Let's take a few examples from the constant swirl of the global village. The abduction of the toddler Jamie Bulger from a Liverpool shopping mall was impersonally captured by a video surveillance camera, providing chilling evidence of the ease with which the crime was both committed and detected. At the same time, despite the theory that constant surveillance provides increased security, it in fact did nothing to help prevent the child's abduction and eventual murder. The bombing at the 1996 Atlanta Olympic

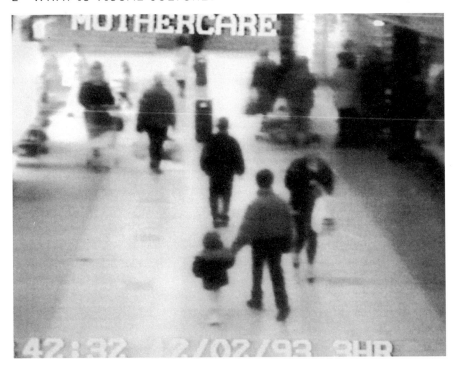

Figure 1 A still of the abduction of Jamie Bulger

Games was captured for endless replay by a casual interface of visual technology involving an amateur camcorder and a German cable TV station interviewing American swimmer Janet Evans. Someone is nearly always watching and recording. Yet no one has been prosecuted to date for the crime. For the visualization of everyday life does not mean that we necessarily know what it is that we are seeing. When TWA Flight 800 crashed off Long Island, New York in July 1996 scores of people witnessed the event. Their accounts differed so widely that the FBI ended up crediting only the least sensational and unembellished accounts. In 1997, the FBI released a computer animation of the crash, utilizing materials ranging from radar to satellite imagery. Everything could be shown except the actual cause of the crash – that is, the reason why the fuel tank exploded. Without this answer, the animation was essentially pointless. Even more strikingly, the world watched in 1991 as the American armed forces replayed video footage from their "smart" bombs as they homed in on their targets during the Gulf War. The film seemed to show what Paul Virilio has called the "automation of perception," machines that could "see" their way to their destinations

(Virilio 1994: 59). But five years later it emerged that while the weapons certainly "saw" something, they were no more accurate than traditional munitions in actually hitting their intended marks. In September 1996, American cruise missiles struck Iraqi anti-aircraft defenses twice in two days, only for American planes to be fired at by the Iraqis several days later. Did the Gulf War never happen, as Jean Baudrillard has provocatively asserted? What are we to believe if seeing is no longer believing?

The gap between the wealth of visual experience in postmodern culture and the ability to analyze that observation marks both the opportunity and the need for visual culture as a field of study. While the different visual media have usually been studied independently, there is now a need to interpret the postmodern globalization of the visual as everyday life. Critics in disciplines ranging as widely as art history, film, media studies and sociology have begun to describe this emerging field as visual culture. Visual culture is concerned with visual events in which information, meaning, or pleasure is sought by the consumer in an interface with visual technology. By visual technology, I mean any form of apparatus designed either to be looked at or to enhance natural vision, from oil painting to television and the Internet. Postmodernism has often been defined as the crisis of modernism. In this context, this implies that the postmodern is the crisis caused by modernism and modern culture confronting the failure of its own strategy of visualizing. In other words, it is the visual crisis of culture that creates postmodernity, not its textuality. While print culture is certainly not going to disappear, the fascination with the visual and its effects that marked modernism has engendered a postmodern culture that is most postmodern when it is visual. This proliferation of visuality has made film and television entertainment the United States' second largest export after aerospace, amounting to $3.7 billion to Europe alone in 1992 (Barber 1995: 90). Postmodernism is not, of course, simply a visual experience. In what Arjun Appadurai has called the "complex, overlapping, disjunctive order" of postmodernism, tidiness is not to be expected (Appadurai 1990: 328). Nor can it be found in past epochs, whether one looks at the eighteenth-century coffee house public culture celebrated by Jurgen Habermas, or the nineteenth-century print capitalism of newspapers and publishing described by Benedict Anderson. In the same way that these authors highlighted a particular characteristic of a period as the means to analyze it, despite the vast range of alternatives, visual culture is a tactic with which to study the genealogy, definition and functions of postmodern everyday life from the point of view of the consumer, rather than the producer. The disjunctured and fragmented culture that we call postmodernism is best imagined and

understood visually, just as the nineteenth century was classically represented in the newspaper and the novel.

That is not to suggest however, that a simple dividing line can be drawn between the past (modern) and the present (postmodern). As Geoffrey Batchen has argued, "the threatened dissolution of boundaries and oppositions [the postmodern] is presumed to represent is not something peculiar to a particular technology or to postmodern discourse but is rather one of the fundamental conditions of modernity itself" (Batchen 1996: 28). Understood in this fashion, visual culture has a genealogy that needs exploring and defining in the modern as well as postmodern period (Foucault 1998). For some critics, visual culture is simply "the history of images" handled with a semiotic notion of representation (Bryson et al. 1994: xvi). This definition creates a body of material so vast that no one person or even department could ever cover the field. For others it is a means of creating a sociology of visual culture that will establish a "social theory of visuality" (Jenks 1995: 1). This approach seems open to the charge that the visual is given an artificial independence from the other senses that has little bearing on real experience. In this volume, visual culture is used in a far more active sense, concentrating on the determining role of visual culture in the wider culture to which it belongs. Such a history of visual culture would highlight those moments where the visual is contested, debated and transformed as a constantly challenging place of social interaction and definition in terms of class, gender, sexual and racialized identities. It is a resolutely interdisciplinary subject, in the sense given to the term by Roland Barthes: "In order to do interdisciplinary work, it is not enough to take a 'subject' (a theme) and to arrange two or three sciences around it. Interdisciplinary study consists in creating a new object, which belongs to no one". As one critic in communications studies has recently argued, this work entails "greater levels of uncertainty, risk and arbitrariness" than have often been used until now (McNair 1995: xi). There would be little point in breaking down the old disciplinary barriers only to put up new ones in their place.

To some, visual culture may seem to claim too broad a scope to be of practical use. It is true that visual culture will not sit comfortably in already existing university structures. It is part of an emerging body of post-disciplinary academic endeavors from cultural studies, gay and lesbian studies, to African–American studies, and so on, whose focus crosses the borders of traditional academic disciplines at will. In this sense, visual culture is a tactic, not an academic discipline. It is a fluid interpretive structure, centered on understanding the response to visual media of both individuals and groups. Its definition comes from the questions it asks and issues it seeks to raise. Like the other approaches mentioned above, it hopes

to reach beyond the traditional confines of the university to interact with people's everyday lives.

Visualizing

One of the most striking features of the new visual culture is the growing tendency to visualize things that are not in themselves visual. Allied to this intellectual move is the growing technological capacity to make visible things that our eyes could not see unaided, ranging from Roentgen's accidental discovery of the X-ray in 1895 to the Hubble telescope's "pictures" of distant galaxies that are in fact transpositions of frequencies our eyes cannot detect. One of the first to call attention to these developments was the German philosopher Martin Heidegger, who called it the rise of the world picture. He argued that "a world picture . . . does not mean a picture of the world but the world conceived and grasped as a picture The world picture does not change from an earlier medieval one into a modern one, but rather the fact that the world becomes picture at all is what distinguishes the essence of the modern age" (Heidegger 1977: 130). Consider a driver on a typical North American highway. The progress of the vehicle is dependent on a series of visual judgements made by the driver concerning the relative speed of other vehicles, and any maneuvers necessary to complete the journey. At the same time, he or she is bombarded with other information: traffic lights, road signs, turn signals, advertising hoardings, petrol prices, shop signs, local time and temperature and so on. Yet most people consider the process so routine that they play music to keep from getting bored. Even music videos, which saturate the visual field with distractions and come with a soundtrack, now have to be embellished by textual pop-ups. This remarkable ability to absorb and interpret visual information is the basis of industrial society and is becoming even more important in the information age. It is not a natural human attribute but a relatively new learned skill. For the medieval philosopher, St Thomas Aquinas, sight was not to be trusted to make perceptual judgements by itself: "Thus sight would prove fallible were one to attempt to judge by sight *what* a colored thing was or *where* it was" (Aquinas 1951: 275). According to one recent estimate, the retina contains 100 million nerve cells capable of about 10 billion processing operations per second. The hyper-stimulus of modern visual culture from the nineteenth century to the present day has been dedicated to trying to saturate the visual field, a process that continually fails as we learn to see and connect ever faster.

In other words, visual culture does not depend on pictures themselves but the modern tendency to picture or visualize existence. This visualizing

makes the modern period radically different from the ancient and medieval worlds. While such visualizing has been common throughout the modern period, it has now become all but compulsory. This history might be said to begin with the visualizing of the economy in the eighteenth century by François Quesnay, who said of his "economic picture" of society that it "brings before your eyes certain closely interwoven ideas which the intellect alone would have a great deal of difficulty in grasping, unravelling and reconciling by the method of discourse" (Buck-Morss 1989: 116). Quesnay in effect expresses the principle of visualizing in general – it does not replace discourse but makes it more comprehensible, quicker and more effective. Visualizing has had its most dramatic effects in medicine, where everything from the activity of the brain to the heartbeat is now transformed into a visual pattern by complex technology. Most recently the visualizing of computer environments has generated a new sense of excitement around the possibilities of the visual. Computers are not, however, inherently visual tools. The machines process data using a binary system of ones and zeros, while the software makes the results comprehensible to the human user. Early computer languages like ASCII and Pascal were resolutely textual, involving commands that were not intuitive but had to be learned. The operating system promoted by Microsoft, better known as MS-DOS, retained these technocratic features until challenged by Apple's point-and-click interface. This system, relying on icons and drop-down menus, has become standard with Microsoft's conversion to the Windows environment. With the development of the Internet, Java computer code now allows the untutored home computer user access to graphics that were once the preserve of élite institutions like the MIT Media Lab. As computer memory has fallen in price and with the arrival of programs like RealPlayer and Shockwave, often available free over the Net, personal computers can play real-time video with full-color graphics. It is important to remember that these changes were as much consumer as technology driven. There is no inherent reason that computers should use a predominantly visual interface, except that people now prefer it this way.

Visual culture is new precisely because of its focus on the visual as a place where meanings are created and contested. Western culture has consistently privileged the spoken word as the highest form of intellectual practice and seen visual representations as second-rate illustrations of ideas. The emergence of visual culture develops what W.J.T. Mitchell has called "picture theory," the sense that some aspects of Western philosophy and science have come to adopt a pictorial, rather than textual, view of the world. If this is so, it marks a significant challenge to the notion of the world as a written text that dominated so much intellectual discussion in the wake of linguistics-

based movements such as structuralism and poststructuralism. In Mitchell's view, picture theory stems from "the realization that *spectatorship* (the look, the gaze, the glance, the practices of observation, surveillance, and visual pleasure) may be as deep a problem as various forms of *reading* (decipherment, decoding, interpretation, etc) and that 'visual experience' or 'visual literacy' might not be fully explicable in the model of textuality" (Mitchell 1994: 16). While those already working on visual media might find such remarks rather patronizing, they are a measure of the extent to which even literary studies have been forced to conclude that the world-as-a-text has been replaced by the world-as-a-picture. Such world-pictures cannot be purely visual, but by the same token, the visual disrupts and challenges any attempt to define culture in purely linguistic terms.

One of the principal tasks of visual culture is to understand how these complex pictures come together. They are not created from one medium or in one place, as the over precise divisions of academia would have it. Visual culture directs our attention away from structured, formal viewing settings like the cinema and art gallery to the centrality of visual experience in everyday life. At present, different notions of viewing and spectatorship are current both within and between all the various visual subdisciplines. It does of course make sense to differentiate. Our attitudes vary according to whether we are going to see a movie, watch television, or attend an art exhibition. However, most of our visual experience takes place aside from these formally structured moments of looking. A painting may be noticed on a book jacket or in an advert, while television is consumed as a part of domestic life rather than as the sole activity of the viewer, and films are as likely to be seen on video, in an aeroplane or on cable as in a traditional cinema. Just as cultural studies has sought to understand the ways in which people create meaning from the consumption of mass culture, so does visual culture prioritize the everyday experience of the visual, from the snapshot to the VCR and even the blockbuster art exhibition. If cultural studies is to have a future as an intellectual strategy, it will have to take the visual turn that everyday life has already gone through.

The first move towards visual culture studies is a recognition that the visual image is not stable but changes its relationship to exterior reality at particular moments of modernity. As philosopher Jean-François Lyotard has argued: "Modernity, wherever it appears, does not occur without a shattering of belief, without a discovery of the *lack of reality* in reality – a discovery linked to the invention of other realities" (Lyotard 1993: 9). As one mode of representing reality loses ground another takes its place without the first disappearing. In the first section of this book, I show that the formal logic of the *ancien régime* image (1650–1820) first gave way to a dialectical logic of

the image in the modern period (1820–1975). This dialectical image has in turn been challenged by the paradoxical or virtual image in the last twenty years (Virilio 1994: 63). The traditional image obeyed its own rules that were independent of exterior reality. The perspective system, for example, depends upon the viewer examining the image from one point only, using just one eye. No one actually does this but the image is internally coherent and thus credible. As perspective's claim to be reality lost ground, film and photography created a new, direct relationship to reality such that we accept the "actuality" of what we see in the image. A photograph necessarily shows us something that was at a certain point actually before the camera's lens. This image is dialectical because it sets up a relationship between the viewer in the present and the past moment of space or time that it represents.

However, it was not dialectical in the Hegelian sense of the term – which would be to say that the thesis of the formal image was first countered by the antithesis of photography and then resolved into a synthesis. Perspective images sought to make the world comprehensible to the powerful figure who stood at the single point from which it was drawn. Photographs offered a far more democratic visual map of the world. Now the filmed or photographic image no longer indexes reality because everyone knows they can be undetectably manipulated by computers. As the example of the "smart" bombs shows, the paradoxical virtual image "emerges when the real-time image dominates the thing represented, real time subsequently prevailing over real space, virtuality dominating actuality and turning the concept of reality on its head" (Virilio 1994: 63). These virtualities of the postmodern image seem to constantly elude our grasp, creating a crisis of the visual that is more than simply a local problem. On the contrary, postmodernism marks the era in which visual images and the visualizing of things that are not necessarily visual has accelerated so dramatically that the global circulation of images has become an end in itself, taking place at high speed across the Internet.

The notion of the world-picture is no longer adequate to analyze this changed and changing situation. The extraordinary proliferation of images cannot cohere into one single picture for the contemplation of the intellectual. Visual culture in this sense is the crisis of information and visual overload in everyday life. It seeks to find ways to work within this new (virtual) reality. To adapt Michel de Certeau's description of everyday life, visual culture is a tactic, for "the place of the tactic belongs to the other" (de Certeau 1984: xix). A tactic is carried out in full view of the enemy, the society of control in which we live (de Certeau 1984: 37). Although some may find the military overtones of tactics offputting, it can also be argued that in the ongoing culture wars, tactics are necessary to avoid defeat. Just as

earlier inquiries into everyday life sought to prioritize the ways in which consumers created different meanings for themselves from mass culture, so will visual culture explore the ambivalences, interstices and places of resistance in postmodern everyday life from the consumer's point of view.

Visual power, visual pleasure

Most theorists of the postmodern agree that one of its distinctive features is the dominance of the image. With the rise of virtual reality and the Internet in the West, combined with the global popularity of television, videotape and film, this trend seems set to continue. The peculiar dimension to such theory is, however, that it automatically assumes that a culture dominated by the visual must be second-rate. This almost reflex action seems to betray a wider doubt about popular culture itself. Such criticism has a long history, for there has always been a hostility to visual culture in Western thought, originating in the philosophy of Plato. Plato believed that the objects encountered in everyday life, including people, are simply bad copies of the perfect ideal of those objects. He compared this reproduction as being like the shadows cast by a fire on a cave wall—you can see who or what cast the shadow but the image is inevitably distorted from the original's appearance. In other words, everything we see in the "real" world is already a copy. For an artist to make a representation of what is seen would be to make a copy of a copy, increasing the chance of distortion. Furthermore, the ideal state Plato imagined required tough, disciplined individuals, but the arts appeal to our emotions and desires. So there was no place for the visual arts in his Republic: "Painting and imitation are far from the truth when they produce their works; . . . moreover, imitation keeps company with the worst part in us that is far from prudence and is not comrade or friend for any healthy or true purpose" (Plato 1991: 286). This hostility to the image has had a lasting influence on Western thought to the present day. Some images have been deemed too dangerous to exist, leading iconoclasts to seek their destruction or removal from public view. In such campaigns, distinctions between high art and popular culture have carried little weight with the incensed righteous. The fifteenth-century monk Savonarola had burnt in Florence, in the words of a contemporary, "numbers of profane paintings and sculptures, many of them the work of great masters, with books, lutes and collections of love songs" (Freedberg 1989: 348), just as Senator Jesse Helms and his colleagues in the United States Senate have been as eager to limit pornography on the Internet as to cut money from the National Endowment for the Arts to punish it for sponsoring the work of

photographer Robert Mapplethorpe. The contemporary hostility to the visual in some contemporary criticism thus has deep roots.

All such criticism shares an assumption that a visually-dominated culture must be impoverished or even schizophrenic. Although television, for example, has won a place in the academic establishment, there is still a strong suspicion of visual pleasure in intellectual circles. Television is often described, in David Morley's phrase, as "radio with pictures," as if the pictures were mere decoration. This concentration on the textual dimension to television may be appropriate for news and other "talking head" formats but has nothing to say about television's distinctive formats such as soap opera, game shows, nature programs, and sports coverage. It is noticeable that a remote control always comes with a "mute" button but never a device to eliminate the picture. Programs can easily be followed with the sound off, a common domestic device to enable television to be part of the household activity, rather than its center. We watch television, not listen to it.

This simple fact causes many intellectuals to lose patience. Intellectuals like sociologist Pierre Bourdieu have joined forces with campaigning groups like Britain's White Dot and an array of university professors to lament that television has dumbed down Western society. Particular outrage is poured on universities for turning away from the study of what have become known as the Great Books towards television and other visual media. Such criticism is seemingly unaware of the hostile response towards novels themselves in the Enlightenment that accused literary forms of the same corrupting influence on morals and intellect with which television is now reproached. Even Michel de Certeau spoke of "a cancerous growth of vision" (de Certeau 1984: xxi). Fredric Jameson gives vent to his hostility at greater length:

> The visual is *essentially* pornographic, which is to say it has its end in rapt, mindless fascination; thinking about its attributes becomes an adjunct to that, if it is unwilling to betray its object; while the most austere films necessarily draw their energy from the attempt to repress their own excess (rather than from the more thankless effort to discipline the viewer). Pornographic films are thus only the potentiation of films in general, which ask us to stare at the world as though it were a naked body The mysterious thing reading [becomes] some superstitious and adult power, which the lowlier arts imagine uncomprehendingly, as animals might dream of the strangeness of human thinking.
>
> (Jameson 1990: 1–2)

The oddity of this position is that it renders America's leading Marxist critic a diehard defender of the bourgeois subject, as classically expressed through the novel. Such narrative archetypes as the coming-of-age story, the *Bildungsroman*, and the twentieth-century staple of the novel about writing a novel, all express the centrality of literature to the formation of the bourgeois, individual subject. Viewing visual images is, by contrast, very often a collective experience, as it is in a cinema. Computer technology now allows a visitor to a website to be present at the same time as perhaps hundreds or thousands of others and, in the case of chat rooms or bulletin boards, to interact with them. Further, the inherent multiplicity of possible viewpoints available to interpret any visual image make it a potentially far more democratic medium than the written text. In Jameson's view, those who have the temerity to enjoy visual pleasure, rather than the discipline of reading, are pornographers at best, most likely animals. The physicality of the visual marks it as a debased activity for Jameson, whereas reading is somehow divorced from the physical processes of perception. His position is derived from the film theory of Christian Metz and other film theorists of the 1970s, who saw the cinema as an apparatus for the dissemination of ideology, in which the spectator was reduced to a wholly passive consumer. However, Jameson goes beyond such intellectual theorizing by presenting cinema audiences as lowlier beings, more comparable to animals than serious intellectuals like himself. The no doubt unintentional echoes of racist thought in this depiction are distasteful but necessarily implied by his colonial need to master the visual by writing.[1] Indeed, the generalized antipathy of intellectuals to popular visual representations may be a displaced hostility to those who participate in and enjoy mass culture. In the eighteenth century, this hostility was directed at theater. It is now focused on film, television and increasingly the Internet. In each case, the source of hostility is the mass, popular audience, not the medium in itself. From this perspective, the medium is not the message.

On the other hand, cultural studies–which seeks to privilege popular culture – has an awkward gap around the visual, leading to the bizarre situation that any viewer of *Star Trek* can be defined as "oppositional", while any viewer of art is the dupe of the "dominant classes." To borrow Meaghan Morris' term, it is just as banal to dismiss everyone who ever looks at art as it is to celebrate every consumer of mass culture. In a methodological short cut, "art" has become the oppressive Other for cultural studies that allows popular culture to define itself as popular. The empirical basis for this casual division of culture into two is often derived from Pierre Bourdieu's sociological study of the uses of culture, undertaken in 1963 and 1967–68. By analyzing the responses of a 1,200 person sample, Bourdieu argued that

social class determined how an individual might respond to cultural production. Rather than taste being a highly individual attribute, Bourdieu saw it as a by-product of education and access, generating a "cultural capital" that reinforced and enhanced the economic distinctions of class. His study was an important rejoinder to those who believed that appreciation of "high" culture was simply a mark of intellectual quality that served to distinguish between the intellectual élite and the masses. Art was one of the clearest divisions in Bourdieu's survey. Museum-going was almost exclusively the province of the middle and upper classes (in the European sense of these class distinctions) while the working classes were almost unanimous in disdaining both the value of art in general and modern art in particular. Yet the questions posed to the respondents seemed to seek such answers, making it easier to give generally negative responses to art. People were asked to choose between five statements, three of which provided generally negative responses to art[2] and two specific cases of approval.[3] You could not answer that you liked art in general (Bourdieu 1984: 516–17). Bourdieu's findings simply confirm the prejudices implanted into his questions, that "they" would not like "our" élite culture and must be studied as a discrete phenomenon, the popular.

Furthermore, it is reasonable to question whether a survey based on the stuffy and traditional French museums of the 1960s should continue to determine our attitude to the far more outgoing and approachable museum culture of the 1990s. Bourdieu's research was carried out before the advent of the "blockbuster" museum exhibition and before the shift in grant and donor attention to diversifying museum audiences. While it cannot be denied that there is still a long way to go, the situation is not as clear cut as it might have seemed thirty years ago. When a million people visit a Monet exhibition in Chicago and five million visit New York's Metropolitan Museum annually, art and museums are in some sense a part of mass culture, not its opposite. Nor does Bourdieu's account carry historical weight. The annual Parisian exhibition of painting and sculpture known as the Salon attracted audiences of one million spectators in the mid-nineteenth century and was as popular an event as can be imagined. If we extend the definitions of art beyond the formal realm of the art gallery and museum to include such practices as carnival, quilting, photography and computer-generated media, it quickly becomes obvious that the neat division between "progressive popular culture" and "repressive high art" does not hold. The role played by culture of all varieties is too complex and too important to be reduced to such slogans. This intellectual history creates a difficult legacy for visual culture studies. Visual culture seeks to blend the historical perspective of art history and film studies with the case-specific, intellectually engaged

approach characteristic of cultural studies. As this very integration is precisely what many scholars in these fields have sought to prevent by defining their fields as opposites, visual culture has to proceed by defining both the genealogy of the visual that it seeks to use and its interpretation of the loaded term "culture."

Visuality

Rather than divide visual culture into opposed halves, I shall instead examine how visuality has come to play such a central role in modern life. In so doing, I shall seek to create what Michel Foucault termed a genealogy of visual culture, marking out a broad trajectory for the emergence of contemporary visuality, without pretending to exhaust the richness of the field. That is to say, the task at hand is not a futile quest for the "origins" of modern visuality in past time but a strategic reinterpretation of the history of modern visual media understood collectively, rather than fragmented into disciplinary units such as film, television, art and video. In place of the traditional goal of encyclopedic knowledge, visual culture has to accept its provisional and changing status, given the constantly shifting array of contemporary visual media and their uses.

The constituent parts of visual culture are, then, not defined by medium so much as by the interaction between viewer and viewed, which may be termed the visual event. When I engage with visual apparatuses, media and technology, I experience a visual event. By visual event, I mean an interaction of the visual sign, the technology that enables and sustains that sign, and the viewer. In calling attention to this multiple interaction, I am seeking to advance interpretive strategies beyond the now familiar use of semiotic terminology. Semiotics – or the science of signs – is a system devised by linguists to analyze the spoken and written word. It divides the sign into two halves, the signifier – that which is seen – and the signified – that which is meant. This binary system seemed to offer great potential for explaining wider cultural phenomena. Semiotics gained its strength from its denial of any necessary or causal relationship between the two halves of the sign. A drawing of a tree is taken to signify a tree not because it really is in some way tree-like but because the viewing audience accepts it as representing a tree. It is thus possible for modes of representation to change over time or to be challenged by other means of representation. In short, seeing is not believing but interpreting. Visual images succeed or fail according to the extent that we can interpret them successfully. The idea that culture is understood by means of signs has been a part of European philosophy since the seventeenth century. It has achieved such attention in the last thirty years

because linguists and anthropologists attempted to use the structure of the sign as a means of interpreting the structures of society. Many critics, however, wanted to do much more with the sign. In the first enthusiasm for semiotics, theorists came to believe that all interpretation was a derivative of reading, perhaps because as academics they were so acculturated to reading in their everyday life. As a result, books abounded seeking to describe visual culture as "texts" or to "read" films and other visual media. In this view, any use of a sign is an instance of the total language system. A sign is thus an individual act of speech which stems from the total language system that makes such speech possible. The structuralists, as they came to be known, sought to examine the ways in which people used individual signs in order to understand the "deep structures" of society that generated these individual instances. Led by anthropologist Claude Lévi-Strauss, structuralists hoped to discover the structures that underlay all societies and cultures. Lévi-Strauss, for example, argued that the incest taboo and the distinction between raw and cooked food are two central structures of all societies. However, to all intents and purposes, what we have to work with is the individual instance not the total system. Nor can any sign system ever be regarded as closed – new meanings and ways of creating meaning are constantly available to any language user. If the total system cannot be known, then it is of little use to insist that the concrete example is a manifestation of that system. Thus the sign becomes highly contingent and can only be understood in its historical context. There is not and cannot be a "pure" sign theory that will successfully cross the borders of time and place. Structuralism was in the end unproductive. It may be possible to reduce all texts to a series of formulae but in so doing the crucial differences between and within texts were elided. Visual culture, like any other means of sign analysis, must engage with historical research.

In the visual field, the constructed nature of the image was central to the radical technique of montage in film and photography in the 1920s and 1930s. Montage was the artificial juncture of two points of view to create a new whole, through the use of cross-cutting in film and the blending of two or more images into a new whole in photography. In the early Soviet Union, film-maker Sergei Eisenstein saw montage as a means of conveying the radical experience of the Bolshevik Revolution. Perhaps his most celebrated film chronicled the mutiny onboard the *Battleship Potemkin* during the unsuccessful 1905 uprising that foreshadowed the events of 1917. A particularly dramatic montage combined shots of Tzarist soldiers mowing down the rebels and a close-up of the despairing reaction of a mother who has herself been shot, causing her to let her baby carriage fall down a flight of steps. German photographers John Heartfield and Hannah Hoch took the

technique of montage into the single frame by combining elements from different photographs into one new image. Heartfield continued to use montage politically, blending quotations from Nazi party leaders with satirical illustrations of what they might actually mean. To illustrate Adolf Hitler's claim that "All Germany Stands Behind Us," Heartfield showed the Führer standing in characteristic pose with an upraised arm in salute, montaged with an image of a rich industrialist handing him a wad of money. The result is that Hitler appears to be taking the cash and thus unwittingly illustrates the left-wing contention that the Nazi party was the tool of major capitalist enterprise, rather than the representative of the German people it claimed to be. Whether in film or photography, montage was created in the editing suite or dark room rather than on location. The artificiality of the technique asked spectators to question what it was that they were being shown and to extend that scepticism to more "realistic" images. However, despite these radical usages, it soon became clear that there was nothing *inherently* radical in the new technique. Cross-cutting and the cutaway shot have become Hollywood and soap opera staples, while montage could be used to create effects that were simply absurd or even to serve the political right-wing. In the 1990s, montage is a visual experience of everyday life in a world with fifty "basic" cable television stations in the United States. It is no longer even surprising to call attention to the constructed nature of the sign when Fred Astaire can be seen using a Dirt Devil vacuum cleaner, the image of the late John Wayne sells beer and every MTV video is saturated with montage.

Although literary criticism has moved on from structuralism, it continues to play a surprisingly important role in visual criticism. Mieke Bal, one of the more sophisticated semioticians at work in art history, has recently called this practice "reading art." Her method shares with reading texts that "the outcome is *meaning*, that it functions by the way of discrete visible elements called *signs* to which meanings are attributed; that such attributions of meaning, or *interpretations*, are regulated by rules, named *codes*; and that the subject or agent of this attribution, the reader or viewer, is a decisive element in the process" (Bal 1996: 26). Yet in discussing specific works, this approach fails to convince. For in concentrating solely on linguistic meaning, such readings deny the very element that makes visual imagery of all kinds distinct from texts, that is to say, its sensual immediacy. This is not at all the same thing as simplicity, but there is an undeniable impact on first sight that a written text cannot replicate. It is the feeling created by the sight of the spaceship filling the screen in *2001: A Space Odyssey*, by seeing the Berlin Wall come down on live television, or by encountering the shimmering blues and greens of Cézanne's landscapes. It is that edge, that buzz that separates the

remarkable from the humdrum. It is this surplus of experience that moves the different components of the visual sign or semiotic circuit into a relation with each other. Such moments of intense and surprising visual power evoke, in David Freedberg's phrase, "admiration, awe, terror and desire" (Freedberg 1989: 433). This dimension to visual culture is at the heart of all visual events.

Let us give this feeling a name: the sublime. The sublime is the pleasurable experience in representation of that which would be painful or terrifying in reality, leading to a realization of the limits of the human and of the powers of nature. The sublime was first theorized in antiquity by Longinus who famously described how "our soul is uplifted by the true sublime; it takes a proud flight and is filled with joy and vaunting, as though it has itself produced what it had heard" (Bukatman 1995: 266). The classical statue known as *Laocoon* is typical of the sublime work of art. It shows the Trojan warrior and his children fighting a serpent that will soon kill them. Their futile struggle has evoked the sublime for generations of viewers. The sublime was given renewed importance by Enlightenment philosopher Immanuel Kant who called it "a satisfaction mixed with horror." Kant contrasted the sublime with the beautiful, seeing the former as a more complex and profound emotion leading a person with a taste for the sublime to "detest all chains, from the gilded variety worn at court to the irons weighing down the galley slave." This preference for the ethical over the simply aesthetic has led Lyotard to revive the sublime as a key term for postmodern criticism. He sees it as "a combination of pleasure and pain: pleasure in reason exceeding all presentation, pain in the imagination or sensibility proving inadequate to the concept" (Lyotard 1993: 15). The task of the sublime is then to "present the unpresentable," an appropriate role for the relentless visualizing of the postmodern era. Furthermore, because the sublime is generated by an attempt to present ideas that have no correlative in the natural world – for example, peace, equality, freedom – "the experience of the sublime feeling demands a sensitivity to Ideas that is not natural but acquired through culture" (Lyotard 1993: 71). Unlike the beautiful, which can be experienced in nature or culture, the sublime is the creature of culture and is therefore central to visual culture. Of course, the representation of natural subjects can be sublime, as in the classic example of a shipwreck or storm at sea. However, the direct experience of a shipwreck cannot be sublime because one would presumably experience only pain and the (sublime) dimension of pleasure would be missing.

However, there is no question of a blanket endorsement of Lyotard's reworking of Kant. On the one hand, Kant dismissed all African art and religion as "trifling;" as far removed from the sublime as he could imagine.

To less prejudiced eyes, African sculptures like the nail-laden *minkisi* power figures (see chapter 5) are remarkable instances of the combination of pleasure and pain that creates the sublime, as well as being motivated by the desire to show the unseeable. This naive Eurocentrism is not directly commented on by Lyotard but is echoed in his endorsement of a very traditional chronology of the avant-garde, in which the Impressionists give way to Cézanne who was demolished by the Cubists, in turn challenged by Marcel Duchamp. Any student who has taken an introductory art history class will recognize this pattern, which privileges the rise of abstraction as the pre-eminent story of modern art. Yet by now, and even when Lyotard was writing in 1982, it is clear that abstraction has ceased to be useful in destroying the contemporary sense of reality. Indeed, it has become a trivial part of that reality, signified most notably by the predilection of corporate buyers and sponsors for abstract art. When the great works of abstraction sit comfortably in the corporate boardroom, can it really continue to be a means to challenge what Lyotard rightly calls the "victory of capitalist technoscience"? When Philip Morris, the multinational tobacco company, enjoys sponsoring modern art retrospectives, like those of Picasso and Robert Rauschenberg in New York, under the slogan "The Spirit of Innovation"– suggesting of course that the true innovator defies convention and smokes – then the history of modernism has come to be repeated as farce.

The (post)modern destruction of reality is accomplished in everyday life, not in the studios of the avant-garde. Just as the Situationists collected examples of the bizarre happenings that pass as normality from the newspapers, so can we now see the collapse of reality in everyday life from the mass visual media. In the early 1980s, postmodern photographers like Sherrie Levine and Richard Prince sought to question the authenticity of photography by appropriating photographs taken by other people. This dismissal of photography's claim to represent the truth is now a staple of popular culture. The cover story on the *Weekly World News* for February 25, 1997 was a follow-up to their 1992 "story" of the discovery of the skeletons of Adam and Eve in Denver, Colorado. Further analysis of the photograph now showed the skeleton of a baby girl, disclosing that the first couple had a hitherto unknown daughter. The subhead reads: "Puzzled Bible experts ask: Did Cain and Abel have a little sister?" The technique of enlarging photographs to reveal significant details is routinely used in surveillance and spy operations and was a standard device in films like *Bladerunner* and *Rising Sun*, enabling the heroes to make key breakthroughs in their cases. The *Weekly World News* parody offers an amusing counterpart to such beliefs in the power of photography to reveal hidden truths. At the same time, it contributes to a climate of suspicion in which O.J. Simpson's lawyer can plausibly dismiss a

photograph showing his client wearing the rare Bruno Magli shoes worn by the killer as fakes, only to be outdone when thirty more pictures were discovered. One photograph alone no longer shows the truth.

In fact some of the most avidly followed television series take reality apart in order to convey to their viewers a convincing sense of the experience of everyday life. Soap operas set aside the conventions of realistic drama in terms of style, content and narrative. The key element that distinguishes soap from other television drama is its open, serial form. A soap should ideally run for years on end in numerous episodes, like the daytime classic *All My Children* which has featured five times a week on ABC for over twenty years. Viewers have watched key characters like Erica Kane grow from teenager to middle-age through extraordinary adventures. In this unusually long time-frame, the return of a long-lost twin brother is scarcely cause for comment and the apparent death of a character is not to be taken as any indication that he or she will not later return. Characters in *All My Children* routinely hold conversations in which both parties are standing facing the camera. In order to facilitate these scenes, all the actresses are a head

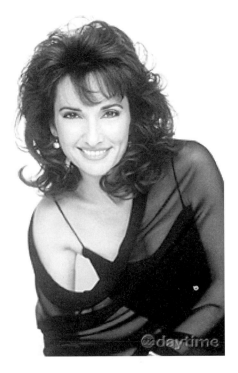

Figure 2 Erica Kane from *All My Children*

shorter than the actors. Such devices are essential because soap is essentially structured around talk, especially the spread of information as gossip or rumor and the extensive working out of the problems caused by such talk. Far from feeling patronized by the artificiality of soap opera, its viewers regard acquiring an understanding of the visual and textual conventions of a particular show as part of the pleasure of watching. Further commentary and information are now available on official and unofficial websites. Just as it may take years for an uninitiated viewer to understand baseball or cricket broadcasts, a true soap opera viewer is formed in years, not weeks. As Robert C. Allen puts it, "Denied the omnipotent reading position to be found in more closed narrative forms, soap opera viewers are asked to relate to the diegetic families of their serials as they are expected to do to their own. They must exercise patience and tolerance in the face of unending tribulation, wresting pleasure from consolation and sympathy rather than from any expectation of final resolution" (Allen 1995: 7). In this sense, the experience of soap opera is in fact more realistic than the average "serious" drama which neatly wraps up all its loose ends in an hour.

Researchers who have turned their attention to soap have found that the complex narrative structure of the serials allow viewers a similarly complex viewing experience. Louise Spence argues that soap opera's slow unfolding means that it is experienced in the present, rather than the traditional past tense of the novel or play. In this conflation of soap reality and the viewer's reality, "viewers always bring some idea of 'reality' into the viewing process, testing the fiction for 'plausibility,' according to the worlds they know (both fictional and real), and adding their private associations to the specific sounds and images broadcast" (Spence 1995: 183). This completion of the text by the viewer sounds intriguingly like the techniques advocated by avant-garde filmmakers, as Charlotte Brunsdon has famously argued: "Just as a [Jean-Luc] Godard film requires the possession of certain forms of cultural capital on the part of its audience to 'make sense' – an extra-textual familiarity with certain artistic, linguistic, political and cinematic discourses – so too does . . . soap opera" (Brunsdon 1997: 17). However, because soap opera has traditionally been watched primarily by women these complex viewing skills have been seen as less important than those required by the "serious," hence masculine, world of avant-garde film. Even now that soaps are watched by both sexes and even feature gay and lesbian characters, it is still seen as a "feminine," trivial medium because of its very popularity (Huyssen 1986).

In 1997, ABC decided that U.S. soap opera viewers would benefit from a more up-to-date visual style and a more realistic setting. They transferred a group of characters from a failing soap called *Loving* to New York City and

established a new series called *The City*. The show was set at a real address on Greene Street in SoHo in the heart of New York's art world and fashion scene. To reinforce this contemporary feel, the show utilized fashionable techniques like fast-cutting and hand-held cameras, derived from MTV and now imported to evening dramas like *NYPD Blue*. However, neither the location nor the style were suited to the open seriality of American daytime television. Viewers' awareness of the constantly changing cityscape of New York undercut the plausibility of the continuity essential to the medium. Visual techniques intended to speed up the narrative of a 3-minute music video or 50-minute drama were also against the grain of the everyday feel of daytime television. Unsurprisingly, the show was cancelled in 1997. In the different context of British television, where there are relatively few soap operas, the BBC had a success with *This Life*, using exactly the same fashionable visual techniques. However, *This Life* had an evening slot on BBC2 as a "continuing drama" where it did not need to adhere to the conventions of American daytime television, and in fact the series concluded in August 1997.

Soap is perhaps the most international visual format, commanding national attention in countries as disparate as Russia, Mexico, Australia, and Brazil. Soap creates its own reality to such an extent that Mexican telenovelas are the most watched shows on Russian television, where a soap called *The Rich Also Cry* commanded a 70 percent audience share in 1992. These exports are a striking economic achievement, consistent with the global domination of the television export market by companies like Televisa and RedeGlobo. At the same time, Spanish-language telenovelas broadcast in the United States help create a Latina/Latino identity for their viewers (Barker 1997: 87–9). Meanwhile, life grinds to a halt daily in Trinidad for the American soap *The Young and the Restless*. Despite the obvious material differences between the average Trinidadian and the fantasy life of American soaps, one viewer expressed a widely-held belief that "people [in Trinidad] look at it because it is everyday experience for some people. I think people pattern their lives on it" (Miller 1995: 217). Furthermore, Trinidadians create their own meanings from the show, which is seen as exemplifying the island's carnivalesque approach to life known as "bacchanal" and the "commess," or confusion, that results from it. Soap is not simply idle pleasure but can have significant political importance. It became part of the solution to the Bosnian crisis in 1998. After the ousting of the extremist government loyal to indicted war criminal Radovan Karadzic in the Serbian Republic of Bosnia, Serbian television responded by cutting off pirated copies of the immensely popular Venezuelan soap "Kassandra." The United States government intervened to obtain legal copies of the show from the American-based

distributors in order to prevent disaffection with the new regime (*New York Times* February 11, 1998). Reality is being reconfigured daily in hour-long slots across the globe.

Popular visual culture can also address the most serious topics with results that traditional media have sometimes struggled to achieve. One of the most profound challenges facing any contemporary artist is the question of how or whether to represent the Nazi Holocaust. When the philosopher Theodor Adorno dismissed any attempt to write lyric poetry after the Holocaust as "barbaric," many extended his thoughts to all representations of the Shoah, in keeping with the feelings of many survivors that in the face of such enormity, only silence was appropriate. At the same time, others believe that is crucial to revisit and remember these terrible events in the hope of making them impossible in the future. At the time of writing, controversies over Swiss banking during the war and new accounts of the culpability of ordinary Germans have put the issue back onto the front pages. In his remarkable comic book *Maus*, Art Spiegelman has directly addressed these issues in a format more often devoted to the adventures of caped super-heroes. Spiegelman used a deliberately simple graphic style, showing the Jews as mice and the Germans and Poles as dogs or pigs in the manner of George Orwell's *Animal Farm*. The very direct visual style was combined with a remarkable narrative sophistication using a flashback format to describe the events of the Holocaust while also depicting his complex relationship with his father and how this influenced his story. As a result, Spiegelman was able to approach some of the complexities of his subject that other accounts had to elide. For instance, Stephen Spielberg's film *Schindler's List* showed scenes of Jews scheming to enrich themselves in the early stages of the war, seeming to play up old stereotypes while celebrating Schindler's own profiteering. By constrast, the Spiegelman mouse worries that the depiction of his father Vladek might appear "just like the racist caricature of the miserly old Jew." His stepmother Mala retorts: "You can say that again!" In this way, Spiegelman allows the reader to see the situation from several points of view. Vladek's hoarding tendencies drive his contemporary American family mad. On the other hand, this same characteristic was vitally useful in helping him and his wife Anja survive the camps. Most importantly, by allowing Jews to make the criticism, he shows that thrifti-ness is a personal rather than ethnic characteristic. These nuances are achieved in a few frames, providing compelling testimony of the power of visual media when well handled to approach even the most complex moral issues.

At this point, many readers will be tempted to use the "common sense" retort. That is to say, common sense tells us that there is no need

to over-intellectualize the moment of looking. It is entirely obvious who looks, who is looked at and why. However, some reflection might lead us to conclude that looking is not as straightforward an activity as might be supposed. Why, for example, can the United States Supreme Court provide no better definition of obscenity than "I know it when I see it"? The Court has distinguished between the "indecent," which is permissible and the "obscene," which is not. However, while everyone understands the concept of pornography, it is hard to get any substantial number of people to agree what becomes obscene and therefore should be banned. When the city of Cincinnati prosecuted its own museum for exhibiting the photographs of Robert Mapplethorpe, the prosecution felt the obscenity of his work was such that it only needed to be shown to a jury for a conviction to follow. After listening to a number of museum curators and art historians, the jury disagreed. Similarly, in striking down the Communications Decency Act (1996), which sought to ban "indecent" material on the Internet, the United States Third Circuit Court of Appeals found the Act's definition of indecency hopelessly vague. The Act held to be indecent anything that: "in context, depicts or describes, in terms patently offensive as measured by contemporary community standards, sexual or excretory activities or organs." Chief Judge Dolores K. Sloviter saw the possibility that such general terms could be used to prosecute the contemporary equivalents of James Joyce's novel *Ulysses*, banned for obscenity on publication and now universally regarded as a classic. Neither truth nor obscenity are plain to see any longer. Milos Forman made his film *The People vs Larry Flynt* as a celebration of the First Amendment, but many feminists saw it instead as glorifying the degradation of women in *Hustler*. This crisis of truth, reality and visualizing in everyday life is the ground on which visual culture studies seeks to act.

Culture

For many critics, the problem with visual culture lies not in its emphasis on the importance of visuality but in its use of a cultural framework to explain the history of the visual. A 1996 survey published in the art journal *October* seemed to demonstrate a widespread nervousness amongst art historians that the cultural turn would lead to the relativizing of all critical judgement. Speaking from the eminence of Yale University, art historian Thomas Crow saw visual culture as being to art history what New Age mysticism is to philosophy. He thundered: "To surrender [the] discipline to a misguidedly populist impulse would universally be regarded as the abrogation of a fundamental responsibility" (*October* 1996: 35). Crow takes it to be self-

evident that his condescending reference to the "mass-market bookstore"—his only argument as to why a democratic approach to visual media would be "misguided"— will produce a sympathetic shudder of horror in his readers. Much of the rest of the survey was devoted to demolishing what Carol Armstrong called the "predilection for the disembodied image" that is oddly attributed to visual culture (*October* 1996: 27). It may seem surprising that formalist art historians would be so concerned at these supposed practices, but, as Tom Conley pointed out, they are using a "fraudulent" scare tactic designed to distract from the pleasure of realizing that visual culture "cannot find a disciplinary place" (*October* 1996: 32) and therefore challenges the cozy familiarity of traditional university power structures.

The rush to condemn culture as a frame of reference for visual studies relies on it being possible to distinguish between the products of culture and those of art. However, any examination of the term quickly shows that this is a false opposition. Art is culture both in the sense of high culture and in the anthropological sense of human artifact. There is no outside to culture. Rather than dispose of the term, we need to ask what it means to explain certain kinds of historical change in a cultural framework How does visual culture relate to other uses of the term culture? Using culture as a term of reference is both problematic and inescapable. Culture brings with it difficult legacies of race and racism that cannot simply be evaded by arguing that in the (post)modern period we no longer act as our intellectual predecessors did, while continuing to use their terminology. Nor can an assertion of the importance of art – whether as painting, avant-garde film or video – escape the cultural framework.

For, as Raymond Williams famously observed, culture is "one of the two or three most complicated words in the English language." The term acquired two meanings in the nineteenth century that continue to shape popular and academic understandings of the cultural. In 1869, the English scholar Matthew Arnold published an influential book entitled *Culture and Anarchy* which posed the two terms as opposites in conflict. Arnold was later influentially to define culture as the product of élites: "the best that has been thought and known." For many scholars and general consumers of literature and the arts, this sense of culture as high culture remains the most important meaning of the term. It was adopted by art critic Clement Greenberg in his famous essay "Avant-garde and Kitsch" (1961), which defended the avant-garde project of modernist high art against the mass-produced vulgarities of kitsch. However, culture was also used in a different sense as being the entire social network of a particular society. It is in this sense that we speak of someone being from a particular culture. For the Victorian anthropologist E.B. Tylor and many subsequent anthropologists, the key question was not

to determine what were the best intellectual products of a particular time and place but to understand how human society came to construct an artificial, non-natural and hence cultural way of life. Tylor introduced the notion in his book *Primitive Culture* (1871): "Culture or Civilization, taken in its widest ethnographic sense, is that complex whole which includes knowledge, belief, art, morals, law, custom, and any other capabilities and habits acquired by man as a member of society" (Young 1995: 45). Anthropology thus subsumed not just the visual arts and crafts but all human activity as its field of enterprise.

Clearly, cultural studies and visual culture owe their sense of culture as an interpretive framework far more to Tylor than to Arnold. This legacy is not without its problems. Tylor was a firm believer in race science, arguing that "a race may keep its special characters for over thirty centuries, or a hundred generations" (Young 1995: 140). Thus, while evolution of different races was possible in theory, Tylor here asserted that there had been no important change throughout recorded human history, setting the different races at very different levels of attainment. In other words, different human societies manifested different stages of human evolution, allowing the anthropologist to read the story backwards. The anthropological sense of culture came to rely on a contrast between the modern present time of the (white, Western) anthropologist and the pre-modern past of his or her (non-white, non-western) subject. This linear model of evolution was made intelligible by being visualized, a process anthropologist Johannes Fabian has called visualism: "The ability to visualize a culture or society almost becomes synonymous with understanding it" (Fabian 1983: 106). This visualism is strikingly similar to the postmodern desire to visualize knowledge and forces us to examine whether visual culture can escape this racialized inheritance.

In finding a way out of the culture labyrith, visual culture develops the idea of culture as expressed by Stuart Hall: "Cultural practice then becomes a realm where one engages with and elaborates a politics." Politics does not refer to party politics but to a sense that culture is where people define their identity and that it changes in accord with the needs of individuals and communities to express that identity. In the global diaspora of the postmodern world, transcultural approaches will be a key tool. Both the anthropological and artistic models of culture rest on being able to make a distinction between the culture of one ethnicity, nation, or people and another. While it has been important to deploy what Gayatri Spivak called a "strategic essentialism" in order to validate the study of non-white and non-Western visual culture in its own right, it is now important to do the hard work of moving beyond such essentialism towards an understanding of the

plural realities that coexist and are in conflict with each other both in the present and in the past. The wrong way to do this is already much in evidence, as an insistence on a return to the High Modernist tradition. Visual culture, by contrast, must describe what Martin J. Powers has called "a fractal network, permeated with patterns from all over the globe." There are several implications to recasting visual culture as fractal, rather than linear. First, it precludes any possibility that any one overarching narrative can contain all the possibilities of the new global/local system, for fractals may always be extended. Second, a fractal network has key points of interface and interaction that are of more than ordinary complexity and importance. For example, the detail of a Mandelbrot pattern can be observed more and more closely until it suddenly opens into another "layer" of the pattern. Thus the "culture" section of this volume looks at a number of specific instances of the intersection of race, class and gender in visual media in order to elucidate their complex operations. While Modernism might have cast these patterns into a disciplinary grid, the network is now a far more satisfactory model for the dissemination of visual culture. Powers does not simply argue for an all-inclusive World Wide Web of the visual image, but emphasizes the power differentials across the network. At present, it must be recognized that visual culture remains a discourse of the West about the West but in that framework "the issue", as David Morley reminds us, "is how to think of modernity, not so much as specifically or *necessarily* European . . . but only contingently so" (Morley 1996: 350) – see chapters 4 to 6. Seen in the long span of history, EurAmericans, to use the Japanese term, have dominated modernity for a relatively brief period of time that may well now be drawing to a close.

Western culture has sought to naturalize these histories of power. Perhaps the most glaring instance of such condescencion in recent times was the 1984 exhibition "Primitivism in 20th Century Art: Affinity of the Tribal and the Modern" at New York's Museum of Modern Art. Here works by leading European modernists such as Picasso and Giacometti were exhibited alongside works of art from African and Oceanian cultures as if the only function of these objects was to be appropriated as a formal influence by Western artists. The pieces displayed were alotted no value or meaning in themselves except as sources for the superior modernist artists the exhibition wished its audience to focus upon. A decade later curator William Rubin sees nothing wrong in this strategy: "Modernism is a modern Western tradition, not an African or Polynesian one. What should be wrong with MoMA showing tribal art within the context of its interests?" (Grimes 1996: 39) The problem lies in the assumption that the "West" is a hermetically sealed cultural entity, whose border patrols may allow in other cultures as sources

for Western ideas but never as equal and interactive entities. In forming approaches to visual culture, a key task is to find means of writing and narration that allow for the transcultural permeability of cultures and the instability of identity. For despite the recent focus on identity as a means of resolving cultural and political dilemmas, it is increasingly clear that identity is as much a problem as it is a solution for those between cultures – which, in the global diaspora of the present moment, means almost all of us. The Peruvian-born artist Kukuli Verlade Barrioneuvo has given this dilemma eloquent expression:

> I am a Westernized individual. I do not say I am a Western individual, because I did not create this culture – I am a product of colonization. . . . We have to face that reality. To face it is to acknowledge my mixed race, to acknowledge that I am not Indian, and that I am not white. That does not mean I have an ambiguity, but that I have a new identity: the identity of a colonized individual. I feel hurt when I see what colonization has made of the people I come from – the mixed race. I am not an Indian person, I have both heritages.
>
> (Miller 1995: 95)

This experience of two or more heritages combining to form a new third form is what I shall call transculture, following Fernando Ortiz. The "culture" in visual culture will seek to be this constantly changing dynamic of transculture, rather than the static edifice of anthropological culture (see chapter 4).

Everyday life

The transcultural experience of the visual in everyday life is, then, the territory of visual culture. How can we determine what should be called "everyday life"? Henri Lefebvre argued in his influential *Introduction to Everyday Life* that it is a key site of the interaction between the everyday and the modern: "two connected, correlated phenomena that are neither absolutes nor entities: everyday life and modernity, the one crowning and concealing the other, revealing it and veiling it" (Lefebvre 1971: 24). Visual experience in this sense is an event resulting from the intersection of the everyday and the modern that takes place across the "wandering lines" marked by consumers traversing the grids of modernism (de Certeau 1984: xviii). In his analysis of *The Practice of Everyday Life*, Michel de Certeau celebrated patterns of "[d]welling, moving about, speaking, reading, shopping and cooking" that

seemed to offer a range of tactics to the consumer beyond the reach of the surveillance of modern society (de Certeau 1984: 40).

The consumer is the key agent in postmodern capitalist society. Capital began as money, the means of exchange between goods, and was accumulated through trade. It achieved independence in the early stages of capitalist culture as finance capital, generating interest on investments and loans. In Marxist analysis, capitalism creates profit by exploiting the difference between the revenue generated by hired labor and the amount it costs to hire that labor. This "surplus value" was the basis for Marxist economics and politics for a century after the publication of *Capital* in 1867. Yet it is now clear that capital continues to generate profits far in excess of any surplus value that can be extracted from individual workers. Capital has commodified all aspects of everyday life, including the human body and even the process of looking itself. In 1967 the Situationist critic Guy Debord named what he called the "society of the spectacle," that is to say, a culture entirely in sway to a spectacular consumer culture "whose function is to make history forgotten within culture" (Debord 1977: 191). In the society of the spectacle, individuals are dazzled by the spectacle into a passive existence within mass consumer culture, aspiring only to acquire yet more products. The rise of an image dominated culture is due to the fact that "[t]he spectacle is *capital* to such a degree of accumulation that it becomes an image" (Debord 1977: 32). One of the most striking examples of this process is the all but autonomous life of certain corporate logos, like the Nike swoosh or McDonalds' Golden Arches, which are inevitably legible in whatever context they are encountered. The connection between labor and capital is lost in the dazzle of the spectacle. In the spectacular society we are sold the sizzle rather than the steak, the image rather than the object.

Jonathan L. Beller has termed this development the "attention theory of value" (Beller 1994: 5). Media seek to attract our attention and in so doing create a profit. Thus the modern film costs a spectacular amount of money in order to catch our jaded attention and thus turn a profit on its investment. However, given that over three-quarters of Hollywood movies fail, it is a high-risk enterprise that only the most wealthy corporations can afford to underwrite. Cinema is in fact archetypal of the capitalist enterprise in Beller's analysis: "Assembly line production, which entails the cutting and editing of matter/capital is a proto-cinematic process, while the circulation of commodities was a form of proto-cinema – images, abstracted from the human world and flowing just out of reach" (Beller 1996: 215). Yet, as consumer capitalism continued to accelerate, it soon became clear that Debord's society of the spectacle was itself the product of the postwar consumer boom, rather than a newly stable form of modern society. French

philosopher Jean Baudrillard announced the end of the society of the spectacle in 1983. Instead, he declared the age of the "simulacrum," that is to say, a copy with no original. The simulacrum was the final stage of the history of the image, moving from a state in which "it masks the *absence* of a basic reality" to a new epoch in which "it bears no relation to any reality whatever: it is its own pure simulacrum" (Baudrillard 1984: 256). Baudrillard's famous example was the theme park Disneyland which he saw as existing "to conceal the fact that it is the 'real' country, all of 'real' America, which is Disneyland" (Baudrillard 1984: 262). Behind this simulacrum lay "the murderous capacity of images, murderers of the real." Baudrillard's nostalgia for a past in which a "basic reality" could actually be experienced is analogous to the American critic Fredric Jameson's Marxist critique of what he sees as the image culture of "late capitalism" (Jameson 1991). For the pattern of modernity described by Lefebvre and de Certeau can no longer be used as the backdrop to everyday life. Far from being unknown, patterns of consumption are mapped with remarkable precision by ATMs, credit cards, and check-out scanners, while urban movement is recorded by police and other security scanners.[4] There is a generalized sense of crisis in everyday life, without any clear solutions being available.

In his analysis of the global culture of postmodernism, Arjun Appadurai has highlighted several new components of contemporary life that move us beyond de Certeau's celebration of local resistance. Firstly, Appadurai notes a consistent tension between the local and the global, the one influencing the other and vice versa that he terms the interaction between homogenization and heterogenization (Appadurai 1990: 6). As a result, it no longer makes sense to locate cultural activity solely within national or geographic boundaries, as in the terms Western culture, French film, or African music. To take the last example, much African music is now distributed and produced in Paris rather than on the continent itself. That is not to say that it is no longer African and has become French but that the geographical location of cultural practice is not the key to its definition. The local, subcultural approach of so much cultural studies work has been overtaken by the complexities of the global cultural economy. Appadurai proposes that this economy is dominated by

> a new role for the imagination in social life. To grasp this new role, we need to bring together: the old idea of images, especially mechanically produced images . . .; the idea of the imagined community (in Anderson's sense); and the French idea of the imaginary, as a constructed landscape of collective aspirations The image, the imagined and the imaginary – these are

all terms which direct us to something critical and new in global
cultural processes: *the imagination as a social practice.*"

<div align="right">(Appadurai 1990: 5)</div>

At stake is a relationship between the globalization of culture, the new forms
of modernity and the mass migrations and diasporas that mark the present
moment as being distinct from the past.

For many, the difficulty of imaging and imagining this constantly changing
situation is experienced as a crisis. Describing the collapse of everyday life in
Cameroon that has unfolded since 1990, Achille Mbembe points to the
breakdown in the modern apparatus of circulation, such as traffic regulations,
skyscrapers, electric lighting and automobiles. In this moment, "the physi-
cality of the crisis reduces people to a precarious position that affects the very
way in which they define themselves." The sudden failure of the capitalist
mode of circulation does not lead simply to poverty but to a situation in
which "Cameroonian society's long-standing capacity to 'imagine' itself in a
certain manner – to mentally author, and from this, institute itself – has been
contradicted and now seems thrown into question" (Mbembe 1995). Of
course, such dilemmas are not limited to Central Africa but could equally
apply to parts of Russia, Italy and American cities like Washington D.C. In
order for these new forms of social practice to be comprehensible, they will
have to be imagined and imaged – visualized – in ways that go beyond the
"imagined community" of the nation-state or the daily life imagined by
individuals in de Certeau's analysis. Appadurai asserts that "The work of
the imagination . . . is neither purely emancipatory nor entirely disciplined
but is a space of contestation in which individuals and groups seek to annex
the global into their own practices of the modern Ordinary people have
begun to deploy their imaginations in the practice of their everyday lives"
(Appadurai 1997: 4–5). In this new situation, cultural studies will have to
modify its traditional preference for identifying and celebrating the sites of
resistance in everyday life, while dismissing other aspects of the quotidian as
banal or even reactionary. New patterns of the imagination are being created
in highly unpredictable fashion. Who, for example, might have anticipated
that the death of a flamboyant princess would have mobilized the global
popular imagination as it did in September 1997 (see chapter 7)? As Irit
Rogoff observes, individuals create unexpected visual narratives in everyday
life from "the scrap of an image [which] connects with a sequence of a film
and with the corner of a bill board or the window display of a shop we have
passed by" (Rogoff 1998). Such everyday visual experience, from the Internet
to the Met, is still beyond the reach of the spin doctors, pollsters and other
demons of the contemporary imagination.

In this moment, it is becoming clear that a new pixelated mode of global intervisuality is being formed that is distinct from the cinematic assembly-line image and from the simulacrum of 1980s postmodern culture. In the nineteenth century, photography transformed the human memory into a visual archive. By the early twentieth century, Georges Duhamel complained that: "I can no longer think what I want to think, the moving images are substituted for my own thoughts." Confronted with the question of whether photography was art, Marcel Duchamp said that he hoped photography would "make people despise painting until something else will make photography unbearable." The pixelated image has made photography unbearable, both literally as Princess Diana's relationship to the paparazzi attests, but also metaphorically. In the work of contemporary photographers like Cindy Sherman, David Wojnarowicz and Christian Boltanski, photography is unbearable in the sense that it is sublime.

The pixelated image is perhaps too contested and contradictory a medium to be sublime. As a means of image creation, the pixelated screen is created of both electronic signals and empty space. A pixel, a term derived from the phrase "picture element," composes the electronic image of the television or computer monitor. Pixels are not just points of light but are also memory units, with the number of pixels possible depending on computer memory or signal bandwidth. Even the most sophisticated screen has a certain emptiness to it, even if that space is invisible in high bandwidth media like television, but which can be clearly seen in the low-resolution media favored by many contemporary film and video makers, not to mention the computer screens that most people use. Unlike photography and film which attested to the necessary presence of some exterior reality, the pixelated image reminds us of its necessary artificiality and absence. It is here and not here at once. It is interactive but along lines clearly set by the global corporations that manufacture the necessary computer and television equipment. The global freedoms of the Internet are only possible because of the Cold War need to create an indestructible communications network. Life in the pixel zone is necessarily ambivalent, creating what might be called "intervisuality."

For providers – those who used to be called artists, film and video makers, television programmers and so on – what is at stake is the difficult task entitled "Capturing Eyeballs" by the futuristic *Wired* magazine (October 1997). This task is of such weight to the new forms of the capitalist economy that it has transformed leisure into a new form of work. This process has already been fully realized in the United States' film industry. On any given Friday night at the two peak seasons of summer and the Christmas holiday season, as many as a dozen major new films may open in American cinemas. By Saturday night, their fates will be determined by the first two days'

receipts. Subsequent screen bookings, length of theater release and speed of descent to the film hell of airplane and video programming are all set in motion. For the consumer, this means that going to a film represents a strategic choice as to what will be available in the subsequent weeks and beyond. Serious fans of Woody Allen or *Star Trek* movies may choose to catch what they suspect to be an inferior version of the genre just to ensure that there will be another, hopefully better, one. The highly engaged fans of *Titanic* rewrote the rules for screen bookings by continuing to see the film over and over again. As a result, media ranging from the tabloid TV show *Entertainment Tonight* to the austere *New York Times* all carry details of box-office receipts that would formerly have been published only in *Variety*. This visual engagement has extended not just to individual programming in film, television and the Internet but to what kinds of visual media will continue to be available. We are all engaged in the business of looking. Where our eyes alight determines what it is possible to see. You may choose to use Netscape as your Internet browser, only to find that certain sites are inaccessible without Microsoft Explorer. That choice will help determine the future of the Internet. Entire formats, like Digital Video Disk and WebTV, will succeed or fail according to their ability to attract new users. In this complex interface of reality and virtuality that comprises intervisuality, there is nothing everyday about everyday life any more. Visual culture used to be seen as a distraction from the serious business of text and history. It is now the locus of cultural and historical change.

Notes

1 Jameson's comment also falls into what Eric Michaels called "the fallacy of the unilineal evolution of culture," in assuming that reading was somehow a higher evolutionary stage of human intelligence than visual formats, while ignoring the self-evidently visual nature of reading (Michaels 1994: 82–83).

2 Paintings don't interest me. Galleries aren't my strong point; I can't appreciate them. Paintings are nice but difficult; I don't know enough to talk about them.

3 I love the Impressionists. Abstract painting interests me as much as the classical schools.

4 Many of these technologies were in use in the United States by the early 1980s but only reached Europe towards the end of the decade. France itself now has gained ubiquitous access to the *Carte Bleu* credit card and cash dispensing net-work, as well as the national information system Minitel.

Bibliography

Allen, Robert C. (1995), *To Be Continued: soap operas around the world*, London, Routledge.

Appadurai, Arjun (1990), "Disjuncture and Difference in the Global Cultural Economy," *Public Culture* 2 (2), Spring.

—— (1997), *Modernity at Large: Cultural Dimensions of Globalization*, Minneapolis, Minnesota University Press.

Aquinas, St Thomas (1951), *Commentary on Aristotle's "De Anima,"* trans. K. Foster and S. Humphries, London.

Bal, Mieke (1996), "Reading Art," in Griselda Pollock (1996).

Barber, Benjamin R. (1995), *Jihad vs. McWorld*, New York, Times Books.

Barker, Chris (1997), *Global Television: An Introduction*, Oxford, Blackwell.

Barthes, Roland (1981), *Camera Lucida: Reflections on Photography*, New York, Noonday.

Batchen, Geoffrey (1996), "Spectres of Cyberspace," *Artlink* 16 (2 & 3), Winter: 25–28.

Baudrillard, Jean (1984), "The Precession of Simulacra," in Brian Wallis (ed.), *Art After Modernism: Rethinking Representation*, New York, New Museum of Contemporary Art.

Beller, Jonathan L. (1994), "Cinema, Capital of the Twentieth Century," *Postmodern Culture* 4 (3), May 1994.

—— (1996), "Desiring the Involuntary," in Rob Wilson and Wimal Dissanayake (eds), *Global/Local: Cultural Production and the Transnational Imaginary*, Durham, NC, Duke University Press.

Bourdieu, Pierre (1984), *Distinction: A Social Critique of the Judgement of Taste*, Cambridge, MA, Harvard University Press.

Bhabha, Homi (1994), *The Location of Culture*, London, Routledge.

Brewer, John and Bermingham, Ann (1995), *Consumption and Culture*, London, Routledge.

Brunsdon, Charlotte (1997), *Screen Tastes*, London, Routledge.

Bryson, Norman, Holly, Michael Ann and Moxey, Keith (1994), *Visual Culture: Images and Interpretations*, Hanover and London, Wesleyan University Press.

Buck-Morss, Susan (1989), *The Dialectics of Seeing: Walter Benjamin and the Arcades Project*, Cambridge, MA, MIT Press.

Bukatman, Scott (1995), "The Artificial Infinite," in Lynne Cook and Peter Wollen, *Visual Display: Culture Beyond Appearances*, Seattle, Bay Press.

Butler, Judith (1990), *Gender Trouble*, New York, Routledge.

Debord, Guy (1977), *The Society of the Spectacle*, London, Black and Red.

De Certeau, Michel (1984), *The Practice of Everyday Life*, trans. Stephen F. Rendall, Berkeley and Los Angeles, University of California Press.

Fabian, Johannes (1983), *Time and the Other*, New York, Columbia University Press.

Foucault, Michel (1998), "Nietzsche, Genealogy, History," in *Michel Foucault:*

Aesthetics, Method, Epistemology, James D. Faubion (ed.), New York, New Press.

Freedberg, David (1989), *The Power of Images: Studies in the History and Theory of Response*, Chicago, IL, Chicago University Press.

Greenberg, Clement (1961), "Avant-garde and Kitsch," in *Art and Culture*, Boston, MA, Beacon Press [1939].

Grimes, William (1996), "A Portrait of a Curator Amid Grand Finale of Picassos," *New York Times*, Section 2, May 5: 1, 39.

Heidegger, Martin (1977), "The Age of the World Picture," in William Lovitt trans., *The Question Concerning Technology and Other Essays*, New York and London, Garland.

Huyssen, Andreas (1986), *After the Great Divide: Modernism, Mass Culture, Postmodernism*, Bloomington, Indiana University Press.

Jameson, Fredric (1990), *Signatures of the Visible*, New York, Routledge.

—— (1991), *Postmodernism*, Durham, NC, Duke University Press.

Jenks, Christopher (1995), *Visual Culture*, London, Routledge.

Kushner, David (1997), "Networks Hatch Plans for Digital TV," *Wired News* November 14.

Lefebvre, Henri (1971), *Everyday Life In the Modern World*, trans. Sacha Rabinovich, New York, Harper and Row.

Lyotard, Jean-François (1993), *The Postmodern Explained*, Minneapolis, Minnesota University Press.

Mbembe, Achille (1995), with Janet Roitman, "Figures of the Subject in Times of Crisis," *Public Culture* 7: 323–352.

McNair, Brian (1995), *An Introduction to Political Communication*, London, Routledge.

Miller, Daniel (1995), "The Consumption of Soap Opera: 'The Young and the Restless' and Mass Consumption in Trinidad," in Allen (1995).

Miller, Ivor (1995), "We the Colonized Ones: Kukuli Speaks," *Third Text 32*, Autumn 1995: 95–102.

Mitchell, W.J.T. (1994), *Picture Theory*, Chicago, IL, Chicago University Press.

Morley, David (1996), "EurAm, modernity, reason and alterity: or, postmodernism, the highest stage of cultural imperialism," in David Morley and Kuan-Hsing Chen (eds), *Stuart Hall: Critical Dialogues in Cultural Studies*, London, Routledge.

October (1996), "Questionnaire on Visual Culture," *October* 77, Summer: 25-70.

Plato (1991), *Plato's Republic*, trans. Allan Bloom, New York, Basic Books.

Pollock, Griselda (1996), *Generations and Geographies in the Visual Arts: Feminist Readings*, London, Routledge.

Rogoff, Irit (1998), "Studying Visual Culture," in Nicholas Mirzoeff (ed.), *The Visual Culture Reader*, London, Routledge.

Spence, Louise (1995), "'They killed off Marlena, but she's on another show now,': Fantasy, reality, and pleasure in watching daytime soap operas," in Allen (1995).

Virilio, Paul (1994), *The Vision Machine*, London, British Film Institute.

Young, Robert (1995), *Colonial Desire*, London, Routledge.

Visuality

PICTURE DEFINITION
Line, color, vision

WHY DO PICTURES look real? How does the notion of the real change? The first section of this book examines three constitutive modes of representing reality in modern Western visual culture–the picture, the photograph and virtual reality. In the era of the manipulated, computer-generated image it now seems obvious that images are representations, not real in themselves. Earlier periods have debated whether visual images seem real because they actually resemble the real or because they successfully represent reality. This chapter looks at how the high art image was able to claim to be the most sophisticated means of representing reality until challenged by photography in the mid-nineteenth century. We shall consider how the key components of color and line come to constitute an image by resemblance or representation, looking at certain critical moments in the early modern period (1650–1850) when these definitions were challenged or changed. For the conventions used to make an image intelligible are not necessarily true in the scientific sense and vary according to time and place. Pictures are defined not by some magical affinity to the real but by their ability to create what Roland Barthes called the "reality effect." Pictures use certain modes of representation that convince us that the picture is suffi-ciently life-like for us to suspend our disbelief. This idea in no way implies that reality does not exist or is an illusion. Rather it accepts that the primary function of visual culture is to try and make sense of the infinite range of exterior reality by selecting, interpreting and representing that reality. A key part of this account highlights the ways in which the image gradually came to be understood as representation, rather than as something that directly

resembled the real. These conventions are nonetheless both powerful and significant and it will not be enough to simply "expose" them as social constructions. The more important question is why one system prevails over another and in what circumstances a system of visual representation might change.

Perspectives

Visual culture does not change in simple accord with scientific thought on vision but is always a hybrid of what scientists would consider advanced and outdated ideas. The key to creating visual culture is intelligibility, not compatability with scientific thought. This is true even of those aspects of visual culture that seem to claim a scientific validity. A key example is the system of converging lines used to convey depth in a two-dimensional visual image that we call perspective. Perspective is a hybrid of medieval theories of vision with the modern need to picture the world. It is often referred to as an early modern scientific way of representing vision that was then superceded both by Einstein's theory of relativity and by the demolition of pictorial space by the Cubist techniques of Pablo Picasso in the early twentieth century. Unfortunately, this neat parallel between scientific knowledge and visual representation does not hold up under closer analysis. Perspective was not one agreed system but a complex of representational strategies ranging from popular entertainments to geometric displays and means of social organization.

When perspective became a commonplace in European art, the workings of the eye were still a mystery. Until the seventeenth century Europeans were not even sure whether the eye worked by absorbing rays of light from the outside (intromission) or by emitting its own rays to perceive exterior reality (extromission). The Greek philosopher Democritus combined both theories, arguing that objects emit a copy of themselves which contracts in size until it enters the eye through the pupil. The eye thus literally reconstructs a model of what is seen for the mind to judge and interpret. The Arab scholar Alhazen solved the question in the eleventh century by noticing the after-images that can be seen with closed eyes after looking at a bright object, such as the sun. He thus proved that light enters the eye and not the other way around. Although Europeans knew of his work, it took them 600 years to reach the same conclusion because they were not really interested in the question. What the eye did was irrelevant, what mattered was the intellect or the soul. The senses were part of the fallible human body, whereas the soul was divine. The key question, then, was how information was conveyed to the soul via the eye. The processes by which the soul

interpreted this visual information were to all intents and purposes unknow-
able precisely because they belonged to the divine sphere. One of the most
difficult questions for medieval scholars was how to account for the human
ability to see very distant or very large objects, given the smallness of the
eye. Alhazen responded by defining the existence of what he called a "visual
pyramid," whose point was in the eye and whose base was at the object
viewed. Although his wider theory of vision was contested, the visual
pyramid became a staple of medieval and early modern notions of vision.
The adoption of a convention of converging lines to convey depth in Italian
painting from the thirteenth century onwards was based on an attempt to
represent this visual pyramid in art. Perspective is often held to have been
invented in Italy by artists of the fourteenth and fifteenth centuries. These
Renaissance artists were, however, well aware that their work was based on
earlier efforts. In fact, many artists saw their use of perspective as the
rediscovery of an art known to the Greeks and Romans. The sculptor
Lorenzo Ghiberti assembled a selection of key sources for perspectival art
that began with Alhazen and included all the other leading medieval optical
theorists (Kemp 1990: 26). Perspective has classically been defined as a
picture of the view seen from a window. This framing shapes and defines
what can be seen and what is out of view. Of course, what is seen from a
window can be understood because the viewer is familiar with the context of
what is being looked at or in the last resort by going outside. For, in the
words of Leonardo da Vinci:

> Perspective is a rational demonstration whereby experience con-
> firms that all objects transmit their similitudes to the eye by a
> pyramid of lines. By a pyramid of lines, I understand those lines
> which start from the edges of the surface of bodies and, conver-
> ging from a distance meet in a single point; and this point, in this
> case, I will show to be situated in the eye, which is the universal
> judge of all objects.
>
> (Lindberg 1976: 159)

Notice that Leonardo assumes that Alhazen's notion of the visual pyramid
was not a theory but the product of rational experiment, which corresponds
to reality. He then combined it with the Greek notion of similitudes–copies
descending the pyramid into the eye–in order to produce the decisive theory
that the eye is a "universal judge." With the exception of certain learned
artists like Piero della Francesca and Paolo Uccello, it is clear that most
Renaissance artists followed this compromise position. They provided for an
overall sense of recession and depth without following a rigid geometric

perspectival scale, especially in depicting the human figure. In his later work, Leonardo even came to reject the perspectival thesis altogether, claiming that "every part of the pupil possesses the visual power and that this power is not reduced to a point as the perspectivists wish" (Kemp 1990: 51). Consequently, many Renaissance artworks, particularly church decorations, were located so that the viewer could not be at the designated perspectival viewpoint. In John White's analysis: "The advent of a focused perspective system makes no material alteration to a decorative pattern well established in [the thirteenth century] and itself unchanged from the time when spatial realism was of no concern to the viewer" (White 1967: 193). The Renaissance use of perspective certainly changed the appearance of images but this change did not entail a new attitude to perception or reality.

In short, spectators learnt to accept this visual convention for what it was, an approximation that adequately met the needs of the viewing situation. In the same way, cinema audiences would later come to accept the patent unreality of "special effects" – prior to the creation of computer graphics – as part of the entertainment. When perspectival space was new, audiences judged paintings according to the extent they managed to be convincing, just as audiences of *Jurassic Park* flocked to see newly-realistic illusions. Perspective is not important because it shows how we "really" see, a question that physiologists continue to grapple with, but because it allows us to order and control what we see. As Hubert Damisch has argued, it "does not imitate vision, any more than painting imitates space. It was devised as a system of visual presentation and has meaning only insofar as it participates in the order of the visible, thus appealing to the eye" (Damisch 1994: 45). Visual culture, then, does not "reflect" the outside world and nor does it simply follow ideas created elsewhere. It is a means of interpreting the world visually. Perspective created a new means of representing visual power from already available materials. Systems of representation are not inherently superior or inferior, but simply serve different ends. While Westerners have taken one-point perspective to be the natural way to depict space since the fifteenth century, Chinese artists had known how to give the illusion of depth since the tenth century. However, they would also make long picture scrolls whose range of imagery cannot be seen at once and certainly not from one point. The power of the Imperial Chinese court relied on a different system of power/knowledge that did not require the viewpoint of perspective. It was also common for medieval Japanese artists to use "flat" conventions of pictorial space that are thought of as being modern in the West. The difference of Western perspective was not its ability to represent space but the fact that it was held to do so from one particular viewpoint.

For Leonardo, and one suspects the majority of his fellow artists, what

mattered was not geometrical precision but this ability to convey "visual power." Perspective was one device by which artists sought to capture and represent visual power. Thus the first written description of perspective by Leon Battista Alberti, *On Painting* (1435), describes the line which runs directly from the eye to the object as the "prince" of rays (Kemp 1990: 22). The prince was the ruler of the Renaissance city states who commissioned the art of the period. His authority was celebrated by the fifteenth-century Florentine political theorist Niccolo Macchiavelli, whose name has come to describe ruthless use of power. The prince was not simply a metaphor for artists. When perspectival sets were used at the French royal palace of Versailles in the seventeenth century, King Louis XIV was seated directly on this line so that he alone had the perfect place from which to see the perspective. In creating any system of representation, there is a distinction between the ideal viewer imagined by the system and the actual viewer who looks at the image. In Renaissance and early modern court culture, the ideal viewer and the actual viewer were often the same person – the king, prince or other authority figure for whom the work was made.

The notion of resemblance was thus at the heart of Renaissance perspective theory, from Leonardo's belief in similitudes to the equivalence of the ideal viewer and Absolute monarch in the perspective system. Resemblance was at the heart of the all-embracing system of natural magic, sharply distinguished from sorcery, or black magic. In the words of Giovanni Batista della Porta, whose *Natural Magic* (1558) remained influential until the late seventeenth century, magic was "a consummation of natural Philosophy and a supreme science" (Porta 1650: 2). Magic, although based on a complex system of affinities and correspondences, was far from superstition, and indeed homeopathic medicine is still based on the principle of similitude. Vision was a key part of the magical "chain of being" that connected all knowledge to other knowledge. In Porta's view, "magic contains a powerful speculative faculty, which belongs to the eyes both in deceiving them with visions drawn from afar and in mirrors, whether round, concave or diversely fashioned; in which things consists the greatest part of magic" (Porta 1650: 4). In his many writings on vision, Porta provided the first description of the *camera obscura*, a darkened room into which light was admitted through a small opening, often containing a lens, causing an inverted image of the outside world to be cast onto the back wall. Porta also made use of perspective to create "marvellous experiences . . . whose effects will transport you in forming diverse images" (Porta 1650: 339). Perspective was then an effect, rather than reality, a device that enabled the artist or magician to impress the viewer with their skill in creating something that resembled reality rather than representing it. In 1638 the French monk

Niceron summed up the existing view of perspective as a form of magic: "True magic, or the perfection of sciences, consists in Perspective, which allows us more perfectly to know and discern the most beautiful works of nature and art, which has been esteemed in all periods, not only by the common people but even by the most powerful Monarchs on earth" (Niceron 1638: Preface). Strikingly, Niceron assumed that perspective was in no way a recent development and was more associated with popular entertainments than élite arts and sciences.

This understanding of perspective remained intact even when seventeenth century scientists radically transformed the understanding of vision. The Dutch scholar Thomas Kepler was the first to argue that the lens of the eye presents an inverted image on the retina. But he did not assume that this change in understanding of the physical process of sight brought him any closer to understanding vision and continued to see the eye as a judge:

> I say that vision occurs when the image of the whole hemi-sphere of the world that is before the eye . . . is fixed on the reddish-white concave surface of the retina. How the image or picture is composed by the visual spirits that reside in the retina and the nerve, and whether it is made to appear before the soul or the tribunal of the visual faculty by a spirit within the hollows of the brain, or whether the visual faculty, like a magistrate sent by the soul, goes forth into the administrative chamber of the brain into the optic nerve and the retina to meet this image as though descending to a lower court – this I leave to be disputed by the physicists.
>
> (Lindberg 1976: 203)

For Kepler, the process of vision was still one that could only be described in terms of legal authority. In the early modern legal system, the judge was in a far more powerful position than is typically the case today. There were no juries and only the judge could call evidence and render verdicts. It is not surprising, therefore, that even Dutch artists of his day who were extremely interested in perspective do not seem to have taken account of Kepler's theories as they did not change the central interest of the artist in capturing visual power. In fact both Samuel von Hoogstraten and Samuel Marolois, Dutch artists who wrote important treatises on perspective, adhered to the extromission theory of vision (Kemp 1990: 119). Artists and visual theorists alike were concerned with establishing a place from which to see, and thus create the effect of perspective, rather than fully understanding the physiology of perception which they took to be unknowable.

For those writing with the benefit of hindsight, it is clear that the philosophy of René Descartes, set out in his famous *Discourse on Method* (1637), marked a clear break with the concepts of vision that had prevailed until his time. Descartes challenged past tradition by considering light to be a material substance with concrete being, as the historian A.I. Sabra notes: "The Cartesian theory was the first to assert clearly that light itself was nothing but a mechanical property of the luminous object and of the transmitting medium" (Sabra 1982: 48). Rather than consider light a manifestation of the divine, he used everyday metaphors to describe it, such as the use of sticks by the blind to replace their lost vision. Like the stick, light touches the object under consideration directly. This physical concept of light allowed Descartes to apply mathematics to all its characteristics. For if light were a purely spiritual medium, no human device could measure it. Thus by detailing the operations of refraction in the eye, that is to say the "bending" of light rays by lenses, he was able to explain the old problem of the perception of large objects.

Crucially, he displaced perception itself from the surface of the retina to the brain. Thus the image formed on the retina was not exactly the same as what is perceived. While Kepler was unable to explain the inversion of the image on the retina, Descartes saw that inversion as part of the means by which perception was relayed from the eyes to the brain. Thus he believed that "perception, or the action by which we perceive, is not a vision . . . but is solely an inspection by the mind." When we look at a rose, the sensation that it is red is then confirmed by a judgment that it is in fact red, rather than appearing red because of a distortion of the light. Judgement is then the essential aspect of Descartes' system of perception in which the sensory information perceived is nothing more than a series of representations for the mind to categorize. He clearly distinguished his representational theory from the preceding theory of resemblances, noting that the old philosophers could not explain images because "their conception of images is confined to the requirement that they should resemble the objects they represent." By contrast, Descartes insisted on the conventional nature of representation, arguing that "it often happens that in order to be more perfect as an image and to represent an object better, an engraving ought not to resemble it" (Descartes 1988: 63). It was then up to the judgment to discern the image for what it was supposed to represent. While Descartes changed the understanding of the physics of vision, he continued to rely on Kepler's model of the soul as the interpreting judge of sensory perception. The difference was that he was so skeptical of sensory information that he mused: "It is possible that I do not even have eyes with which to see anything" (Crary 1990: 43). In the Cartesian system of vision, representation replaced resemblance.

From this point on, the modern picturing of the world as representation became possible.

Perspective now took on a key role as the boundary between resemblance and representation. For Descartes noted that resemblance did play a limited role in his representational system, insofar as it recalls the shape of the seen object: "And even this resemblance is very imperfect, since engravings represent to us bodies of varying relief and depth on a surface which is entirely flat. Moreover, in accordance with the rules of perspective they often represent circles by ovals better than by other circles, squares by rhombuses better than by other squares, and similarly for other shapes. Thus it often happens that in order to be more perfect as an image and to represent an object better, an engraving ought not to resemble it." Descartes insisted that the same process took place in the brain, which interpreted the sensory data presented to it. In Descartes' view, perspective is thus a natural law, which can be observed in the images formed by the *camera obscura*, but also a representation. Thus photography, which was immediately able to give a recognizably accurate depiction of the shape of objects represented in one-point perspective displaced painting and the other visual arts as the prime representational medium almost as soon as it was invented. This fusion of resemblance and representation in perspective accounts for its centrality in all accounts of the Cartesian legacy, where the two are often all but equated.

Some critics have recently gone so far as to think of Cartesianism as the "ancien scopic regime," that is to say, the dominant theory of vision in early modern Europe from the mid-seventeenth century until the outbreak of the French Revolution in 1789. Given that Descartes' work was so sharply different from that of his predecessors, and so influential with scientists and philosophers, this view is tempting. From here, it is possible to generalize that "there is a singular and determining 'way of seeing' within modern Western culture" at any given moment (Jenks 1995: 14). I shall argue by contrast that visual culture is always contested and that no one way of seeing is ever wholly accepted in a particular historical moment. Just as power always creates resistance, so did the Cartesian way of seeing generate alternatives.

Cartesianism was accepted by scientists and philosophers, often working outside the network of royal patronage. But artists and others working in visual media were far from immediately convinced by Cartesian theory. In 1648, Louis XIV established the French Academy of Painting to decorate his palaces and towns and provide drawings for the important royal tapestry manufactures. The Academy was granted a monopoly over art education and trained such artists as Boucher, Fragnonard, Watteau and David. However, the Academicians were vehemently opposed to Cartesian theories of vision,

based in part on politics, in part on optics. At first, they tried to insist on using Michelangelo's method of organizing space around a multiple pyramid, which was seen the form of "a flame, that which Aristotle and all other philosophers have said, is the most active element of all" (Pader 1649: 5). But their own professor of perspective, Abraham Bosse, insisted on teaching a geometric theory of perspective that made startling claims for the power of the technique: "The words PERSPECTIVE, APPEARANCE, REPRESEN-TATION and PORTRAIT are all the name for the same thing" (Bosse 1648). In other words, learning perspective would enable a student to carry out all the necessary aspects of painting itself. This modern-sounding idea was contradicted by Bosse's belief that vision took place because the eye emitted rays to perceive objects, as proposed by Democritus and long since falsified by Alhazen. The Academy quickly fired Bosse but had to elaborate their own theory of perspective. They argued correctly that perspective could only reproduce the perception of one eye at a time, whereas we obviously see with two eyes. Furthermore, in strict perspective theory, only one spot provides the true angle of vision necessary to understand the perspective and it was unlikely that viewers would locate this position unaided (Mirzoeff 1990). These objections to the new optics permitted the Royal Academy to pursue political necessity. For its very existence depended on glorifying the King and presenting His Majesty as above all his subjects, no small matter in France after a century of civil unrest had culminated in civil war from 1648–53. Strict application of perspective could have meant that the King might appear smaller than one of his subjects, a politically impossible result. The Academic sense of seeing the King was best embodied in the Hall of Mirrors built for Louis XIV by the director of the Academy, Charles Le Brun (see Figure 1.1). In a lengthy gallery, decorated with elaborate paintings and studded with mirrors, the courtiers could observe themselves and others paying homage to the King and make sure that the appropriate protocols were performed. The King's domination of even his greatest subjects was thus made fully visible. Even away from the exalted depiction of the royal body, the Academy argued that the curves and surfaces of the human body were too subtle to be rendered in geometric perspective. The result would be an ugly, badly proportioned body that would damage the imagination "because these depraved and disorderly objects could recreate in the mind past reveries, or lugubrious dreams, which had previously been experienced in illness or fevers" (Huret 1670: 93). In the Platonic tradition, the French monarchy believed that representations could produce physical disturbances, leading to political disobedience.

The Academy thus evolved a compromise. Buildings and background space were to be rendered in a perspectival fashion, conveying a sense of depth

Figure 1.1 The Hall of Mirrors, Versailles

recession. This led to the creation of painted perspectival scenes to enhance the grandeur of a garden view, also known as a perspective (see Figure 1.2). Figures, on the other hand, were to be depicted according to the classical scale of proportion. In this way, the primary figure in a painting would set the physical scale against which all others were measured and no other figure would exceed his size (gender intentional) or prominence. The advantage of this method was that it relied on the artist's own judgement to create visual space, rather than the increasingly complex mathematics of perspective that often demanded abstruse mathematical skills (see Figure 1.3). In its guide to students entering the prestigious Rome Prize, the Academy advised paying attention to "perspective with regard to the arrangement of figures and of the source of light" (Duro 1997: 74), rather than the control of space. This system was given the name 'ordering' by the theorist Charles Perrault in the late seventeenth-century and can clearly be observed in artists' practice. To take a famous example, let us consider Jacques-Louis David's *Oath of the Horatii* (1785) – see Figure 1.4. The pictorial space creates an approximately perspectival viewpoint. The pavement recedes in appropriate perspectival

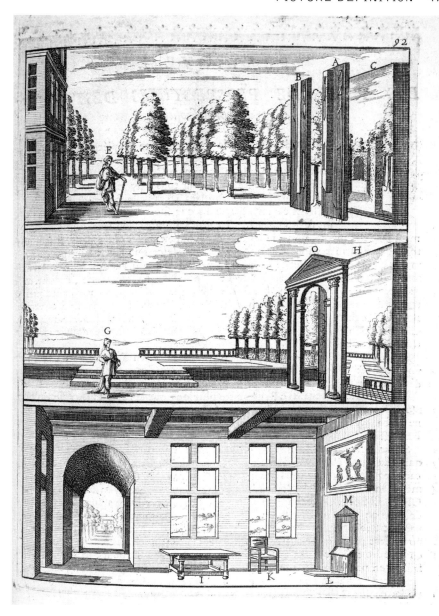

Figure 1.2 From *La Perspective Pratique*

Figure 1.3 Nouvelle et Brève Perspective

fashion, although the large squares do not correlate to the smaller ones. The wall on the right hand side veers exaggeratedly outwards to create the sense of a visual pyramid, while that on the left is flat. The figures are not treated in perspective, as many critics both in the eighteenth century and thereafter have noted. The male figures are all the same size, while the women are "correctly" proportioned as three-quarters of male size. David has not sought any degree of mathematical exactitude. Instead, his goal was what the eighteenth century called *vraisemblance*, verisimilitude, or the "reality effect."

A popular alternative use of perspective was anamorphosis. This is a system in which the vanishing point is not constructed in "front" of the image but in the same plane as the picture surface to one side or the other. Consequently, it is necessary for the viewer to place his or her eyes level with the picture and to the side in order to interpret the image, which, seen from the usual position, appears to be nothing other than a triangular mass. Anamorphosis reveals that perspective is simply a visual convention and one

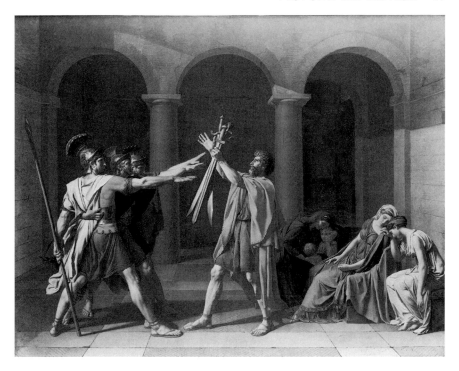

Figure 1.4 David, *Oath of the Horatii*

that, when pushed to extremes, generates unnatural results. It was at first part of perspective theory at élite levels. An anamorphosis can be seen in a sixteenth-century painting entitled *The Ambassadors* (1519) by Hans Holbein, depicting two powerful figures at court. It forms a curious spiral shape in the foreground that is revealed to be a skull when seen from the correct viewpoint. Holbein thus used the anamorphosis to show that, for all the worldly power of the ambassadors, they will die and face judgement like everyone else. Similarly, Jesuit missionaries in China used the device to prove their contention that worldly appearances were illusory. Anamorphic designs also appeared in prints and other popular media as early as the sixteenth century with examples still being produced in the late nineteenth century. Very often such drawings had illicit subjects, ranging from mildly titillating erotic scenes to scatological images. These anamorphic drawings were certainly not great art. They do show a popular alternative to the neatly receding spaces of geometric perspective and figure dominated official art. Their scandalous subject-matter was an index of this resistance to the élite modes of representing sight.

There was, then, no single scopic regime in the early modern period. Geometric perspective was used by mathematicians and engineers in ever more complex ways. Architects and artists used perspective as a key tool to creating an illusion of reality and in controlling the power of the visual image. In response, popular visual culture used a version of perspective as a form of entertainment, satirizing the pretensions of the upper classes.

It has, however, become common for modern theorists to assert that, in the words of film critic Christian Metz, perspective "inscribes an empty emplacement for the spectator–subject, an all-powerful position which is that of God himself, or more broadly, of some ultimate signified" (Metz 1982: 49). Yet as we have seen it was precisely the concern of the absolutist monarchies of the seventeenth and eighteenth century to prevent such a floating position of power from being inscribed in visual culture, with the aim of keeping that power for themselves. Thus, one-point perspective was avoided for figures except where it was clearly the King that was to be the viewer, as in the royal theater. However, in late eighteenth and early nineteenth centuries, a new system of social organization came into being that centered around the control of the generalized body through visibility from a single point. With this new system of discipline in place, it becomes possible to think of the perspectival viewpoint as becoming truly all-powerful.

Following the research of French philosopher Michel Foucault, the standard illustration of this radical shift has become the panopticon devised in 1791 by Jeremy Bentham, an English philosopher. The panopticon – literally, the place where everything is seen – was Bentham's device for a model prison. It consisted of an outer ring of cells, supervised from a central control tower. It was constructed so that each prisoner could neither see his fellows nor the supervisors in the tower but was fully visible to anyone watching from the tower. The vanishing point that organized perspective had now become a point of social control. The guards could thus see the prisoners without being seen themselves. Rather than control prisoners with expensive fortifications and numerous guards as was traditionally the case, they could now be managed from one central point. As Foucault put it, in the panopticon "visibility is a trap" (Foucault 1977: 200). The panopticon sought to control prisoners and keep discipline through a system of visibility: "And, in order to be exercised this power had to be given the instrument of permanent, exhaustive, omnipresent surveillance, capable of making all visible as long as it could itself remain invisible. It had to be a faceless gaze that transformed the whole social body into a field of perception" (Foucault 1977: 214). The disciplinary society was not a necessary consequence of the perspectival system, any more than perspective was a creation

of scientific discoveries in optics. Both visual systems simply adapted materials that came to hand in creating new mode of visualizing the world.

A key difference from the early modern system of visibility was that it ceased to matter exactly who was watching so long as individuals continued to be visible. Whereas the Hall of Mirrors displayed the body politic itself, that is to say, the symbolic power of the King as manifested in his individual person, in the panopticon it did not matter who was looking. Bentham specified that while the system was devised so that the prison governor could supervise the inmates, anyone could be substituted, even the servants, because the prisoners could not see who was looking. They knew only that they were being watched. Perspective ordered the visual field and created a place from which to see. The panopticon created a social system around that possibility of seeing others. The panopticon became the ideal model of modern social organization for what Foucault called the "disciplinary society" centered around schools, military barracks, factories and prisons. In the twentieth century, the factory was adopted by the influential Bauhaus school of architecture as a general system of design, leading to the functional style of so much modern architecture. The key to this visualized system was that those who could be observed could be controlled.

Discipline and color

The discipline established by the panoptical system even extended as far as color, the presumed opposite of perspective and other geometric systems of ordering space. Color presents an interesting complementary case to that of perspective, rather than a radical contrast. Throughout the early modern period, color was an alternative method of pictorial construction to the geometric perspective system. Obviously, color perception is a crucial part of human eyesight. Unlike perspective, it has been possible to describe color in exact scientific terms as a property of light, but the perception of color varies from person to person, even before the vexed questions of taste and color symbolism can be addressed. As a consequence, artists, scientists and visual technicians have sought various ways to render the depiction of color without the possibility of variation or dispute. In this way, the representational aspect of the visual image could be balanced with the resemblance provided by accurate depiction of color. However, color's seemingly infinite variations of hue, tint and shade provide stubborn resistance to such classification. Artists and scientists devised a seemingly endless array of color charts, triangles and wheels that were the analog to the perspectivists' geometric diagrams. No one was ready to go into the picture space unaided.

Many accounts of modern art history hold that the predominance of perspective and line as the official system of visual representation in Academic art and modern society led avant-garde artists to turn to color as an alternative means of creating picture space. This history rests on two incorrect assumptions–that perspective was unpopular and that color was a daring alternative. On the contrary, perspective effects were among the most popular art forms in the early nineteenth-century, the period in which Romanticism was promoting color as the best means of pictorial composition. For example, the British artist John Martin's painting *Belchassar's Feast* (1820) depicted the Biblical story of the fall of the Babylonian monarch on a vast scale with a dizzying perspective effect. It was so convincing that a railing had to be put up in order to stop spectators trying to walk into the painting. Contemporaries saw that the perspective effect was the primary emotional goal of the painting, as this comment from a perspective handbook attests: "Throughout his extraordinary performances, the magic of linear and aerial perspective is substituted for that great level of our sympathies, the portrayal of passion and sentiment. . . . The mysterious and electrifying suggestions of boundless space and countless multitudes which their wonder-working elements shadow forth, captivate the fancy, by entangling it in a maze of unearthly suggestions" (Kemp 1990: 162). The latter half of this comment seems to describe Mary Shelley's *Frankenstein* rather than an oil painting. Louis Daguerre's Diorama, invented in 1822, similarly presented dramatic sights from history and world travel to an immobile spectator. These spectacular, theatrical scenes relied on the stable perspective viewpoint to create their effects and were enormously popular.

Nor was the use of color in visual representation rebellious in and of itself. In the present moment, artists who make bold use of color, such as Matisse and Monet, remain the most popular with exhibition and gallery audiences and are usually presented as radical innovators. But these artists were usually careful to subject color to the same systematic control that neo-classical artists imposed on drawing and official art on perspective. During the Enlightenment, the very variability of color perception made it a seemingly natural part of theories of the sublime. For French art theorist Roger de Piles, color was "the difference of painting," that which distinguished it from drawing, just as reason separated man from the animals (de Piles 1708: 312). De Piles emphasized the role of the spectator in creating the effects of a work of art, especially as regards the sublime. The picture had to attract the attention of the spectator by causing her or him to feel enthusiasm for the work. In turn the spectator had to analyze the image in order to find the sublime, the highest goal in art: "In short, it seems to me that enthusiasm seizes us and we seize the sublime" (de Piles 1708: 117). In order for this

interaction to work, a mutual process of recognition was required. By responding to the artificiality of the picture, the spectator attested to her or his cultured status, as well as naming the object looked at as a work of art. Attaining the sense of the sublime was a second higher stage within culture. As the distinguishing mark of painting, color was central both to attracting the spectator and to creating the sublime. There is an ambiguity here as to whether the spectator or the picture is, as it were, responsible for reaching this higher level. If it is a measure of the work, then a failure to experience the sublime is simply a failure of artistic attainment. On the other hand, if the viewer was responsible, it implied that he or she was insufficiently cultivated to appreciate the artwork, accounting in part for the rise of published art criticism in the eighteenth century so that gallery visitors could appear suitably informed. De Piles' seemingly open-ended aesthetic system in fact implied the appearance of a new form of social distinction between those who did and did not "appreciate" art, a worry that continues to haunt spectators to the present day.

No effective system could be devised for standardizing the construction of picture space by color. Artistic uses of color very soon differed from the scientific understanding of the subject. Painters from the seventeenth century onwards have held that all colors can be created using three primary colors, namely blue, red and yellow. However, in his famous *Opticks* (1704), Isaac Newton showed that light was composed of seven prismatic colors: red, orange, yellow, green, blue, indigo and violet. By the mid-nineteenth century the German scientist and philosopher Helmholtz was able to show that there was a fundamental difference between additive and subtractive means of making color. Colored light relies on adding light together, based on the primary colors red, green and blue. Paint and other forms of pigment absorb certain forms of light from the spectrum in order to generate the perception of a specific color, and thus used blue, red and yellow as primaries (Kemp 1990: 262). Helmholtz's explanation has since been shown to be flawed but at the time it helped explain why artists and scientists had differed over the very composition of color for 150 years.

Normalizing color: color blindness

The normalization of vision around the perception of color can be illustrated with the case of color blindness. It was in the first half of the nineteenth century that ophthalmologists first discovered the existence of color blindness and then devised tests to diagnose the condition. The British scientist John Dalton had recognized his own inability to perceive red in the 1790s, naming the condition "Daltonism." It remained a curiosity until the progress

of the industrial revolution in the early nineteenth century made it impera-
tive to be able to detect color-blindness in the industrial workforce, as all the
medical literature indicated. For when safety depended upon, for example,
the ability to distinguish between a red and green railway signal, it was
important that an employee could register that difference. In this example,
we see the double-edged nature of modern discipline. It is clearly in the
interests of all passengers and railway employees that signal staff be able to
distinguish between the lights. For those staff, the color blindness tests,
using strands of often imperfectly dyed wool, presented another hurdle to
employment and potential reason for dismissal.

Science was not content to rest here. After Charles Darwin's *The Origin of
Species* (1859) had given wide currency to the notion of evolution, intellec-
tuals began to play with the idea that color vision had evolved in humanity
within historical time, rather than in the mists of prehistory. This is an
excellent example of the misuse of evolution to explain differences within
one species, namely the human species, rather than relative patterns of
development between species. In order to explain this discrepancy, scientists
postulated that the human species was in fact composed of different races
who were biologically different from each other. It must be emphasized that
despite a century of scientific endeavor to identify these differences, no
definable biological difference between humans has been found. Indeed,
genetic science has clearly shown that all humans share the same gene
pool. Nonetheless, social Darwinism – as this application of evolution to
humans was called – has flourished for over a century as a means to seek
rational explanations for the irrationality of racial prejudice. So far reaching
were these efforts in the nineteenth century that intellectuals claimed to
have identified historical differences in color perception amongst the differ-
ent "races." Anthropologists combined old antisemitic and racist prejudices
with the new "science" of race to provide a racial origin for the complaint.

In 1877, the German philologist Hans Magnus conducted a study of color
in the work of the ancient Greek poet Homer. He found a very restricted
number of Homeric terms for color, most of which appeared to distinguish
light from dark more than they did particular tints. He concluded that Greeks
of the period had in fact seen in black and white and that the color sense was a
recent and developing aspect of human evolution that would soon permit
humans to perceive the ultra-violet elements of the spectrum. Magnus
developed this argument to explain color-blindness in hereditary terms:
"Beginning from the opinion that, in the most distant periods of human
evolution, the functional capacity of the retina was restricted to detecting
manifestations of light, . . . we are inclined to believe that cases of complete
congenital color-blindness must be considered a type of atavism" (Magnus

1878: 108). These ideas were given dramatic support by the British prime minister and noted classical scholar, William Gladstone. Gladstone conducted his own study of ten books of the *Odyssey* and found only "thirty-one cases in nearly five thousand lines, where Homer can be said to introduce the element or the idea of color; or about once in a hundred and sixty lines" (Gladstone 1877: 383). For the Victorians, Homer's prestige was so great that this oversight could not be attributed to mere indifference to color or simple failure of description, it had to indicate a profound truth. Gladstone therefore concluded that the Greeks' perception of color was like a photograph, that is to say black and white. His empirical evidence came from the colonies: "Perhaps one of the most significant relics of the older state of things is to be found in the preference, known to the manufacturing world, of the uncivilized races for strong, and what is called in the spontaneous poetry of trading phrases, loud colour" (Gladstone 1877: 367). That is to say, if color vision evolved gradually, it was only natural that the least evolved preferred strong, intense colors that were easy to distinguish.

As these remarks from one of the most distinguished Liberal prime ministers of the century show, all Europeans casually assumed their superiority to other "races," such as Africans, Asians or Jews, who demonstrated that inferiority by their vulgar taste for loud colors. This prejudice continues to be expressed against Mexican immigrants to the United States, Indians in Great Britain and Jewish communities everywhere. Soon racial "science" advanced the belief that, because of their presumed intermarriage since Biblical times, Jews were especially prone to color blindness as an atavisitic throwback to early human history. Africans and other colonized peoples were already perceived as being "stuck" at this early stage of development, as evidenced by Western military and technological superiority. The peculiar combination of literary and political authority, mingled with the empirical "truths" of colonialism and anthropology that gave rise to the notion of the evolution of the color sense was simply too embedded in nineteenth-century common-sense to be challenged. The result was that the disciplinary system of vision that had been instituted in the early nineteenth century became racialized around the issue of color. By adding the "scientific" dimension of race to the fugitive trace of color, it became possible to restore a dimension of presumed objectivity to the subjective perception of color that color blindness had been revealed to be far from universal.

Light over color

Nineteenth-century avant-garde art, such as that of the Romantics and Impressionists, is usually thought of as being far removed from such

prejudices. Yet their assertion of the domination of color and then light in art often made explicit or implicit use of such racialized imagery. In the 1830s, French art was polarized between neo-classical and Romantic factions, the former supporting drawing, the latter color as the dominant principle of representation. The Romantic artist Eugène Delacroix first explicitly theorized his color system while on a military expedition to Morocco in 1832. He devised a blue, red and yellow color triangle and attributed his "discovery" to the exotic environment. He noted that "on the heads of the two small peasants, there were violet shadows on the yellow one and green shadows on the one that was more sanguine and red" (Delacroix 1913: 68). He used these observations to place his complementary colors on the triangle. For while the Romantic artists held color to be a natural counterpoint to the stolid official culture represented by linear drawing, they never endorsed the spontaneous application of color. Ironically, therefore, some art labeled "colorist" is in fact less brightly colored than art supposedly based on line, like the Orientalist paintings of Ingres. As both the Romantic and official art theorists made clear, what mattered was not color for its own sake but as a means of making visual images more comprehensible and especially more true to life. In his *Theory of Colors*, the Romantic poet Goethe explained that "savage nations, uneducated people, and children have a great predilection for vivid colors; that animals are excited to rage by certain colors; that people of refinement avoid vivid colors in their dress and the objects that are about them, and seem inclined to banish them altogether from their presence" (Goethe 1970: 55). Here avant-garde and official art in fact agreed. In his guide to the visual arts, Charles Blanc, the director of the élite École des Beaux-Arts, held that "drawing is the masculine sex of art; color is its feminine sex," implying that the latter was therefore inferior (Blanc 1867: 22). In support of this assertion he noted, like Goethe, that "all Oriental artists are colorists, infallible colorists" (Blanc 1867: 595), drawing on the colonial prejudice that Middle Eastern and North African men were effeminate by nature. It followed that they would be natural colorists but real (male, Western) artists needed to learn careful rules in the application of color. As Anthea Callen cogently puts it in her discussion of the Impressionist use of color: "Color, like Algeria, had to be colonized, mastered by the authority of line; only the draughtsman-cartographer could impose order and 'draw' meaning from this shifting, deceptive landscape. Like color, woman was a desert waiting to be mapped by the male text" (Callen 1995: 114). The formal quality of the application of color thus involved a complex interaction of race, gender and colonial politics.

This range of allusions was perhaps too suggestive. Later nineteenth-century artists sought to control color by again subjecting it to racial theory

and ultimately by concentrating solely on light. Through this focus on light, the Impressionists and later modern artists have sought to control reality itself. The pro-Impressionist critic Edmond Duranty asserted that light in itself "reflects both the ensemble of all the [color] rays and the color of the vault that covers the earth. Now, for the first time, painters have understood and reproduced, or tried to reproduce these phenomena" (Broude 1991: 126). What is at stake, just as with perspective and the panopticon, is the control of vision and visual representation through a seemingly exact system of knowledge that can overcome the ambiguities of representation. A few years later another Impressionist supporter, the poet and art critic Jules Laforgue, gave these ideas an explicitly racialized context, mixing them with his understanding of Darwin in his famous 1883 essay on Impressionism:

> The Impressionist eye is, in short, the most advanced eye in human evolution, the one which until now has grasped and rendered the most complicated combinations of nuances known . . . [E]verything is obtained by a thousand little dancing strokes in every direction like straws of color – each struggling for survival in the overall impression. No longer an isolated melody, the whole thing is a symphony, which is living and changing, like the 'forest voices' of Wagner, all struggling for existence in the great voice of the forest – like the Unconscious, the law of the world, which is the great melodic voice resulting from the symphony of consciousnesses of races and individuals. Such is the principle of the *plein air* Impressionist school. And the eye of the master will be the one capable of distinguishing and recording the most sensitive gradations and decompositions, and that on a simple flat canvas.
>
> (Nochlin 1966: 17).

Laforgue's endorsement of the Modernist aesthetic of flatness has ensured his place in the critical canon, but his belief that Impressionism was the product of a Darwinian struggle for cultural existence dominates the essay. His references to the Teutonic forest clearly identified the Impressionists as Northern, or Aryan. For he was less concerned with the means of representation than the internal effect caused by the painting, which was above all perceptible to the "eye of the master," that is to say, the master race.

Two years later, the avant-garde theorist Félix Bracquemond separated color from light altogether, noting that a drawing specialist used color without understanding the effects of reflections and complementary color, with the result that such work looked like an Oriental carpet. As we have seen, this

remark was not a compliment but an assertion that the artist had a primitive understanding of color and thus of visual representation itself. The colorist did not in fact rely on the constantly changing range of color but on light: "art isolates color and makes an image from it by using the intensities of light [*clarté*], which are relatively stable and always verifiable in their proportions" (Bracquemond 1885: 47). Light disciplines color. By extension and implication, the Northern "race" disciplines the Southern. In both cases, the Western perception is that the evasive element is controlled by a more powerful force.

This insistence of the primacy of light over color entailed some surprising conclusions. It is unexpected to hear Vincent Van Gogh argue that the rules of color contradict traditional notions of artistic genius: "The *laws* of the colors are unutterably beautiful, just because they are *not accidental*. In the same way that people nowadays no longer believe in a God who capriciously and despotically flies from one thing to another, but begin to feel more respect and admiration for, and faith in nature – in the same way and for the same reasons, I think that in art, the old fashioned idea of innate genius, inspiration etc., I do not say must be put aside, but thoroughly reconsidered, verified – and greatly modified" (Gage 1993: 205). Ironically, Van Gogh has become the archetype of the modern artistic genius, evidenced above all by his vivid use of color. By the late nineteenth-century, color seemed to have been as thoroughly subdued as the colonies in Africa and Asia that it was held to represent. When Henri Matisse developed his stunning palette of colors in works like *Blue Nude – Souvenir of Biskra* (1907) that directly evoked Western travel to Africa, he was direct enough to say that, far from being a radical gesture, he saw his art as being like "an armchair for the tired businessman."

White

In order to understand how this disciplining of color operated in specific cases, let us consider the apparently simple case of the color white. This one color alone will take us from Ancient Greece to the Spanish conquest of South America and the rise of fascism. The range of different meanings attributed to white and whiteness exposes the familiar distinction between complex texts and simple visual materials as worthless. White takes us to the place that was held to be both the origin of Western art and its highest known form, Greek and Roman sculpture. In the nineteenth century, the beauty of these sculptures was epitomized by their pure white marble. It is then inconvenient for such theories, to say the least, that the ancient Greeks themselves colored their statues with bright primary color paint, a fact

known to classical scholars since the 1770s. But in the nineteenth century, Greek statues were held to be white because whiteness conveyed the exquisite taste of the Greeks as well as their "Aryan" racial origins, and served as evidence of their monochrome vision (described above). So strong was this belief that the British Museum had the Elgin Marbles, sculptures from the Parthenon in Athens, vigorously scrubbed in the 1930s because they appeared insufficiently white (see Figure 1.5).

Whiteness came to convey an intense physical beauty in itself. In Oscar Wilde's novel, *The Portrait of Dorian Gray* (1892), the aesthete and aristocrat Lord Henry Wotton compares Gray to a Classical sculpture: "He was a marvellous type, too, this lad . . . ; or could be fashioned into a marvellous type at any rate. Grace was his, and the white purity of boyhood and beauty, such as old Greek marbles kept for us. There was nothing that one could not do with him. He could be made a Titan or a boy" (Jenkyns 1980: 141). Two seemingly contradictory forces run through this passage. On the one hand, whiteness expresses the ideal racial type, as made explicit by the Victorian painter Frederick Lord Leighton: "In the Art of the Periclean Age we find a new ideal of balanced form, wholly Aryan and of which the only parallel I know is sometimes found in the women of another Aryan race," that is to say, the Germans (Jenkyns 1980: 145). The consequences of such racial thinking reached their disastrous peak in the Nazi Third Reich, which produced vast numbers of neo-classical sculptures to combat what it saw as "degenerate" modern art. They had to go to great lengths to deny the element of homoerotic attraction, one of the reasons that their art is so lifeless. Yet even here the repressed would return. In Leni Riefenstahl's film *Olympia* (1936), a lengthy opening sequence dwells on Greek sculptures that

Figure 1.5 The Elgin Marbles: East Pediment of the Parthenon

then come to life and carry the Olympic torch from Athens to Berlin. The implication was clearly that the Aryan ideal of manhood that had been Greek in antiquity was now German. One of the sculptures most lovingly depicted by the camera was a plaster cast of *The Barberini Faun*, a reclining male nude with distinctly homoerotic overtones. The statue that Riefenstahl brings to life, like a cinematic Pygmalion, was a fake version of the Discus Thrower, complete with exaggerated musculature in the fashion of Nazi sculptor Arno Breker but not, as the film itself makes clear, the Greeks themselves.

On the other hand, there was more than a hint of homoeroticism in Wilde's writing, making a by-then familar connection between Greek sculpture, whiteness and the homoerotic. His Victorian contemporary Walter Pater, who similarly praised the "white light" of Greek sculpture, traced the homoeroticism it engendered back to the writing of J.J. Winckelmann. Winckelmann's eighteenth-century investigations into ancient sculpture – especially his *History of Ancient Art* (1764) – are usually considered the first works of modern art history. Furthermore, at the time he was writing "for many worldly Europeans 'Rome,' as well as 'Greek art,' already signified sexual freedom and available boys" (Davis 1994: 146), in the same way that Christopher Street or San Francisco's Castro district have gay resonances today. Winckelmann did not make this connection explicit but he stressed the importance for the art historian of understanding male beauty: "I have noticed that those who fix their attention only on the beauties of women, and who are only feebly affected by those of our own sex do not in any way possess the sentiment of beauty to the degree necessary to constitute a real connoisseur" (Winkelmann 1786: 244). Pater elucidated such careful statements as meaning "that his affinity with Hellenism was not merely intellectual, that the subtler threads of temperament were inwoven in it, is proved by his romantic, fervent friendships with young men These friendships, bringing him in contact with the pride of human form, and staining his thoughts with its bloom, perfected his reconciliation with the spirit of Greek sculpture" (Jenkyns 1980: 150). By the late nineteenth century it was a commonplace that the whiteness of Greek sculpture was a mark of its aesthetic quality. In turn for both Pater and Wilde, the Oxford aesthetes, those able to appreciate these qualities of whiteness found both a justification for and a reflection of homosexual desire.

How could the same color give rise to notions of racial supremacy and of homosexuality, "the love that dare not speak its name"? As Eve Kosofsky Sedgwick has argued, the rediscovery of ancient Greece created "for the nineteenth century a prestigious, historically underfurnished imaginative

space in which relations to and among human bodies might be newly a subject of utopian speculation. Synecdochically represented as it tended to be by statues of nude young men, the Victorian cult of Greece gently, unpointedly, and unexclusively positioned male flesh and muscle as the indicative instances of 'the' body" (Sedgwick 1990: 136). This new imaginative space allowed unusual connections to be made through the male body. It was further a consistent justification of the European colonization of America that it would prevent the sodomy of the indigenous peoples. As early as 1519, a few years after the first contact, the Spanish conquistador Cortés reported home: "They are all sodomites" (Goldberg 1992: 193). This blanket description served to mark the absolute difference between the Europeans and the indigenous peoples. Yet at the same time, Europeans forcibly sodomized those they defeated as a mark of absolute domination. Anthropologist Richard Trexler has shown that the Spanish army transferred its own system of discipline via forced sodomy to the Amerindians (Trexler 1995). Domination and difference came to be signified as sodomy, or at least as sexual relations between men. In the nineteenth century, it was equally possible to think of male same-sex relations as being a partnership between two people who were essentially the same, or as being an attraction that crossed a fundamental difference, such as that of age or social class.

Skeptics may wonder if these multiple interpretations of white were really seen by nineteenth-century audiences. It is of course impossible to know whether every spectator had these sentiments but they were certainly noticed at the time. In his 1851 novel *Moby Dick*, the American novelist Herman Melville recounted an epic saga in which Captain Ahab leads his crew to disaster in his obsessive pursuit of the white whale known as Moby Dick. Melville speculated at length as to why white induced what he termed "a certain nameless terror." He noted that "in many natural objects, whiteness refiningly enhances beauty, as if imparting some special virtue of its own, as in marbles, japonicas and pearls." The white beauty of marble leads directly to a discussion of the imperial quality of the color, which "applies to the human race itself, giving the white man ideal mastership over every dusky tribe." As he digresses on other aspects of the fear induced by white, Melville names the Peruvian capital Lima as "the strangest, saddest city thou can'st see. For Lima has taken the white veil; and there is a higher horror in this whiteness of her woe. Old as Pizarro, this whiteness keeps her ruins for ever new; admits not the cheerful greenness of complete decay; spreads over her broken ramparts the rigid pallor of an apoplexy that fixes its own distortions." The journey within whiteness from sculpture to race theory and the Spanish conquest of Latin America outlined above was also taken by Melville. Unlike many of his fellows, Melville saw whiteness as terror, oscillating from one meaning to the

next but all symbolized by this color, "a colorless, all-color of atheism from which we shrink" (Melville 1988: 188–195).

Coda

The contradictions within these nineteenth-century attitudes to color could not always be resolved. They came to a head with the invention of photography. The new medium was at once able to claim the perfect reflection of exterior reality or resemblance that artists had sought for centuries using perspective or color systems. Color was at first beyond the technical means of photographers, meaning that their work was also clearly a representation. One consequence was the painterly preoccupation with color in the nineteenth century that we have followed above. Photographers quickly resorted to hand-coloring their images, a practice that was immensely popular with audiences from the everyday portrait client right up to Queen Victoria herself. The firm of A. and G. Taylor advertised themselves as "Photographers to the Queen," offering "cartes enlarged to life-size and finished in oil or water." Was the resulting colored photograph to be called a photograph or a portrait? Was it a resemblance or a representation? This seemingly pedantic question sparked great controversy, summed up by one writer in 1859:

> Colored photographs occupy an undeservedly questionable situation: the artist curls his lip at them, and the photographer regards them with a sneer. The one says they are no paintings, the other that they are no photographs; thus the art of photographic coloring, unrecognized by either, must seek consolation in the fact that it is embraced none the less eagerly by both. At exhibitions of paintings colored photographs are peremptorily refused, and it is very frequently advised that they should not be received for photographic exhibitions.
>
> (Henisch and Henisch 1996: 29)

Even today, artistic photography is far more likely to be in black-and-white than color even though everyday photography is almost exclusively in color. In this view, the intrusion of color into the photographic image disrupted its claim to be accurate by distracting the eye. Its mechanical exactitude nonetheless prohibited its being considered art. The impossibility of classifying colored photography shows that the formal rules that had governed the visual image since the early modern period no longer held good. Resem-

blance now belonged to the camera, not to perspective or color. Visual culture had entered the age of photography.

Bibliography

Aquinas, St Thomas (1951), *Commentary on Aristotle's "De Anima"*, trans. K. Foster and S. Humphries, London.

Blanc, Charles (1867), *Grammaire des Arts du Dessin*, Paris, Jules Renouard.

Bosse, Abraham (1648), *Manière Universelle de Mr Desargues pour pratiquer la Perspective*, Paris.

Braquemond, Felix (1885), *Du Dessin et de la Couleur*, Paris, G. Charpentier.

Broude, Norma (1991), *Impressionism: A Feminist Reading*, New York, Rizzoli.

Callen, Anthea (1995), *The Spectacular Body: Science, Method and Meaning in the Work of Degas*, London, Yale University Press.

Crary, Jonathan (1990), *Techniques of the Observer: On Vision and Modernity in the Nineteenth Century*, Cambridge, MA, MIT Press.

Damisch, Hubert (1994), *The Origin of Perspective*, trans. John Goodman, Cambridge MA, MIT Press.

Davis, Whitney (1994), "Winckelmann Divided: Mourning the Death of Art History," *Journal of Homosexuality* 27 (1–2): 141–59.

Delacroix, Eugène (1913), *Le Voyage de Eugène Delacroix au Maroc*, Paris, J. Terquem.

de Piles, Roger (1708), *Cours de Peinture*, Paris.

Descartes, R. (1988), *Selected Philosophical Writings*, J. Cottingham, R. Stoothoff and D. Murdoch (eds), Cambridge, Cambridge University Press.

Duro, Paul (1997), *The Academy and the Limits of Painting in Seventeenth-Century France*, New York, Cambridge University Press.

Foucault, Michel (1977), *Discipline and Punish: The Birth of the Prison*, Harmondsworth, Penguin.

Gage, John (1993), *Colour and Culture: Practice and Meaning from Antiquity to Abstraction*, London, Thames and Hudson.

Gladstone, William E. (1877), "The Colour Sense," *The Nineteenth Century* 1, September.

Goethe, Johann (1970), *Goethe's Theory of Colors*, Cambridge MA, MIT Press.

Goldberg, Jonathan (1992), *Sodometries: Renaissance Texts, Modern Sexualities*, Baltimore, MD, Johns Hopkins Press.

Henisch, Heinz K. and Henisch, Bridget A. (1996), *The Painted Photograph: Origins, Techniques, Aspirations*, University Park PA, Pennsylvania State University Press.

Huret, Grégoire (1670), *Optique de Portraiture et Peinture*, Paris.

Jenks, Christopher (1995), *Visual Culture*, London, Routledge.

Jenkyns, Richard (1980), *The Victorians and Ancient Greece*, Cambridge MA, Harvard University Press.

Kemp, Martin (1990), *The Science of Art: Optical Themes in Western Art from Brunelleschi to Seurat*, New Haven and London, Yale University Press.

Lindberg, David C. (1976), *Theories of Vision from Al-Kindi to Kepler*, Chicago, IL, University of Chicago Press.

Magnus, Hans (1878), *Histoire de l'évolution du sens des couleurs*, trans. Jules Soury, Paris, C. Reinwald.

Melville, Hermann (1988), *Moby Dick*, Evanston and Chicago, IL, Northwestern University Press and the Newberry Library [1851].

Metz, Christian (1982), *Psychoanalysis and Cinema: The Imaginary Signifier*, London, Macmillan.

Mirzoeff, Nicholas (1990), "Pictorial Sign and Social Order: L'Académie Royale de Peinture et Sculpture, 1639–1752," PhD Diss., University of Warwick.

Niceron (1638), *La Perspective Curieuse*, Paris.

Nochlin, Linda (ed.) (1966), *Impressionism and Post-Impressionism 1874–1904: Sources and Documents*, Englewood Cliffs NJ, Prentice-Hall.

Pader, Hilaire (1649), "Discours sur le sujet de cette Traduction," in his *Traicté de la Proportion Naturelle et Artificielle des choses par Jean Paul Lomazzo*, Toulouse.

Porta, Giovanni B. della (1650), *La Magie Naturelle*, trans. Lazare Meysonnier, Lyons.

Sabra, A.I. (1982), *Theories of Light from Descartes to Newton*, Cambridge, Cambridge University Press.

Sedgwick, Eve Kosofsky (1990), *The Epistemology of the Closet*, Berkeley, CA, University of California Press.

Thompson, Robert Farris (1983), *Flash of the Spirit: African and Afro-American Art and Philosophy*, New York, Random House.

Trexler, Richard J. (1995), *Sex and Conquest: Gendered Violence, Political Order and the European Conquest of the Americas*, Ithaca, NY, Cornell University Press.

White, John (1967), *The Birth and Rebirth of Pictorial Space*, London, Faber.

Winckelmann, Johann (1786), *Receuil de différentes pièces sur les Arts*, Paris.

THE AGE OF PHOTOGRAPHY (1839–1982)

PHOTOGRAPHY ELUDED THE traditional classifications of arts and crafts precisely because of its modernity. If visual culture is the product of the encounter of modernity with everyday life, then photography is the classic example of that process. The invention of photography came as the culmination of decades of experimentation with visual media in an effort to find a quicker and more exact means of representation than those offered by the traditional visual arts. As various means of "writing light" – the literal meaning of photography – were invented in Europe from the 1820s on, it was at once clear to everyone who saw them that a new age had dawned (Batchen 1997). From then on, the world was pictured first as a photograph and then as a film, rather than as a formal image. With its low cost and availability, photography democratized the visual image and created a new relationship to past space and time. For the first time, it was possible for the ordinary person to record his or her life with certainty and to create personal archives for future generations. With the rise of computer imaging and the creation of digital means to manipulate the photograph, we can in turn say that photography is dead. Of course photography will continue to be used every day in vast quantities but its claim to mirror reality can no longer be upheld. The claim of photography to represent the real has gone.

The death of painting

In 1839 the French painter Paul Delaroche saw a daguerreotype, the first process that we would now call photography and famously exclaimed:

"From today, painting is dead!" (Batchen 1994). Given that the French art of the next century would give birth to Impressionism, Post-Impressionism, Cubism and Surrealism, it might seem that Delaroche was simply wrong. However, his remark did not imply that painting was no longer possible but that it was no longer necessary as a means of recording exterior reality. Since the invention of oil painting in the fifteenth century, it had become accepted not only as the highest branch of the visual arts but as the most faithful means of imitating the real. Despite the indifferent quality of many early photographic processes, it was at once clear to nineteenth-century audiences that photography was going to take over the latter quality. Artists and critics devoted enormous energies to an ultimately successful effort to ensure that painting continued to be seen as the most artistic medium.

When Delaroche spoke of the death of painting, he was not speaking of all painting so much as the particular style of painting that he practised and which had been dominant in France for fifty years. This neo-classical academic style produced painting so finely finished that no trace of the brush could be seen. It offered figures in crisp outline and with precise, historically-researched detail. This pictorial style was to become the pre-ferred rendering of photography and was perhaps inspired by the popular camera obscura device. The camera obscura was a darkened space into which light entered through a lens, producing an inverted image of the outside world on the rear wall. In the seventeenth century, Descartes had used the camera obscura as an analogy to explain his materialistic concept of vision. By the eighteenth century, it had become a popular fairground entertainment and images abound of children being held rapt by the spectacle. At the other end of the social scale, the artist Carle Van Loo depicted a French prince playing with a camera obscura in his *Portrait of the Dauphin* (c.1762) – the future Louis XVI. Van Loo's painting expressed the tensions inherent in French visual culture and wider society on the eve of the French Revolution. The heir to the throne, a literally divine being, is seen being amused by the same sideshow toy that any child might have enjoyed. Although oil painting was still the most élite genre of the arts, the circular canvas imitated the camera obscura image produced by the lens. By the late eighteenth century, official painting aspired to be photographic and was thus immediately side-lined by the invention of a technical process that could offer the highest degree of imitation instantly.

Photography did not come to such results by accident. Researchers sought to produce effects similar to those valorized by fine art and dismissed alternative means of representation. After Nicéphore Niepce first exposed a plate to light in 1826, he and Louis Daguerre (1789–1851) worked together for nearly a decade to perfect what was to become known as the

daguerreotype. In this process, a copper plate was covered in light-sensitive chemicals and then exposed to light, producing a positive image on the plate. The disadvantage of the daguerreotype was that it could not be reproduced. The true photograph, in which a plate exposed to light produces a negative that can be used to make theoretically an infinite number of copies, was first produced in France by Hippolyte Bayard and in England by Fox Talbot around the same time as the daguerreotype. The success of the negative method was ensured by the refinements to the process made by the French photographer Nadar in the 1850s but people continued to take daguerreotypes until the late nineteenth century. The new medium had yet to establish its own standards, both technically and in terms of the image produced. As late as 1864, the British photographer Julia Margaret Cameron responded to critics of her work by demanding: "What is focus and who has the right to say what focus is the legitimate focus?"

Photography's ambivalent status as both scientific record and a new art form generated an uncertainty as to what constituted "legitimate photography," and equally important, who had the right to practice it. Take the controversy over the portrait photographs by Antoine Samuel Adam-Salomon (b.1818). His portraits, such as that of the writer Alphonse Karr, were described as "the finest photographic portraits in the world" (see Figure 2.1). However, some found his achievement suspicious and asserted that they must have been retouched by the artist. Needless to say, painted portraits were continually reworked so as to flatter the sitter but retouching seemed to contradict the very nature of photography as the record of a particular instant. One critic satirized this debate in his review:

> If such results could be obtained by retouching, I should be disposed to exclaim, "Let it be as lawful as eating." But I must confess that I have been a little amused, in common with one of your previous correspondents, when I remember how deeply injured photographers have felt because photography has been denied the recognition of a fine art, and yet when results beyond challenge, on art grounds, are produced, photographers are the first to exclaim that such results are due to extraneous means, and not to legitimate photography.
>
> (Buerger 1989: 58)

Salomon and other professional photographers found themselves caught in a double-bind: if their work achieved remarkable results then they were accused of fraud, but if not it was dismissed as an illusionist's trick.

However much photography owed to its predecessors in terms of style, it

Figure 2.1 Adam-Salomon's portrait of Alphonse Karr

was immediately seen as a dramatic departure from past media. The result was what Maurisset's famous print labeled "daguerreotypomania." The print shows a vast crowd flocking to have their photo taken in an anonymous landscape filled with the signifiers of modernity. A balloon, steam train and steamship all appear in the background as the harbingers of the new era

definitively ushered in by photography. Queues wait for their chance to have their portrait taken and made available within 13 minutes. This combination of speed and low cost doomed all other reproductive media, satirically alluded to by a sign offering "Gallows for hire by engravers." In an allusion to what would become one of the most popular uses of photography, a Bohemian type offers a "camera for travelling." Remarkably, this print was produced in the same year that Daguerre first demonstrated his device.

The newness and importance of photography stem from its most obvious capability: its rendering of a precise moment in time. The click of the shutter captures a moment of time that is immediately past but is none-theless the closest thing there is to a knowledge of the present. The experience of modernity is contained in this paradox. When Virilio describes the logic of the modern image as dialectical, he is referring to this tension between time past and the present, as expressed by the German critic Walter Benjamin: "An image is that in which the then and the now come together into a constellation like a flash of lightning. In other words: an image is dialectics at a standstill. For while the relation of the present to the past is a purely temporal, continuous one, the relation of the Then to the Now is dialectical: not of a temporal, but of an imagistic nature" (Charney and Schwartz 1995: 284). This dialectic – the productive conflict of oppo-sites – was most clearly visualized in the photograph. For while a painting might depict the past, it was necessarily created over an extended period of time, whereas even the photographic prototypes of the 1830s completed their exposures in minutes. By the 1880s, exposure times were measured in fractions of a second as they are today. Photography created a new relation-ship to the experience of time that was thoroughly modern.

Time became modern in three central aspects. First, the development of railways and other mass communications led to the adoption of standardized time zones and national time. As a result, all clocks in England were calibrated to the same time whereas they had previously respected the actual variation of time created by geography so that a clock in London would be a few minutes ahead of one in Bristol. Second, the destruction of the old world and its replacement by a new, modern society was one of the most com-mented upon features of the nineteenth century. The classic example was the rebuilding of Paris in the 1850s and 1860s by Baron Haussmann, who drove broad new boulevards through the narrow maze of early modern streets in the center of the city. In so doing, he at once destroyed many working-class districts of the city, provided the means to move troops into Paris in the event of an insurrection and created the cityscape that was to be celebrated by the Impressionists. Finally, the West saw itself as modern in relation to its colonies in Africa, Asia, and Australasia. Europeans presumed that the

indigenous peoples they encountered were "living fossils," to use Charles Darwin's phrase, examples of what was now the past in Europe, preserved by accident for their study. For nineteenth-century Europeans, time moved in a straight line, parallel to progress, and both were moving at ever-increasing speed.

While nineteenth-century critics were uncertain exactly how to define photography, it was clear to them that this aspect of capturing a specific moment in time was essential. Photography was a key tool in recording and describing the time differential between viewer and object. In Charles Marville's photographs of Old Paris, he deliberately set out to record areas of the city that were about to be demolished during Haussmann's rebuilding. Here photography's capturing of time past is its entire function, to record what is about to pass into non-existence. In a well-known essay published in 1859, Oliver Wendell Holmes commented ironically on the transformation of memory and record caused by photography:

> Form is henceforth divorced from matter. In fact, matter as a visible object is of no great use any longer, except as the mould on which form is shaped. Give us a few negatives of a thing worth seeing taken from different points of view, and that is all we want of it. Pull it down or burn it up if you please. . . .
>
> There is only one Colosseum or Pantheon; but how many millions of potential negatives have they shed – representatives of billions of pictures – since they were erected. Matter in large masses must always be fixed and dear; form is cheap and transportable.
>
> (Gunning 1995: 18)

Photography, in this scheme, is to form as art is to matter. Photography is transportable and cheap, while art is expensive and relatively hard to move. Just as oil painting on canvas had prevailed over the wood panel in the fifteenth century for its ease of mobility and greater truth of imitation, so had painting now been superseded by photography. In this fashion, the French photographer Blanquart-Evrard made a daguerrotype of a Renaissance house in Lille that was about to be demolished in 1850. In ironic confirmation of Holmes' theory, Joly de Lotbinière recorded the exact time and date of his photographs of the Parthenon "because each year these celebrated ruins might sustain further changes in appearance. A catastrophe could occur, just as a friendly and generous hand could raise from the ground, and make of that which was one of the most beautiful temples, a most imposing ensemble" (Buerger 1989: 49). Such was the death of

painting observed by Delaroche. The capturing of time past in the photograph changed the very nature of human perception and made possible the creation of what Benjamin called the "optical unconscious." Experience became understood as an image because photography could capture decisively the individual moment in a way that seemed unquestionable.

Further, photography made possible ways of seeing that were previously unimaginable. The most striking example of this new vision was the rendering of movement by Etienne-Jules Marey and Eadward Muybridge. At roughly the same time in Paris and California, the two scientists devised methods of capturing the different segments of movement that the human eye could not register. To satisfy a bet for his patron Leland Stanford, Muybridge famously proved that a horse's feet do not point forwards and backwards in a gallop as artists had always depicted them. In an instant, Muybridge demonstrated that centuries of equine painting were completely inaccurate. Using what he called a "camera-rifle," Marey set up a photographic station in Paris where the movement of humans and animals was shot in front of calibrated scales. The camera took numerous shots of a particular movement allowing the precise calculation of the range of motion. Marey was convinced that his observations were far more accurate than unaided human perception, which he believed the camera would now replace. Capturing movement was, of course, the prime achievement of cinema and the prosthetic eye became reconfigured as the movie camera. The early Soviet director Dziga Vertov so identified with this process that he claimed: "I am the cinema-eye. I am a mechanical eye. I, a machine, can show you the world as only I can see it" (Burgin 1996: 13). Visuality was now photographic.

The birth of the democratic image

Despite the attempts of Daguerre and Fox Talbot to claim élite status for their devices, photography was quickly claimed as the people's medium. The history of photography can never be fully written because, as soon as the medium was invented, countless images were created and continue to be created. In 1991, 41 million photographs were taken every day in the United States alone. Even though the apparatus itself was expensive at first, obtaining images was not. Just as the era of computer imaging and virtual reality already seems to offer far more than the technology can actually now deliver, so too did photography's possibilities at once become apparent to the mass audience. However, unlike computer imaging, photography was democratic from its first appearance. For the first time in history, the broad mass of the people had access to a means of recording their appearance for posterity. In a very real sense, time past became available as a mass

commodity. With the invention of the collodion-glass negative process in 1852, prints became affordable to all. In France, a photographic portrait could be purchased from a street vendor for 2 francs at a time when the average daily wage for a labourer was 3 francs 50, making it a luxury, but one affordable to all working people. They availed themselves of this resource en masse to the despair of élite critics who disparaged the results as "fried fish pasted onto metal plaques."

Yet we can distinguish between the different types of photography that were practised. For Ernest Lacan, editor of the first art photography journal *La Lumière*, it was clear in 1852 that

> [photography] was installed first in the attics, on the roofs – it is often from these that great things come: then it entered the study of the man of letters, the atelier of the painter, the laboratory of the savant, the salon of the millionaire, finally the boudoir of our most charming unemployed. It inscribed its name on every street corner, on every door, on the most sumptuous facades of the boulevards and promenades; it goes back and forth on the walls of the jostling omnibus!
>
> (Buerger 1989: 51)

Just as the Parisian apartment block was differentiated by class, with the wealthy taking the mansion apartment on the first floor and the impover-ished living in the garrets, so did photography travel from class to class, taking a different form at each level of the social ladder. Lacan argued that each photograph could be precisely correlated on a map of Paris by price and location: "One can establish this mathematical proportion: a photographer of such and such a street is to a photographer of such and such a boulevard as 2 francs is to 55." In so doing, Lacan sought to defuse the democratic potential of the photograph by arguing that the type of photograph one purchased inevitably revealed your social class. Quality of photography thus mirrored social quality, to use the nineteenth-century term, that was again perfectly reflected by price. He even sub-divided photographers into four classes, corresponding to social class: the basic photographer (working class or artisan); the artist-photographer (bourgeois); the amateur, in the sense of connoisseur, hence aristocrat; and the distinguished photographer-savant, who claimed the classless status of the artist. Thus those who saw themselves as the photographic élite argued that "legitimate photography" was that which could be identified as belonging to a specific place, time and class. It is hardly surprising that Lacan's belief that social class could be precisely calibrated from a photograph using the twin axes of cost and location was

not always accurate in practice (McCauley 1994). But in a time of dramatic social change, photography seemed to offer a chance to make class positions transparent, both for photographer and client, even if only for the instant in which the picture was taken. In this sense, photography did not reflect class, it *was* class.

This attempt to give photography what Rosalind Krauss has called "singularity" cut across what was to be its most revolutionary feature, namely mass reproducibility. In his famous essay, "The Work of Art in the Age of Mechanical Reproduction," Walter Benjamin argued that the reproducibility of photography undercut the aura of art. For while a painting is unique, many identical prints can be made from one negative. On the other hand, Benjamin saw that this new availability of the image would help popularize the arts: "Mechanical reproduction of art changes the reaction of the masses toward art. The reactionary attitude toward a Picasso painting changes into a progressive reaction towards a Chaplin movie" (Benjamin 1968: 234). In fact, by the time Benjamin wrote his essay in 1936, photography had long since been coopted into the museum system along the lines suggested by Ernest Lacan. That is to say, the self-proclaimed photographic élite were able to make a clear distinction between their work as art and all other photography which was merely craft. As early as 1855, there was a photography exhibition at the World's Fair of that year. In 1859, photography was admitted to the Salon, the annual exhibition of the fine arts in Paris and by 1863 French law recognized that some photography could be recognized as art for legal and copyright purposes, after several years of court cases. Today it is still the case that if a photograph can claim serious artistic merit, then it legally cannot be obscene. This artistic distinction rests firmly on the class distinctions made by photography's early champions, which have been accepted for so long that they now seem "natural."

Death and photography

> All photographs are *memento mori*. To take a photograph is to participate in another person (or thing's) mortality, vulnerabliity, mutability. Precisely by slicing this moment and freezing it, all photographs testify to time's relentless melt.
>
> (Sontag 1973: 15)

In his meditation on photography, Roland Barthes described it as "*the impossible science of the unique being*" (Barthes 1981: 71). By this he meant that photography seeks to record with the highest degree of realism the

individuality of its subject, but that this sense of an individual is exactly what cannot be photographed. At the same time, photography is distinct from other media because it shows that something was definitely there when the shutter was opened. What the object photographed is to be called and what judgement we make of that is up to the viewer, but the fact that something was present to be photographed cannot be denied. As a result, photography is a past-tense medium. It says "that *was* there" not what is there. It emphasizes the distance between the viewer of the photograph and the time in which the photograph was taken. In a secular society the photograph is Death's point of entry into everyday life, or as Barthes puts it: "With the Photograph, we enter into *flat death*" (Barthes 1981: 92). The past that the photograph presents cannot be recaptured and emphasizes the "imperious sign of my future death" (Barthes 1981: 97). The same can be said of cinema. For the silent film director Jean Cocteau, the camera "filmed death at work" (Burgin 1996: 85).

In Barthes' analysis, the specificity of time and place sought by early photographers was attainable only insofar as it evokes a response in the viewer. Barthes named this response the *punctum*, the point, contrasting it to the *studium*, or general knowledge that is available to every viewer. He seems to offer two versions of the *punctum*. One is the casual, everyday notion of irrational preference for a particular detail in a photograph. It may be that this detail calls to mind something similar in the viewer's own experience or simply that it appeals for an unknown reason, as Barthes specifies that what can be named or described in a photograph belongs to the *studium*. At the punctum, we are dealing with that ineffable difference in pose that causes us to select one portrait photograph over another or to say that a photograph does or does not "look like" its subject. A photograph looks like its subject by definition: what we refer to is that "impossible science" of resemblance to character, personality or ego. On the other hand, there is also the sense in which the *punctum* is a wound. In this instance, the photograph evokes something very powerful and unbidden in the viewer. Barthes found this *punctum* in a photograph of his mother taken when she was a little girl. In this photograph, which he discovers after her death, it seems to him that he discovers his mother "as she was": "this photograph collected all the possible predicates from which my mother's being was constituted" (Barthes 1981: 70). No photographer could set out to create an image with such multiple meanings. They are brought to the image by the viewer for whom the *punctum* creates the means to connect memory with the subconscious drives for pleasure and death. Through the unknowable *punctum*, photography becomes sublime. The most important and yet most unknowable

singularity of photography is this power to open a *punctum* to the realm of the dead.

Photography came into being at a time of profound social change in attitudes to the dead and to death. It thus participated in a new means of configuring death at the same time as it offered an everyday reminder of death. The experience of mass industrial society led to a desacralization of death and its experience from a public religious ceremony in the early modern period into the private, medicalized case history of modernity. By the 1860s even the Goncourt brothers, conservative French art critics, observed that "as societies advance or believe themselves to advance, to the degree that there is civilization and progress, so the cult of the dead, the respect for the dead, diminishes. The dead person is no longer revered as a living being who has entered into the unknown, consecrated to the formidable '*je ne sais quoi*' of that which is beyond life. In modern societies, the dead person is simply a zero, a non-value" (Nochlin 1971: 60). When Gustave Courbet's monumental painting *A Burial At Ornans* (1849) was first shown at the Salon of 1851, it caused a scandal. Ten years later the experience of death had become the province of photography and was simply a "non-value."

Death was a part of nineteenth century everyday life in a way that is now difficult for Westerners to conceive. Death took place in the home, rather than the hospital, and was often a public spectacle, attended by friends and family. With very high infant mortality rates and low life expectancy, no family was unfamiliar with loss. In place of the wax death mask or death bed engraving, photography came to be the prime means of capturing the image of the departed. Due to its lower cost, it opened remembrance to a wider strand of society than ever before and it became common to see photographs displayed on headstones. In this way, death became not just a metaphorical means of understanding the power of photography, but one of its privileged subjects. The celebrated early French photographer Nadar claimed a coup in 1861 with his photographs of the Paris catacombs. By devising a means of artificial lighting, he showed something that could not previously be reproduced while at the same time claiming the kingdom of the dead for photography.

Ten years later, the photography of death took center stage in French politics. Following the defeat of France in the Franco-Prussian war, the citizens of Paris staged a revolt against the conservative government newly installed in Versailles, declaring the capital an independent Commune in March 1871. This utopian gesture was doomed from the outset but caught the imagination of Europe as an inspiration to radicals and socialists and a dreadful warning to élites and governments. The Commune was repressed

by force in May 1871, leaving at least 25,000 dead. In its wake, a flood of photographs of the events were published, some taken during the Commune but most afterwards. Two images in particular came to represent the conflict. On the one hand, Eugène Appert published a series of sensational photographs depicting the outrages of the Commune, centering on the execution of Generals Clément-Thomas and Lecomte by the Communards. In fact, the picture was produced by montage, involving a staged recreation of the execution at the actual site with hired actors. The figures were placed according to an engraving published in the journal *L'Illustration* and therefore convinced audiences that it was correct not by evoking the actual scene but by reproducing an already familiar representation of the scene (Przyblyski 1995: 267). The scene was completed by montaging portraits of the generals onto the space left empty for them. Although it was recognised as a fake, this photograph was nonetheless widely reproduced as evidence of the savagery of the Commune. On the other side, a photograph of the bodies of the dead Communards, piled up in their coffins after the final executions in the Père Lachaise cemetery, served as a token of remembrance for the Left by evidencing the brutality of the repression. However, like many documentary photographs, it could be read more than one way. For the government party, the same picture could provide evidence of the degenerate criminal types who supported the Commune. In short, photography could provide evidence but did not in and of itself convict.

In the early twentieth century, Eugène Atget (1857–1927) set out to record Old Paris, the Paris that the renovations of the nineteenth century had brought to the verge of disappearance. Atget had experimented with a variety of careers from merchant seaman to actor until he had settled on photography for artists. He became sufficiently well-known for his images of Old Paris that both French museums and Surrealist artists like Man Ray bought his work. He called these photographs documents, implying that their interpretation and use would be left to others. Despite their documentary intent, Atget's images seem to want to be placed in a story. For example, in his series depicting traditional Parisian restaurants, ghostly figures can often be seen behind the glass of the door. His photograph of *Au Tambour, 63 quai de la Tournelle* (1908) allows us to see two men standing in the doorway of the restaurant as well as the reflection of the banks of the Seine and Atget's photographic apparatus (see Figure 2.2). The old and the new literally merge on the screen of the photographic surface. Not surprisingly, these images fascinated Walter Benjamin, who famously appreciated:

Figure 2.2 Au Tambour, 63 quai de la Tournelle

the incomporable significance of Atget who, around 1900, took photographs of deserted Paris streets. It has quite justly been said of him that he photographed them like scenes of a crime. The scene of a crime too, is deserted; it is photographed for the

purpose of establishing evidence. With Atget, photographs become standard evidence for historical occurences and acquire a hidden political significance. They demand a specific kind of approach; free-floating contemplation is not appropriate to them.

(Benjamin 1968: 226)

Atget's work marked the coming-of-age of photography, which had finally separated itself from the traditional visual media. It now demanded a specific kind of attention to its subject matter that could be generalized as the depiction of time past for the purposes of evidence. As such, it inevitably and insistently evoked the presence of death in the visual field.

Modern photography was consistently haunted by these themes. Around 1910, a photographer of the Mexican revolution took a picture of a man standing at ease in his shirtsleeves, foot poised on a rock, smoking a cigarette. His cool gaze makes him an icon for guerilla chic, until one reads the accompanying caption and discovers that he is about to be shot. The cigarette becomes the last cigarette, the quaintly decaying wall becomes a wall ravaged by the repeated shock of the firing squad and the photograph acquires an intense vividness that seems to attest to the preciousness of life even in its last moments. Look at the famous Robert Capa photograph, *Near Cerro Muriano (Córdoba front) September 5, 1936* (Figure 2.3). It simply shows a Republican soldier in the Spanish Civil War at the moment in which he has been shot. His rifle is still within his hand as his knees give way and he falls back. The image has an intense power that is enhanced by the absence of any other significant detail in the frame. But very soon, questions were asked. It seemed that there had been no action on the Córdoba front that day and that the photograph must therefore be a fake. Unlike Appert's photograph of the Commune, the fact that Republicans were certainly being killed daily in the struggle against Fascism was not felt to absolve Capa. Photography had become too central to modern life for such equivocations to be accepted. Intriguingly, it was announced in 1996 that a historian had discovered that there was one death that day on the Republican side. The victim's sister was still alive and claimed Capa's photo did indeed show her brother. At sixty years distance who can say if her memory was accurate?

From photo noir to post-photography

In order to cross the gap between the middle years of the twentieth century when photography told the truth and our own more suspicious age, let us compare the work of two American-Jewish photographers, Weegee and Nan Goldin. Both feature the underside of East Coast city life in their work, from

Figure 2.3 Near Cerro Muriano (Córdoba front)

violence to sexual transgression. Both made their names with photo-essay books – his *Naked City* (1945), hers *The Ballad of Sexual Dependency* (1986) – and went on to success in the art and fashion worlds. Both even featured photographs of the Duke and Duchess of Windsor as the prime example of romantic passion, only Goldin's photograph is of a waxwork sculpture. The contrast comes in their attitude to their work. While Weegee adopted the camera as the weapon of the voyeur, Goldin turned the camera back on herself, doubting her right to intrude where she was not known.

Weegee (1899–1968) was born Arthur Fellig in Zlothev, Austria and grew up in New York, the son of a failed peddlar who later became a rabbi. Like Atget and so many others, Weegee took an unconventional route to photography, mixing photography with being a busboy, living rough, selling candy on the streets and even being a violin player accompanying silent films: "I loved playing on the emotions of the audience as they watched silent movies. I could move them either to happiness or sorrow. . . . I suppose my fiddle playing was a subconscious kind of training for my future in photography" (Weegee 1961: 27). For although Weegee did a variety of photographic work, his most characteristic images were his graphic depictions of New York street life. In these photographs, Weegee presented documents of the

city's underclass amongst whom he had grown up that were nonetheless carefully constructed for maximum effect. In 1938 he acquired a police radio in his car: "At 12 o'clock I'd get in the car, ride around and if anything happened on the police radio, I was right there. Sometimes, I was right in the same block where the thing happened. I would get there before the cops did" (Stettner 1977: 8). The results were dramatic, fulfilling the logic of photography's obsession with death and evidence by capturing murder victims at the scene of the crime. Weegee used an intense flash that flattened the scene, saturated the blacks and often provided what he called a "Rembrandt light," evoking the rich chiaroscuro of the Dutch painter. Even then the power of the moment never seemed enough for Weegee and he always sought out an ironic twist. In his 1940 picture, *On the Spot*, the title seems self-evident as your attention is grabbed by a body in the foreground, lying on his back with blood running stereotypically into the gutter. The flash obliterated all details of the man's face or clothing, or the faces of the four policemen in the middleground but illuminated the bar sign above – The Spot Bar and Grill. In another undated shot, a body lies under a sheet while a policeman writes in his notebook. In the foreground, a mailbox advises "Mail early for delivery before Christmas," a holiday that the victim will of course never see. Capturing that instant was the essence of photography as Weegee saw it: "People are so wonderful that a photographer has only to wait for that breathless moment to capture what he wants on film . . . and when that split second of time is gone, it's dead and can never be brought back" (Weegee 1945: 241) [ellipsis original].

This cultivated hard-boiled personality came straight out of the *film noir* with which it was contemporary. *Film noir* set aside the established realistic conventions of Hollywood cinema in favour of dramatic lighting with deep shadows (hence the appelation *noir*), unusual camera angles and a jaundiced view of humanity. Its heyday came in the postwar years with films like *The Big Sleep* and *The Sweet Smell of Success*, followed by a revival in the 1970s with films like Martin Scorcese's *Mean Streets*, and a postmodern pastiche in the 1990s, led by Quentin Tarantino. Weegee borrowed its visual style for his work to such an extent it that can be called photo noir. He modelled himself on the detective character Nick Carter (Weegee 1945: 11) and was later to work as an actor in a number of Hollywood movies. His book *Naked City* was adapted into a 1948 Oscar-winning movie by Mark Hellinger, directed by Jules Dassin, that became a *film noir* classic in its own right. The cinema was also the scene of some of his most unusual work, using infra-red film, with the result that he could take pictures without a flash and hence be unobserved. A pair of photographs entitled *Lovers at the Movies* (1940) evokes the full range of modern visual media (Figure 2.4). The film

Figure 2.4 Lovers at the movies

being shown was in 3-D so all the spectators are wearing the plastic glasses required to generate the effect. Weegee's camera revealed a young man making advances on his female companion. In the first shot, she seems to resist but the infra-red film penetrated (pun intended) the sheer fabric of her blouse to reveal her bra. In the next shot they are kissing but while the woman has removed her glasses the young man has not, presumably wishing to experience the moment to the full. Their neighbor, a middle-aged woman, seems put out by the whole affair. Here the voyeurism of Weegee's photography, its desire to see what ordinarily cannot be seen, and its very masculine sexual politics all seem strongly apparent.[1]

The photography of Nan Goldin (b.1953), by contrast, is marked by a unique degree of personal intimacy. No one in her photographs is unknown to her and, more important, all are aware of being photographed. Her photographs are the record of her private life, made art by her decision to exhibit them. More than that, her work changes the nature of photography itself from the act of a voyeur to that of a witness. A witness physically participates in a scene and later reports on it, whereas the voyeur tries to see without being seen. While Weegee's photographs might serve as evidence in the judicial sense, Goldin's witness her scenes in the ethical sense of testifying to existence. Rather than take her camera out into the street

and document what she finds, Goldin takes her pictures indoors in the apartments of her social circle and in their public meeting places. Despite her intense investment in the medium, Goldin can be seen as perhaps the first post-photographer. Post-photography is photography for the electronic age, no longer claiming to picture the world but turning on itself to explore the possibilities of a medium freed from the responsibility of indexing reality (Mitchell 1992).

Goldin traces her need to photograph to the suicide of her sister Barbara Holly Goldin in 1965, a young woman who could find no place for her sexual identity in the suburban America of that time. Just as Roland Barthes located a key image of his mother as being one taken before his own birth, so in her 1996 exhibition *Children*, Goldin showed a reprinted family snapshot of her mother, taken when she was pregnant with her older sister. In a seemingly prophetic moment, her mother is holding a large, red balloon that is inflated but not tied. The balloon was no doubt intended to predict the dimensions of a heavily pregnant woman but it also seems to foretell the explosive short life of the unborn Barbara. Immediately following this trauma, Goldin was "seduced by an older man. During this period of greatest pain and loss, I was simultaneously awakened to intense sexual excitement." It should be noted that she was only 11 years old when these events took place. As she grew older, it seemed possible that her life would repeat the pattern of her sister's, so she ran away from home aged fourteen. At 18, she began to take pictures: "I don't ever want to be susceptible to anyone else's version of my history. I don't ever want to lose the real memory of anyone again" (Goldin 1996: 9). Photography became her prosthetic memory, literally a defense against death and symbolically a resistance to the loss of memory.

Goldin's work records the lives of a group of young people who first came together in the early 1970s around the end of the Vietnam War and whose radical experiments with the experience of everyday life came in turn to be ended by the onset of AIDS. For these young aspiring artists, mostly white, but open to all varieties of narcotic and sexual experimentation, there was a strong sense of being special:

> In my family of friends, there is a desire for the intimacy of blood family, but also a desire for something more open-ended. Roles aren't so defined. These are long-term relationships. . . . We are bonded not by blood or place, but by a similar morality, the need to live fully and for the moment, a disbelief in the future, a similar respect for honesty, a need to push limits, and a common history. We live life without consideration, but with considera-

tion. There is among us an ability to listen and to empathize that surpasses the normal definition of friendship.

(Goldin 1996: 7)

This belief in the uniqueness of a certain social group is in fact common to most groups of friends in their twenties, as movies like *Diner*, *St Elmo's Fire*, *The Big Chill* and even *Trainspotting* attest. The difference is that Goldin captured the unfolding dynamic of an actual group of individuals.

It is often said that Goldin's work uses popular snapshot photography as the source for her work. While this notion accurately reflects the intimacy of her work, it misses the radicalism of her project. Most sets of snapshots do not include scenes of people making love, injecting drugs, on the toilet, cross-dressing, masturbating or bleaching their eyebrows but such moments are the core of Goldin's work. She arrived at this style very early in her explorations of photography, while still a student at the alternative Satya Community School and then later at the School of the Museum of Fine Arts, Boston. In her portrait of *Ivy with Marilyn, Boston* (1973), Goldin captures one of her friends from the cross-dressing scene at the Boston night club The Other Side, dressed and ready to go out (see Figure 2.5). Ivy strikes a glamourous pose beneath a reproduction of Andy Warhol's silk-screened portrait of Marilyn Monroe. In this photograph, the notion of femininity as masquerade and performance that have recently become current in feminist theory (Butler 1990) were pictured and given personal form by the 20-year old Nan Goldin. Goldin saw transvestites, bisexuals and others prepared to experiment with gender roles as a "third gender," a vanguard group pushing forward the frontiers of identity.

Since 1973, much of her work has been in color. Memory needs color in order to be vivid. Goldin's skill as a photographer lies in part in finding the intense colors in everyday lives that might otherwise be depicted in the grainy black-and-white style favoured by Weegee and most other documentary photographers: "Nan's eye could take the most squalid corner of the worst dump and find colors and textures in it no one else saw. The blues were oceanic, the oranges crepuscular, the reds seductively hellish" (Sussmann 1996: 101). For example, *Vivienne in the green dress, New York 1980*, places her subject against a green wall, finding color contrasts in a red watch and blue radio to provide a lesson in the effects of complementary color. By contrast, in her portrait of *Siobhan with a cigarette, Berlin 1994*, the figure appears against a neutral gray-brown background that evokes photography's stylistic roots in the neo-classical portrait (see Figure 2.6). At the same time, her composition is remarkable. Like Siobhan, her figures appear to stand out in three-dimensions against a background that seems to recede

Figure 2.5 *Ivy with Marilyn, Boston*

as if in a stereoscope. Goldin offers her friends a mirror in which to see themselves and herself anew.

These pictures have achieved a far wider audience than any snapshot and Goldin's style has become iconic for life in postmodern plague-ridden America. While her subjects must have their own personal response to her work, it is also true that in the decade in which Goldin has been displaying her work, they have in a sense become our acquaintances as well. We recognise certain faces and locations, even artifacts, from one scene to the next. By erasing the public/private distinction in her work, Goldin creates a narrative that is as compelling as a television soap opera. Both she and her friends often refer to their sense that, in Luc Sante's words,

Figure 2.6 Siobhan with a cigarette, Berlin 1994

"we were living a movie of youth in black-and-white that in order to be grand needed to be stark" (Sussmann 1996: 95). At this distance, however, her photographs seem more televisual than filmic. Her cast of characters— David, Suzanne, Siobhan, Cookie – recur and return over a 20 year span so that the spectator acquires the illusion that he or she "knows" them, just as we come to "know" television characters over time. For those Douglas Rushkoff has called "screen-agers," such identification is as important as it was to the reader of the nineteenth-century serial novel. The self-conscious "cool" of Goldin's work in fact helps a generation raised on irony and detachment to make this connection. This detachment saves her work from being either maudlin or boring and in fact her intense focus on subject-formation and identity in the virtual age makes her work a mirror for all her viewers, not just the subjects of the photographs.

The key photograph in Goldin's *Ballad of Sexual Dependency* is the traumatic *Self-Portrait One Month after being Battered* (1984) – see Figure 2.7. In the introduction, she alerts the reader that this is the key event in her sexual dependency, a moment in which she finally sought to avoid her destructive relationship. Goldin's face fills the frame, with the bruises and cuts caused by her attack painfully evident. Her left eye is still filled with blood even at one month's distance and in fact she came close to losing her sight in that eye. Her bright red lips offer a seemingly ironic contrast, the traditional

Figure 2.7 Self-Portrait One Month after being Battered

enticements of femininity alongside the all-too-familiar consequences of male violence. The photograph was taken in order that she should never forget what happened and was intended to prevent her from relapsing. Photography becomes a prosthetic memory, not just for Goldin but for all her viewers as to what the sexual revolution of the 1960s failed to change. Here, where you might least expect it, there is an echo of Weegee's work. A favourite location in *Naked City* is the bar Sammy's on the Bowery, a venue patronized both by the local working-class and by uptown partygoers seeking the "dreadful delight" of mingling with the people (Walkowitz 1992). The bar even served later as the venue for the book's launch party. One photograph captures *Ethel, Queen of the Bowery*, a middle-aged woman clutching an unlit cigarette between her lips and smiling at the camera despite her vivid black eye. Her companion, a slightly older Jewish man, looks on over his beer. Behind the couple, a display of photographs is partly visible. It is not made clear from the text whether this was her batterer or another companion, but it seems that Ethel's relationships all ended in such domestic violence: "Ethel, Queen of the Bowery generally sports a pair of black eyes that nature did not give her" (Weegee 1945: 138). These two pictures, taken 40 years apart, provide a similar shock – an environment that has been portrayed, even romanticized, as nurturing turns out to be the exact opposite, whether it was the Bohemian youth of the 1980s or the

Jewish working-class of the Lower East Side in the 1940s. The difference is, of course, that while Weegee remains carefully out of frame, Goldin is her own subject. While Weegee allows himself, and by extension the viewer, the detached observation of the voyeur and the anthropologist, Goldin becomes a witness, not just to her own experience but to that of women in American culture. Witnessing provides a means for the artist to take a personal moment and invest it with a wider significance.

The onset of the AIDS epidemic gave a further unwanted twist to Goldin's witnessing and challenged her belief in the power of the image. Many of her friends, who were also the subjects of her work, fell prey to the virus as a legacy of their decade-long experiments with drug use and sexuality. Tragically, this road led not to liberation, as so many had hoped, but to death. The epidemic was the occasion of some of Goldin's finest work. When her close friend Cookie fell ill, she documented the passage of her disease in some searing images that strongly evoke the sublime. For example, *Cookie Being X-Rayed, October 1989* is a dark photograph in which all that can be seen is Cookie's face partially illuminated in a golden light, with dark bars breaking up her countenance. The photograph records a medical procedure yet seems to evoke what Dylan Thomas called "the dying of the light." Such photographs make earlier shots like *Cookie in Tin Pan Alley* (1983), where a seemingly melancholy Cookie sits alone in a bar, seem curiously prophetic, showing that photography can also create retrospective memories. In 1989, Goldin was one of the artists involved in an exhibition protesting the toll caused by AIDS in the artistic community, entitled *Witnesses: Against Our Vanishing*, that was to become part of the National Endowment for the Arts controversy. In his catalog essay, the artist David Wojnarowicz testified to his change of outlook since being diagnosed. On a trip to New Mexico, he suddenly experienced intense rage while looking at the desert landscape: "I couldn't buy the con of nature's beauty; all I could see was death. The rest of my life is being unwound and seen through a frame of death" (Sussmann 1996: 375). Suddenly, Goldin's photographs all appeared to be set in the same frame. In a series of photographs of her friends Gilles and Gotscho, taken in Paris between 1991 and 1993, Goldin documents Gilles' passage from a healthy, confident man to an emaciated victim of AIDS. In her photographs, he retains his personality even in the hospital, that most depersonalizing of locations. Death can no longer be denied or displaced to the photograph.

In an afterword to the 1996 edition of the *Ballad of Sexual Dependency*, Goldin reflected: "photography doesn't preserve memory as effectively as I had thought it would. A lot of the people in the book are dead now, mostly from AIDS. I had thought that I could stave off loss through photographing. I

always thought if I photographed anyone or anything enough, I would never lose the person, I would never lose the memory, I would never lose the place. But the pictures show me how much I've lost. AIDS changed everything" (Goldin 1996: 145). Despite the advances made in drug therapy, AIDS changed the West because it is more than a disease, it is the sign of a changed culture. The self-confidence of Goldin's circle in the 1970s was at once Romantic and modernist. That is to say, Goldin had a belief in progress and the power of art to change life that manifested itself in her total committment to photography. Further, like so many modern Bohemians, she believed that this change would come from the marginal groups in society whose very marginality enabled them to go farther than the mainstream culture could even imagine. Neither position seems convincing after two decades of the epidemic. Only someone with Goldin's sustained engagement with her medium could have taken it to the point where its transformation was even apparent to the artist herself. Paradoxically, it was Goldin's very belief in modernist photography that enabled her to become the first post-photographer of note.

The death of photography

After a century and a half of recording and memorializing death, photography met its own death some time in the 1980s at the hands of computer imaging. The ability to alter a photograph digitally has undone the fundamental condition of photography–that something must have been in front of the lens when the shutter was opened, even if questions remained as to the authenticity of what was then recorded. It is now possible to create "photographs" of scenes that never existed without the fakery being directly observable. As early as 1982, the special effects company Lucasfilms declared that their work implied "the end of photography as evidence for anything." In addition to the possibility of adding new elements to a scene, each pixel (picture element) in a digitized image can be manipulated for color, brightness and focus (Ritchin 1990: 13). One of the most (in)famous examples of this technique came during the O.J. Simpson criminal trial, when *Time* magazine altered Simpson's photograph to make him appear darker-skinned and thereby, presumably, more threatening to *Time*'s white readership. Such technology was the province of specialized technicians and expensive equipment in the 1980s but programs like Adobe PhotoShop for the domestic manipulation of photographs can now be bought for as little as $50 and are often given away with the appropriate hardware. Some newspapers have begun to use notation to record whether an image has been manipulated or not. The point is that the photograph is no longer an index of

reality. It is virtual, like its fellow postmodern visual media, from the television to the computer.

Perhaps the clearest indication of photography's virtual status in contemporary society has come from the changed attitudes to the use of photography as evidence. When Rodney King was beaten by Los Angeles police in 1990, the event was recorded by amateur cameraman George Halliday. With such evidence in hand, a conviction seemed a matter of course. The defense turned to that very evidence to undermine the prosecution. By slowing down the tape and analyzing it second by second, the lawyers managed to make a case that King had presented a threat to the police. The argument was sufficiently credible for an all-white jury – no doubt predisposed to acquit – to find in favor of the defendants. Ironically, the technique of frame by frame analysis was first developed in film studies by critics seeking to define the specificity of film techniques. Despite the obvious sociological factors that led the jury to acquit, it is impossible to imagine the video evidence being so effectively displaced unless there was already a suspicion that photographic media in general are so open to distortion that they must be treated with extreme caution.

This suspicion has now become part of the everyday use of photography. Kodak and other film companies now sell digital cameras, specifically designed to allow computer manipulation of the image. For decades Kodak relied on selling film as prosthetic memory, encapsulated in their slogan: "It's a Kodak moment." Now their executives argue that "photographs aren't just memories any more. They are information." Digital cameras are now competitive in price, if not yet in quality, with traditional film cameras. As such, photographs warrant no more respect than any other virtual medium. The 1996 American elections provided a graphic example of this process in action. Senator John Warner of Virginia was running in a close race against a Democratic opponent, Mark Warner. His campaign produced a television advertisement featuring a photograph showing Mark Warner shaking hands with the unpopular former (black) Governor Douglas Wilder in order to back up the Republican claim that he was a "liberal." It soon transpired that the "photograph" was a digital fake, morphing Mark Warner's head onto another Democrat's body. Ten years ago an election might have been lost on such grounds. Senator Warner won re-election comfortably.

Note

1 In his autobiography, Weegee refers to setting up a similar scene for the magazine *Brief* using paid models in a Forty-Second Street movie theatre, but dates the event to 1951 (Weegee 1961: 117).

Bibliography

Barthes, Roland (1981), *Camera Lucida: Reflections on Photography*, New York, Noonday.
Batchen, Geoffrey (1994), "Ghost Stories: The Beginnings and Ends of Photography," *Art Monthly Australia* 76, December 1994.
—— (1997), *Burning With Desire*, Cambridge, MA, MIT Press.
Benjamin, Walter (1968), *Illuminations*, New York, Shocken.
Buerger, Janet E. (1989), *French Daguerreotypes*, Chicago, IL, Chicago University Press.
Burgin, Victor (1996), *In/Different Spaces: Place and Memory in Visual Culture*, Berkeley, CA, University of California Press.
Butler, Judith (1990), *Gender Trouble: Feminism and the Subversion of Identity*, New York, Routledge.
Charney, Leo and Schwartz, Vanessa R. (eds) (1995), *Cinema and the Invention of Modern Life*, Berkeley and Los Angeles, CA, University of California Press.
Coplans, John (1982), *Weegee's New York*, Munich, Schirmer/Mosel.
Goldin, Nan (1996), *The Ballad of Sexual Dependency*, New York, Aperture.
Gunning, Tom (1995), "Tracing the Individual Body: Photography, Detectives and Early Cinema," in Charney and Schwartz (1995).
McCauley, Elizabeth (1994), *Industrial Madness*, New Haven, CT, Yale University Press.
Mitchell, William J. (1992), *The Reconfigured Eye*, Cambridge, MA, MIT Press.
Nochlin, Linda (1971), *Realism*, London, Penguin.
Przyblyski, Jeannene M. (1995), "Moving Pictures: Photography, Narrative and the Paris Commune of 1871," in Charney and Schwartz (1995).
Ritchin, Fred (1990), *In Our Own Image: The Coming Revolution in Photography*, New York, Aperture.
Sheldon, M. French (1892), *Sultan to Sultan: Adventures among the Masai and other Tribes of East Africa*, Boston, MA, Arena.
Sontag, Susan (1973), *On Photography*, New York, Farrar, Strauss and Giroux.
Stettner, Louis (1977), *Weegee*, New York, Alfred A. Knopf.
Sussmann, Elizabeth (1996), *Nan Goldin: I'll Be Your Mirror*, New York, Scalo.
Walkowitz, Judith (1992), *City of Dreadful Delight: Narratives of Sexual Danger in Late Victorian London*, Chicago, IL, Chicago University Press.
Weegee (1945), *Naked City*, New York, Essential Books.
—— (1961), *Weegee by Weegee*, New York, Da Capo.

VIRTUALITY
From virtual antiquity to the pixel zone

V IRTUALITY IS EVERYWHERE. It goes by a variety of names and can be accessed by a wide range of machines. By definition virtuality is an image or space that is not real but appears to be. In our own time, these include cyberspace, the Internet, the telephone, television and virtual reality. Perhaps one of the most familiar definitions of virtual reality is the space that comes into being when you are on the phone: not exactly where you happen to be sitting, nor wherever the other person is, but somewhere inbetween. A great deal of money now exists in no other form than the virtual. It moves as electronic impulses from the computer of an employer to that of a bank and only materializes when you access your bank account through an automated teller machine – the cash that emerges comes from an interface between reality and virtuality. These obvious definitions lead many people to assume that virtuality is a very recent development. In fact, it has a long history from the experience of classical and neo-classical art in the eighteenth century to today's Internet and tomorrow's virtual reality. These older experiences of virtuality were, however, always a passive contemplation of the not quite real. What computer-generated environments can offer for the first time is an interactive version of virtuality. Many utopian claims are being made for virtuality. But if we compare virtuality to the dialectical image offered by photography, it becomes clear that the new media are still marked by the old hierarchies of race, gender and class. Virtuality is not an innocent place. On the other hand, there is now increasingly little difference between what used to be distinguished as the real and the virtual. The complex terrain of the interaction between the

global and the local that is the site of contemporary cultural practice is both real and virtual at once, hence the paradoxical title virtual reality.

Interfaces with virtuality

When the poet Goethe visited Rome in 1786, he went to see the famous antique sculpture of a male torso known as the Apollo Belvedere, a surviving fragment of a full-sized statue. In his journal he noted that he had been "transported out of reality" (Massa 1985: 69). Goethe was recording one of the first visits to virtual reality, or to be more exact, to the unreal place viewers of classical art felt themselves to visit. I shall call this place virtual antiquity. Virtual antiquity was a surprisingly common experience in the late eighteenth century. When the future American President Thomas Jefferson saw a neo-classical painting entitled *Marius and the Gaul* by the young French painter Jean-Germain Drouais, he was at once in virtual antiquity: "It fixed me like a statue for a quarter of an hour, or half an hour. I do not know which, for I lost all ideas of time, even the consciousness of my existence" (Crow 1995: 68). Neo-classicism provided access to an interiorized virtual world, the space of virtual antiquity. The experiences of Goethe and Jefferson indicate that virtuality can be understood as the transformation of space away from exterior three-dimensional reality to the polydimensional interior world of the self.

What did such space signify to the art viewer at the turn of the eighteenth century? The answer to this question is not as simple as it might seem. Space is a multiple phenomenon, far from being simply "empty": "[S]pace is both a static existential fact (inasmuch as we cannot exist outside space), and a phenomenon that is shaped dynamically and socially" (Boyarin 1992: 3). First, there was the social space of the art gallery or museum where the user could access virtual antiquity. These spaces form part of what has been called the "public sphere" of early modern Europe, a series of social institutions ranging from the coffee house to the theater, where private individuals came together to form what became known as the "public." Second, there was the pictorial space represented in the picture, which in neo-classical art meant a representation of the space of antiquity. Despite the attention to historical detail, antiquity was an imaginary place in which to tell stories set in an imagined past. This version of history was nonetheless constructed so as to signify the historic present, that is to say, a past experience that continued to have relevance in the present. Finally, there was what one might call the mental space of the viewer, the space of perception in which such representations and social practices of spectatorship were combined in the act of perception. In eighteenth century theories of judgment, perception took

place at a specific point within the body, whether in the eyeball, the pineal gland or an indeterminate space in the brain (Lindberg 1976). Nonetheless, all such theories assumed that perception took place in real physical space within the body, in turn making the intellectual processes of vision real (Soja 1989).

Paradoxically, the more real perception itself was thought to be, the more interested people became in virtuality. The vast scale of neo-classical paintings inspired the development of the panoramas (1792), a theatrical presentation of life-sized painted scenes, offering panoramic views of cities and historical events. As the nineteenth-century art theorist Quatremère de Quincy observed: "[the panorama] makes an architectural work of the painter's field of activity. The name panorama, in fact, refers both to the edifice on which the painting is hung and to the painting itself" (Virilio 1994: 40). Virtuality had moved from being pure mental space into virtual architecture, a critical new direction, as we shall see. This popular presentation soon evolved into the diorama (1822) that used illuminated translucent watercolors to provide a variety of three-dimensional scenes to spectators seated in darkness, thus refiguring virtuality, as film historian Anne Friedberg explains: "[T]hese devices produced a spatial and temporal mobility – if only a 'virtual' one" (Friedberg 1993: 20). While classical painting and sculpture had transported the viewer to an imaginary realm, both the panorama and diorama offered complex illusions that seemed real, that could be explored and that could change. The devices were found to be so realistic by their audiences that painters sent their students there to study from "nature." In *The Prelude*, the poet William Wordsworth called panoramas "those mimic sights that mimic the absolute presence of reality." The virtual aspect to these depictions of reality thus came from the apparent sense of mobility offered to the spectator, the chance to experience what distant sights were "really" like without having to travel.

Both élite and popular culture found ways to disseminate the experience of what Friedberg calls the "mobilized virtual gaze" beyond the confines of theaters specifically devoted to such entertainment. Painters like the American Frederick Church created vast panoramic landscape scenes that offered the viewer a dramatic view of exotic sights such as the Andes or the American West. The sheer size of the canvas made it impossible for the viewer to take in such scenes at a single glance, or from the single viewpoint of one-point perspective. The painter relied instead on a wandering eye constantly discovering new features of the scene, creating in Scott Bukatman's apposite phrase "a dynamic, kinetic spectatorial gaze" (Bukatman 1995: 276). These artists blurred the distinction between élite and popular culture

by exhibiting their works as sideshows, more often reserved for the "freak," the "bearded-lady," or the "savage."

It was the stereoscope that brought such virtual tourism within reach of most homes. Invented in the 1830s by David Brewster, the stereoscope was a device held up to the eyes like a mask, containing a holder for the stereoscopic card (see Figure 3.1). This consisted of two photographs mounted side by side of the same view, often taken with a special camera designed to produce such negatives. Viewed at the correct distance and with the necessary relaxation of the eyes, the stereoscope produced a startling effect of three-dimensionality. The view did not gradually recede, as in a perspective painting, but seemed set back in layers that resolved into a foreground, middleground and background. The background often seemed rather ethereal, even when it represented architectural views. By far the most popular use for the stereoscope was in sets of cards depicting foreign cities and landscapes. The stereoscopic tourist was soon able to "visit" all the major American and European sites, as well as much of the Middle East and Africa. The American critic Oliver Wendell Holmes found himself in "a dream-like exaltation in which we seem to leave the body behind us and sail away into one strange scene after another, like disembodied spirits. . . . I leave my outward frame in the arm-chair at my table, while in spirit I am looking down upon Jerusalem from the Mount of Olives" (Batchen 1996: 26) Holmes found himself in a similar virtual space to that experienced by Goethe and Jefferson, except that he now knew exactly where he was. His description of being on an imaginary journey, while remaining aware that he was in fact seated in his chair also seems to anticipate the invention of

Figure 3.1 A stereoscopic card of Place de la Concorde, Paris

cinema. This passive experience of virtuality was to remain the rule until the creation of virtual computer environments.

However, it should be added that such passive experience of the virtual was not simply the sensation of mobility. It was also the modern sublime. In the nineteenth century, the experience of modernity and the opportunities it brought were so frightening that it seemed, in the classic phrasing of *The Communist Manifesto* (1848), that "all that is solid melts into air." The new media from panorama to cinema were one means of negotiating the unsettling transformations of everyday life and society created by mass industrialism. Moving pictures were invented in accord with a sense that modernity itself was a moving image: "Modern attention was vision in motion. Modern forms of experience relied not simply on movement but on the juncture of movement and vision: moving pictures" (Charney and Schwartz 1995: 6). In his influential 1903 essay "The Metropolis and Mental Life," Georg Simmel emphasized that the city was the place in which such images were seen: "The rapid crowding of changing images, the sharp discontinuity in the grasp of a single glance, and the unexpectedness of onrushing impression: these are the psychological conditions which the metropolis creates." In 1895, when the Lumière brothers first showed their film *Arrival of a Train in the Station*, the unexpectedness of this onrushing impression was such that several people fled the room as if a real train was approaching.

Remarking on such features as the close-up and slow motion, Walter Benjamin claimed that "evidently a different nature opens itself to the camera than opens to the naked eye – if only because an unconsciously penetrated space is substituted for a space consciously explored by man" (Benjamin 1968: 236). Film creates access to a dimension of the optical unconscious that previously could not be explored. One of its prime characteristics is shock, the shock that comes from being exposed to new images one after another and often to images of disaster. This shock can be seen as an intensified version of the sublime. It is striking how often early cinema deals with death and destruction. In his early film, *Electrocuting an Elephant* (1903), Thomas Edison showed the electrocution of an elephant in gruesome detail, right down to the smoke emitted from the animal's feet. Similarly, *Searching Ruins on Broadway, Galveston, for Dead Bodies* (1900) dealt with the effects of a Texas hurricane, while *Reading the Death Sentence* and *An Execution By Hanging* (1905) depicted the execution of a female convict (Doane 1993: 6–7). Even though modern audiences would find the documentary aspects of such films repulsive, they have not remained impressed by such reality effects in fiction. Now the cinematic sense of wonder requires devastating explosions as in the *Die Hard* series, spectacular natural disasters like those in *Twister*, *Dante's Peak*, and *Deep Impact*, or special effects that could never be seen in reality – from

the dinosaurs of *Jurassic Park* to the spaceships of science fiction movies. Popular culture has been accused of bringing about the end of élite culture for two centuries. Ironically, the devices used to access virtuality have become the place where the highest aesthetic attainment of all, the sublime, has found its home.

Virtuality goes global

It was with the advent of television that virtuality became global. As Timothy Leary has put it: "Most Americans have been living in Virtual Reality since the proliferation of television. All cyberspace will do is make the experience interactive instead of passive" (Friedberg 1993: 144). The virtual and visual aspects of television have been much underplayed by critics who argue that it is little more than radio with pictures (Morley 1992). This description may well usefully describe the heyday of network television, when television offered a straightforward, "realistic" representation of the world. At this time (1945–75), television consisted of a few national channels, often broadcasting only in evening hours. Its standard visual space was the familiar proscenium space used in the theater, in which the audience sees the action as if through an arch created by removing the fourth wall from a room. Sustaining this illusion, narrators in shows like *Dragnet* or *Dixon of Dock Green* addressed the audience directly at the beginning and end of each episode, taking the place of theatrical prologues and epilogues in marking the division between reality and the suspension of disbelief. But in the fragmented era of "narrow-casting" created by cable, digital and satellite television, stations increasingly rely on visual style to attract and retain viewers, who zap from channel to channel with the sound muted, seeking an attractive program or segment (Caldwell 1995). Network television has responded to the alternative styles adopted by cable stations like MTV (Music Television), VH1 and BET (Black Entertainment Television) by developing their own cinematic visual style, emphasizing production values and increasingly special effects. Drama series of the 1980s and 1990s like *Miami Vice*, *thirtysomething*, *NYPD Blue* and *ER* are valued not just for the revenue that they create but for the superior "quality" feel that they bring to network television. Indeed, *thirtysomething*'s audience share was often in the low to mid-teens in the early 1980s, well below the level that could justify its very high production costs. In 1997, the producers of *ER* signed a deal with NBC that made it literally impossible for NBC to profit on the advertising segments sold in that hour. The calculation was rather that *ER* anchors the central Thursday evening of "Must See TV" and will keep viewers tuned to NBC throughout the evening. On the other hand, the 1998 mini-series *Merlin* won NBC an audience share

that had not been achieved for a similar program since the advent of fully-fledged cable service in 1984. Producer Robert Halmi Sr. spent over $30 million creating more than 500 special effects for the series, figures that until very recently would only have been contemplated for a motion picture (*New York Times* April 4, 1998: B5). Just as Hollywood uses the visual lure of special effects to draw people in to cinemas rather than renting videos, so too has network television opted for visual spectaculars to try and hold its ground against the ever-proliferating cable networks.

The transformation in visual style is not simply cosmetic but implies a different kind of televisual spectatorship, at once more engaged when actively viewing and more liable to distraction. This shift can be seen in the reworking of one of television's most distinctive genres, access television, in which television cameras enter places the audience would not normally be able to see. This televisual spectatorship of everyday life was a key development in 1970s televison with the American series *An American Family* (1973) and Britain's *The Family* (1974) presenting "fly-on-the-wall" documentaries of everyday life. The directors of both series sought to make the presence of the cameras so natural to the families concerned that their everyday lives would continue as "normal" for the viewer's fascinated gaze. These documentaries took the proscenium principle of traditional television to the furthest possible extent by creating a space in which the absorption of the "actors" was so pronounced that they forgot that they were being observed. Both shows were long, multi-part series that in effect mirrored the television spectator. Research studies in this period indicate that people watching television often gave it only fragmentary attention, as it competed with other domestic activities such as eating, ironing, or babysitting (Ellis 1982). Likewise, both *An American Family* and *The Family* often drifted along, with occasional moments of high drama as attention-grabbing counterpoints. Most notably, during the filming of *An American Family* the family broke up, causing Jean Baudrillard to remark that "it is really a question of a sacrificial spectacle offered to 20 million Americans. The liturgical drama of a mass society" (Baudrillard 1984: 271).

Television's conventions are now so widely accepted as "natural" that the carefully-established tele-verité of access television has been replaced with far more stylized and specifically televisual formats. Perhaps the most striking example of this transformation is MTV, whose influence has become global. Its emphasis on visual style has transformed television since the station first aired in 1980. Along with other cable innovators like CNN, MTV pushed television away from reliance on texts and narrative to an image-based culture, dominated by graphics, stylization and special effects. MTV is now almost shorthand for a visual style comprising rapid alternation

of clips or viewpoints with computer graphics and a "handheld" camera style that emphasizes the artificiality of the medium and its incompleteness as a visual record. Its self-promotion spots have become 15- or 30-second versions of independent cinema, adopting the visual and narrative techniques of alternative cinema as an advertising style. Belying the notion that television is radio with pictures, it has now become essential for bands to get their video into MTV rotation – the video sells the song, not the other way around. When the channel first began, it was little more than extra advertising for the music industry. Now it is the place where new images, trends and sounds are defined.

In the past five years, MTV has moved beyond a constant relay of music videos to originating its own programing. For just as the initial focus on music videos challenged the "official" television style, so has MTV become a style in itself. It is now engaged in the increasingly desperate attempt to constantly redefine "youth TV" for its favored demographic, the 18–24 age group. One of its key innovations has been a series entitled *The Real World* that first aired in 1992. The premise is simple: MTV rents a house in a fashionable city, stocks it with interesting young people and records the results of their living together. Here is virtual reality indeed. Despite the title, MTV never tried to create a reality effect like that of *An American Family* or *The Family* in *The Real World*. Instead of taking an actual family, MTV creates its own group of young people. Furthermore, participants are asked to express their thoughts to camera about things happening in their lives and their relationships with their housemates. In this way, the audience gets the gossip and intrigue it really wants, without having to wade through the dreary ebb and flow of family rows and financial worries. *The Real World* demands attention from its viewers, as the show moves from one high point to the next with a "live" incident being shown, followed by later responses from the key participants. Yet this virtual format allows for discussion of issues that might remain unspoken in the traditional family. Most notably, Pedro Zamora, a participant in the 1994 San Francsico series was HIV-positive, leading to extensive discussions of issues relating to living with HIV, friendship and love in the plague years. *The Real World* allowed one young man a chance to discuss the AIDS crisis on television but in an artifical situation to a minority audience on a cable channel. Sadly Zamora died on 20 November 1994, one day after the last show in the series had aired. On the other hand, Kevin Powell – a black participant in the 1992 New York series – later complained that an argument he had had with a white woman over the Los Angeles riots of that year was omitted from the program, leaving only shots of the two arguing furiously (Johnson and Rommelmann 1995: 26). It seems that only some reality is allowed to intrude into *The Real World*.

However, the creation of a low-tech, high-access version of access television on cable and other minority formats has not displaced traditional access television. With its high cost and emphasis on production values, access television continues to be important in Britain, where five terrestrial channels compete with one successful satellite provider and a weak cable sector. Furthermore, Britain retains its traditionally secretive and élitist establishment, safe in the absence of a Freedom of Information Act. In 1996, an access television series called *The House* became an unlikely national scandal. The program presented a behind-the-scenes look at the Royal Opera House, Covent Garden, revealing remarkable backstage tiffs and a strikingly aloof attitude to the rest of the world. While on camera, the Opera's director Jeremy Isaacs informed a cabdriver that he could easily afford £100 ($160) for two tickets, a comment that seemed to epitomize the disdain of Britain's élite for ordinary people. In the United States, access television no longer plays an important role as any participant in a major event will eagerly seek to appear on talk shows and news entertainment magazines like *20/20* or *Primetime Live* in order to create momentum for a best-selling book. Access television has lost its niche, descending via such seeming parodies as *Lifestyles of the Rich and Famous* to being the title of an early evening entertainment news show, *Access Hollywood*. The latter trades on a commonplace of postmodern mass media that we are all insiders now. This view holds that access was once limited to an élite, becoming visible only in special circumstances, but is now available to all. It is certainly true that tabloid television and newspapers offer a plethora of trivia concerning celebrity but such access has no intention of challenging the power structures that sustain celebrity, as access documentaries like those of Fred Wiseman once aspired to do.

Telesublime

Ninety-nine percent of American homes have at least one television set that is on for an average of 7 hours and 48 minutes every day. If newspapers formed a sense of national identity in the nineteenth century, as Benedict Anderson has suggested (Anderson 1983), television has become the imagined community of the late twentieth century (Adams 1992). To be without television would, in many ways, to be disenfranchised. While television is consumed in conjunction with other domestic activities, there are certain moments when television offers a collective experience of the fragmented postmodern world. For example, half of Britain's population watched the England football team compete in the 1996 European Championship semi-finals, possibly the only way in which the hybrid

Afro-Caribbean, Chinese, Indian, Pakistani, Scottish, and Welsh communities might experience a sense of being English. There is a sense in which seeing an event like the release of Nelson Mandela on television offers what one might call the televisual sublime – an event that very few could hope to witness in reality that seems to take us out of the everyday if only for a moment. Other examples of this telesublime might be Boris Yeltsin addressing the Moscow crowd from a tank during the attempted conservative coup of August 1991, or the Chinese protestor defying a column of tanks attempting to crush the 1989 student pro-democracy movement in Tiananmen Square. It seemed for a while that such moments belonged to the Cold War past until the death and funeral of Princess Diana showed that we have in fact only just entered the era of truly global television (see chapter 7).

The dramatic growth of television into global networks like CNN and ESPN has been accompanied by a fragmentation of domestic markets into cable, satellite and the increasingly beleaguered terrestrial networks. In this context, it no longer makes sense to speak of television in the singular on a day-to-day basis. There are now multiple televisions from the global network to the national station and the local broadcaster. At the local level, Australian Aboriginal peoples have recently turned to television as a means of sustaining their traditional identities in public and private. The Tanami video-conferencing network facilitates connections between widely-scattered communities in rural Central Australia, creating a new sense of community. The creation of Ernabella Video Television in South Australia has led to a revitalization of local Aboriginal culture, using equipment costing only $1,000. In the public sphere, the Walpiri Media Association has created striking television programs depicting traditional Aboriginal rituals from the early 1980s onwards. The first shows featured frequent pans across the landscape, designed to show, for example, "where dreamtime figures are in that tree." Despite their relative lack of familiarity with the medium, Walpiri television thus uses the medium in strikingly hyperreal fashion. In Eric Michaels' words, "the camera is tracking inhabitants of the landscape, historical and mythical figures who reside there but are not apparent to normal vision" (Michaels 1995: 202). Later tapes use indigenous music and language with English subtitles, and a fast-cutting visual style reminiscent of MTV, interspersed with abstract images taken from Aboriginal art (Ginsburg 1993).[1] Here the Aboriginal television producers explode notions of the "savage" mind by combining the "Western" documentary style with a "primitive" mode of representation. Rather than simply acculturate to Western norms, they have made television serve their own ends. Far from the earnest presentation of Western anthropological film, the style is light-hearted and the hosts address the viewer directly. While Westerners

might fear that such technologizing of traditional cultures would lead to their inevitable diminishment, the Aboriginal peoples believe that a video showing of a ritual actually enhances its powers. The cultural shock for Westerners seeing "their" technology used by supposedly primitive peoples was enhanced by the 1987 Aboriginal film production *Baba Kiueria*, in which Aboriginal "explorers" discover white Australian lifestyles, such as the barbeque area of the title, in anthropological fashion. This culture shock had been explored as early as 1969 when the ethnographic filmmaker Jean Rouch depicted an African named Damoure anthropologizing the French in *Petit à Petit* (Shohat and Stam 1994: 34). One of the most powerful images in Marshall McLuhan's famous volume *The Medium is the Massage* showed a group of Africans, in suitably primitive attire, watching television. McLuhan imagined a world in which local cultures all became subordinate to the international style of the mass media. It seems that the global village is not quite working out according to plan. Television is not simply producing a homogeneous global market for the advertising of hamburgers and Coke. Rather, the sheer success of television has created a fragmented multi-channel medium, constantly in dialogue with video and the camcorder, that is generating transcultural opportunities for exactly those people who never used to be seen on television.

Virtual reality

The fragmentation of the televisual public community has been accelerated by the development of virtual computer environments, often referred to as virtual reality. John Walker, a software engineer who has created virtual environments for architects, sees virtual reality as the sixth stage in the gradual evolution of the computer from remote tool to an interactive part of the human user. Beginning with the early generations of plugboards, punch cards and the first keyboard-and-screen machines, the two subsequent generations of menu driven programs and the current graphic interface have brought users close to virtual reality (Morgan and Zampi 1995: 20). The virtual mobility of the photograph has now been enhanced by the Webcam, a device that places a constantly updated camera image from a fixed location on the Internet. One site displaying downtown Tokyo had registered 433, 877 visits by 1998 (see Figure 3.2). It is now possible to see things in virtuality that could never be seen in any other way. For example, at the VR94 exhibition in London, an Italian company called Infobyte created a virtual representation of the chapel decorated by Giotto in the Cathedral of St Francis, Assisi. Wearing special glasses, the viewer not only "sees" the chapel in three dimensions but can walk around and concentrate

Figure 3.2 An image from a Tokyo Webcam

on different areas. As a final effect, you could "enter" the frescos them-
selves, and this would then become the entire virtual environment, creating
a series of fantasy townscapes (Morgan and Zampi 1995: 11–12). In 1997,
scientists created a supercomputing version of the Internet called the Very
High Performance Backbone Network Service, connecting some of the
United States' supercomputers with a very high bandwidth fiber optic net-
work. The result is a virtual reality facility called the Cave that can visualize
the collision of our galaxy with the neighboring Andromeda galaxy or, at the
other end of the scale, what a protein does to an antibody. The viewer can
manipulate the image, thus changing the computer's calculations, a shift that
would otherwise require scrutiny of endless printout (Shapley 1997). This
new visual medium has quickly found practical applications, such as the
"Monster Plan" created by NASA for their 1997 Mars mission. Team
members wearing special goggles were able to look at a 3-D, stereoscopic,
color panorama of the landing site "as if they were on the surface them-
selves" (Sawyer 1997).

 As these examples show, virtual reality creates a virtual experience that
cannot be known in any other form, a new form of reality generated by the

extreme specialization of computer technology. The user of virtual reality has an "interface" with the computer which provides him or her with physical access to a visualized world that is entirely "interior," in that it cannot be experienced in the three-dimensional world of everyday life, and yet is convincingly "real" (Woolley 1992). There are two crucial differences between computer-generated virtual reality and the other forms of virtuality that have been discussed above. The viewpoint onto the virtual environment is controlled by the user not the medium. That is to say, when we watch a film or a television program, we have no choice as to how to look at the scene represented. The camera's point of view inevitably becomes ours. While we may chose to identify with the Indians rather than the cowboys, we cannot stop the cowboys from winning. In virtual reality users are no longer confined to a single viewpoint but can change their relationship to the space at will. At the same time, the virtual environment is now interactive, meaning that the user can alter the conditions he or she discovers within certain limits. This interactive, user-controlled dimension to virtual reality takes it beyond the traditional picture space, even if it inevitably retains the three-dimensional space of traditional geometry.

Much of the excitement about the Internet and virtual reality is generated by a sense of what it will become, rather than what it currently is. In computer magazines, advertising is dominated by the future tense, always driving the consumer towards as yet unrealized goals. This progressive, future-oriented aspect to virtual reality makes it very modernist, despite the tendency in cyberpunk fiction to imagine the future as, for the most part, a desolate wasteland. The by-now classic definition of cyberspace came from William Gibson's cyberpunk novel *Neuromancer*: "A consensual hallucination experienced daily by billions of legitimate operators, in every nation Unthinkable complexity. Lines of light ranged in the nonspace of the mind, clusters and constellations of data. Like city lights, receding" (Gibson 1984: 67). Gibson's vision is at once very abstract ("the nonspace of the mind") and very urban ("city lights receding"), making it quintessentially modernist. In Neal Stephenson's *Snow Crash* (1992), his equivalent future virtual reality is called the Metaverse, dominated by the Street where the urban parallel is directly evoked: "It is the Broadway, the Champs Élysées of the Metaverse. It is the brilliantly lit boulevard that can be seen miniaturized and backward, reflected in the lenses of his goggles. It does not really exist. But right now, millions of people are walking up and down it" (Stephenson 1992: 24). Unlike Gibson's abstract space, the Street has addresses, a railway and places to obtain virtual clothes. Here people appear as avatars: "Your avatar can look any way you want it to, up to the limitations of your equipment. If you're ugly, you can make your avatar beautiful. . . . You can look like a

gorilla or a dragon or a giant talking penis in the Metaverse. Spend five minutes walking down the Street and you will see all of these" (Stephenson 1992: 36). Like postmodern art of the same period, visualizations of virtual reality have become more realistic and less abstract in the past decade, partly because of the ever-increasing ability of computers to imitate reality and partly because abstraction came to seem less appealing. The avatar is now available on the Web at sites ranging from games to art installations. The avatar is one means of "being" in cyberspace that is not wholly dependent on the viewpoint of perspectival space and suggests that cyberspace will generate new ways of seeing that do not depend on the "window on the world" device beyond the current "special effects" motifs. At the same time, cyberreality is still haunted by modernist myths of primitivism. Gibson's cyberspace is home to the spirits of Haitian vodou, while Stephenson elaborates a new-age philosophy for the computer. These modernist aspects to cyberspace are a good example of the definition of postmodernism that I have been using throughout this book – it is a crisis of the modern, not a radical break with the modern. Even in the fantasy realm of science fiction, the modern city with its bars and boulevards remains a frontier for the imagination.

Virtual reality and everyday life

There are widely differing assessments of what difference computer virtuality can be said to make to everyday life. These positions have been summarized ironically by Allucquère Rosanne Stone as "everything" and "nothing." For many computer freaks to affirm the former is an article of faith, without which it is obvious that you do not "get" it. On the other hand, artist and critic Simon Penny declares that virtual reality "blithely reifies a mind/body split that is essentially patriarchal and a paradigm of viewing that is phallic, colonializing and panoptic" (Penny 1994: 238). For both sides in this debate, no middle position is possible. Yet it seems increasingly clear both that computer environments do offer some genuinely new experiences and that they are structured by many of the hierarchies that have determined ordinary reality throughout the modern period, albeit in a different shape.

The Internet is a space that is as historically and culturally determined as any other. Despite the much-vaunted claims of its radical equality, it is given shape by race, gender and class. One of the considerable, if unspoken, appeals of Internet life for many people is that is an environment where you can be sure to avoid the underclass. In this regard it fulfills the promise first held out by shopping malls of a safe, clean space in which to spend time and, increasingly, to shop. It is of course true that anyone may access the

Internet. Basic requirements for this access include a computer costing at least $1,000 – down from $2,000 in mid-1997 – software, a modem, a phone line and access to an Internet provider. Unlike photography which was almost immediately within everyone's budget, the Internet is open only to those with considerable disposable income. Although the Net is by no means exclusively white, as sites like NetNoir clearly demonstrate (Figure 3.3), Net users are disproportionately likely to be white, even within the cyber-privileged world of the United States. Furthermore there are more and less desirable Internet addresses that do not necessarily equate to their realworld equivalents. Although William J. Mitchell asserts that Net addresses are irrelevant, his own institution has one of the most desirable of all Internet addresses, located at the Massachussets Institute of Technology, home of Nicholas Negroponte's famous Media Lab (Mitchell 1995: 9). Academics, for example, are able to claim privileged access to the Internet, although they are held in increasingly low regard by many people, because the Net grew out of the American ARPAnet university network established for military purposes by the Advanced Research Projects Agency in 1957. By contrast, an address at America Online is the equivalent of living in a tract home in a subdivision. For unlike MIT's sophisticated network access, users on these commercial services find themselves waiting considerable lengths of (billable) time simply to get to particular sites. Downloading any form of graphics from such addresses is a lengthy process. It has been estimated that the Internet became 5 percent slower in 1997, increasing waiting times and costs for the virtual middle class. The slight disjuncture between real and virtual addresses is in fact closing. New apartment complexes on Park Avenue in Manhattan offer high-speed access to the Internet as a standard feature, while the first town to be entirely Internet accessible will be Fremont in California's Silicon Valley, already a very desirable address. There are no projects in cyberspace.

For Internet access is still only a fantasy in many parts of the under-developed world, with 95 percent of all computers being found in the developed world. Although estimates of the number of people worldwide with access to the Net rose from 50 to 90 million in 1997, this is still a tiny minority of global population. The global pattern of distribution remains

Figure 3.3 View of NetNoir website

uneven. Some Latin American countries, like Argentina and Mexico, have considerable presence on the Net, in keeping with Chéla Sandoval's assertion that "the colonized peoples of the Americas have already developed the cyborg skills required for survival under techno-human conditions as a requisite for survival under domination for the last three hundred years" (Sandoval 1994: 76). On the other hand, with the exception of South Africa, sub-Saharan Africa does not exist in the virtual reality of the Internet, generating less than 0.1 percent of Internet traffic in 1993 (Kirshenblatt-Gimblett 1996: 27). However, African telecommunications are improving rapidly, with the number of television sets in the continent rising from 6.6 million in 1984 to over 21 million a decade later (Barker 1997: 4). Other "developing" countries like Malaysia and Singapore have made enormous efforts to become "hardwired," while also seeking to ensure that online does not mean democratic by censoring access to sites and refusing to allow any online criticism of their regimes. In January 1998, the Chinese government created a wide range of Internet "crimes," such as engaging in political subversion and "defaming government agencies." These steps were taken even though there are officially only 49,000 host computers and 250,000 personal computers in China. Perhaps the key class distinction in the coming decades will be between the electronic haves and have-nots, who will often, but not always, turn out to be the same people currently empowered or not. With the next generation of the Internet now being constructed, how can access be guaranteed even for the minority who currently have it?

At present, the virtual world seems a way of regaining ground for many middle-class Americans – 60 percent of all users, hosts and networks on the Internet are American – in an age where the global economy is increasingly leaving them behind. As John Stratton has argued, cyberspace has become the locale for (re)creating the idealized small-town that has so long dominated the (white) American imagination, with all the exclusivity and limitations implied by this picket-fence model (Stratton 1997). Although relatively little actual commerce takes place via the Web in comparison with traditional markets, everyone is convinced that they must be represented on the most rapid and modern of all media. In 1997, IBM ran an advertising campaign specifically designed to win over skeptical middle-management, who tend to be older and less computer-friendly, to the idea of "doing business on the Web." At stake here is not so much access to new markets as access to people's attention, an extremely limited commodity in modern society. The dramatic expansion of the Internet since 1995 is motivated by a sense that the key contest in modern capitalism is the "competition for media, pathways, forms of circulation" (Beller 1996: 203). The mobile phone, car fax, electronic organizer and portable computer have generated

a new maze of such media pathways. It is estimated that over $20 billion worth of business will be conducted over the Internet in 1998, demonstrating that the new medium is now fully capitalized. Already, over one million people work as computer programers in the United States, compared with 800,000 in automobile manufacture. The much-vaunted bridge to the twenty-first century is already here.

Virtual identity

The question of access to the new virtual world of business thus becomes central. In principle, virtual environments are race and gender blind to the extent that these critical markers of identity in everyday life might become superfluous in cyberspace. While this utopian possibility is still available in theory, the results so far have not been encouraging. One of the most enthusiastic proponents of the information age has been the magazine *Wired*, which uses a combination of full-color graphics, unusual design and celebrity science and science-fiction writers to generate a palpable sense of excitement about the new technology. Such faith in the new is of course highly attractive to advertisers and the magazine has flourished in the United States. *Wired* has, however, become the venue for a new form of social Darwinism, arguing that computing is a stage of social evolution, separating the higher online sections of humanity from those stuck at the lower levels of the industrial economy. The economic distinction between the electronic haves and have-nots is being biologized insidiously as a form of "natural" selection on the Darwinian model: that is to say, those most able to deal with computing environments have become the new technocratic élite on merit, while less able people have fallen behind. This attitude turns contempt for the poor, especially those of color, into a scientific theory that would be laughable if it were not being taken seriously by significant numbers of people.

In the early years of their existence, the Internet and other virtual environments also seemed to offer new forms of sexual and gender identity. In Multi-User Domains and bulletin boards, users can adopt gender and sexual orientation at will in creating an online persona. For all that, the new world seems very familiar. Even in the self-consciously progressive Multi-User Domain, LambdaMOO, most characters present themselves as stereotypes from the heterosexual masculine imagination: "Lambdans create and recreate themselves as gendered archetypes: troops of long-haired women are counter-posed by gangs of tall men with piercing eyes; virgins and whores face poets and athletes; vampires face dreamers; and slavers, their slaves" (Bassett 1997: 549). For all the apparent possibilities of the Internet,

the most requested search term on the Yahoo search engine is still "sex," while the Playboy site claims 1.4 million page hits a day. This trend seems set to continue as the technology of the Internet becomes increasingly visual. The old Multi-User domains were exclusively text-based, but technology now permits real-time video contact. Indeed, some have argued that the desire to sell pornography over the Web has been one of the key factors behind the development of virtual visual technology such as videoplayers. For example, the new industry of adult video conferencing, where the user pays to see a nude model live, allows some companies to take in $1 million a month (Victoria 1997). Even the habit of referring to the Internet as the Information Superhighway seems to indicate that it is an updated version of the male obsession with cars. Just as cars were once sold on the basis of their high speeds and powerful engines, now computers boldly claim ever faster chips and ever larger hard drives. In an era where real roads are jammed with traffic or under repair, the Infobahn is a man's last chance for a drive.

This skepticism should, however, be set alongside an evident nervousness as to the effects of the information age on gender and sexual roles. A good example can be seen in the film *Disclosure* (1994), based on the book by Michael Crichton and directed by Barry Levinson. The film tells the story of middle-aged exective Tom Sanders, played by Michael Douglas, at a Seattle software firm, engaged in designing a new, visualized data retrieval system, known as the Arcamax drive. The film creates a sense of established (gender) order under threat from the outset. It opens with an image of email being opened only to reveal that Sanders' young daughter is operating the computer. Sanders' Arcamax system is operating at only 29 percent efficiency. The implied threat to the nuclear family from this juxtaposition of female competence and male failure in the vital realm of new technology is soon reinforced as one of Sanders' fellow-commuters into Seattle reveals that he has become "surplus" after 28 years with IBM. Sanders himself is rumored to be in line for a promotion but he has received no confirmation. Even the building in which he works proclaims the existence of a new era, as it is a former warehouse or factory converted into offices. This postindustrial space is the central location for the film and creates a key tension between vision, gendered female, and hearing, gendered male. For while the factory system depended on all operations being visible to management at any time, while the worker concentrated on his or her stretch of the assembly line, in the information-era office space, seeing can be powerless without hearing. All the offices have glass walls, so conversations can be observed but not heard. The camera often begins a shot outside in silence, only to zoom in and gain access to the action via the soundtrack. It soon becomes crucial for Sanders to determine whether his colleagues have "heard anything" regarding a

merger and management shake-up as it seems that, far from being promoted, his job may be on the line. He has in fact lost the management position to Meredith Johnson (Demi Moore). There then follows the wildly improbable scene in which Meredith sexually assaults Tom in an after-hours office meeting (Figure 3.4). He wins an even more unlikely prosecution of a sexual harrassment charge because Meredith chose to make her "attack" at the moment Tom gained access to a friend's answering machine via his mobile phone. The answering machine is fortunately not a model that limits the length of message and records the whole encounter, especially Tom's cries of "No." Here the fetishism of being permanently in contact brings concrete, material results. The rhetoric of "No means no," designed to protect women from male assaults, was deployed by *Disclosure* to save the beleaguered white male. It is again the spoken word, and the familar technology of the telephone, that resolves the issue in favor of the man over the treacherous feminized realm of appearances.

Even now, all is not what it seems. Meredith's real plan involves out-housing the drive assembly project to a Malaysian firm, whose manual assembly of the machine is causing the loss of efficiency. Meredith is thus doubly demonized as a sexually avaricious woman and as ethnically suspect by association. In the central struggle of the film, Sanders encounters her in

Figure 3.4 Still from *Disclosure*

the virtual environment of the data retrieval system. While Meredith busily erases the incriminating files, Tom attempts to save the day by appealing to the "angel," a help system visualized as a male angel. But this homosocial plea fails, as the angel is only a virtual creature. Instead, Tom is able to retrieve the virtual data as hard printout from back-up files. He uses the information to win the contest between the male, hearing world and the feminized visual/virtual reality in a dramatic speech to the assembled company, like Hercule Poirot announcing the inevitable solution to a mystery. His clincher is the use of a video-clip from Malaysian TV showing Meredith's nefarious negotiations with her Asian partners. The use of "hard copy" from the accepted journalistic media allows Tom to turn the tables of the feminized virtual reality against his female enemy. While *Disclosure* won notoriety for its depiction of sexual harassment charges by a man, its real theme was the broader male fear of a newly "feminized" work environment, where software dominates over hard heads and the old rules no longer apply. These anxieties are all encapsulated in the fear of a virtual, hence visual, planet.

Indeed, the metaphor of webs and weaving have been much used by feminist critics to describe an alternative mode of thinking to patriarchal logical positivism. With its ever-expanding maze of sites and links, unknowable by any one individual, the Web is the postmodern incarnation of Penelope's always unfinished weaving. One major Internet resource for scholars, "The Voice of the Shuttle," takes its name from the legend of Philomela who pictured her rapist Tereus in a weaving after he had cut out her tongue to ensure her silence. The Web can indeed be gendered and a tool in the gender wars. Furthermore, the techniques of the computer, far from being totally unprecedented, have much in common with the practices of weaving. This parallel produces an interesting tension: "Weaving, as a practice, is a matter of linkage – a connectedness that extends the boundaries of the individual. This sense of open-ended connection and inter-relation is precisely what Western notions of technology, in their instrumentality and emphasis on the individual, tend to repudiate" (Gabriel and Wagmister 1997: 337). Indeed, one can trace a counterpoint between weaving and the invention of computing itself.[2] For the British engineer Charles Babbage (1791–1871), who is now widely credited with devising the first computer, made his essential breakthrough by connecting his Difference Engine, a calculating machine, to weaving technology in order to create the Analytical Engine now held to be in effect a computer. The Frenchman J.M. Jacquard (1752–1834) had created a system whereby a series of pasteboard cards with punched holes instructed a mechanical loom as to which threads to use and in what pattern. Babbage saw that he could extend this idea to calculation: "the analogy of the Analytical Engine with this well-known

process is nearly perfect" (Babbage [1864] 1994: 89). Thus his Analytical Engine consisted of two parts like an automated mill: a store, where the variables were kept, and a mill, where the required operations could be performed. In short, the practice of modern, automated weaving made the idea of computer programing possible. One might then see the famous saboteurs, who threw their shoes (*sabots*) into the mechanized looms as the creators of the first computer viruses. Seen in this light, computers are both digital and analog machines, new and old, virtual and manual. The interaction between these poles is played out across the body of the user, whether weaver or programer.

Net life

Virtuality asks some intriguing questions about the definition of the body and, by extension, of the self. Virtual domains seem to be one example of the perception that the body need not stop at the skin but can be an open and complex structure. Virtual environments can thus be liberating for those with motor disabilities in allowing all users equal freedom of movement. For deaf people, cyberspace is at present one domain where no one can tell if you can hear. The proliferation of close-captioning devices, email, fax and TTD machines has allowed many deaf people a far greater degree of interaction with the hearing world than was previously possible. Video-conferencing permits long-distance sign-language conversations to take place for the first time. Perhaps even more remarkably, many autistic people have come to rely on the Internet as a means of communication, away from the distractions presented by N.T.s (Neurologically Typical). As one user describes it, this representational medium is far more interactive for the autistic person than real life encounters: "Reading faces is like looking into a rippling pond. I am too distracted by the edges, glints of light, to make much of it." For the writer Temple Grandin, who has autism, the Internet is a metaphor for her mind: "I talk Internet talk because there is nothing out there closer to how I think" (Blume 1997). As such experiences multiply, many are wondering what personal identity will come to mean in a virtual society.

Let us take some examples from the proliferating virtual world. Allucquère Rosanne Stone has described the intriguing story of "Julie Graham" (Stone 1995: 65–81). In 1982, a psychologist called Sanford Lewin joined a CompuServe online discussion group under this name, having discovered by chance that women approached him very differently if his online persona was female. "Julie" was also a psychologist, disabled as the result of a car crash: "She was now mute and paraplegic. In addition, her face had been severely

disfigured, to the extent that plastic surgery was unable to restore her appearance" (Stone 1995: 71). She had become a recluse but CompuServe changed her life and enabled her to socialize again in an online environment. This identity was thus very well tailored to meet the expectations of online users as to the radical potential of the new medium. Here was a woman, unable to function in everyday life, restored to sociability, not to mention sexuality. "Julie" became a popular source for advice and ideas on the network but she was not willing to stop there. A successful lecturing career and marriage in real life were invented by Lewin and broadcast over the Net until the deception became too great and he attempted to kill her off, like a soap-opera character. However, Julie's fans were distraught, beseiging the chat-lines with messages, offers of help and advice, forcing a miraculous recovery. Suspicions were aroused: "It was the other disabled women online who pegged her first. They knew the real difficulties – personal and interpersonal – of being disabled" (Stone 1995: 74). Ironically, it was exactly the way in which "Julie" ignored the practicalities of being a disabled woman that made her seem so perfect to the able-bodied. When the deception was revealed, many women in particular felt extremely upset, often rationalized as a sense of betrayal and loss. Given that the chat-line lends itself so readily to this kind of posturing, the truly surprising element of the story might be that people were so surprised by the deception. The important element here is the date, 1982, a time when the medium was sufficiently new that utopian hopes could still be entertained for it. As a disabled woman turned successful lecturer, "Julie" met those expectations perfectly, in retrospect, too well. The unveiling of "Julie Graham" was one of the ways in which the Web lost its innocence.

The Julie Graham incident took place on a very different Internet from that which is now being discovered by millions of users worldwide. The almost exclusive focus on text that was the inevitable corollary of limited computer memory has given way to an intensely visualized space. Where it seemed at first that the Net had simply adapted the traditional spaces of representation for its own use, it is now creating new modes of visual experience. At many sites, the visitor may only gain access to certain spaces if his or her cursor happens to pass over a particular spot. Links may appear and disappear before you have time to access them. Space is not transparent, as it is in the perspective model, but dense and mobile, offering possibilities that may or may not be seen. One consequence of these new spaces is to put more power in the hands of the site organizers. At the intriguing site "Bodies©INCorporated," designed by Victoria Vesna, freedom and power are mediated across the body (see Figure 3.5). The user can design and name a new avatar body, using twelve possible textures of material ranging from

Figure 3.5 View of Bodies©INCorporated website

black rubber to lava and water. It is then equipped with a particular sound, such as that of chaos. These additional pyschological features were added so that the site was not perceived as being simply about sexuality. Only then are age, gender and sexuality rendered at the owner's choice. Thus your left leg could be masculine and the right feminine. The avatar can be heterosexual, homosexual, bisexual, transgendered or other (specify). Age can be from 0 to 999. The avatar can play a number of roles in relation to the actual user, such as alter ego. At each stage, the user can view the avatar and modify any aspect that is unsatisfactory. But the user's freedom is explicitly limited by the ArchiText of the designers, who place themselves in the role of "God/dess." The avatar may be "deceased" at any time or consigned to "Limbo," a space on the site where only names and statistics appear. Alternatively, users can and do opt to be placed in Limbo or the Necropolis, indicating that submission to power has its own pleasures. The most dramatic space is

known as "Showplace!!!," where the user's "body" is displayed for all to see. As the site description explains: "Immediately available is a mirror image of yourself. The camera zooms in, you feel an enormously warm and glowing light directly above you. Your image is projected onto a large billboard that millions of people are watching. Appearing larger than life gets you sexually aroused. You are being watched by countless eyes and through multiple lenses – all in sharp focus." This highly visualized, sensual experience of being both consumer and commodity at once can be seen as an expression of Netlife itself at the current moment, far from its original text-based formats.

More pixels anyone?

At the time of writing, the Internet is the site of an interesting conflict of new modes of virtual visuality that will significantly determine what the first years of the next century look like. Broadly speaking, what is at stake is making television and the Internet in some way interactive. The two leading contenders to claim this hybrid medium of the immediate future are the evidently artifical pixelated screen and the hyperreal resolution of high definition television. Both will bring about dramatic convergences of the Internet and traditional television but in very different environments. Many are predicting that WebTV will be the machine of the near future. WebTV was developed by executives from leading California computer companies like Apple and QuickTime to provide an interface between the Internet and cable television. Subscribers place a box, like the familiar cable transcriber, on top of a specially designed television set that is operated by a remote or a keyboard which sends signals to the WebTV by infrared waves. The latest generation, called the WebTV Plus Network, allows viewers to integrate their television-watching with appropriate websites. Channels like Discovery, PBS ONLINE, MSNBC and Showtime are already participating in the network. WebTV allows the television picture to "nest" within the interactive space of an appropriate website and vice versa. By clicking on an icon, viewers might be able to participate in a chat room discussing a show as it goes out, check statistics related to a sports game, or receive the latest appropriate showbiz gossip. Of course, what the manufacturers really want the audience to do is click on the advertisers' icons that accompany brand-name commercials, like those of General Motors, Honda, and AT&T, who have all become charter advertisers for the new system. This convergence of pixelated media is made possible by the empty space of the pixelated image. Information is sent in a new programing language called TVML that makes it possible to "nest" TV video images within HTML Internet content. It is sent

by using line 21 of the Vertical Blanking Interval integrated into the standard NSTC television signal used in the United States. These intervals were once simply space between the pixels in the visual field. Now line 21 carries close-captioned information for the deaf and hard-of-hearing as well as V-chip data for the filtering of program content. For a company that was only established in March 1995, there is a great deal of hard cash behind this seemingly futuristic idea. WebTV was acquired by the all-powerful Microsoft Corporation in August 1997 and its hardware is made in conjunction with Sony, Phillips, Magnavox and Fujitsu. All this investment has been placed into a service that had no more than 250,000 subscribers in early 1998. Most of these subscribers were new to the Web and use the basic WebTV service as a cheap way to experiment with online life. However, market research promises that there will be a million WebTVs, each accomodating up to six people's preferences, by the year 2000. In 1998, both Microsoft and Cable and Wireless launched rival WebTV experiments in the more homo-geneous media market of Great Britain, with the stated aim of going national by 1999 or 2000. At this point, it is hoped that a critical mass will have been reached, inducing 15 million Americans to sign up by 2002. When you consider that there are currently 105 million television sets in the United States, the potential market is staggering. WebTV is a literal convergence of the most successful mass medium of the modern period with the quintes-sential postmodern medium. It makes no effort to conceal or deny its artificiality using a proliferation of icons, picture-in-picture options and image–text interface. It is perhaps no coincidence that Microsoft's 1997 "Thank God It's Monday" advertising campaign made conspicuous use of pixelated imagery or that Chuck Close's seemingly pixelated portraits have become immensely popular, crowned by a one-person show at New York's Museum of Modern Art in 1998.

Other visions of television's future go in exactly the opposite direction. Digital television promises to offer ultra-crisp sound and image resolution, advancing the direction already taken by many consumers towards giant "home theater" televisions. Like cinema, such television seeks to seduce spectators into its hyperreal imaginary, enhanced by the new flat receivers in cinematic letter-box format. Due to its fiber optic network, digital television holds the further promises of what is now called "multi-casting" and Web-like interactivity. With the arrival of cable, television moved away from the traditional search for the broadest possible audience towards what is known as "narrow-casting," such as Lifetime's self-promotion as the "television for women," or ESPN's exclusive focus on sports. Multi-casting allows a station to offer a variety of programing at the same time, according to viewer's preferences. For the most part this seems to mean endless start times for

pay-per-view movies but other more interesting possibilities abound. For example, France's Canal+ allows a subscriber to see any of the day's football (soccer) matches that he or she chooses as they take place. In Britain, where digital television began transmitting on a variety of platforms in 1998, the BBC has plans to create a variety of interactive broadcasts. Debates over the necessarily limited access to digital services have now slowed their introduction. On the one hand, shows may be offered in conjunction with appropriate Websites in the manner of WebTV. More intriguingly, BBC Digital Media are planning to create a virtual version of the popular soap "EastEnders" in which viewers "take on their favorite characters, while writers from the show provide dialog and scenes. 'It's inhabited TV,' [executive director Robin] Mudge said, 'where the viewer is inside the TV'". If you inhabit your television, it will become your alternative or virtual reality. There cannot be any artificiality in that virtual world if it is to seem convincing. As Joe Milutis argues, "the projected goal of HDTV is to remove the disconcerting pixel from consciousness." Ironically, such a goal can only be achieved by creating still more pixels, whose reduced size will eliminate the "blockiness" associated with the pixelated image, while in fact increasing the fragmentation of the image.

Two very different visual futures are available based on the interaction of television and the Internet, one that highlights its artificiality, another that seeks to conceal it. Both rely on complexity of the pixelated screen as a unit of both illumination and computer memory in a visual field that may appear saturated but in fact relies on the possibility of limitless subdivision. What is intriguing about this contest is that it will be determined by where we choose to direct our attention.

Virtual bodies

In mass media commentaries on the new electronic media, a consistent worry expressed is that they will elide the distinction between reality (natural and unmediated) and culture (artificial, always mediated). As Geoffrey Batchen has recently suggested, the unfolding of modernity has reached a point where it now becomes apparent that there is no meaningful difference between nature and culture (Batchen 1997). Nowhere is this erosion of boundaries more apparent than in the transformations of the modern body. Once considered the clear frontier between internal subjective experience and external objective reality, the body now appears to be a fluid and hybrid borderland between the two, as subject to change as any other cultural artifact. In this sense, virtual reality is an awareness that the reality produced by the disciplinary society of modernity was always surreal

and there are no norms against which people can reliably be measured. In Elizabeth Grosz's view, there is no opposition between

> the "real," material body in the one hand and its various cultural and historical representations on the other. . . . These represen- tations and cultural inscriptions quite literally constitute bodies and help to produce them as such. . . . As an essential internal condition of human bodies, a consequence of perhaps their organic openness to cultural competition, bodies must take the social order as their productive nucleus. Part of their own "nature" is an organic or ontological "incompleteness" or lack of finality, an amenability to social completion, social ordering and organization.
>
> (Grosz 1994: xi).

Given all the means by which the body may be manipulated, from dieting and body-building to laser surgery and pharmaceutical changes to brain chem- istry, none of us inhabit a purely natural body and no one's body is complete.

The French performance artist Orlan has made the exploration of the boundaries between self and image the center of her work in dramatic fashion. In a series of performances entitled *The Reincarnation of Saint Orlan* (1990–present), she turns cosmetic and reconstructive surgery into a dis- cursive event as to the nature of femininity (Figure 3.6). Whereas Sanford Lewin could simply claim femininity as Julie Graham in a textual online environment, Orlan has herself surgically reconstructed to look like the ideals of female beauty found in Western art. In fact, cosmetic surgeons also use such principles, offering women faces derived from what they take to be the highest ideals of Western art, describing how "the harmony and symmetry [of the face] are compared to a mental, almost magical, ideal subject, which is our basic concept of beauty" (Balsamo 1992: 211). Thus, a visitor to the Renaissance-Facial Cosmetics Surgery Center website is greeted by the face of Sandro Botticelli's Venus, scanned from his famous painting *The Birth of Venus* (1484–86), as if to suggest that this beauty is on offer (Figure 3.7). Orlan, however, makes her choices against the grain, choosing a nose modeled on that of a School of Fontainebleau sculpture of the goddess *Diana* "because the goddess was aggressive and refused to submit to the gods and men" (Hirschhorn 1996: 111). Orlan arranges for simultaneous video transmission of her surgeries, undertaken using only local anesthetic, during which she gives readings of selected critical texts and even answers viewers' questions. Later she exhibits computer-generated images of her face morphed with these artistic enhancements, alongside

Figure 3.6 Orlan screengrab

photographs of her experience taken for 41 days after surgery. She calls these exhibits *In Between Two*, neither the "before" nor the "after" of traditional cosmetic surgery images.

Orlan's work takes some familiar questions regarding the impact of the cosmetic industry on the female body and its image and gives them a new urgency by applying them to her own body. The tensions in her work stem from the contradiction between her critique of the Western fantasy of the ideal body and her participation in surgical enhancements designed to enact that body. Her work attracts intensely personal criticism from some journalists: "Still rather ugly – even after six operations . . . her pug-like face would need something more than the skill of a surgeon's knife to reach the Grecian ideal of perfection" (Hirschhorn 1996: 117). That is, of course, Orlan's point, that the ideal is only attainable in the visual image and not on the surface of the physical body. Each of her performances begins with a quotation from psychoanalyst Eugenie Lemoine-Luccioni: "one never is what one has, and there are no exceptions to the rule" (Hirschhorn 1996: 122). What it is that one has is precisely the question put into play by virtual experiences like those of "Julie Graham" and Orlan. Sanford Lewin was unable to be the person identified as Julie Graham under his own

Figure 3.7 The face of Boticelli's Venus

name but "Julie" undoubtedly affected and helped many people. Where did that person come from and where did she go once Lewin's game was revealed? Or to put it another way, who is Orlan? Is there a real person inside, or, as the insistence on baroque styles in her performances might suggest, is everything surface, designed to entice and trap the eye? The French philosopher Gilles Deleuze has suggested that the fold – his figure for the baroque – is particularly characteristic of such effects, a fold that "moves between the inside and the outside. Because it is a virtuality that never stops dividing itself" (Deleuze 1993: 35). The divide between the inside and the outside of the body that seems so natural has now become a fold leading to virtuality rather than reality.

 This relationship between the inside and the outside of the body was the subject of an astonishing installation by Mona Hatoum entitled *Corps Étranger*. This work by the Lebanese artist now working in Britain went a step further

down the road marked out by Orlan. On approaching *Corps Étranger*, you first see a shining white circular tower, looking both futuristic and somehow evocative of medieval castles, with two low doorways on either side. On entering the tower there is an immediate sense of dislocation. The space is filled with loud, rhythmic noise and there is a projection entirely filling the floor-space. It becomes clear that you are seeing a journey into and around someone's body and you try not to step on the projection as it seems somehow violent to do so. The body is Hatoum's own and the projection records both the inside and outside of her body using fiber optic techniques, while the sound is that made by her breathing and heartbeat as if heard from within the body. The title of the piece, *Corps Étranger* (Foreign Body), suddenly strikes a new meaning, as you come to think of your own body as being a foreign place. As you enter the work at a random point in the projection, it is hard to tell where and what you are looking at on the artist's body. Certain points appear clearly only to disappear, orifices loom and shrink, hairs intrude from all points. It is unclear if this body is able-bodied or disabled, where it is, what it is doing. Since the creation of the perspective system, visual culture has relied on a distinction between exterior reality and the interior of the body where perceptual judgements about that reality are made. In Hatoum's strange body, that boundary no longer seems secure. As Judith Butler argues: "What constitutes through division the 'inner' and 'outer' worlds of the subject is a border and a boundary tenuously maintained for the purposes of social regulation and control" (Butler 1990: 133). If for centuries we have sought to see into artists' minds, now we look into their bodies and find only absences. The performance artist Stelarc (Stelios Arcadiou), who has suspended himself above the ground using cables attached through his skin (see Figure 3.8), and who has created cyborg performances with a third "arm" called *Handswriting* (1982) and *Elapsed Horizon/Enhanced Assumption* (1990), holds that "THE BODY IS OBSOLETE . . . It is no longer meaningful to see the body as a *site* for the psyche or the social but rather as a *structure* to be monitored and modified" (Dery 1996: 160). Even the body has become virtual.

For recent feminist criticism, the virtual body has become the starting point for new investigations of gender, sexuality and identity. Donna Haraway has argued that all bodies are becoming cyborgs, losing the earlier sense that the human was essentially different from animals on the one hand and machines on the other. There is danger and opportunity here:

> A cyborg world is about the final imposition of a grid of control on the planet, about the final abstraction embodied in Star Wars, apocalypse waged in the name of defense, about the

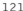

Figure 3.8 Stelarc with cables through his skin

final appropriation of women's bodies in a masculinist orgy of war. From another perspective, a cyborg world might be about lived social and bodily realities in which people are not afraid of their joint kinship with animals and machines, not afraid of permanently partial identities and contradictory standpoints.

(Haraway 1991: 154)

In the past few years, Haraway's argument has mostly been used to pursue discussions of fictional cyborgs like the Terminator character played by Arnold Schwarzenegger and the developing interface between the human and the machine. In one sense this interface has been the pre-eminent story of modernity from the development of the assembly line and its classic product, the automobile. In both making and operating cars, humans become extensions of machines and vice versa, as Charlie Chaplin classically highlighted in his film *Modern Times* (1936). The development of electronics and miniaturization has now made it possible to envisage the interface of humans and machines within the body, as already occurs for people with artificial heart pacemakers or valves.

It may be that the animal border of Haraway's dissolution of the human is

the site of more radical developments. In February 1997, it was announced that a Scottish research team led by Dr. Ian Wilmut had successfully cloned a sheep, which they named Dolly. This dramatic development led to instant calls for a ban on human cloning. President Clinton established a task force to create recommendations to this end the very next day. Meanwhile Wilmut's team continue to make advances, producing genetically engineered lambs that have human genes in every cell. If Dolly is simply an identical twin to her clone, these lambs are something else again, neither sheep nor human but a hybrid. Farmers have been producing hybrids by trial and error for millennia but these deliberate interventions at the microscopic level clearly seem to open up a new arena. There are already genetically engineered tomatoes – firmer and longer lasting – under consideration at the Food and Drug Administration, while British stores already sell genetically engineered tomato paste. Scientists have tried to minimize the importance of these developments as simply small additions to existing procedures. While this may be true, everything seems to have changed at the conceptual level. Where is the boundary between human, animal and vegetable now located?

This question recalls the manner in which the very notion of the human was established in Western culture in the seventeenth and eighteenth centuries. In his study *The Order of Things*, philosopher Michel Foucault argued that what we now call the humanities or human sciences "appeared when man constituted himself in Western culture as both that which must be conceived of and that which is to be known" (Foucault 1970: 345). He showed that the new concepts of life as the principle of biology, wealth as the creator of new forms of production, and language as the key to knowledge, created in this period became the basis for the development of the humanities. At the end of his book, Foucault made his most famous and most derided prediction: "If those arrangements were to disappear as they appeared, if some event of which we can at the moment do no more than sense the possibility . . . were to cause them to crumble, as the ground of Classical thought did, at the end of the eighteenth century, then one can certainly wager that man would be erased, like a face drawn in sand at the edge of the sea" (Foucault 1970: 387). Thirty years after Foucault wrote those words, his wager may be coming to pass. For the classical notions of labor as being the basis of wealth production that is measured in money have disappeared into the electronic complexities of the global market, where those who make the most money are people who buy, break up and sell companies without producing anything. With the invention of cloning, the basis of biology can no longer be taken to be naturally occuring life, for life forms exist that were created solely by human intervention. The last teetering leg of the human tripod then is the science of language as the unifying

principle of the human sciences that has generated so much controversy over the last three decades. Ironically, those who most strenuously asserted the importance of the linguistic theory of culture are now the most strident in denouncing the rise of visual culture. For linguistics is the key to the the humanistic tradition, as Foucault noted: "Linguistic analysis is more a perception than an explanation: that is, it is constitutive of its very object" (Foucault 1970: 382). The fear is that in a visual culture, humanity may find itself in a "serene non-existence" (386), unable even to frame the new paradigm. While such a crisis appears highly unlikely, there is certainly a localized crisis of the humanities within the Western university system. It will not be resolved by pretending that nothing has happened. Visual culture exists and it is now the task of intellectuals to find ways to represent it in a world where the humanistic distinction between the real and the virtual has dissolved.

By following the different, overlapping orders of visual representation in the modern and postmodern periods, we have found ourselves needing in the end to turn to culture to complete the analysis. Visual culture does not lead to the unilateral divorce of vision from the body, as some have asserted, in some fantastic globalization of the Universal Eye of the Enlightenment. Such accusations are better understood as displaced criticisms of the panoptical disciplinary system. Rather, any pursuit of the history of visuality leads us inevitably to the cultural, providing that the cultural be understood as a framework for asking questions rather than an answer in itself. Such questions center less on the physical processes of sight than on the meaning that is to be drawn from sensory experience. Visual culture is not then a casual collision of two fashionable terms but a necessary bringing together of the key constituent parts of modern life. The second half of this book therefore examines the dynamics of culture as a framework for the vicissitudes of the visual.

Notes

1 I was able to see the Walpiri videos at a presentation by Professor Faye Ginsburg entitled "First Nations, Media and the National Imaginaries" at the SUNY Stony Brook Humanities Institute and I am grateful for her permission to refer to her research.

2 My thanks to Geoff Batchen for pointing this connection out to me.

Bibliography

Adams, Paul C. (1992), "Television as a Gathering Place," *Annals of the Association of American Geographers* 82 (1): 117–35.

Anderson, Benedict (1983), *Imagined Communities*, London, Verso.

Babbage, Charles (1994), *Passages from the Life of a Philosopher*, ed. Martin Campbell-Kelly, New Brunswick, NJ, Rutgers University Press [1864].

Balsamo, Anne (1992), "On the Cutting Edge: Cosmetic Surgery and the Technological Production of the Gendered Body," *Camera Obscura* 22, January: 207–29.

Barker, Chris (1997), *Global Television: An Introduction*, Oxford, Blackwell.

Bassett, Caroline (1997), "Virtually Gendered: Life in an On-Line World," in Ken Gelder and Sarah Thornton (eds), *The Subcultures Reader*, London, Routledge.

Batchen, Geoffrey (1996), "Spectres of Cyberspace," *Artlink* 16 (2 and 3).

——— (1997), *Burning With Desire*, Cambridge, MA, MIT Press.

Baudrillard, Jean (1984), "The Precession of Simulacra", in Brian Wallis (ed.), *Art After Modernism: Rethinking Repression*, New York, New Museum of Contemporary Art.

Beller, Jonathan L. (1996), "Desiring the Involuntary: Machinic Assemblage and Transnationalism in Deleuze and *Robocop 2*," in Rob Wilson and Wimal Dissanayake (eds), *Global/Local: Cultural Production and the Transnational Imaginary*, Durham, NC, Duke University Press.

Benjamin, Walter (1968), *Illuminations*, New York, Shocken.

Blume, Harvey (1997), "Technology," *New York Times* June 30, D6.

Bukatman, Scott (1995), "The Artificial Infinite," in Lynne Cooke and Peter Wollen (eds), *Visual Display: Culture Beyond Appearances*, Seattle, WA, Bay Press.

Boyarin, Jonathan (1992), *Storm from Paradise: The Politics of Jewish Memory*, Minneapolis, Minnesota University Press.

Butler, Judith (1990), *Gender Trouble: Feminism and the Subversion of Identity*, New York, Routledge.

Caldwell, John Thornton (1995), *Televisuality: Style, Crisis and Authority in American Television*, New Brunswick, NJ, Rutgers University Press.

Charney, Leo and Schwartz, Vanessa R. (1995), *Cinema and the Invention of Modern Life*, Berkeley, CA, University of California Press.

Crow, Thomas (1995), *Emulation: Making Artists for Revolutionary France*, New Haven, CT, Yale University Press.

Deleuze, Gilles (1993), *The Fold: Liebniz and the Baroque*, Minneapolis, University of Minnesota Press.

Dery, Mark (1996), *Escape Velocity: Cyberculture at the End of the Century*, New York, Grove.

Doane, Mary Ann (1993), "Technology's Body: Cinematic Vision in Modernity," *differences* 5 (2), 1993.

Ellis, John (1982), *Visible Fictions: Cinema, Television, Video*, London, Methuen.

Foucault, Michel (1970), *The Order of Things*, London, Tavistock.

Friedberg, Anne (1993), *Window Shopping: Cinema and the Postmodern*, Berkeley and Los Angeles, CA, University of California Press.

Gabriel, Teshome H. and Wagmister, Fabian (1997), "Notes on Weavin' Digital" T(h)inkers at the Loom," *Social Identities* 3 (3) 1997.

Gibson, William (1984), *Neuromancer*, London, HarperCollins Science Fiction and Fantasy.

Ginsburg, Faye (1993), "Aboriginal Media and the Australian Imaginary," *Public Culture* 5 (1993): 557–78.

Grosz, Elizabeth (1994), *Volatile Bodies: Toward a Corporeal Feminism*, Bloomington, Indiana University Press.

Haraway, Donna (1991), *Simians, Cyborgs and Women*, New York, Routledge.

Hirschhorn, Meredith (1996), "Orlan: Artist in the Post-human Age of Mechanical Reincarnation: Body as Ready (to be re-) Made," in Griselda Pollock (ed.), *Generations and Geographies in the Visual Arts: Feminist Readings*, London, Routledge.

Johnson, Hilary and Rommelman, Nancy (1995), *The Real Real World*, New York, MTV Books.

Kirshenblatt-Gimblett, Barbara (1996), "The Electronic Vernacular," in George E. Marcus (ed.), *Connected: Engagements With Media*, Chicago, IL, University of Chicago Press.

Lindberg, David C. (1976), *Theories of Vision from Al-Kindi to Kepler*, Chicago, IL, University of Chicago Press.

Massa, Rainer Michael (ed.) (1985), *Pygmalion Photographé*, Geneva, Musée d'Art et d'Histoire.

Michaels, Eric (1995), "The Aboriginal Invention of Television in Central Australia 1982–86," in Peter d'Agostino and David Talfer (eds), *Transmission: Towards a Post-Television Culture*, London, Sage.

Mitchell, William J. (1995), *City of Bits*, Cambridge, MA, MIT Press.

Morgan, Conway and Zampi, Giuliano (1995), *Virtual Architecture*, New York, McGraw Hill.

Morley, David (1992), *Television, Audiences and Cultural Studies*, London, Routledge.

Penny, Simon (1994), "Virtual Reality as the Completion of the Enlightenment Project," in Gretchen Bender and Timothy Druckrey (eds), *Culture on the Brink: Ideologies of Technology*, Seattle, WA, Bay Press.

Sandoval, Chéla (1994), "Re-entering Cyberspace: Sciences of Resistance," *Dispositio/n* XIX 46 (1994): 75–93.

Sawyer, Kathy (1997), "Mars Robot Set to Explore Red Planet," *Washington Post* July 13, 1997.

Shapley, Deborah, "Now in Release: Internet, the Next Generation," *New York Times* January 27, 1997, D1–4.

Shohat, Ella and Stam, Robert (1994), *Unthinking Eurocentrism: Multiculturalism and the Media*, London, Routledge.

Soja, Edward (1989), *Postmodern Geographies. The Reassertion of Space in Critical Social Theory*, London, Verso.

Stephenson, Neal (1992), *Snowcrash*, New York, Bantam.

Stone, Allucquère Rosanne (1995), *The War of Desire and Technology at the Close of the Mechanical Age*, Cambridge, MA, MIT Press.

Stratton, John (1997), "Cyberspace and the Globalization of Culture," in David
 Porter (ed.), *Internet Culture*, New York, Routledge.
Victoria, Laura (1997), "For a good time, click here," *The Web Magazine* March: 35–
 37.
Virilio, Paul (1994), *The Vision Machine*, Bloomington, Indiana University Press.
Woolley, Benjamin (1992), *Virtual Worlds*, Oxford, Blackwell.

Internet sites

(These sites were active at time of going to press)
Bodies©INCorporated: http://www.arts.ucsb.edu/bodiesinc
Independent Living, autistic user group: http://www.inlv.demon.nl/
Deafworld: news, information and chatrooms for the Deaf:
 http://dww.deafworldweb.org/
Netnoir: http://www.netnoir.com/
Keith Piper, interactive artist's site: http://www.iniva.org/piper/welcome.html
Renaissance-Facial Cosmetic Surgery Center: http://www.facial-cosmetics.com
Stelarc: http://www.merlin.com.au/stelarc/index.html
Voice of the Shuttle: http://humanitas.ucsb.edu

Culture

TRANSCULTURE
From Kongo to the Congo

O N A HOT SUMMER DAY in 1920, the poet Langston Hughes was on a train to Mexico. At sunset outside St. Louis, the train crossed over the Mississippi and Hughes set to thinking about the importance of rivers in African-American history: "Then I began to think about other rivers in our past – the Congo, and the Niger, and the Nile in Africa – and the thought came to me 'I've known rivers'." Within 15 minutes, he wrote perhaps his most famous poem on the back of an envelope:

> I've known rivers:
> I've known rivers ancient as the world and older than the
> flow of human blood in human veins.
> My soul has grown deep like the rivers.
> I bathed in the Euphrates when dawns were young.
> I built my hut near the Congo and it lulled me to sleep.
> <div align="right">(Hughes 1993: 55)</div>

The view from a moving train was a central visual experience in the formation of modernism, opening the possibility that modernity itself could be envisioned as a moving image. Hughes places this vision in a different context from the standard modernist linear narrative of forward-moving history. His diasporic modernism replaces the linear evolution model with the river; it replaces a single flow of time with what Walter Benjamin called *Jetzeit*, that is to say, "a past charged with the time of the now." Thus the French revolutionaries imagined themselves to be Ancient Romans in order

to think the unthinkable idea of a state without a king, while Serbs and Croats have recently referred to events dating as far back as the fifteenth century as live issues, still requiring resolution. As these examples show, *Jetzeit* is not progressive or reactionary in itself, it is simply a different understanding of the passing of time.

By contrast, European modernism saw itself as the logical end product of a long linear evolution. As George Stocking puts it, the Victorians sought to create "a single cultural ladder by which man could have climbed unassisted from brute savages to European civilization" (Stocking 1987: 177). Turning to culture as a framework for historical explanation is thus, as noted in the introduction, a dangerous but unavoidable step. In the nineteenth and early twentieth centuries, anthropology created a visualized system of cultural difference whose effects are still with us long after its "scientific" basis has been discredited. Dependent on a notion of forward moving evolution, this visual anthropology used culture to equate differentials of time and space: that is to say, the nations designated as "Western" were and are understood to be modern and those countries that are "non-Western" are not modern (Shohat and Stam 1994). One of the clearest examples of this belief came in the layout of the new museums that were built throughout Europe in the period, often with state support. Beginning with the designs of Karl-Friedrich Schinkel for the *Altes Museum* in Berlin (1822–30), all such institutions began their displays with the earliest periods and progressed towards the present. The visitor was guided through rooms arranged by country and time period, expressing the view that each epoch has its own particular spirit, named the *Zeitgeist*, or spirit of the times, by the philosopher Hegel. This linear notion of the passing of time, parceled up into different national spaces, has come to seem so natural that it can be difficult to conceptualize what it would mean to abandon it. Consequently, as Foucault warned, it is no longer "possible to disregard the fatal intersection of time with space" (Foucault 1986: 22). Working with visual materials in a cultural framework means finding new ways to intersect the visual with time and space.

The anthropological view of culture depended upon a clear distinction being drawn between "their" culture and "our" civilization. It was the anthropologist's task to research and discover the wholly different ways in which those cultures were organized. The rationale for this work might be more or less explicitly racist but it always depended on this spatial and temporal distinction: over there, they live in a different way from us that is equivalent to going back in time. James Clifford has called this interpretive structure the "art–culture system" in which the status of Western art is dependent on its being distinguished from non-Western culture. Both are

also distinguished from their negatives, such as commercial reproductions in the case of art. If non-Western objects are sufficiently admired, like Benin bronzes or Ming vases, they can be transferred to the "art" side without disturbing the system. Further, Clifford suggests that it is possible for art to move towards the culture side, as has happened at Paris' Musée d'Orsay, where Impressionist art has been arranged "in the panorama of a historical-cultural 'period'" (Clifford 1988). From present-day perspectives, the monuments of élite culture and anthropological data alike both point in a different direction, towards a modern visual culture that is always cross-cultural, and always hybrid – in short transcultural.

In this chapter, I want to suggest that visual culture studies should use culture in the dynamic, fluid sense suggested by Langston Hughes rather than in the traditional anthropological sense. This notion is what the Cuban critic Fernando Ortiz called "transculture," which implies not "merely acquiring another culture, which is what the English word *acculturation* really implies, but the process also necessarily involves the loss or uprooting of a previous culture, which could be defined as deculturation. In addition, it carries the idea of the consequent creation of new cultural phenomena, which could be called neo-culturation" (Ortiz 1947: 103). Transculturation is then a three-way process involving the acquisition of certain aspects of a new culture, the loss of some older ones and the third step of resolving these fragments of old and new into a coherent body, which may be more or less whole. Although this process sounds typically "postmodern," it should be remembered that Ortiz was writing in 1940. Given the nature of transculturation, it is not a once and for all experience but a process renewed by each generation in their own way. The difference in the late twentieth century is that those places that formerly considered themselves at the cultural center are also experiencing what it is to go through transculturation. For as Antonio Benítez-Rojo has commented, transculture "takes us to what lies at the heart of postmodern . . . analysis: a questioning of the concept of 'unity' and a dismantling, or rather unmasking, of the mechanism we know as the 'binary opposition'" (Benítez-Rojo 1996: 154). Rather than continue to work within the modernist oppositions between culture and either art or civilization, transculture offers a way to analyze the hybrid, hyphenated, syncretic global diaspora in which we live.

The contemporary Cuban artist José Bedia, who has worked in Cuba, Mexico and the United States has described how this experience has affected his work: "The process – transcultural to call it something – which is currently produced in the heart of many autochthonous cultures, I try to produce it in me in a similar yet inverted manner. I am a man with a 'Western' background who, by means of a voluntary and premeditated

system, strives for a rapprochement with these cultures and moreover experiences their cultures in an equally transcultural way" (Mesquita 1993: 9). For all its theoretical rigor, Bedia's work also makes great use of humor. In his piece *The Little Revenge From the Periphery* (1993), a track carrying airplanes and faces runs around a central print bearing the title in English. Bedia recognizes the central importance of air travel in greatly enlarging the transcultural world, but within the circle the focus is on past time. A print showing the nineteenth-century classification of races places a Native American, an African, an Asian and an ape in orbit around the figure of a white male. The little revenge of the title derives from the fact that the white figure is filled with arrows and a stone ax, tools that deliberately evoke the tension between the presumed modernity of the center and its antonym, the primitive periphery. Bedia recognizes that racial categories continue to place non-white people in the past in relation to the postmodern EurAmerican. His strategy is at once to undermine such assumptions with humor and to create a new map of cultures in space and time that does not revolve around the white male. For transculture is the experience of the periphery over the past several centuries that has now returned to sender, offering a new sense of culture itself as, to quote Benítez-Rojo, that which "has no beginning or end and is always in transformation, since it is always looking for a way to signify what it cannot manage to signify" (Benítez-Rojo 1996: 20). Writing on Bedia's art, Ivo Mesquita describes how transculture's work "resembles that of a traveler who, traversing different landscapes, describes routes, points out passages, establishes landmarks, fixes the boundaries of a specific territory" (Mesquita 1993: 19). Such a description inevitably recalls the colonial travel narratives of the nineteenth century that presented colonized territories as blank spaces awaiting the arrival of Europeans to become places. Yet by consistently exposing that history and asking how the visualism of the present can be distinguished from that of the past, visual culture can play its part in redefining culture as a constantly changing, permeable and forward-looking experience of transculture, rather than as a clearly definable inheritance from the past.

Inventing the heart of darkness

For evolutionary anthropologists and Hughes alike, one spot was of particular importance – the Congo. Far from being the mythical origin of the primitive, the Congo was in fact a key locus of transculture since the fifteenth century. While the Congo was one of the sites of Hughes' diasporic memory, European slavers and colonizers transformed the Central African Kongo civilization of the Bakongo people into the Congo, the degree zero of

modern space–time. For anthropologists and eugenicists alike, the Congo was the most primitive place in Africa, itself the Dark Continent left behind by progress. As such, the Congo served as the anchor or base for the evolutionist ladder that led up to the West. As the heart of "darkest Africa," the Congo was supposed to epitomize the binary distinction between the civilized West and its primitive Other. The Congo became notorious to Westerners after Henry Morton Stanley (of "Dr Livingstone, I presume" fame) published a famous account of his journey from East Africa to the Atlantic coast down the Congo river, entitled *Through the Dark Continent* (1878). Stanley helped the Belgian monarchy establish a vast colony that nonetheless centered entirely around the river itself.

The centrality of the tension between the modern and the primitive in such varied fields as modern political culture, race science, anthropology and modern art suggests that, far from being an irrelevant locale on the periphery of cultural history, Kongo was integral to the unfolding history of modernity. For it was and is a dramatic example of the power of transculturation to create and destroy at once. Its peculiar reputation as the very origin of the primitive made it a key site for the constitution of Western notions of modernity that are always in tension with the primitive and primitivism. Several factors make the Congo a place of particular interest for visual culture. The Congo was a key point in what has been called the Black Atlantic, first created by the Atlantic triangle of slavery, but now understood by scholars of the African diaspora as "a means to re-examine the problems of nationality, location, identity, and historical memory" (Gilroy 1993: 16). As Hughes' poem recalls, a high percentage of those Africans taken in slavery from the sixteenth to the nineteenth centuries were from Kongo. As a result, Kongo practices were often recreated in the Americas by the enslaved, contributing many words like "jazz" to the English language and playing a central part in the Santería religion currently practiced across the Caribbean and increasingly in the United States. Second, the Congo was the birthplace of American Studies, the home of cultural studies in the American academy. For it was in the Congo that Perry Miller, who would go on to found the discipline of American Studies, experienced what he called an epiphany while unloading oil drums from a tanker. In "the jungle of central Africa" he suddenly saw "the pressing necessity for expounding my America to the twentieth century" (Kaplan and Pease 1993: 3). What Miller saw as the emptiness of Africa offered a blank slate against which he was able to see clearly his vision of America. The evolutionist ladder created in the nineteenth century to account for the superiority of Western civilization ironically prepared the ground for the success of cultural studies whose avowed aim is to contest

such reactionary beliefs. Third, the Congo was the site both of some of the most egregious colonial violence and the most principled resistance to colonialism by both Africans and Europeans. This history, pursued in this chapter and the next, makes the Congo a key point for the definition of the colonial project, which created a new everyday reality both in the colonies and in the colonizing nations. With the achievement of indepedence in the 1960s, a new round of transculturation was set in motion that continues to be played out with the overthrow of Mobuto Sese Soko's Zaire and Laurent Kabila's reinstituted Democratic Republic of Congo in 1997. The focus on the Congo in this and subsequent chapters is not, however, intended to suggest that only the Congo – rather than, say, Latin America or East Asia – is representative of the transculturation of modernity but that it is one important site of that process. I concentrate upon it in this and subsequent chapters for the sake of coherence and continuity, which might be lost in a global account. Further, I think it important to emphasize that Africa also has had its part to play in modernity from the earliest contact between Europeans and Africans despite its continuing characterization as the "Dark Continent," amply in evidence in media coverage of President Clinton's 1998 visit to Africa.

The construction of the Congo as the most primordial point of space–time was part of the reorientation of European political economy as it turned from slavery to colonialism, involving a remarkable rewriting of historical and popular memory. In a few decades, Europeans seemed willfully to forget all that they had learned about Africa since the fifteenth century – in Ortiz's terms, they deculturated Kongo in order to acculturate themselves and Africans to the new entity they had created named the Congo. This loss of knowledge involved turning what had been a place back into empty space so that it was suitable for the civilizing mission of colonialism. Amnesia as a political strategy was directly advocated by the philosopher Ernest Renan, whose racial theories were central to the consolidation of the French Third Republic (1870–1940). In an 1882 lecture entitled "What is a Nation?", Renan baldly asserted that: "Forgetting, I would even go so far as to say historical error, is a crucial factor in the creation of a nation" (Renan 1990: 11). The creation of the imperial nations of the late nineteenth century involved forgetting the Africa of the Atlantic slavery period and reinventing it as an untouched wilderness. Maps from the early modern period show detailed knowledge of African geography and place names, while eighteenth-century published collections of voyages offered the reader a wide range of information about the major African peoples. In the mid-nineteenth century, Europeans placed this knowledge aside, and created in its place the myth of the Dark Continent, a wild place whose customs were both unknown and

barbaric. For Captain Camille Coquilhat, who was one of Stanley's deputies and later District Commissioner of Balanga in the Congo Free State, commercial progress was far easier to achieve in the Congo than civilization:

> The people of Upper Congo, given over to cannibalism, human sacrifice, judgments by poison, fetishism, wars of plunder, slavery, polygamy, polyandry and deprived of all unity in government, science, writing, and medicine, are less advanced in civilization than the Celts were several centuries before Christ. All of a sudden, without any transition, they saw appear on their savage waterway European steamships of the nineteenth century. In industry, the blacks can be advanced more quickly. But in moral order, progress will not advance with precipitation.
>
> (Coquilhat 1888: 483)

It was the task of the Europeans to assist the "infant" Africans to the maturity that had taken two millennia in the West. At the same time that African diaspora peoples were discovering what W.E.B. Dubois called their "double-consciousness" as both Africans and residents of their diaspora nations, Europeans were reinventing Africa as a primitive wilderness. In this cultural geography, Africa now had to be remapped by anthropologists, explorers and photographers whose combined efforts at describing African primitivism would re-enter European modernism with Picasso's use of motifs derived from Dan sculpture in his famous Cubist painting *Les Demoiselles d'Avignon* (1905).

Nineteenth century maps of the Congo showed a squared white space, traversed only by the complicated flow of the Congo and its tributaries (see Figure 4.1). For Europeans, the Congo had yet to become a place and was simply a series of stops along the waterway. It may have been the sight of such charts that prompted the novelist Joseph Conrad to undertake his journey to the Congo, the last of what he called "the blank spaces on the earth," which he later fictionalized in his famous novella *Heart of Darkness* (1899). Photographers like the Belgian Emile Torday devoted thousands of exposures to the impossible task of recording and representing the Congo river, which defied photography due to its sheer size (see Figure 4.2). The river itself was intensely alien to Europeans, as in this typical and widely quoted assessment by Count Pourtalès in 1888:

> A leaden atmosphere envelopes you, rendered even more oppressive by the heat which engulfed the sunshade of our little steamer. In the river, two or three rocky islands without any

Figure 4.1 Map of the Congo River

Figure 4.2 Flocks of birds on the Congo River

vegetation except the trunks of one or two dead trees, thrusting a naked branch towards the sky, as if tortured by suffering and despair. On the bank are monstrous crocodiles, and occasionally, in the shade of a rock, the silhouette of a huddled and immobile Negro, looking at our boat without making any movement as if petrified. Over all of this is spread something of that indefinable and mysterious thing that characterizes Africa.

The European is not accustomed to see an immense river without shipping and with no habitation on its banks. Here, there is nothing except the noise of eddies produced by a current of such power that our boat, in certain places, seemed unable to

advance. . . . However, this lugubrious spectacle, this silence, this immobility in creation are surprisingly severe and grandiose.

(Coquilhat 1888: 35)

For Europeans accustomed to the modern spectacle of circulation, whether of goods, people or traffic, the Congo river was perceived as a spectacle of primitivism that was almost impossible to visualize.

While the Congo river defined the Congo for Europeans, Kongo peoples saw water as the dividing line between this world and the world of spirits and the dead. The Kongo world view could not have been more different from European beliefs in linear evolution and progress. It was encapsulated in what has been called the cosmogram, a cross of two intersecting lines within a circle forming four quarters representing "an ideal balancing of the vitality of the world of the living with the visionariness of the world of the dead" (Thompson 1983: 106). The top half of the cosmogram represented the world of the living and the bottom that of the dead. Life was envisaged as a circle in which the individual passed from the land of the living to that of the dead and back again, while the community as a whole was constantly engaged with the spirits of the dead. In between was the water of the river and the sea. Just as Hughes was later to see the river as a site for diasporic memory, Kongo peoples saw it as a place of complex connection between the past and the present. Europeans were convinced that the elimination of such beliefs was an essential step in converting Kongo primitivism into the modern, urban civilization of the Congo in which the river would come to serve as a waterway for the transportation of goods and the central avenue of settlement.

Figures like Stanley and Conrad who traveled in Congo around the turn of the twentieth century liked to portray themselves as the first Europeans to have set foot in the region, venturing into wholly unknown territory. When the Belgian Musée du Congo began to publish its holdings in 1902, the first volume was prefaced with the simple statement: "Twenty-five years ago, the Congo was unknown" (Notes 1902: 1). In fact, Portuguese navigators first reached Kongo in 1483, initiating two centuries of conversion efforts by Catholic missionaries. The Kongo king Afonso I Mvemba Nzinga (1506–43) not only learnt Portuguese but compiled erudite commentaries on religious texts and sent some of his relatives to Portugal, where one became a bishop. This first transcultural exchange was forgotten with the rise of Atlantic slavery in the seventeenth century that destroyed the political structures in Kongo. Hundreds of thousands of Kongo people were forcibly expatriated into slavery and many more died as a consequence of the slavers' activities. The centralized monarchy gave way to a system of matrilineal clans, whose

chiefs rose and fell according to their relationship with the slavers. Un-surprisingly, Christianity "declined to the point of disappearance until Protestant missionaries began to arrive in the 1870s" but trade links continued even after the end of the slave trade (MacGaffey 1993: 31). While anthropologists later assumed that Africans "evolved" from tribes to kingdoms, the reverse was in fact true – Europeans destroyed the king-dom of Kongo and created the Congo tribes as part of their divide-and-rule policy. As historian Wyatt MacGaffey has emphasized: "In Kongo, an area where one would expect to find tribes, if such things existed, we find instead a constant flux of identities" (MacGaffey 1995: 1035). The process of deculturation here took the most violent form imaginable, forcing the peoples of Kongo to acculturate to new political realities and create new cultural practices from religion to art and medicine. While Europeans sought to invent the home of "primitive culture" in the Congo, everyday objects, African sculpture, and European photography alike attest that the region continued to develop in transcultural fashion. Even in what Europeans saw as the very origin of the primitive, they created a record that often contradicts their own texts. The objects created by Kongo people were, in the Western sense, both realistic and abstract. They both resisted the colonizers and accommodated them. Their influence reaches back to the Christianized Kongo of the fifteenth century and forward to postmodern Paris.

The colonial venture into the Congo began in earnest after the Berlin Conference of 1885 had assigned the region to Belgium's king Leopold II. By this arbitrary act of division, Europeans reinvented Africa as a mirror of their own balance of power. For all the countries involved, imperial success in Africa became a key measure of national standing and influence. It is in this sense that the contemporary African philosopher V.Y. Mudimbe has sug-gested that the very idea of Africa is Western, for only the Europeans could have had the notion of sitting down at a table to divide up an entire continent amongst themselves. The Congo Free State, as it was ironically enough now known, was created from a vast region of Central Africa equivalent in size to the entirety of Western Europe. It was all but a personal fiefdom of the Belgian monarch, who was at a stroke of the pen able to transform his country into a major colonial power. By 1895, the disorderly colony was nonetheless on the verge of bankruptcy, but the discovery of rubber trans-formed it into one of the most profitable of all colonial ventures. The dramatic European commercial expansion into the Congo made it possible for anthropological and natural history expeditions to reach the interior with ease. Anthropologists were fascinated by the so-called "pygmies," or Mbuti peoples of the forest regions, while naturalists hoped for dramatic dis-

coveries. In 1901 Sir Harry Johnston fulfilled this ambition when he became the first European to see the hitherto unknown okapi. Subsequently, all the major natural history museums mounted expeditions to the region in order to obtain their own specimens and perhaps to discover other unknown species. However, the violent excesses of the Belgian authorities in extracting the maximum profit from the Congo for the personal use of King Leopold were such that they caused a scandal even in the high noon of imperialism. Even travel and natural history accounts of the region took positions for and against the colonial regime until the publication of a report by the British consul Roger Casement in 1904 finally made the violence and arbitrary exercise of authority in the Congo an international scandal. Joseph Conrad wrote to Casement congratulating him on his report, noting that "it is an extraordinary thing that the conscience of Europe which seventy years ago has put down the slave trade on humanitarian grounds tolerates the Congo state today. It is as if the moral clock had been put back" (Pakenham 1991: 656). Thus, the Anglo-Polish writer pointed out to the Anglo-Irish diplomat the exercise in (trans)cultural amnesia that the British themselves were content to ignore.

The result of this combination of anthropology, natural history and political scandal was a remarkable quantity of photographs, travel narratives and appropriation of African art and material culture that present the historian with an unusually rich range of materials with which to analyze the colonial Congo. Further, the almost entirely textual nature of the European re-invention of the Congo in the 1870s gave way to a visual representation of the heart of darkness. This revisualization was primarily enabled by the advances in dry-plate photography in the 1880s that enabled amateur photographers to take pictures even while on long trips. It sought to deny the excesses of colonialism and to instead represent it as a civilizing mission. What Conrad called the "threshold of invisibility" was the subject of innumerable visual representations as the first rung of the cultural ladder built by European science that led upwards to Western Europe. Photography was a key tool in visualizing colonial possessions and demonstrating Western superiority over the colonized. As the Europeans consolidated their hold on Africa, there followed a seemingly endless supply of "adventurers" and "explorers," who nearly all felt the need to publish an account of their journey. In these writings resistance to colonialism becomes rewritten as savagery.

European travelers consistently congratulated themselves on surviving the rigors of what Adolphus Friedrich, Duke of Mecklenberg called "this dark corner of the world" (Friedrich 1913: 3). In fact, the colonial regime had long since facilitated travel for well-to-do Europeans and created what might

be seen as a virtual Congo for visitors to experience, photograph and retell back home. For example, Friedrich records his visit to a theatrical company, a race-course and a regatta in the course of one day. No doubt these recreations of European civility were as dull in Africa as they would have been in Bavaria. Nonetheless, they allowed European visitors to ports like Mombasa to retain some sense of being at "home," while acculturating to Africa. From there, the journey always led to the interior. In the Congo, the Belgian authorities laid down railway lines and operated river steamers, allowing the visitor to reach the "bush" quickly. Albert Lloyd, a British missionary, photographed the arrival of one such steamer at Avakubi, intending to show the remoteness of the place. One actually sees a large crowd of Africans calmly awaiting the steamer, bringing goods and offering services such as portering (Figure 4.3). No European carried his own baggage but instead had Africans carry large loads of 50 to 60 pounds a person, ensuring that British and German explorers traveled in such comfort that they could dispute the appropriate point in their meal to drink the port (indeed the prodigious quantity of alcohol consumed can be seen from the fact that during a supplies crisis at Leopoldville, officials had to restrict each European to half a bottle of port a day). The government maintained a network of paths and resthouses spaced out every 10 to 20 miles, allowing an expedition to proceed at a gentle but satisfactory pace (see Figure 4.4).

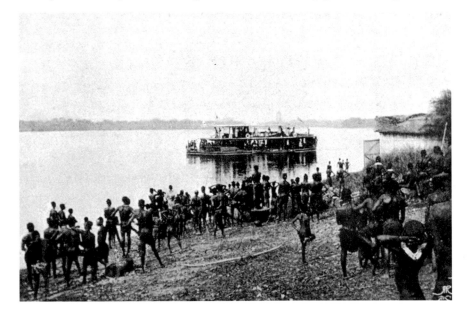

Figure 4.3 Arrival of the steamer

They also created obvious opportunities for photography that few passed up. Friedrich illustrated his account with a photograph entitled "A Glade in the Virgin Forest" to demonstrate his courage in taking on the African elements (see Figure 4.5). Instead, the photograph clearly shows a well-beaten path heading directly through the scrub. These paths were sufficiently well-maintained that one Marguerite Roby was able to ride her bicycle through much of the Congo in 1911 (see Figure 4.6). The work involved was performed by the Congolese to meet the taxation demands levied on them by the Belgians, realized either with colonial products such as ivory and rubber or with unpaid labor. The local people were also responsible for supplying the resthouses with food and water. This government care of the European traveler was well-rewarded, as most travel accounts supported the government against the reformers. The photographs in such books were taken as key evidence of the authenticity of the traveler's account. While they no doubt did record what European visitors had experienced, that experience had been carefully prepared for them by the colonial administration.

For most European travelers, African resistance was only encountered symbolically in resistance to photography. Their books are filled with pictures of Africans permitting themselves to be photographed, because they had no choice, but withholding consent by refusing to strike a pose

Figure 4.4 A station village in the Congo

Figure 4.5 "A Glade in the Virgin Forest"

or smile. For Europeans, this lack of cooperation could only be explained as a superstitious fear of cameras, rather than as an acknowledgment that Western military technology was in a position to enforce consent. In one typical account published in 1892, M. French-Sheldon, the self-styled "Bebe Bwana" asserted simply that "the natives' horror of being photographed makes it most difficult to obtain satisfactory portraits of them. Once, and only once, with their knowledge I held up my camera before a group of natives employing the photographer's fiction to attract their attention, 'Look here and you will see a bird fly out.' The result justified the deception. Their

Figure 4.6 Leaving Elizabethville with gun-bearer and bicycle-runner

good-natured, laughing physiognomies depict anything but brutality or savagery" (French-Sheldon 1892: 414). French-Sheldon's self-confidence in her superiority was such that she completely failed to see the mockery on the faces of her subjects, who were fully aware of what she was doing. These stories were repeated so often that they have become part of the Western myth of its own technical, hence moral, superiority.

What they conveniently forget is that such fears in fact originated in Europe. The French novelist Honoré de Balzac, whose own work concentrated on describing modern society, at first refused to be photographed for fear that the camera would steal a layer of his soul. The photographer Nadar recalled that Balzac "concluded that every time someone had his photograph taken, one of the spectral layers was removed from the body and transferred to the photograph. Repeated exposures entailed the unavoidable loss of subsequent ghostly layers, that is, of the very essence of life." Nadar was later able to persuade Balzac to be photographed in dramatically Romantic style, as photography quickly became naturalized and normalized as part of Western society. The gap between Balzac's fear of the camera and the later

attribution of that fear to Africans was precisely that in which Europeans forgot one version of Africa and invented another.

Anthropologists were no more perspicacious when it came to describing human society in Kongo. Friedrich documented what he described as "A Cannibal from the Border Mountains of Congo State." The proof that this man was a cannibal lies in his sharpened teeth that he is conveniently baring for the camera. This decorative tradition led many Mbuti people to be falsely described as cannibals. One such man named Ota Benga was actually displayed as an exhibit at the Bronx Zoo in New York City in 1906. Cannibalism has long been used to justify colonization. The British accused the Irish of being cannibals in the seventeenth century, for example, while Indian Hindus thought Christians were cannibals when they proclaimed the Eucharist to be the body of Christ. Cannibalism, in the sense of the routine eating of human flesh, has been nothing more than an enabling ideology to justify European expansion.[1] For colonists could claim that the formerly prevalent practice of anthropophagy had died out as soon as their regime took control, thus taking credit for eliminating something that had not existed in the first place.

Nor could any human equivalent of the okapi be found, a suitably exotic variant on the European definition of the human to satisfy their sense of physical superiority. The best that could be done was to identify the Mbuti people as the "Pygmies," a people supposedly notable for their shortness and reclusive behavior. One English writer, A.F.R. Wollaston, who accompanied the British Museum (Natural History) expedition to the Kongo region in 1905–6 moved directly from his discussion of the okapi to the Pygmies: "who can climb trees like a squirrel and can pass through the thickest jungle without disturbing a twig. . . . The first Pygmy that I met greeted me with a shout of 'Bonzoo, Bwana (sir)'; he had been for a time in a Congo post, and 'Bonzoo' was his version of 'Bon jour'" (Wollaston 1908: 153). In one of the more surreal moments of colonialism, an Englishman thus criticizes an Mbuti for his French pronunciation in the Congo rainforest, while blithely insisting that this person is also an example of Darkest Africa. In 1853 a group of Mbuti dressed in European clothing even went on a tour of Britain, where they played piano to show how "civilized" they could be (Fusco 1995: 43). The more that Europeans tried to insist on the profound difference of Africans, the more they seem to provide evidence of the transcultural and hybrid world created by colonialism.

One of the longest missions to the region was that of the American Museum of Natural History, led by Herbert Lang and James Chapin from 1909–15 (Mirzoeff 1995: 135–61). In over 10,000 photographs, Lang obsessively documented both natural and human sights of interest, taking

especial care to record the way of life of the Mangbetu people. Despite his extended fieldwork, Lang reproduced images not of the "authentic" Mangbetu way of life but of the colonial order imposed by the Belgians, and Mangbetu attempts to negotiate with this power. In one photograph, Lang showed "Danga, a prominent Mangbetu chief" seated in front of a large crowd, whom we may suppose to be Danga's subjects (Figure 4.7). As Lang noted in his caption, Danga is wearing his brass insignia of office, given to him by the Belgians, "of which he is inordinately proud." As well he might be, for the Belgian badge was Danga's only connection to power. The North-eastern region of the Congo had actively resisted Belgian control until an army of over 15,000 African troops, commanded by Belgian soldiers, had suppressed dissent in 1895. Even then, outbreaks of rebellion persisted well after 1900. The Belgians installed their former soldiers, recruited elsewhere in the Congo, as chiefs of the subjugated rebels. Danga was most probably not even Mangbetu, let alone a "chief." Here Lang recorded nothing more than the colonial attempt to create a manageable "tribal" order in what they called the Congo from ruins of the vast Kongo kingdom. Furthermore, despite Lang's attempt to record only authentic local culture, a man wearing a Western white linen suit topped with a felt hat can be seen on the right hand side of the picture.

In one case, the transformation of colonial text into image that is typical of the visual culture of the Congo in this period took concrete form. When

Figure 4.7 Danga, a prominent Mangbetu chief

Lang arrived in the Mangbetu region, he expected to see a great hall that he had read about in Schweinfurth's book *In the Heart of Africa* (1874). By this time, no such hall existed if indeed it ever had. Once the local chief Okondo realized that Lang was upset by this disruption of his vision of the colonial order, he set about rectifying matters. He had a hall built, 9 meters high by 55 meters long and 27 meters wide. As Lang himself noted, "five hundred men worked at the structure, of course with continual interruptions for dancing and drinking" (Schildkrout 1993: 65). One can only imagine how amusing the Mangbetu must have found re-imagining this structure on the basis of Lang's description. At the same time, it was worth their undoubted exertions and cost to build this hall if by so doing they could avert the violence of the colonizers. Needless to say, when the building was finished Lang photographed it. The photograph is a powerful testament to a particular version of what Homi Bhabha has called the mimicry of the colonial order (Bhabha 1994: 85–92). In this case, the Mangbetu were mimicking the colonizers' ideas of how "natives" ought to live, right down to the local architecture. Once one becomes aware that Lang's photographs do not show what they purport to represent, it becomes difficult to place trust in any of them. When we see, for example, "Chief Okondo in dancing costume," is this really a dancing costume used by Mangbetu, or a suitably exotic masquerade dreamt up to satisfy a colonial whim (see Figure 4.8)? Given that Okondo seems to have worn his Belgian army uniform for day to day clothing, his dancing costume seems all the more stylized to meet a colonial need.

Okondo's strategy was not unusual in the upside-down world of colonial empires. In neighboring Cameroon, King Njoya of Bamum had found himself under considerable pressure from the German colonial authorities to donate his beaded throne to their anthropological museum. Njoya agreed to make an identical copy of his throne for the Germans but when a delegation arrived to collect it, the copy had not been finished. Njoya simply gave them the throne he had been using and kept the copy for himself. He later donated copies of the throne to British and French colonial officials and made five copies in all. From the Western perspective, only the German example is the "real" throne and the others are simply inauthentic copies. But as Michael Rowlands explains, "in Bamum aesthetic terms there was no single original work to be copied but rather a number of equal alternatives. Any one of them could be desacralized as a gift or resacralized as a state throne. There was no reason to privilege one of them in particular although none of them should have been sold. The creation of an authentic original to suit European sensibilities was achieved by Njoya's gift, transforming ritual object into artwork" (Rowlands 1995: 15). Leaders like Njoya and Okondo

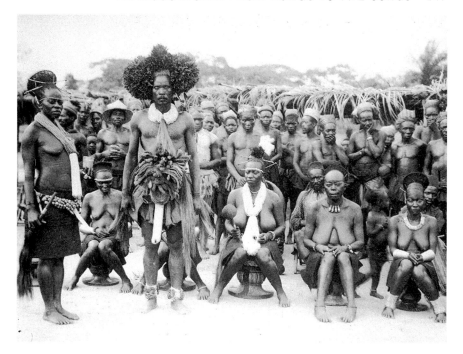

Figure 4.8 Chief Okondo in dancing costume

helped Europeans invent Africa in the way they envisaged it, as an untouched primitive dark continent with a native culture on the verge of extinction that had to be preserved in the only suitable location, a Western museum. This strategy of acculturating colonialism provided a space for Africans and Europeans to coexist in the uneasy cold war of colonial settlement. For Europeans, the visual documentation of Africa was central to their transculturation of the continent into a land fit for colonization. Africans aided this process as an alternative preferable to the kind of violence that led to an international outcry over conditions in the Congo from 1897 onwards.

Resistance through ritual

Resistance to colonial rule also took more direct forms, especially in regions remote from the main military centers. Many accounts record attacks on Europeans throughout the "scramble for Africa" period that were always presented as rank treachery but seem to testify better to colonial gullibility

or naiveté. Friedrich recorded one such incident in which the Sultan of the Massalits attacked a party led by Captain Fiegenschuh at a peace conference in 1910: "The Sultan rode to meet Captain Fiegenschuh, accompanied by hundreds of his warriors, as is customary in a friendly reception. The too-confiding Captain took this as a sign of peaceable intentions, never suspecting treachery. The Massalits hurled themselves upon the astonished Frenchmen, whose weapons were not even loaded, and cut them to pieces" (Friedrich 1913: 48).

In the more policed areas of the region such direct action was not possible. Resistance instead came to center on a remarkable type of object, the Kongo *minkisi* (singular *nkisi*). *Minkisi* were power objects that, when called upon by a skilled operator, the *nganga*, would intervene on behalf of the supplicant against his or her enemies or evil spirits (Figure 4.9). Europeans characterized these and other African religious objects as "fetishes," by which they meant inanimate objects that have powers of their own. Wyatt MacGaffey exhorts us to "remember that 'fetish' is an entirely European term, a measure of persistent European failure to understand Africa" (MacGaffey 1993: 32). These extraordinary complex figures defy the usual descriptive categories for they were the result of the transculture process, creating a striking new cultural form. The skill with which they are made and the visual power they present obviously qualifies them to be considered as art, but the practical and religious uses to which they were put also implies that were ritual objects and a part of everyday life. Nails were driven into the figure as an injunction for it to carry out the mission that the client was seeking to accomplish. When activated by the appropriate medicine and rituals, the *nkisi* was able to invoke the powers of the dead against hostile forces, whether illness, spirits or individuals, and to interact with the forces of nature. It is clear from the great numbers of *minkisi* made in the colonial period and the care with which the colonizers sought to destroy or remove them that both Africans and Europeans thought these power figures were an effective part of the resistance to colonialism: "*minkisi* were important components of African resistance. The destruction of these objects was also justified as part of the eradiction of 'heathen' religions and the missionary effort to spread the 'civilizing' influence of Christianity. Missionaries burned *minkisi* or carried them off as evidence of a paganism destroyed; military commanders captured them because they constituted elements of an opposing political force" (MacGaffey 1993: 33). The Belgians understood that removing the *minkisi* was a necessary military action, as the curators of Belgium's Congo Museum in Tervuren explained:

> Generally intelligent, the fetish operators pursue anyone who crosses their designs with an inveterate hatred. The Europeans

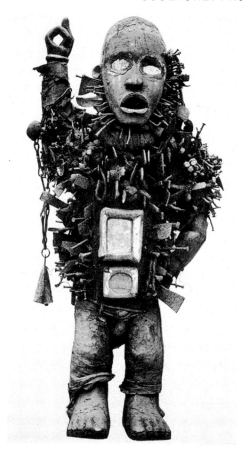

Figure 4.9 Nkisi Power Figure

are the particular object of their hostility. If our compatriots relent-
lessly pursue them to prevent their misdeeds, for their part, the
fetishists return in hate and perfidy all the damage done to their illicit
industry. Many rebellions, crimes against Europeans, and outrages
against authority are due to this hostility. The fetishists understand
that the reign of civilization introduced to the Congo by the Belgians
is the signal for the ruin of their prestige and their disappearance.
Thus they never let any occasion to intrigue against the whites pass.

(Notes 1902: 169)

In this text, anthropology quickly becomes identical to colonial authority.
Anthropologists and colonial officials alike pursued the *minkisi* because they

represented a new mode of everyday life (that the Belgians termed an "industry") for Africans under colonial rule. Furthermore, they could not deny that some *ngangas* did have a "real mysterious power" that was directly opposed to colonial rule. The very existence of the *minkisi* allowed Africans to imagine themselves as subjects within the colonial system rather than merely its servants or objects.

The care with which these missions to eliminate the *minkisi* were carried out means that there are significant numbers of *minkisi* in European museums. The collector Arnold Ridyard explained, "the Portuguese and French governments are taking these Fetishes away by force as they stop the trade of the country" (MacGaffey 1993: 42). Here Ridyard is referring to the worry that the *minkisi* were enabling Kongo peoples to resist producing rubber, ivory and the other colonial products needed by the Belgians. An especially frequent figure in such colonial collections is the *nkisi Kozo*, representing a double-headed dog (see Figure 4.10). As dogs were key to the hunt, Kozo was an especially powerful *nkisi*. Furthermore, he has two heads to represent the Kongo belief in the ability of dogs to see both the land of living and that of the dead, metaphorically understood as the village and the forest. This doubled vision of Kongo was unavailable to the colonizers and represents a way of looking back at the colonial gaze represented by the photograph. It was not simply a stereoscopic vision but a way of seeing that was more than ordinarily human, able to see forwards and backwards at once. The *minkisi* were not relics of archaic religions but a means of organizing resistance to colonial culture and creating an alternative means of representing reality for the colonized. It was not for nothing that the Belgians named them an "industry," for it was a productive and organized

Figure 4.10 Nkisi Kozo

social structure that enabled the colonized to think of themselves as subjects and not merely objects.

It was common for *minkisi* to have pieces of European cloth fixed to them, indicating the target for the spirits, or even be equipped with a gun to help the struggle against the colonizers (MacGaffey 1993: 98–100). Some carved figures are known that represented either Africans dressed in European clothing or Europeans (Notes 1902: pl. LIII) – see Figure 4.11. The difficulty we now have in classifying these particular figures is a good indication of the limitations of the taxonomic gaze. A sculpture of a man wearing European clothing pouring a drink from a bottle into a glass is a good example. For the curators of the Congo Museum, it was clear that the clothing was European, as was the man himself, while the dog was Congolese (Notes 1902: 293). These judgments are hard to support from the visual evidence. The man's hair seems to be a stylized representation of African hair but none of his features conform to Western stereotypes of the African. He may of course be the child of one European and one African parent (see chapter 6). His clothes are Western in style but a curious fusion of what looks like an eighteenth-century jacket with modern trousers and shoes, the whole topped off with a remarkable hat that has aspects of the top hat but with unusual decoration. The museum curators discovered traces of what they termed "magic substances" in the hat of this and other similar hybrid figurines. Just as the top hat was a symbol of authority for European men, often replaced by the pith helmet in Africa, so too was the hat a location of power in these Kongo figurines. At this distance, we should not be drawn into the anthropological game of trying to determine their "real" ethnic type. Rather this figure attests to the transcultural complexities of the colonial Congo.

For the *minkisi* are not what they might at first appear. To Western eyes, these objects may seem almost uniquely "African," wholly drawn from another culture than that of the EurAmerican tradition. Indeed, an *nkisi* figure served as the frontispiece for the catalog of the *Primitivism in 20th Century Art* exhibition (1984), presumably because it was seen as a dramatic example of the exotic primitivism that was held to influence modern artists with its authentic power (see Introduction). However, not only do the *minkisi* derive their meaning and function from the interaction with colonizers of the Scramble period, but their distinctive style may owe something to a much earlier contact with Europeans. Even the Belgian authorities recognized that "incontestably there are notions of obscure European provenance in the fetishist ideas of several Congo peoples" (Notes 1902: 147). Anthony Shelton has suggested that the use of nails to invoke certain *minkisi* may derive from the Christian imagery of the fifteenth century: "The origins [of

Figure 4.11 European figures

the *minkisi*] . . . remain enigmatic, but is probable, though historically unproven, that they emerged from a synthesis of Christian and Kongo beliefs." An especially close parallel can be seen in the fact that "images of the pierced body resulting from the martyrdom of saints or the crucifixion of Christ have dominated Christian iconography" (Shelton 1995: 20). Christian images had been retained by Kongo chiefs despite the decline in Christian beliefs, as the cross could easily be assimilated as a cosmogram. The striking confluence between medieval Christian iconography and the *minkisi* figures suggests that the pierced body image was transculturated – that is to say, the image was acculturated in Kongo during the Christian period, deculturated as Christian observance diminished and given neo-cultural form in the *minkisi*.

Cultural memory

After the Second World War, African peoples began to demand and achieve independence from the European powers that had all been exhausted by six years of conflict. Africa at once became a chessboard in the complicated game that was Cold War geopolitics. In 1960, the Belgian Congo became the independent nation of Congo under the presidency of the radical Patrice Lumumba. His regime was soon challenged by rebel forces, leading to a desperate civil war with Cold War overtones. A series of reports in *Life* magazine from the key months of February, March and April 1961 show how the West continued to depict the Congo as the heart of primitivism, while also continuing to be disturbed by the power of the *minkisi*. In February 1961, the civil war reached a turning point with the assassination of Lumumba, as *Life*'s lead story reported: "Anarchy, armed and uncompromising, ranged the land and ruled it. Four provincial Congolese armies fought among themselves, seemingly without knowing why. New-made nationalists reverted to tribesmen again and took the vengeance of old hates." The only innocents in this conflict were children, depicted as the "victims of the deepest tragedy of the Congo, they were the deathly [sic] harvest of an anarchy which called itself freedom" (*Life* February 17, 1961). Such reporting depicts the Congolese as simple primitives, dressed up as nationalists by "the Communists," whose child-like actions end up hurting their own children most of all.

One week later, the geopolitical implications of the Congo crisis made the front page as the "U.N.'s Gravest Hour." The reporting took on a hysterical edge as global protest against the murder of Lumumba reached the United Nations itself. Readers were reminded that Lumumba was a "communist pawn . . . [whose] fiery speeches against the colonial nations made him an international symbol of black men's anger at long years of white exploitation." Photographs showed the response to his death around the world as a "spectacular, global onslaught" culminating with a demonstration at the United Nations. One shot of well-dressed Congolese in Paris protesting the assasination of Lumumba in 1961 was captioned as an "anti-colonialist riot." Photographs showing African-Americans taking the same protest to the United Nations were described as showing "U.S. Negro extremists" on the rampage, who "intended to foment black anger against the white race" (*Life* February 24, 1961). Now the fear was that African nationalism could spread to African diaspora peoples in the West, especially the United States. Just as the Belgians interpreted anti-colonial activism as genocidal war against whites, so the *Life* photo-essays presented the protests surrounding Lumumba's death as a global African-Communist conspiracy against white

people. With hindsight, it seems almost comical but the stakes at the time seemed very high. It is important to note that another view of the Congo was possible. In the Ghanaian version of the multi-racial South African magazine *Drum*, a 1961 photograph by Christian Gbagbo showed the con-quest of the Congo not by primitivism but by the West African music highlife. Gbagbo's picture showed Ghanaian soldiers from the United Nations peacekeeping force and Congolese civilians mixing happily (*In/sight* 1996: 226). The dance hall was a modern structure, with plaster relief on the ceiling, electric light and amplification – a marked contrast with Western depictions of the primitivism of the Congo. No such representation of Congolese modernity ever appeared in *Life*.

The new African nations now formed the largest bloc at the United Nations, one that appeared to be lending its support to the Soviet Union. Western media depicted Africa as still in the thrall of superstition and therefore incapable of rational politics. Under a banner headline declaring "black magic [to be] a vital force in new African nations," *Life* journalist Robert Coughlan pronounced in April 1961: "what goes on in the African mind is an important matter – and we must realize that it may not be the product of logical reasoning or even of the operation of physical laws as they are understood in the West. Instead, it is fairly often the product of magical influences." Alongside this text, as if to prove the point, the reader was confronted with a large, out of focus photograph of an *nkisi* figure captioned as "fetish figure used by African sorcerers who jab nails into it to put curse [sic] on their enemies." The threat that such "sorcerers" represented to whites in Africa was depicted in terms very similar to those used by the Belgians 60 years previously: "Now and again . . . one of these messiahs decides he has received a divine appointment to drive the white men out of Africa. Some of the present antiwhite violence in the Congo is the legacy of such a sect, the Kitawala Society, which the Belgians tried to suppress years ago but which smoldered on in the jungle villages and helped nurture Congolese nationalism." Coughlan attempted to bolster his argument with citations from Freud's *Totem and Taboo*, the famous anthropologist Sir James Frazer and the *Economist*. Nonetheless his piece claims that "near Patrice Lumumba's home territory," Congolese had recently "killed and partially eaten" thirty-four people. The reason for such outbreaks was that given for the original imposition of colonialism, except in reverse: "With the end of white colonialism, the laws that hemmed [magic] in are being weakened, either as a matter of policy on the part of the new governments, or by being slackly enforced, or both" (Coughlan 1961). Just as the Belgians had justified their colonial policy by their supposed ending of cannibalism and the spread of Christianity, now American intervention in the Congo was being justified

on the same grounds. It was only evoked by implication: "A traditional method of exorcising the spirits has been to kill white hens; a more direct method can be left to the imagination." Certainly Western imaginations were working overtime, but this situation is a clear example of Appadurai's assertion that the imagination has become a social practice in the modern world. For such fears of African "magic" leading to attacks on whites, transposed onto the global scale of the Cold War, underpinned Western support for the long dictatorship of Joseph Mobutu, later known as Mobutu Sese Seko, in Congo. Ironically, Mobutu enacted an Africanizing policy, renaming the country Zaire and claiming to adopt a wide range of indigenous practices, while maintaining power principally because of his solid anti-Communism. Yet when Laurent Kabila's forces were on the point of liberating Kisangani in 1996, the *New York Times* once again reported that his soldiers' success could be attributed to the power of magic, making them believe they were impervious to bullets.

At the same time, it was common for such depictions of the primitivism of the Congo to be directly compared to Western culture. Conrad's old fear that the heart of darkness really lay in London, not Africa, was as long lived as the anthropological depiction of the Congo as the home of black magic. For example, the British newspaper the *Observer* reported in 1964 that: "In the Congo, Hell's Angel types are burning the missions . . . These groups have from three to seventy members whose ages range from fourteen to twenty . . . Their leader, Pierre Mulele, is said to have studied guerilla warfare in Egypt and China. He used to be close to Patrice Lumumba, the head of the Congolese government who was assassinated in 1961. The groups of youths are profoundly superstitious. They speak constantly of miniature airplanes in which their leaders travel at night and which can instantaneously transport a man from one location to another." The article thus associates disaffected Western youth culture with African freedom movements, who are in turn seen as both Communist and under the sway of magic. Once again, the attack on white Christians is the outrage that needs reporting. Nonetheless, in the *Observer*'s view, the Congolese youth "merit comparison with the discomfort that afflicts youths under twenty all over the world." The anthropologist-reporter seems unable to decide whether the Mulelists should be classified as Africans – hence local and primitive – or as "youth" – hence global and merely confused. In short, despite the century-old attempt to classify the Congo as the remotest point on the ladder of cultural evolution from the European heights, Kongo and Western peoples have in fact been engaging in transcultural exchange for half a millennium, creating a modernity that came to look very much like a prototype of what has become known as postmodernity.

New visions from the Congo

In postcolonial visual culture, Congolese and African diaspora artists have sought to reclaim the Kongo visual tradition and use it to directly criticize Western culture. It is now the "Western tradition" that is finding itself subject to the disruptive and unpredictable forces of transculture. In a remarkable series of work, the African-American artist Renée Stout has explored the *nkisi* figure as a resource for her own experience. She recalls seeing an *nkisi nkondi* figure in the Carnegie Museum in Pittsburgh at the age of ten: "I saw a piece there that had all these nails in it. And when I first saw that one it was like I was drawn to it. I didn't really know why. . . . Even when I go home, I still go back to that piece and look at it each time, because I feel like I'm coming back with a little more knowledge each time" (Harris 1993: 111). Perhaps the most striking result of this fascination with the *nkisi* figure has been Stout's transformation of her own body into an *nkisi* in her sculpture *Fetish No. 2* (1988). Stout modeled the figure on her own body but gave it the attributes of an *nkisi* figure and a title that a Western ethnographic museum might bestow on such an object. By making the female body the source of power, Stout creates a resonant image suggestive both of African-American feminism and the difficult lives of Kongo women during the Scramble period. This echo is given further force by the contents of the medicine compartment placed in the figure's stomach. Like some Kongo *minkisi*, the compartment is a box under glass containing an old photograph of a baby, an old stamp from Niger and some dried flowers. The baby's photograph recalls the hybrid children born in Kongo during the colonial period and their uncertain fate. The stamp evokes the African diaspora but also the European practice of sending postcards home depicting "native" life. The flowers and the medicine-filled bundles (*bilongo*) around her neck recall the practice of activating the power figure as a resistance to colonialism. For much of Western history, the black woman's body has evoked only the fears and desires of sexuality. Stout does not repress the sexuality of her figure but does not accent it. She concentrates instead on reclaiming her body as a source of power, using a Kongo practice that is well-suited to such resistance.

Similarly, the Congolese artist Trigo Piula uses the *nkisi* figure to reverse the terms of the discussion on fetishism. In his 1988 painting *Ta Tele*, Piula visualizes this strategy by depicting an African audience staring at an *nkisi* figure (see Figure 4.12). Where the medicine compartment would ordinarily be, he places a television screen, showing a duplicate image of the figure's head. Behind the power figure, a range of screens depict a chat show, a soccer match, a view of Paris featuring the Eiffel Tower, a beer commercial,

a white couple kissing, a table laden with food and a view of the Earth from space. These sights create desires in the audience, visible as outlined objects in their heads, as if we can read their thoughts. Different individuals aspire to cars, a meal, love, clothing, a drink, while others keep the space blank, waiting for desire to strike. Piula's work suggests that the Western obsession with consumer goods is the real fetishism that has affected Africa, not some spurious religion. In his theory of capitalism, Karl Marx named this obsession "commodity fetishism," the belief that by buying a certain object, the consumer can change his or her life in some important way. In the advertising-saturated culture in which we live, it is clear that commodity

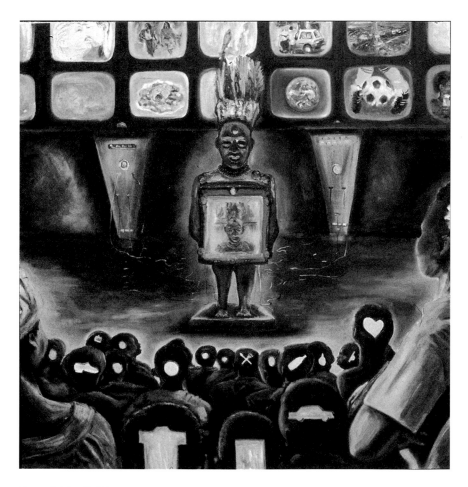

Figure 4.12 Ta Tele

fetishism holds a far greater sway than the users of Kongo power figures could ever have imagined.

Cheri Samba, the Congolese painter, has made this return of the Western gaze by postcolonial Africans the center of much of his work. Samba began his career as an urban artist in Kinshasa, painting murals and other forms of public art. His reputation became such that his work became sought after by Western dealers and *Les Magiciens de la Terre* (The Magicians of the Earth) was featured in the 1989 Paris exhibition (Jewsiewicki 1991: 130–51). As this title suggests, the curators continued to place African art under the heading of fetishism, or magic, rather than as contemporary art. Samba responded by making criticism of the West, especially Paris, a feature of his art. Many Central African people now live in Paris and it is the global center for recording soukous and other popular African music. At the same time, the French government continues to regard sub-Saharan Africa as its sphere of influence and the racist National Front, campaigning on its slogan of "France for the French," recently won around 15 percent of the vote. Samba replies to such hostility in his painting *Paris Est Propre* (1989). It shows a fantasy view of Paris at night, again centering on the Eiffel Tower, flanked by the Palais de Chaillot (Trocadéro), home of the Musée de l'Homme where Picasso was inspired to create his *Demoiselles d'Avignon*. In the foreground, three African men work cleaning up litter and dog excrement. Middle-class Parisians had a craze for large dogs in the 1980s, both for protection from street crime and as a fashion accessory. Samba's text highlights the consequence: "Paris is clean [*propre*]. Thanks to us, the immigrants who don't like to see dog's urine and droppings. Without us, this town would probably be a slagheap of droppings." The title has a double meaning as *propre* can mean clean or honest. The Parisians own dogs to protect them from crimes allegedly perpetrated by African immigrants, yet it is these same immigrants who keep the city from being deluged by the animals' by-products. There are metaphorical meanings at work here as well. Paris is often referred to as the City of Light, emphasized in the brightly-lit buildings, while the Africans from the Dark Continent seem to be placed in the shadows. Samba's painting directly challenges these Western metaphors of divided space and culture to face the reality of an inter-connected and interdependent global culture.

Another of Samba's works asks us to look at Paris as if from Kinshasa, reversing centuries of European inventions of Africa. *Souvenir d'un Africain* (An African's Recollection) shows a scene in a Paris métro station with two Europeans embracing in the foreground. The African of the title stands further down the platform. In contrast to the casual clothes of the Europeans, he is smartly dressed in the fashionable *sapeur* style adopted by

many Africans in Paris. His thoughts appear in the caption: "Why don't these people in the Occident have any shame? Everywhere I go, it's always the same and it always ends like this. It never amounts to anything. What lousy aphrodisiac do they drink that helps them not to get excited?" African sexuality was of course the subject of intense European curiosity and exploration throughout the colonial period. Now Samba reverses that gaze with results that may make Westerners feel uncomfortable. The sexual revolution of the 1960s, for all its faults, seems to many people to have made a real gain in allowing public expression of affection and in moving towards more casual dress for both sexes. The African in this painting sees both developments as failures and, in a direct reference to so many travel and anthropological accounts, highlights what he sees as their lack of appropriate morality. Here Paris is far from *propre*. As the example of these artists shows, it is no longer a question of transculture operating only in the "periphery" of the formerly colonized nations but of its triangulating effect throughout the world. It is perhaps not surprising that some of the most original efforts to represent this striking new viewpoint come from the postcolonial nations and diaspora peoples within the former colonial powers. The experience of dislocation and fragmentation associated with post-modernism in the West has in fact been anticipated in the so-called periphery. As Stuart Hall, the cultural studies theorist, puts it: "Now that in the postmodern age, you all become so dispersed, I become centered. What I've thought of as dispersed and fragmented comes, paradoxically, to be *the* representative postmodern experience." In the era of global diaspora and interconnection, all culture is transculture.

Note

1 While some anthropologists still maintain that cannibalism was practised by some peoples, there seems no incontrovertible evidence of this to outweigh the centuries of prejudice. It may be possible that symbolic consumption of specific body parts took place in warfare. The Christian Crusaders were among those thought to have participated in such cannibalism.

Bibliography

Benítez-Rojo, Antonio (1996), *The Repeating Island: The Caribbean and the Postmodern Perspective*, Durham, NC, Duke University Press.
Bhabha, Homi (1994), *The Location of Culture*, London, Routledge.
Clifford, James (1988), *The Predicament of Culture: Twentieth Century Literature, Ethnography and Art*, Cambridge, MA, Harvard University Press.

Coquilhat, Camille (1888), *Sur Le Haut Congo*, Paris, J. Lebègue.

Coughlan, Robert (1961), "Black Magic: Vital Force in Africa's New Nations," *Life* 50 (16) April 21.

Fabian, Johannes (1983), *Time and the Other*, New York, Columbia University Press.

Fausto-Sterling, Anne (1995), "Gender, Race and Nation: The Comparative Anatomy of 'Hottentot' Women in Europe, 1815–17," in J. Terry and J. Urla (eds), *Deviant Bodies*, Bloomington, Indiana University Press.

Foucault, Michel (1986), "Of Other Spaces," *Diacritics* 16.

French-Sheldon, M. (1892), *Sultan to Sultan: Adventures among the Masai and other Tribes of East Africa*, Boston, MA, Arena.

Friedrich, Adolphus (1913), *From the Congo to the Niger and the Nile*, London, Duckworth.

Fusco, Coco (1995), *English is Broken Here: Notes on Cultural Fusion in the Americas*, New York, New Press.

Gilroy, Paul (1993), *The Black Atlantic: Modernity and Double-Consciousness*, Cambridge, MA, Harvard University Press.

—— (1991), *"There Ain't No Black in the Union Jack": The Cultural Politics of Race and Nation*, Chicago, IL, University of Chicago Press.

Harris, Michael D. (1993), "Resonance, Transformation and Rhyme: The Art of Renée Stout," in MacGaffey (1993).

In/sight (1996), *In/sight: African Photographers, 1940 to the Present*, New York, Guggenheim Museum.

Jewsiewicki, Bogomil (1991), "Painting in Zaire," in Susan Vogel (ed.), *Africa Explores: 20th Century African Art*, New York, Center for African Art.

Kaplan, Amy and Pease, Donald E. (eds) (1993), *Cultures of United States Imperialism*, Durham, NC, Duke University Press.

MacGaffey, Wyatt (1993), *Astonishment and Power*, Washington, DC, National Museum of African Art.

—— (1995), "Kongo Identity, 1483–1993," *South Atlantic Quarterly* (94: 4), Fall.

Mesquita, Ivo (1993), *Cartographies*, Winnipeg, Winnipeg Art Gallery.

Michaud, Eric (1996), "Nord–Sud: Du Nationalisme et du Racisme en Histoire de l'Art. Une Anthologie," *Critique* March: 163–87.

Mirzoeff, Nicholas (1995), *Bodyscape: Art, Modernity and the Ideal Figure*, London, Routledge.

Mudimbe, V.Y. (1988), *The Invention of Africa: Gnosis, Philosophy and the Order of Knowledge*, Bloomington, Indiana University Press.

Notes (1902), *Notes Analytiques Sur les Collections Ethnographiques du Musée du Congo*, Brussels, Annales du Musée du Congo.

Ortiz, Fernando (1947), *Cuban Counterpoint: Tobacco and Sugar*, New York, Knopf.

Pakenham, Thomas (1991), *The Scramble for Africa*, New York, Random House.

Renan, Ernst (1990), "What is a Nation?", in Homi Bhabha (ed.), *Nation and Narration*, London, Routledge.

Rowlands, Michael (1995), "Njoya's Throne," in Christopher Pinney et al., *The*

Impossible Science of Being: Dialogues between anthropology and photography, London, Photographers' Gallery.

Schildkrout, Enid (1993), *African Reflections: Art from North-Eastern Zaire*, New York, American Museum of Natural History.

Shelton, Antony (1995), "The Chameleon Body: Power, Mutilation and Sexuality," in his *Fetishism: Visualizing Power and Desire*, London, South Bank Centre.

Shohat, Ella and Stam, Robert (1994), *Unthinking Eurocentrism: Multiculturalism and the Media*, London, Routledge.

Stocking, George (1987), *Victorian Anthropology*, London, Free Press.

—— (1988), *Bones, Bodies, Behavior: Essays on Biological Anthropology*, Madison, WI, University of Wisconsin Press.

Thompson, Robert Farris (1983), *Flash of the Spirit: African and Afro-American Art and Philosophy*, New York, Random House.

Wollaston, A.F.R. (1908), *From Ruwenzori to the Congo*, London, John Murray.

SEEING SEX

S EXUALITY DISRUPTS. If culture is often presented as a discrete object, a seamless web of social relations, sexuality is the loose end that undoes the garment. The coexistence of culture with power necessarily evokes the modern preoccupation with gender, sexuality and "race." Rather than seeing sexuality as a means of constituting identity, it can instead now be described, in Kobena Mercer's phrase, "as that which constantly worries and troubles anything as supposedly fixed as an identity" (Mercer 1996: 119). While the categories of gender and sexuality were enormously creative ways to conduct new cultural research in the 1970s and 1980s, their continued instability is leading towards new definitions of culture itself. For the personal and cultural functions of gender and sexuality do not cohere into a stable pattern. Indeed, given that these categories mark some of the most fundamental distinctions within humanity, it is remarkable how often their definitions have changed in the modern period. In this chapter, I shall look at ways in which Western culture has sought to visualize gender and sexual distinctions, while at the same time creating phantasmatic ways of looking that are in themselves constructed by gender and sexuality. In what I call the fetishism of the gaze, what is perceived is never exactly the same as what is there in a material sense. Nowhere is this failure of the classificatory gaze more apparent than where it matters most in this field, the sight of the sex organs themselves, of reproduction and its offspring.

Fetishizing the gaze

It is a curious fact that the two most important psychoanalytic theories of looking, namely fetishism and the gaze rely on the viewer's misrecognition of what he or she sees (especially he). In his 1927 essay on "Fetishism," Sigmund Freud sought to account for the fact that numerous men could only achieve sexual gratification via a specific material object that he called the fetish object, such as fur or velvet. By using the colonial term "fetish," created by Europeans to (mis)describe African ritual objects such as the *minkisi* described in the previous chapter, Freud immediately created an overlap between race and sexuality to which we will return later. In Freud's view, the fetish is always a penis-substitute: "To put it plainly: the fetish is the substitute for the woman's (mother's) phallus which the little boy once believed in and does not wish to forego." The little boy had believed that his mother possessed a phallus just as he did, until at some point he becomes aware that her genitals are different from his, that she lacks a penis. There is an obvious threat: "if a woman can be castrated then his own penis is in danger." The boy is both aware of what he has seen and denies it: "He retains this belief but he also gives it up." The fetishist displaces his belief in the female phallus onto the fetish object, "possibly the last impression received before the uncanny traumatic one." While relatively few men actually become clinical fetishists, this trauma is universal: "Probably no male human being is spared the terrifying shock of threatened castration at the sight of the female genitals. We cannot explain why it is that some of them become homosexual in consequence of this experience, others ward it off by creating a fetish and the great majority overcome it" (Freud 1959). There are then three possible outcomes from the moment of (mis)recognition: heterosexuality, homosexuality or fetishism.

Fetishistic viewing is not limited to the neurotic fetishist but can be said to be a critical part of everyday visual consumption. The disavowal of the fetishist is not absolute. As phrased by Octave Mannoni, it is better expressed as "I know . . . but nonetheless" [Je sais . . . mais quand même]. In the fetishistic gaze, reality exists but has the viewer's desire superimposed over it. It is in this way that we casually accept film and photography as "realistic," while being fully aware of their conventionality. For example, in the opening sequence of a film, we scan the crowd of figures seeking the "star," so that we know where to concentrate our attention. That search does not disrupt the film's illusion but rather is part of our active suspension of disbelief. A key part of everyday looking consists in this ability to keep two incompatible approaches in play at once. The recent hit horror films *Scream* and *Scream II* have made subverting our expectations in the

horror genre central to their enjoyment. In *Scream*, for example, the most famous actress in the cast, Drew Barrymore, is killed in the opening minutes of the film (Figure 5.1). As the serial killers go on the rampage, the characters joke that leaving the room alone would lead to their death in a horror film – only to be killed leaving the room alone.

In later Freudian analysis, looking has been reconceptualized as the gaze, taking a still more central position in the formation of gender identity. The gaze is not just a look or a glance. It is a means of constituting the identity of the gazer by distinguishing her or him from that which is gazed at. At the same time, the gaze makes us aware that we may be looked at, so that this awareness becomes a part of identity in itself. In Jean-Paul Sartre's example, one may look through a keyhole without any awareness of self, but if footsteps are heard in the hall: "I see *myself* because *somebody* sees me." Sartre's existential theory involving a Self and an Other was internalized in Freudian terms by the psychoanalyst Jacques Lacan: "the gaze is outside, I am looked at, that is to say, I am a picture." Lacan placed the gaze at the center of the formation of the ego in his famed mirror stage. In the mirror stage, the infant learns to distinguish between itself and the (mother's) image by becoming aware of sexual difference. As a result the subject is split, as Carole-Anne Tyler explains: "The subject can never reconcile the split between itself and its mirror imago, the eye which sees and the eye which

Figure 5.1 Drew Barrymore in *Scream*

is seen, the I who speaks and the I who is spoken, the subject of desire and the subject of demand, who must pass through the defiles of the Other's signifiers" (Tyler 1994: 218). When I see myself in the mirror, I can never see the Ideal "I" of the imaginary but only the Symbolic "I."

The infant becomes able to visualize its body as being separate from that of the mother because it becomes aware of the mother's desire for something else. This something is lacking in both mother and child. Lacan calls it the Name of the Father, insisting that it is a linguistic and legal function rather than the real father – who may be absent or otherwise implicated in the child's primary identification – that is meant. Thus, the gaze brings into being that which says "I" and names itself as either male or female, that is to say, the subject or self. These subjects – the gaze and the subject of representation – exist only in relation to each other and combine to form the image/screen, or what is perceived. In this split field of vision, the phallus comes to represent that which divides and orders the field of signification, or the gaze. For Lacan the phallus is a phantasm that the penis comes to represent "because it is the most tangible element in the real of sexual copulation, and also the most symbolic." As Lacan himself pointed out, the penis itself becomes a fetish in this conveniently circular argument, in which the penis is the phallus because of its apparent capacity to be all things at once. In Lacan's analysis, there is no existence that is not fetishistic.

Lacan's scheme was highly controversial in clinical psychoanalysis but has become widely adopted in visual culture studies, especially film criticism. This mode of interpretation was especially associated with the British film journal *Screen* that published a now celebrated essay theorizing visual experience in Lacanian terms by film critic Laura Mulvey in 1975 (Mulvey 1989). She analyzed the operations of visual pleasure in classic Hollywood cinema, arguing that the "paradox of phallocentrism . . . is that it depends on the image of the castrated woman to give order and meaning to its world." It is the woman's lack of the phallus, or symbolic castration, that initiates the formation of the ego and a signifying system that nonetheless excludes women. While the male hero initiates action, "women are simultaneously looked at and displayed, with their appearance coded for strong visual and erotic impact so that they can be said to connote *to-be-looked-at-ness*." Nonetheless, female characters still evoked the specter of castration that needed to be controlled. The woman may be punished in the film to overcome the threat in a sadistic form of voyeurism, or it may be disavowed by fetishism. Just as Mulvey sees castration anxiety as being at the heart of cinematic pleasure, Freud regarded fetishism as clear proof of his theory that men are haunted by the fear of castration, while women are marked by their lack of the phallus. Both formations derive from early visual experience that

causes the infant to adopt a specific view of what she or he has seen, whether of denial, assimilation or displacement. Fetishism led Freud to conclude that even when a "very important part of reality had been denied by the ego," the result was not necessarily psychosis but merely everyday neurosis. From a psychoanalytic standpoint, reality is in the eye of the beholder.

Lacan's reading of psychoanalysis, which privileges the gaze, has obvious affinities with a reading of cinema as an apparatus for the control of the look. In Mulvey's analysis, the visual pleasure of cinema became a suspect category open by definition only to men. It was to be challenged by the deliberately difficult work of avant-garde cinema, whose goal was "to free the look of the camera into its materiality in time and space and the look of the audience into dialectics, passionate detachment." This austere prescription has failed to win over mass audiences who have continued to prefer the stylized cinematic styles of Hollywood, Bombay and Hong Kong over alternative cinema. Looking back on her essay in 1989, Mulvey herself now felt that: "The polarisation only allows an 'either/or.' As the two terms (masculine/ feminine, voyeuristic/exhibitionist, active/passive) remain dependent on each other for meaning, their only possible movement is inversion. They cannot be shifted easily into a new phase or new significance. There can be no space in between or outside such a pairing" (Mulvey 1989: 162).

Indeed, perhaps the most striking aspect of both fetishism and the gaze as systems of analysis is the way in which women are systematically excluded. Both Freud and his French disciple Lacan agreed that there was no such thing as female fetishism (Apter 1991: 103), for the entire psychic mechanism revolved around the real penis and the fear of castration. As part of becoming a woman in the Freudian scheme was abandoning the infant desire to possess the phallus or to be the phallic mother in favor of a passive femininity, marked by the switch from clitoral to vaginal sexuality, there was no corresponding system for women. In the Lacanian system, woman is similarly defined by lack, by her inability to possess the phallus, inevitably excluding her from the signifying system. Feminists have taken this elision of women to indicate that the psychoanalytic binary opposition between male and female was in fact no more than a recasting of sex as being always and already masculine. In this view, there is no such thing as the female sex because the entire system is devised around and for men. In Luce Irigaray's celebrated essay "This sex which is not one," she declares that: "Female sexuality has always been theorized within masculine parameters. Thus the opposition between 'virile' clitoral activity/ 'feminine' vaginal passivity which Freud – and many others – claims are alternative behaviors or steps in the process of becoming a sexually normal woman, seems prescribed more by the practice of masculine sexuality than by anything else" (Irigaray 1985: 99).

From inversion to opposites and ambiguity

Both Freud's theory of fetishism and Lacan's account of the mirror stage take as their origin the primal male moment of recognition that the female genitalia are different. Perhaps it was no coincidence that Lacan owned Gustave Courbet's scandalous oil painting of the female sex, entitled *The Origin of the World*, which hung in his consulting room as if in testament to the centrality of this visual experience. Although the biological difference between men and women might appear "obvious," there have been and continue to be sharp changes in the way the human reproductive system is believed to operate. These changes in the interpretation of biological sex have extended repercussions. In the first instance, they challenge the assumption that sex is natural, while gender is a social construction. The modern logic of sex, gender and sexuality – that biological sex predicates gender which in turn dictates the choice of the opposite gender as a sexual partner – turns out to be a castle built on sand. However, taking sex to be a cultural category poses as many questions as it answers.

Early modern Western medicine had interpreted classical theories of reproduction to generate a one-sex model of the human species. In this view, the sexual organs were essentially the same in men and women, only inverted so that what was inside the woman was outside the man. Yet in Thomas Lacquer's account "[b]y around 1800, writers of all sorts were determined to base what they insisted were fundamental differences between the male and female sexes, and thus between men and women, on discoverable biological distinctions" (Lacquer 1990: 5). The evident biological inaccuracies in the ancient account led to a total transformation, not only of biological interpretations of physiology, but of the social roles accorded to each gender, as stated baldly by the French biologist Isidore Geoffroy Sainte-Hilaire in 1836: "The laws of all nations admit, among the members of the society they rule, two great classes of individuals based on the difference of the sexes. On one of these classes are imposed duties of which the other is exempt, but also accorded rights of which the other is deprived" (Epstein 1990: 128). This shift to what Lacquer calls a "biology of incommensurability" had profound implications for sexual practice as well as classification. Early modern society held that unless they experienced orgasm, in the words of one popular text, "the fair sex [would] neither desire nuptial embraces, nor have pleasure in them, nor conceive by them" (Lacquer 1990: 3). Here the last is perhaps the most important: if it was believed that female orgasm was an indispensable condition to conception, then no man could afford to ignore it. Nineteenth-century medicine observed that female pleasure was not in fact essential to reproduction

and the disciplinary society was free to regulate feminine sexuality as being deviant if it centered on clitoral rather than vaginal pleasure.

In the new two-sex system, it was obviously of the greatest importance that men and women form clearly distinguishable categories. Lesbians and gay men, transvestites, and persons of indeterminate sex challenge the absolute nature of the binary opposition. It was therefore no coincidence that an intense investigation of all these people began in the mid-nineteenth century. Although people of intersex— so-called hermaphrodites—have been recognized since antiquity, this period saw a determined social and medical effort to eliminate all such ambiguity. One remarkable case was that of Herculine Barbin who was raised as a girl in convent schools. However, once she began a romantic liaison with another woman, she was determined to be legally male in 1860. After a few years living in Paris during which time s/he wrote an autobiography, s/he committed suicide in 1868. This text was rediscovered and published by Michel Foucault in 1978, and has been the subject of a remarkable number of competing interpretations, seeming to confirm Barbin's gloomy anticipation of her death: "When that day comes a few doctors will make a little stir around my corpse; they will shatter all the extinct mechanisms of its impulses, will draw new information from it, will analyze all the mysterious sufferings that were heaped up on a single human being; O princes of science, enlightened chemists . . . analyze then if that is possible, all the sorrows that have burned and devoured this heart down to its last fibers" (Barbin 1980: 103). Barbin asserts that the policy of making the absolute division between the sexes visible and open to medical analysis is doomed to failure.

A famous painting of the period seems to bear out her case. In 1875 the American painter Thomas Eakins depicted a well-known surgeon called Samuel D. Gross at work in Philadelphia (see Figure 5.2). Known as *The Gross Clinic*, the canvas shows Gross directing an operation while lecturing to students studying his methods. At first sight the painting is a display of the heroic mastery of modern medicine over the weaknesses of the human body. It depicts a treatment for osteomyelitis, or infection of the bone, a condition that is now manageable with antibiotics but was life-threatening in Gross' day. Eakins was himself well-informed about modern medicine, having studied with Gross himself and at the École de Medicine, Paris (Johns 1983: 48–68). It is then all the more surprising that there is no way of determining whether the patient is male or female. As Marcia Pointon argues, this "indeterminate gender is part of the condition in which this figure functions in the image as a fetish" (Pointon 1990: 50). The fetish here is the modern belief that the human body is absolutely legible and subject to one of two primary classifications by sex. Yet at the very heart of his homage

Figure 5.2 Thomas Eakins, *The Gross Clinic*

to modern medicine, Eakins, like the fetishist, admits to ambiguity even as he denies it. For all his attempts to be as realistic as possible, the artist opens up an ambiguity that undercuts one of the most fundamental notions of the real in the period. Nor could this ambivalence be more inappropriate than in a portrait of Dr Gross. In 1849 he had operated to castrate a child "regarded as a girl" who was found to have testicles. In an article on this procedure, Gross commented:

> A defective organization of the external genitals is one of the most dreadful misfortunes that can possibly befall any human being. There is nothing that exerts so baneful an influence over his moral and social feelings, which carries with it such a sense of self-abasement and mental degradation, . . . as the conviction of such an individual that he is forever debarred from the joys and pleasures of married life, an outcast from

society, hated and despised, and reviled and persecuted by the world.

<div align="right">(Epstein 1990: 121)</div>

Such intensity of feeling created a (male) gender identity for Gross' patient in Eakins' painting for the alternative would have been to question the realistic mode of representation itself. Despite the lack of visual evidence, the fetishistic gaze was able to "see" gender in the patient where it was in fact ambiguous.

The very creation of a standardized notion of the human implies the elision of many individual cases in order to sustain the overarching categories. In her historical survey of attitudes to people of indeterminate gender, Julia Epstein concluded:

> Gender is a historically and culturally relative category, and medical science has recognized the enormous plasticity of both sexuality and gender. Anatomical markers are not always determining. While medicine recognizes the flexibility of the continuum along which sexual differentiation occurs, that recognition has not resulted, as one might have postulated, in a necessary juridical accommodation of those who occupy minority spaces (which are, ironically, its midpoints) on the continuum.
>
> <div align="right">(Epstein 1990: 128)</div>

Thus the clarity of the classificatory principle overrides the existence of specific real people. Indeed, advances in surgery and medical diagnosis, such as genetic testing, now make it possible for "indeterminately gendered individuals" to be simply eliminated either by termination of such fetuses or by early surgical intervention.

Seeing female sex

The right of the medical profession to determine gender, and to restrict that choice to two possibilities, is now being challenged and is receiving a hearing. Since 1996 a group known as the Intersex Society of North America (ISNA) has received favorable media coverage in the United States for their campaign against such surgery. In Britain, questions were asked in the House of Commons of the new Labour government in 1997 over government policy concerning people of intersex. ISNA has entered into dialogue with the medical profession in an attempt to persuade practitioners that surgical intervention should not be used automatically, while recognizing that it may

be appropriate in individual cases. INSA defines intersex as "individuals born with anatomy or physiology which differs from cultural ideals of male and female." This formula regards a purely biological definition of sex as impossible. At the same time, it challenges ideas of culture as a received tradition that shapes identity. The cultural ideal of the perfect human body denies people of intersex the very right to exist. With one in a thousand live births being a person of intersex, this exception is far from insignificant. In pursuit of the cultural ideal of sex, roughly 2,000 girls a year in the United States have unusually large clitorises surgically removed, often causing loss of sexual feeling and psychological disorientation. The rule of thumb appears to be that any sexual organ longer than 2.5cm is retained and called a penis, while anything shorter is excised and rendered into a clitoris. Hormones and additional surgery are often used to finish the task. The fact that INSA refer to this practice as Intersex Genital Mutilation (IGM) shows that the issue touches a faultline in contemporary global cultural politics. Female genital mutilation (FGM) – sometimes incorrectly called female circumcision – is a practice that affects as many as 130 million women in Africa, Asia and the Middle East, although eight African nations have now banned the practice. Women are subjected to the excision of the clitoris and labia and even a practice known as infibulation in which the vaginal opening is sewn shut apart from a small opening. FGM has come to be a *cause célèbre* in Western media, bringing together an unusual alliance of feminists, religious organizations, and medical practitioners. These groups reject the defense of FGM as being the cultural norm in Africa on the grounds of human rights, just as people of intersex have claimed their right to indeterminate gender. As Prathibha Parmar cogently argues: "The expression 'Torture is not culture' tells us quite clearly that we cannot accept ritualized violence as an intrinsic part of any culture" (Parmar and Walker 1993: 95). The success of this campaign in raising public awareness of the issue has made it possible for groups such as the Intersex Society to make their similar case heard against medical inter- ventions in the West. For as Cheryl Chase, a founder of INSA, says: "Africans have their cultural reasons for trimming girls' clitorises and we have our cultural reasons for trimming girls' clitorises. It's a lot easier to see what's irrational in another culture than it is to see it in our own" (Angier 1997).

For if culture is defined as inherited tradition, the practitioners of FGM have history on their side. It was known to the ancient Greek historian Herodotus in the fifth century BCE and has been widely used in the modern era (Klein 1989: 28). Campaigners like the novelist Alice Walker have recast the issue as centering on the woman's right to see herself as a whole person: "Without the clitoris and other sexual organs, a woman can never see herself reflected in the healthy, intact organs of another. Her sexual vision

is impaired and only the most devoted lover will be sexually 'seen'" (Parmar and Walker 1993: 19). The visual perception of the female body is indeed central to the question of FGM, whose defenders assert that female genitalia in the natural state are ugly or unclean. Similar motives lead surgeons in the United States to undertake operations on persons of intersex because, in the words of one doctor, "I don't think parents can be told this is a normal girl, and then have to be faced with what looks like an enlarged clitoris, or a penis, every time they change the diaper" (Angier 1997). One subject of a surgical clitoridectomy in the United States was told: "We had to take it off because you want to look like the other little girls in your class." Suddenly the issue in both FGM and intersex is not what the body essentially is, whether it is male or female, but how it appears.

Walker's sense of the visual impairment resulting from FGM must be contrasted with the local situation where most women are subject to these procedures. Hanny Lightfoot Klein reports that: "Historically speaking, uncircumcised women in Sudan have generally been slaves, and the epithet implies illegitimacy and a non-Arabic origin." Intact women are criticized by other women for "'that thing dangling between [their] legs'"(Klein 1989: 72). In Mali, the Bambara believe that what they call *Wanzo*, or evil power, inhabits a child either in the foreskin or clitoris and that these must be excised in order to maintain social order. At the same time, the maleness of the female and the femaleness of the male are also located in these organs. Thus both FGM and male circumcision are seen as essential to the maintenance of social order and sexual difference. The repugnance felt at the sight of intact sexual organs is in turn motivated by the realization that these distinctions may not be natural at all but rather cultural. Here there is an echo of Freud's theory of sexual difference in which the possession or lack of a phallus defines the nature of a person. This apparently natural distinction nonetheless revolves around a non-existent organ, the maternal phallus. In these terms, FGM could be seen as an exaggerated attempt to insist on essential male/female sexual difference by excising the clitoris, the female organ that might be taken for the phallus. Thus it appears that the culture that is invoked to defend FGM is not culture in the sense of human knowledge and practices but culture used to create "natural" differences between men and women that are validated by their antiquity. The idealization of a phantasmic perfect body – a fetish body, one might say – allows only one means of representation. If we are to take the coercion out of culture, it will be necessary to realign the gaze to allow for multiple viewpoints and for it to look forward rather than back.

Walker further parallels the contemporary Western preoccupation with modifying the body with FGM: "In the 'enlightened' West, it is as if genital

mutilation has been spread over then entire body as women (primarily) rush to change their breasts, their noses, their weight and shape" (Parmar and Walker 1993: 9). The parallel is intriguing, although it is important to note that FGM is usually forced onto young women with or without their consent, whereas Westerners choose to undergo cosmetic surgery, albeit under strong social pressure to conform to the ideal of the "hard body." It is now even possible to have a labiaplasty, a procedure designed "to improve the appearance of female genitalia . . . the ultimate way for women to be gorgeous absolutely everywhere" (Kamps 1998). Although very few women have yet actually had such operations, at least one former patient asserts that the procedure has made her "a lot happier." As such modifications become available for every imaginable aspect of the body, our very notion of the physical body is changing. In Anne Balsamo's striking phrase, the computer-generated visualization of the body used by cosmetic surgeons "transform[s] the material body into a visual medium" (Balsamo 1992). For rather than trying to delve deeper into the body, these procedures can make individual bodies conform to an aesthetic norm: "In this way cosmetic surgery *literally* transforms the material body into a sign of culture." Of course, for those considered racially different, the body has always been such a sign. As in the case of FGM, cosmetic surgeons now seek to apply these cultural definitions of the how a body should signify its gender directly onto that body based, in the words of a standard text on the subject, on a "scale of harmony and balance . . . The harmony and symmetry are compared to a mental, almost magical, ideal subject, which is our base concept of beauty." Unsurprisingly, the "ideal face" turns out to be white, Northern European. Although many more men are now having these procedures, they are primarily aimed at women who are held to be responsible for the various "defects" of their bodies. So strong is the pressure to "get fixed" that some women have procedures over and again, becoming "scalpel slaves" in their late thirties or forties.

However, looking at the widespread fashion for body-piercing, tattooing and cyberpunk fantasies about technological prosthesis, Balsamo suggests that we may need to move beyond a "neoromantic wistfulness about the natural, unmarked body." The natural, unmarked body is exactly what is being defended by campaigners against FGM, revealing a First World/Third World divide as to the uses of the human body. While Western theorists proclaim the end of the body, Third and Fourth World women are claiming, as it were, the right to begin to have their own bodies. How can we get past this impasse? The first move is to abandon these binary oppositions that insist on placing the natural/non-Western in opposition to the cultural/Western. Identity is neither cultural nor natural in terms of the binary opposition but

is a formation in constant flux, drawing on physical, psychical and creative resources to create a sense of self or selves from a range of possibilities that are fractal rather than linear. There cannot be an opposition between a "Western" and "non-Western" body. The case of intersex children shows that even the most fundamental markers of identity are open to question in all locations. Nor does the opposition between Western plastic surgery and non-Western FGM hold up on closer examination. Venezuelan women who want to become part of the phenomenally successful Miss Venezuela organization have to undergo a routine of dieting, liposuction and plastic surgery in order to achieve the desired look. Coco Fusco reports that "birthmarks are removed, noses are narrowed, eyebrows are raised to lend a wide-eyed look, and flat chests receive breast implants" (Fusco 1997: 69). In a different register, it appears to have become common for drug barons to have plastic surgery in order to escape detection, a practice that led to the death of the Mexican godfather Amado Carrillo Fuentes in July 1997 after a drastic 8-hour operation. At the same time, Western nations are having to confront the practice of FGM within their own borders, as global migration brings Africans and Asians into all Western societies. A transcultural approach needs to find ways to see across these divides in a transitive way, rather than perpetuate unproductive divisions. Crossing disciplinary boundaries is not, then, something that is done for intellectual pleasure alone but because it is the only way to move beyond such dilemmas. However, such transformations are far easier claimed than performed. In the remainder of this chapter, I shall sketch one possible route to a transcultural gaze.

Mixing: the cultural politics of race and reproduction

In order to negotiate such a revaluation of the gaze, it is essential to incorporate the question of "race" and its representations. Fetishism is a term that inevitably has connotations of race and colonialism, being derived from the European belief that African religions centered on fetish objects. The production of a "biology of incommensurability" was both challenged by and dependent on the question of miscegenation, where discourses of race and sexuality literally engender reality. The highly-charged term miscegenation refers to the "mixing" of different "races" in sexual repro-duction, leading to the generation of a new hybrid. The linguistic difficulties one encounters in trying to refer to this subject without using racialized terminology are indicative of the persistence of racialized notions in Western everyday life. In the colonial period, the Spanish devised an extremely complicated vocabulary for designating such offspring, measured by degrees

of white, black and Indian ancestry. Some of these terms have survived into current usage such as mulatto/a, the child of one white and one African parent. A mestizo/a was originally the offspring of an Indian with a mulatto/a but the term has come to apply to the web of cross-cultural ancestry that has generated the contemporary populations of the Caribbean and Latin America. As this language has its origin in theories of racial purity, these issues remain extremely charged, as has recently been shown over the controversial proposal to include a "mixed-race" category in the next United States census. Ironically, the simple fact that people of different ethnicities can and do have children with each other, even though it has consistently been either denied or termed morally wrong, gives the lie to the notion of distinct human races. This mixture of affirmation and denial is typical of the fetishistic gaze. Fetishism allowed Western men to disavow what must have been the direct experience of their senses in the long history of miscegenation in Africa, the slave plantations of the Americas, and the Caribbean. Yet, as we shall see, it should also not be forgotten that homosexuality is one possible outcome of the visual experience that leads to fetishism.

It is hard to find rational historical explanations for such an over-determined area as racial categorization of humans. For example, in colonial Jamaica, the British operated a relatively relaxed regime under which anyone who was three generations or more from entirely African ancestry was to be considered white. Yet Edward Long, a passionate British defender of slavery in the eighteenth-century Caribbean, could insist that mulattos were infertile with each other. Following the doctrine of the naturalist Buffon who held that like could only breed with like, he argued that mulattos "bear no resemblance to anything fixed, and consequently cannot produce anything resembling themselves, because all that is requisite in this production is a certain degree of conformity between the form of the body and the genital organs" (Long 1774, vol. II: 335). In other words, the genitalia of the mulatto/a were inevitably deformed due to their mixed origin. Working from this fantastical theory, Long then sought to prove that "the White and the Negro had not one common origin." This was of course his initial premise, which served to justify slavery and colonialism. It had to be upheld even in the face of daily evidence to the contrary.

Scientists sought to confirm these stories with dissections and examinations of the female genitalia, looking for a visible difference that would confirm the deviancy of the African woman. A woman whom we know only as Saartje Baartman, the so-called Hottentot Venus, became the "missing link." In 1810, Baartman was brought to London from South Africa where she had grown up as one of the Khoikhoi or Khoisan peoples. She was

exhibited onstage at the Egyptian Hall of the period, a key London venue for the display of new visual phenomena, later to be the site for both the exhibition of Theodore Géricault's *Raft of the Medusa* in 1824 and the first British commercial film showing in 1896. Early nineteenth-century visitors were above all fascinated by what they saw as her pronounced buttocks that they took as the sign of African deviance. The shape of her buttocks was diagnosed as a medical condition named steatopygia, rendering her body the site of a symptom. However a surgical dissection of her genitalia by the French biologist Georges Cuvier after her death at the age of 26 in 1815 found these to be the true site of deviance, available to the medical gaze but not the casual glance (Fausto-Sterling 1995). Like the contemporary person of indeterminate gender, Baartman was held to have an unusually large clitoris, the sign of her supposed sexual lasciviousness. Such clitoral hyper-trophy is still used as a justification for FGM around the world. As a testament to their key importance as a sign of deviance, Baartman's genitalia have been preserved by the Musée de l'Homme in Paris. It might seem bizarre that one example could serve as the means to classify such an enormous group of people as African women – but such extrapolation was entirely typical of nineteenth-century anthropology. Race, sexuality and gender were inextricably linked in a classificatory system that insisted that these categories be visible on Baartman's body, which was seen as that of a specimen rather than an individual. Baartman's genitalia became a fetish testifying to the existence of a fundamental racial and gender difference that was known at some level to be false but was nonetheless dogmatically defended. She thus established a typology for modern visual classification – the fetishism of the gaze – accounting for the continued fascination with her case from Steampunk novelist Paul Di Filippo to playwright Suzan-Lori Parks and artists such as Frida High Tesfagiorgis in the United States, Ike Udé in Britain and Penny Siopis in South Africa.

In the mid-nineteenth century, racial and sexual classifications were a key subject for artists in the Americas, still grappling with the existence of slavery, which was gradually being abolished by most European countries. One of the most celebrated of these works was a play called *The Octoroon* (1859), adapted from Mayne Reid's novel *The Quadroon* by the Irish play-wright Dion Boucicault. Boucicault had lived in New Orleans during the 1850s, where he would have observed women who were a quarter (quad-roon) or one-eighth African (octoroon) being sold as "Fancy Girls" for five to ten times the price of a field hand. One such woman, Louisa Picquet, recalled being sold in Mobile for $1,500, a substantial sum in the period (Picquet 1988: 17). The reason for this high price was the sexual frisson generated by such women in white men who found exciting what theater

historian Joseph Roach calls "the duality of the subject – white and black, child and woman, angel and wench" (Roach 1992: 180). Here the fetishistic (male) gaze could have it both ways with the liminal woman. It became commonplace to refer to such women as tragic, caught between two worlds. In Boucicault's play, an Englishman named George Peyton finds himself the heir to a Louisiana plantation. On arrival in the South, he falls in love with the octoroon of the title named Zoe. When he proposes marriage to her, she tells him to look at her hands: "Do you see the nails of a bluish tinge?" This mark is also apparent in her eyes and hair: "That is the ineffaceable curse of Cain. Of the blood that feeds my heart, one drop in eight is black–bright red as the rest may be, that one drop poisons all the flood" (Boucicault 1987: 154). Inevitably Zoe dies at the curtain, whereupon her eyes mysteriously change color and lose the stain of Africanness.

Mixing was thus seen in strikingly literal terms – one black drop in eight – that would inevitably leave a visual mark. In his novel *The Mulatto* (1881), the anti-slavery Brazilian writer Aluíso Azevedo continued to subscribe to this belief in the visibility of miscegenation. His hero Dr Raimundo José da Silva, a blue-eyed light-skinned man, seeks the hand of Ana Rosa but is refused because it transpires that he was the son of a slave woman: "[Raimundo] stopped in front of the mirror and studied himself closely, attempting to discover in his pale face some thing, some sign, that might give away his Negro blood. He looked carefully, pushing back the hair at his temples, pulling the skin taut on his cheeks, examining his nostrils, and inspecting his teeth. He ended up slamming the mirror down on the dresser, possessed by an immense cavernous melancholy" (Azvedo 1990: 211). Needless to say, Raimundo dies and his intended recovers to marry an appropriate suitor. The visible mark of race indicates that the bearer is not a full member of society and is hence not entitled to contract marriages or have children. This exclusion was dramatically visualized by the Kentucky painter Thomas Satterwhite Noble in his canvas *The Price of Blood* (1868, Augusta, Morris Museum of Art). It shows a white patriarchal figure, who has just sold his mulatto son into slavery. A seemingly Jewish slave trader reviews the contract of sale while standing over the pile of gold that has been agreed as the asking price. The son looks away with a frown while the father looks out of the frame at the spectator. Noble would have presumed his audience to be white, with the implication that the mixed-race child is not fit to be looked at (Boime 1990: 83–84). To put it in psychoanalytic terms, the mulatto cannot possess the gaze/phallus any more than women. His racial Otherness excludes him from the ranks of patriarchy, especially the key transactions of marriage and childbirth. He is fit only to die or be sold.

If biology did not always provide secure arguments against miscegenation,

morality could always be relied upon to fill the gap. In 1860, the Southern sociologist Henry Hughes proclaimed that: "Impurity of races is against the law of nature. Mulattoes are monsters. The law of nature is the law of God. The same law which forbids consanginous amalgamation forbids ethnical amalgamation. Both are incestuous. Amalgamation is incest" (Rogers 1994: 166). Hughes conceded that sexual reproduction between races was biologically possible but asserted that it was as morally intolerable as incest. The parallel seems odd. Incest is forbidden because of the closeness of the potential partners, while race theory argued that Africans and Europeans were fundamentally different races. If the law of incest was really to be applied in conjunction with the dictates of race science, then miscegenation ought to have been the rule not the exception. The willful defiance of reality in such pro-slavery/anti-miscegenation arguments can be deduced from photographs taken around the time of the abolition of slavery in the United States. A typical group photograph entitled "Emancipated Slaves" from 1863 deliberately placed several light-skinned children in the front row of the photograph in the expectation that this sight would provoke more abolitionist outrage (see Figure 5.3). Abolitionists would use racial prejudice to their advantage in publishing photographs of "white" slave children such as that of "Charles Taylor [who] is eight years old. His complexion is very

Figure 5.3 Emancipated slaves from Louisiana

fair, his hair light and silky." If slavery was defended as the logical extension of the "inferiority" of Africans, such arguments dissolved in the face of the obvious hybridity of the actual slave population in mid-nineteenth century America.

After the abolition of slavery in the United States, the possibilities for white men to have coerced relationships with black women diminished, although they certainly did not disappear, especially in the world of commercial sex. However, in the new African colonies it was almost universal practice for European men to maintain African women as concubines. As ever, European writers claimed to be shocked when they encountered them. Here, for example, is the British naturalist Wollaston describing the situation in the Congo:

> Almost every European official supports a black mistress. The right or wrong of it need not be discussed here, but the conspicuous position which the women occupy is quite inexcusable. It is not an uncommon thing to see a group of these women walking about a post shrieking and laughing, and carrying on bantering conversations with the Europeans whose houses they pass; or, very likely, the Europeans will come out and joke with them *coram populo* [in view of the people]. . . . It is impossible that natives, when they see women of their own race being treated openly and wantonly with familiarity, should feel any great degree of respect for their European masters, and when that is the case, discipline and obedience to authority are quickly lost.
>
> (Wollaston 1908: 182)

It seems that like Conrad's fictional character Kurtz, most colonial officials went "native" in at least this regard. What Wollaston objected to was not the sexual relationships in themselves but the breakdown of respect between Africans and Europeans that they caused. Furthermore, this scandal was fully visible to the Africans, challenging the colonial fantasy that the European was "monarch-of-all-I-survey," to use Mary-Louise Pratt's phrase.

The African women involved were thus in a curious position. On the one hand, they were forced to have sexual relations with the colonial officials but as a result they acquired a form of authority. As Jenny Sharpe has argued in the case of the Caribbean, "slave women used their relationships with free men to challenge their masters' right of ownership." In so doing, they gained what Harriet Jacobs called in her *Incidents in the Life of a Slave Girl* (1861) "something akin to freedom" (Sharpe 1996: 32, 46). In Mexico, this ambivalent figure was symbolized by Malinche, the Aztec woman who

became an interpreter for Herman Cortez. Her gain in personal power has to be offset against the damage done by her work to her own people that led her to be long portrayed as a traitor, until her recent adoption as a symbol by Chicana lesbian feminists (Goldberg 1992: 204).

The choices available to these women were, of course, anything but free. At this point, we find ourselves at the intersection of one of the most enduring myths of colonialism and one of the most difficult problems for postcolonial studies. Colonialism's myth was that the African woman was so sexually lascivious that she would even have relations with primates. The obsession with Bartmann and other African women stemmed from what Robert Young has called "an ambivalent driving desire at the heart of racialism: a compulsive libidinal attraction, disavowed by an equal insistence on repulsion" (Young 1995: 149). This connection became so well-established that when Sigmund Freud was forced to admit his ignorance of female sexuality, he described it as the "dark continent." Africa as a whole had come to symbolize the mysterious forces of female sexuality for European men.

One way to counter this myth has been to try to find out what the women themselves thought of their lives but this has proved difficult, due to the problematic sources. An important historiographical debate on this topic has centered around the experience of *sati*, the practice whereby Hindu women immolated themselves on their husband's funeral pyres. In 1829 the British authorities banned *sati*, thus allowing them to present themselves as the defenders of Indian women. Gayatri Spivak summarizes the debates on *sati* as a discussion between men: "The abolition of this rite by the British has generally been understood as as case of 'White men saving brown women from brown men.' White women – from the nineteenth-century British Missionary Registers to Mary Daly – have not produced an alternative understanding. Against this is the Indian nativist argument, a parody of the nostalgia for lost origins: 'The women actually wanted to die'" (Spivak 1994: 93). The obvious alternative would be to try and understand the motives of the women involved, but Spivak denies that the texts available, whether by British or Indian men, allow the women to be heard and concludes simply "the subaltern cannot speak." While other scholars have sought to mitigate the absoluteness of this pronouncement, the extreme difficulty of retrieving women's experience under colonialism remains, a direct result of their triple oppression by race, class and gender.

One way out of the dilemma can be to try not just to hear the subaltern woman but to see her. While the evidence for the *sati* comes mostly from written texts, it is visual material that supplies what knowledge we have of the Kongo women who became the "mistresses" of the Europeans. For

amongst the piles of ethnographic and landscape photographs of the Congo are to be found many photographs of African women, which often had rather coy titles or included small children in the shot. It seems that without being able to say so, many European men wanted souvenirs of the women they became attached to and the children they had by them. Here we see the women as the colonizers wanted to see them. At the same time, we can see the mixture of self-presentation, adornment and resistance created by Kongo women to win "something akin to freedom." Given the widespread European ignorance of African languages, these relationships, if one can call them that, were unlikely to have been centered around language, whether written or spoken. They were visual encounters in which African women presented themselves in ways that both allowed Europeans to take them for sexually promiscuous "natives" and gave the women themselves a persona that might offer some escape from the harshness of colonial life.

Take Albert Lloyd's 1899 photograph "Bishop Tucker and Pygmy Lady" (see Figure 5.4) It shows Tucker clad in requisite colonial gear, complete with pith helmet, standing in front of his tent. On his right is a young Mbuti (Pygmy) woman and he has his arm around a small child on his left. Given that Lloyd titled his book *In Dwarf Land and Cannibal Country*, it was unusual for him to refer to any African as a "lady." Certainly there is some unpleasant sarcasm here, but its source may well be the unease felt by the

Figure 5.4 Bishop Tucker and Pygmy Lady

traveler at this transgressive relationship. Were Tucker and the Mbuti woman the father and mother of the child? Are they both his children? The facts of this case are now unknowable, but visually this is a family group, carefully posed in front of Tucker's tent to suggest a curious version of Victorian domesticity. By contrast, Herbert Lang, who was both anthropologist and reporter, frequently photographed a woman he titled "A 'Parisienne' of the Mangbetu tribe" during his five-year stay in the Mangbetu region of the Congo from 1910–15 (see Figure 5.5). The term "Parisienne" refers in part to the striking rafia head-dress worn by the woman, as if to suggest she is dressed fashionably. But, as Lang must have known, this head-dress was not a fashion item but a signifier of social rank, to be worn only by the élite. "Parisienne" would have also suggested to Europeans a woman whose sexuality was so marked as to be almost deviant. The Mangbetu woman colluded in Lang's fantasy, at least to the extent of being photographed as the "Parisienne." At the same time, her image resists this characterization because the woman's pose and bearing give her an unmistakeable dignity and pride, despite her subaltern status in relation to the photographer. It is through this self-presentation and demonstration of the ambivalence of the colonial subject that the Kongo women can still "speak" to us, despite the fact that we do not even know their names.

If these pictures do not seem legible in the literary or semiotic sense, it is because these women were deliberately trying to be unproductive. Both slave-owners and colonial administrators alike were constantly complaining that their charges were lazy and work-shy. Marx cited what he called "an utterly delightful cry of outrage" from a Jamican plantation owner in 1857 that the "free blacks . . . regard loafing (indulgence and idleness) as the real luxury good" (Gilroy 1991: 153). With hindsight, it is easy to see how such slow-going was an indirect form of resistance to the force of slavery and colonialism. This type of resistance always ran the risk of violent reprisals from overseers and managers. Kongo women managed to be unproductive in ways that the Europeans could not punish so easily. Gossip and chatter, as noted by Wollaston, is by definition unproductive in the economic sense but can often be the "site of defiance or resistance" (Rogoff 1996: 59). The elaborate head-dresses and body-painting that led Lang to think of Mangbetu women as Parisiennes were very time-consuming activities but ones that Europeans considered appropriate for women and thus had to permit. For Europeans avid to deny the reality of cross-cultural relationships, even the children that they fathered with African women were unproductive. They could not be acknowledged as legitimate children but nor could they be treated as badly as "real" Africans. Unproductive is not the same as meaningless. By being unproductive, these women created an image that

Figure 5.5 A "Parisienne" of the Mangbetu tribe

was fascinating to Europeans precisely because they could not define it. This visual culture of self-presentation and adornment constituted a mode of everyday resistance to colonial power that was necessarily "weak" but nonetheless effective.

Queering the gaze: Roger Casement's eyes

At this point I need to stop the narrative and ask myself: how can I see this scene? Whose eyes am I looking through? In the case of the Congo, the answer is clear: Roger Casement's eyes supplement Langston Hughes' look to allow the late twentieth-century gaze to focus on the Congo. Casement was the British consul to the Congo Free State whose 1904 report to

Foreign Secretary Sir Edward Grey led to international action to reform the Congo. His report dispelled years of dissembling by Belgian officials and European travelers and has remained the "authentic" way for historians to look at the Congo. It is as if we place his eye into the opening of the camera obscura, as recommended by Descartes, in order to see colonial reality. Yet Casement's gaze needs to be understood not as the truth but as a queering of the colonial gaze. Like Hughes, Casement was gay in a culture that had just determined the "homosexual" to be a distinct but inferior species. The Labouchère Amendment to the Criminal Law Amendment Act of 1885 made all sexual contact between men a criminal offence in Britain (Weeks 1989: 102). The statute held gay men to be marked with "the hallmark of a specialised and extraordinary class as much as if they had carried on their bodies some physical peculiarities" (Weeks 1989: 100). In his 1903 diary, Casement seemed to accept the diagnosis while rejecting the cure. He noted the suicide of the soldier Sir Hector MacDonald, accused of being a homosexual: "The most distressing case this surely of its kind and one that may awake the national mind to saner methods of curing a terrible disease than by criminal legislation" (Girodias and Singleton-Gates 1959: 123).

Casement further transgressed the sexual norm by having relations with African men on a regular basis. His diaries, the basis of his later report, occasionally record attractive or well-endowed men alongside the atrocities with no sense of incongruity. In another moment of colonial surrealism, Joseph Conrad and Roger Casement met in the Congo in 1897, where the writer observed the diplomat depart into the forest with only one Loanda man for company with a "touch of the Conquistador in him. . . . A few months later it so happened that I saw him come out again, a little leaner, a little browner, with his sticks, dogs and Loanda boy [sic], and quietly serene as though he had been for a walk in the park"(Girodias and Singleton-Gates 1959: 93). Casement's sexual experience thus takes place offstage, literally obscene. The same-sex cross-cultural encounter that could not be named nonetheless left its physical mark on Casement, as predicted by medical science, producing a darker skin and more effete body.

While Casement retained his colonial privilege, this relationship appears markedly less forced than was usual in colonial society. Indeed, that constituted the real scandal of Casement's later life, for while many Europeans went to Africa to have same-sex relations, they would usually do so with male prostitutes or coercively. Any degree of consent from the African man was to give him a degree of equality unthinkable in the colonial sexual order. Unsurprisingly, Conrad adds of Casement as if he were Kurtz: "He could tell

you things! Things I have tried to forget, things I never did know." But when Casement was later on trial for his life, due to his involvement with the Irish Republican cause, Conrad would not intercede on his behalf, as if his transgression made it impossible to speak for him, or even of him. At the same time, Casement's experience challenges the idea that Europeans intro-duced homosexuality to Africa. Ifi Amadiume's work on gender in Nnobi society shows that woman-to-woman marriages were common in pre-colonial society, loosening ties of gender to biological sex so that a woman could be the "husband" of a family. However, she argues that any suggestion of lesbianism would be "shocking and offensive to Nnobi women" (Amadiume 1987: 7), motivated only by the "wishes and fantasies" of the interpreter. In truth we cannot be sure either way. Yet many have jumped to her standard claiming that Amadiume's work proves the resolute hetero-sexuality of Africans. Sometimes the protesting may be too much, as in Frantz Fanon's assertion that there was no homosexuality in Martinique, even though some men dressed and lived as women. As Gaurav Desai says, "at least in some African contexts, it was not *homosexuality* that was inherited from the West but rather a more regulatory *homophobia*" (Desai 1997: 128).

Casement was aware that he saw things differently from his European colleagues, as he wrote to his friend Alice Green: "I knew the Foreign Office would not understand the thing, for I realized that I was looking at this tragedy with the eyes of another race of people once hunted themselves, whose hearts were based on affection as the root principle of contact with their fellow men, and whose estimate of life was not something to be appraised at its market price." He has been taken to refer to the Irish here but his words might equally apply to gay men, whom British law certainly held to be from "another race of people." The 1895 conviction of his fellow Irishman Oscar Wilde for sodomy must have made Casement realize the precariousness of his position as a British diplomat. One can compare Conrad's description of Casement as a Conquistador to Freud's famous letter to his friend Wilhelm Fliess in 1900, in which he too claimed the Conquistador's gaze for psychoanalysis. The difference is in the affect of the two descriptions. Freud sees himself uncritically as opening up a new intellectual continent for knowledge (a metaphor later adopted by the philosopher Louis Althusser), while Conrad adopts the British view that held the Spanish to be cruel and immoral colonists in order to confirm Casement's homosexuality. Casement refused both categories to claim a subaltern point of view, a mixture of his Irish background and gay sexuality.

Indeed, when Casement himself was sentenced to death for his support of

the Irish republican movement in 1916, the legal adviser to the Home Office resisted appeals for clemency on the grounds that "of later years he seems to have completed the full cycle of sexual degeneracy and from a pervert has become an invert–a woman, or a pathic, who derives his satisfaction from attracting men and inducing them to use him" (Girodias and Singleton-Gates 1959: 27). That is to say, Casement was alleged to have shifted his tastes from penetrating men – perversion – to the inversion of being penetrated by other men and thus becoming in effect a woman. His look at the colonial scene was in a sense almost the same as that of the Congo women – but not quite. Unable to claim his own sexuality, he instead "outed" the Congo Free State. Casement's look was multiply displaced: for the British but not of them, from the point of view of subalterns but not of them either. Such displacement is the effect of the queering of the gaze, that which Lee Edelman describes as: "the undoing of the logic of positionality effected by the sodomitical spectacle" (Edelman 1991: 103). To re-examine the colonial Congo requires exactly such a displaced and displacing vision.

For Freud's third option after the primal scene was homosexuality. Rather than see sexuality as identity, forming a neat unit, "queer" turns towards what Eve Kosofsky Sedgwick has called: "the open mesh of possibilities, gaps, overlaps, dissonances, and resonances, lapses and excesses of meaning when the constituent elements of anyone's gender, of anyone's sexuality aren't made (or *can't* be made) to signify monolithically" (Sedgwick 1993: 18). That is not to say that the issues we have discussed so far are "really" about homosexuality but that considering how lesbian and gay sexuality might fit into the intellectual picture changes the entire approach. The queer viewpoint does not create a "true" point of view but the very exclusion of queer identity from the normative discourses of sexuality reveals the contra-dictions and faultlines in those discourses. From this perspective, sexual and gender identity are seen to overlap with race, ethnicity and nationality in ways that question how identity itself, a very privileged term in the last decade, should be conceived. If, as Judith Butler puts it, gender is a "normative institution which seeks to regulate those expressions of sexuality that contest the normative boundaries of gender, then gender is one of the normative means by which the regulation of sexuality takes place. The threat of homosexuality thus takes the form of a threat to established masculinity or established femininity" (Butler 1994: 24). In short, any corporal identity that falls outside the established parameters for personal identity will encounter disciplinary force, the same disciplinary force that produces heterosexual men and women. In the phallocentric system, there are no outlaws, only deviants.

This displaced queer vision produced what Michael Taussig has called a

"cool realism" in Casement's account of the region as opposed to the fevered hallucinations of accounts like that of Joseph Conrad. At the end of *Heart of Darkness*, Marlow has to tell Kurtz's Intended of his death. Here the Victorian myth of the woman as angel by the hearth was threatened by her Other, the "primitive" sexualized African woman by whom Kurtz had had children. Equally present was the homoerotic relationship between Marlow and Kurtz, the love that dare not speak its name. Marlow seems to hear the room echo with Kurtz's famous phrase "The horror! The horror!" He restores order at the expense of the truth by telling the Intended that Kurtz's last words were her name. "I knew it" she exclaims. The horrors of modernity were constantly displaced into a phantasmic, hence sexualized, colonial order that produced the unquestionable knowledge of the fetishist. Alan Sinfield has recently argued that queer culture can be thought of as a diaspora (Sinfield 1996). Using the Congo experience, I should like to suggest that the formula can be reversed so that diaspora can be thought of as deviant sexuality. That is not to say that Africans were in some sense deviant but that the European sense of order depended on a normative heterosexuality that was always already racialized. The Congo river is a place where the boundaries between subject and object seem to dissolve into identities that we once called postmodern but we can now see to have been modern all along. That seeing is not a matter of Cartesian observation but of viewing from the "perverse angle" (Sedgwick) with the "parallax vision" (Mayne) of "(be)hindsight" (Edelman) that once seemed the marginal view-point but increasingly seems the only available place from which to look at the colonial spectacle, which, as the Situationists pithily observed, came home to the colonizing nations creating what they called "the colonization of everyday life."

One version of the "parallax vision" that brings together race, class and sexuality in order to look towards the future, rather than resuscitate the past can be seen in the photography of Samuel Fosso (b. 1962). Fosso was born in Cameroon but lives and works in Bangui, the capital of the Central African Republic. He began work as a photographer's assistant at the age of 13 and began his remarkable series of self-portraits in 1976, which have recently attracted international attention from Mali to Paris and New York. He chose the backgrounds, costumes and accessories, sometimes adding captions with Letraset. In one shot he appears in white singlet and briefs, standing in front of a fabric curtain with a clothes-line hanging above his head. Around the curtain are festooned numerous examples of standard portrait photography. He looks away to his left, one foot posed on the other, seeming both assured and nervous at once. The photograph as a whole is disquieting. It is as if we see a film still from a movie whose plot we do not know. In other images he

seems more assured. He stands in front of what seems to be a theatrical curtain, in a suitably dramatic pose, hands on hips and one foot arched above the other, showing the whiteness of his soles (Figure 5.6). He wears only swimming trunks, striped with white, giving a suggestive air to the image that is disrupted by the fact that he is wearing large white gloves. There is a rhythm between the black and white tiled floor and the alternating white and black skin and clothing. We rarely meet Fosso's gaze. In one shot he faces the camera directly, only for heart shaped patches on his large sunglasses to obscure his eyes altogether. From reflections in the lenses we can deduce that he seems to be looking at an array of newspapers, magazines or photographs. Again, he wears a bright white shirt, open at the neck. These photographs place the (black and white) photographic print in tension with the sexualized European/African divide quite literally across the body of a young African man exploring his identity. As a citizen of postcolonial Africa, he refuses to appear in the guise of the "native" or any of the other received photographic clichés of Africans. His work was amongst the first to use photography to challenge received notions of identity that has since become famous as the postmodern photographic style associated with Cindy Sherman and other American artists.

Figure 5.6 Samuel Fosso in front of the camera

An interesting complement to Fosso's work can be found in the powerful photographs of Rotimi Fani-Kayode (1955–1989), born in Lagos, Nigeria but resident in England from 1966 after his family fled a military coup. He described how his sense of being an outsider stemmed from issues of race, class and sexuality in diaspora:

> On three counts, I am an outsider: in matters of sexuality; in terms of geographical and cultural dislocation; and in the sense of not having become the sort of respectably married professional my parents might have hoped for. . . . [M]y identity has been constructed from my own sense of otherness, whether cultural, racial, or sexual. The three aspects are not separate within me. . . . It is photography, therefore – Black, African, homosexual photography – which I must use not just as an instrument, but as a weapon if I am to resist attacks on my integrity and indeed my existence on my own terms.
>
> (*In/sight* 1996: 263)

In his photograph *White Feet* (c. 1987), Fani-Kayode shows that his vision is elegiac and graceful, despite the aggressive tone of his words (see Figure 5.7). A naked black man reclines on a chaise-longue, a "feminine" piece of furniture associated in European art with languorous female nudes. Although we cannot see his face, he turns the soles of his feet toward the camera, in an echo of Fosso's self-portrait. Alex Hirst, Fani-Kayode's co-artist, explains that: "Europe is a chaise-longue on which a naked black male sprawls defiantly, showing off the white loveliness of the soles of his feet" (Fani-Kayode 1988: 3). The print is lit so as to accentuate the contrasts between the white and black skin and between the dark mass of the body and the white recliner. There are both similarities and differences with the work of Robert Mapplethorpe. Mapplethorpe similarly aestheticized and eroticized the black male body but claimed only to be a witness of the gay subculture. Fani-Kayode seeks to bring out the political dimension to the representation of "Black, African homosexual photography," taking his testimony to another level in which it becomes an intervention. In his photograph *Union Jack*, Fani-Kayode depicted a nude black figure carrying the Union Jack, the British flag. The picture serves as a retort to the old racist cry "Ain't no black in the Union Jack," while also imagining the black Briton, a category for which there is no image in official British culture.

Yet away from the enclosed space of the art world, the fascination with viewing the Other remains very much alive. In Kagga Kamma Game Park in South Africa, a group of about forty so-called Bushmen, the Khoi Khoi, have

Figure 5.7 White Feet

become a tourist attraction. Visitors pay about $125 to stay the night and then $7 to see the Khoi Khoi who are rewarded with a tiny portion of the profits (Daley 1996). Saartje Bartmann, the "Hottentot Venus," was of course also from this people. While contemporary South African artists and intellectuals have made the recovery of Bartmann's remains from Paris a *cause célèbre*, others are still queuing to see her descendants enact the native for their pleasure. Here culture remains the past, a spectacle for modern enjoyment. Throughout the world, such cultural spectacle is a key part of the vast tourist industry making fake sites like Colonial Williamsburg indistinguishable from the commodified spectacle that historical venues like Versailles and the Tower of London have become. The collective task of postdisciplinary studies in the liberal arts is now to create a forward looking, transitive, transcultural gaze that moves beyond the now sterile opposition between nature and culture.

Bibliography

Amadiume, Ife (1987), *Male Daughters, Female Husbands: Gender and Sex in an African Society*, London, Zed Press.

Angier, Natalie (1997), "New Debate Over Surgery on Genitals," *New York Times* May 13, B1.

Apter, Emily (1991), *Feminizing the Fetish: Psychoanalysis and Narrative Obsession in Turn-of-the-Century France*, Ithaca, NY, Cornell University Press.

Azvedo, Aluíso (1990), *The Mulatto*, London, Associated University Presses [1881].

Balsamo, Anne (1992), "On the Cutting Edge: Cosmetic Surgery and the Technological Production of the Gendered Body," *Camera Obscura* 28, January.

Barbin, Herculine (1980), *Herculine Barbin: Being the Recently Discovered Memoirs of a Nineteenth-Century French Hermaphrodite*, New York, Pantheon.

Boime, Albert (1990), *The Art of Exclusion: Representing Blacks in the Nineteenth Century*, Washington, DC, Smithsonian Institution Press.

Boucicault, Dion (1987), *Selected Plays*, Gerrards Cross, Colin Smythe.

Butler, Judith (1994), "Against Proper Objects," *differences* 6(2–3).

Daley, Suzanne (1996), "Endangered Bushmen Find Hope in Game Park," *New York Times* January 18, A4.

Desai, Gaurav (1997), "Out In Africa," in *Genders 25*, Thomas Foster et al. (eds), *Sex Positives: The Cultural Politics of Dissident Sexualities*, New York, New York University Press.

Edelman, Lee (1991), "Seeing Things: Representation, the Scene of Surveillance and the Spectacle of Gay Male Sex," in Diana Fuss (ed.), *Inside/Out: Lesbian Theories, Gay Theories*, New York, Routledge.

Epstein, Julia (1990), "Either/Or – Neither/Both: Sexual Ambiguity and the Ideology of Gender," *Genders* 7, Spring: 99–113.

Fani-Kayode, Rotimi (1998), *Black Male/White Male*, London, GMP Press.

Fausto-Sterling, Anne (1995), "Gender, Race and Nation. The Comparative Anatomy of 'Hottentot' Women in Europe, 1815–17," in J. Terry and J. Urla (eds), *Deviant Bodies*, Bloomington, Indiana University Press.

Freud, Sigmund (1959), "Fetishism," *Sigmund Freud: Collected Papers*, Vol. V, New York Basic Books.

Fusco, Coco (1997), "Escuela Miss Venezuela," *Latina*, July.

Gilroy, Paul (1991), *"There Ain't No Black in the Union Jack": The Cultural Politics of Race and Nation*, Chicago, IL, Chicago University Press.

Girodias, Maurice and Singleton-Gates, Peter (1959), *The Black Diaries: An Account of Roger Casement's Life and Times*, New York, Grove Press

Goldberg, Jonathan (1992), *Sodometries: Renaissance Texts, Modern Sexualities*, Baltimore, MD, Johns Hopkins Press.

Horne, Peter and Lewis, Reina (1996), *Outlooks: Lesbian and Gay Sexualities and Visual Cultures*, London, Routledge.

In/sight (1996), *In/sight: African Photographers, 1940 to the Present*, New York, Guggenheim Museum.

Irigaray, Luce (1985), *This Sex Which Is Not One*, Ithaca, NY, Cornell University Press.

Johns, Elizabeth (1983), *Thomas Eakins: The Heroism of Modern Life*, Princeton, Princeton University Press.

Kamps, Louisa (1998), "Labia Envy," *Salon* March 16.

Klein, Hanny Lightfoot (1989), *Prisoners of Ritual: An Odyssey into Female Genital Circumcision in Africa*, New York, Haworth Press.

Lacquer, Thomas (1990), *Making Sex*, Cambridge, MA, Harvard University Press.

Long, Edward (1774), *A History of Jamaica*, London.

Mayne, Judith (1993), *Cinema and Spectatorship*, New York, Routledge.

Mercer, Kobena (1996), "Decolonization and Disappointment: Reading Fanon's Sexual Politics," in Alan Read (ed.), *The Fact of Blackness: Frantz Fanon and Visual Representation*, Seattle, WA, Bay Press.

Mulvey, Laura (1989), *Visual and Other Pleasures*, Bloomington, Indiana University Press.

Parmar, Prathibha and Walker, Alice (1993), *Warrior Marks: Female Genital Mutilation and the Sexual Blinding of Women*, New York, Harcourt Brace.

Picquet, Louisa (1988), "The Octoroon," in Anthony G. Barthelemy (ed.), *Collected Black Women's Narratives*, New York, Oxford University Press.

Pointon, Marcia (1990), *Naked Authority: The Body in Western Painting 1830–1908*, Cambridge, Cambridge University Press.

Roach, Joseph R. (1992), "Slave Spectacles and Tragic Octoroons: A Cultural Genealogy of Antebellum Performance," *Theatre Survey* 33 (2), 1992.

Rogers, David Lawrence (1994), "The Irony of Idealism: William Faulkner and the South's Construction of the Mulatto," in Carl Plasa and Betty J. Ring (eds), *The Discourse of Slavery: Aphra Benn to Toni Morrison*, New York, Routledge.

Rogoff, Irit (1996), "Gossip as Testimony: A Postmodern Signature," in Griselda Pollock (ed.), *Generations and Geographies in the Visual Arts: Feminist Readings*, London, Routledge.

Sedgwick, Eve Kosofsky (1993), *Tendencies*, Durham, NC, Duke University Press.

Sharpe, Jenny (1996), "'Something Akin To Freedom': The Case of Mary Prince," *differences*, 8(1).

Sinfield, Alan (1996), "Diaspora and Hybridity: Queer Identities and the Ethnicity Model," *Textual Practice* 10(2): 271–93.

Spivak, Gayatri (1994), "Can the Subaltern Speak?" in Patrick Williams and Laura Crishman (eds), *Colonial Discourse and Post-Colonial Theory*, New York, Columbia University Press.

Tyler, Carole-Anne (1994), "Passing: Narcissism, Identity and Difference," *differences* 6(2/3).

Weeks, Jeffrey (1989), *Sex, Police and Society: The Regulation of Sexuality Since 1800*, London, Longman.

Wollaston, A.F.R. (1908), *From Ruwenzori to the Congo*, London, John Murray.

Young, Robert (1995), *Colonial Desire: Hybridity in Theory, Culture and Race*, London, Routledge.

FIRST CONTACT

From *Independence Day* to *1492* and *Millennium*

I F THE CULTURAL IMAGINARY of colonialism needed to forget slavery, our present postcolonial epoch has equally tried to forget colonialism. Yet the key questions of the colonial era have not disappeared from Western culture but have simply been displaced. One of the most complex relationships entailed by the culture system is that between culture and civilization. Here culture is not simply opposed to nature but divides into two unequal sections. In some uses, they are synonyms, in others antonyms. At the time of the first contacts between Europeans, Africans, Amerindians, Asians and others, Europeans often assumed that the people they met were from different species from their own. For nineteenth-century anthropologists and travelers, the answer was obviously that the West had civilization and its Others did not. More recently, advocates of multi-culturalism have insisted that all human culture is civilization and worthy of equal respect. However much one might sympathize with this position, it is clearly not yet universally accepted in EurAmerican society.

For our television and cinema screens are endlessly debating the culture/ civilization divide in the displaced format of the alien or extraterrestial. Are aliens good or bad? What do non-humans look like? What will the encounter with such beings be like? These questions are posed over and again, consciously and unconsciously replaying and reworking the European encounter with their Others in the eras of exploration, slavery and colonialism. It is no coincidence that the United States calls its immigrants "aliens." This debate is taking place in that non-geographical space that Arjun Appadurai has named the "mediascape," a key location for visual culture that he suggests

"tend to be image-centered, narrative-based accounts of strips of reality, and what they offer to those who experience and transform them is a series of elements (such as characters, plots, and textual forms) out of which scripts can be formed of imagined lives, their own as well as those of others living in other places." One of the most powerful formats for this kind of trans-formative imaginary has been science fiction films and television programs because, in Constance Penley's words, "science fiction film as a genre . . . is now more hyperbolically concerned than ever with the question of *difference*, typically posed as that of the difference between human and non-human" (Penley *et al*. 1991: vii). Yet these films are in themselves careful to restore normality after the disruption caused by the intervention of aliens. It has been the fans of series like *Star Trek* and *The X-Files* who have created a flexible mediascape in which the question of difference can be articulated and re-imagined. The imaginary encounter with non-humans has served as a flexible metaphor for "first contact," from 1492 to the science fiction of the Cold War era, only to find in the postmodern moment that it can no longer account adequately for the difference it sets out to explain. Out of these gaps and inconsistencies in science fiction films and television series, fans have constructed alternative versions of the imagined future that wonder how our present conflicts might be resolved in liberating ways. For all their ultimately normative plots, science fiction media carry with them what Donna Haraway has called moments of "transgressed boundaries, potent fusions and danger-ous possibilities" (Haraway 1985: 71). The science fiction fan world is one place from which a new way of looking is being imagined actively.

Enter the extraterrestrials

In the last forty years, the depiction of aliens has been central to Hollywood cinema, both in blockbuster productions and the cut-price B-movie. While the representation of aliens is by no means exclusive to Hollywood, featuring prominently in Japanese *anime* cartoons, for example, it is perhaps the dominant version of such imaging. As the alien image has no fixed meaning, it takes its meaning from the social context from which it emerges and in which it is used. Science fiction movies address the fears and desires of the present by projecting them onto an imaginary future. The continued fascina-tion with extraterrestials is motivated by the ongoing dilemma as to the definition of humanity itself. Contemporary with the science fiction vogue of the 1950s was Edward Steichen's famous photographic exhibition at the Museum of Modern Art in New York entitled "The Family of Man" (1955). Steichen set out to display how, in his view, photography acted as a "mirror of the essential oneness of mankind throughout the world." This unity was

upheld in the face of the division of the world into two opposing political blocks that was the essential reality of the Cold War. In this context, the science fiction encounter made for a satisfying story because it is usually told exclusively from "our" – that is, the human – point of view and nearly always ends in "our" victory. Science fiction clearly displaced the conflict of the Cold War era into the future so that the contest between United States' capitalism and Soviet communism could be played out. In the Hollywood version, "we" are always American so that, without necessarily being overtly political, the science fiction film upheld the American world view. For example, the classic *Invasion of the Body Snatchers* (1956) displaced anxieties about Communist infiltration of American society onto the alien takeover depicted in the film. The aliens assume human form when an individual goes to sleep in proximity to one of the alien "pods." Playing on the fear of "reds under the bed," the replica human appears the same externally but has no emotions, reduced to a lifeless apparatchik (Sobchak 1987: 121–25). In the same way, "The Family of Man" used photography to reproduce American values and political ascendancy as universal truths. A photograph of a Soviet woman harvesting wheat by hand was juxtaposed to an aerial photograph of a row of American combine harvesters progressing across a vast field (Steichen 1986: 68). The montage made the sense of American superiority visible to all. Even within the carefully selected images on display, contradictions to this view inevitably emerged. Nearly all the pictures of Africa represented naked or half-naked people engaged in "primitive" activities like hunting with spears, carrying water or story-telling. In this view, Africa remains stuck at the primitive origin from which Western nations have long since departed. One small photograph of an industrial worker in the Belgian Congo, staring impassively at the camera in what appears to be a highly mechanized mine, is the only indication that this division into primitive and civilized zones of the world may be oversimplified (Steichen 1986: 72). It was there nonetheless for those who chose to see it in this way. The mapping of anti-communist politics onto the model of colonialism was thus always liable to be disrupted by the actual experience of history.

Science fiction narratives provided an environment in which these contra-dictions could be acted out, perhaps even worked through, while maintain-ing the Cold War certainties of American superiority. Given that the excitement of such films is that humanity has never encountered an alien species, how and why are these representations of aliens found convincing? The political crisis of the Cold War led film producers to create metaphors for the dangerous outsider. Sometimes the aliens were armored, aggressive and technologically superior – see *The War of the Worlds* (1953) or *Invaders*

From Mars (1953) – playing on the political imperative to develop ever-more sophisticated and deadly weaponry to counter the "threat" from without. At the same time, the postwar boom was creating an advanced consumer culture in which people not only aspired to own goods but desired products that were not yet available or did not even exist. Such consumer demand for the future began with the annual updating of car models and continues today with AT&T promoting hi-tech products that are no more than ideas. As a result, audiences became accustomed to imagining the future in very specific terms and to judging different versions of that future against each other. It was this curious fusion of consumer desire and political rhetoric that was to give the science fiction genre its particular resonance, in an early version of what Alluquère Roseanne Stone has called the "war of technology and desire."

In semiotic terms, the alien image is a floating signifier. That is to say, the visual image of the alien is interpreted as such only with reference to other visualizations of aliens and with no reference to "real" extraterrestials. Thus the signifier can "float" from one meaning, or signified, to the next, generating different meanings in each context. In theory, all signs can do this, but in practice, a signifier becomes conventionally attached to a specific meaning in order to make everyday life comprehensible. There are certain signifiers that do float, however, such as the word "thing." I can say "pass me that thing" and it may be perfectly comprehensible to you in context as meaning "pass me the can opener", or it may make no sense, inviting the query "what thing"? The alien is one example of such floating signifiers that take on complex resonances of race, gender and politics.

It is no coincidence that we often find such floating signifiers used in the titles of science fiction films, such as *Them!* (1954), *It Came from Outer Space* (1953) and Howard Hawks' classic *The Thing (from Another World)* (1951), later remade by John Carpenter as *The Thing* (1982). The different handling of these two films indicates the shift in the genre from the classic Cold War period to the uncertainties of the postmodern period. In Hawks' version, the action is set at a United States Air Force base in Anchorage, Alaska, playing on the then common belief that a Soviet attack would most likely come via the polar route. When Captain Pat Hendry learns of a possible plane crash near the pole, he decides to investigate because the Russians might be involved. Instead, the American team discovers a 7-foot tall alien that, although plant-like in structure, feeds on blood. Its food source quickly becomes the expedition members, who resolve to destroy it despite the objections of the scientist Carrington, who represents the military hierarchy. For Carrington, one of the first in a long line of research-crazed scientists in science fiction films, "knowledge is more important than life." The victorious

viewpoint is, however, that of domestic science. When the crew become aware that the alien is invulnerable to bullets, it is the only woman in the group Nikki Nicholson, the doctor's secretary, who suggests that if the alien is a plant, then the answer is to: "Boil it, stew it, bake it, fry it." This opposition between pure (masculine) logic and (feminine) intuition is a key constituent of the science fiction debate over the essence of humanity. Although the science fiction narrative is almost always resolved through force, it is often the feminized attributes of emotion and intuition that mark the difference between humans and aliens and enable human victory.

As the Cold War gave way to *détente*, monsters from outer space came to seem less realistic. Furthermore, the dramatic social upheavals following the revolutions of 1968, Watergate and the Vietnam War made domestic concerns seem far more important to filmmakers and audiences alike. By the 1970s, the way was open for George Lucas and Stephen Spielberg to re-imagine extraterrestials as friendly, almost cuddly beings. In the *Star Wars* (1977) trilogy, science fiction became a cinematic cartoon with little or no attempt to convince the viewer that the events might be real. Alien life was redefined visually in the famous bar scene, in which the hero Luke Skywalker encounters a bar packed with a variety of exotic alien species in a high-tech version of a Wild West saloon. The audience is invited to enjoy special effects for their own sake, rather than as a speculative attempt to imagine the reality of the future. The notion of extraterrestial life as spectacle rather than threat was given full expression in Spielberg's *Close Encounters of the Third Kind* (1977) and *E.T.* (1982). As if to emphasize their new friendliness, the aliens in both films appeared as small, childlike creatures who seemed not to wear clothes despite their capacity for interstellar travel. While the spaceships were literally awe-inspiring – think of the wide screen rendition of the ship at the opening of *Star Wars*, or the dramatic appearance of the mothership in *Close Encounters* – these 1970s aliens were decidedly un-threatening (Bukatman 1995).

In the late 1970s a new dystopian version of the future began to circulate in popular culture. Towards the denouement of John Carpenter's remake of *The Thing*, his protagonist McReady insists to himself: "I know I'm human" (Telotte 1995) – see Figure 6.1. His claim allows him to be the referee of a test for humanity involving placing a hot needle into blood. The "alien" blood runs away from the heat, while human blood stays in place. Such assertions and tests would never have been needed by the 1950s characters who were certain of the clear distinction between themselves and the alien, disagreeing only as to their response. In *The Thing*, most of those being tested display great relief to discover they are still human after all. Carpenter's alien is much closer to the John W. Campbell short story from which the original

Figure 6.1 A still from *The Thing*

movie was supposedly derived, entitled "Who Goes There?" In both the
story and the remade film, the alien is not simply a monster but a shape-
shifter, able to duplicate any living thing, including its thoughts (Von Gunden
and Stock 1982: 31). The threat now comes not from clearly identifiable
(Soviet) enemies but from within: in the disorientating world of global
culture and electronic technology, what is the human self and what are its
borders? Now "aliens" might be indistinguishable from "ordinary" people,
as they were in the *Invasion of the Body Snatchers*. Indeed, McReady's assertion
sounds more appropriate to a defense of personal (hetero)sexual orientation
than it does to biological definition. Carpenter's film further differs from
Hawks' in that all the human characters are male. In this homosocial world,
the alien brings the homophobia of such all-male institutions into the open.
At the same time, McReady's blood test for humanity clearly evokes fears of
racial miscegenation. Although the monster is defeated, McReady is left to
await death from hypothermia at the end of the film, after destroying the
base by fire. The future is no longer a better place but simply another locale
in which to play out our cultural anxieties.

 While Spielberg and Lucas offered a shining promise of technology
married to human fulfillment, films like *Alien* (1979) and *Bladerunner*
(1982) saw no connection between the two (see Figures 6.2 and 6.3).

Figure 6.2 A still from *Alien*

Figure 6.3 Harrison Ford in *Bladerunner*

Both films envisage a future in which dramatic technological achievement has enabled a global corporate culture to emerge, motivated solely by profit. In *Alien*, the Company would rather see the survival of the vicious alien species than its own crew, while *Bladerunner* presented a world in which all human body parts were readily available for sale. Both invite their audiences to see the corporations responsible for the replicants and the rescue of the alien as more inhuman than any alien species or android. In terms of the imagining of alien species, this new generation of films marked both an important new step and a return to the imagery of the 1950s. On the other hand, they created dramatic new visualizations of the dystopic future. Although *Bladerunner* takes place in twenty-first century Los Angeles, its *mise-en-scène* creates a "visual 'trashing' and yet operative functioning of what used to be shiny futurist technology" (Sobchak 1987: 246). The city is dark and bleak, constantly awash with rain and with a hybrid Asian/American/ European population. Class is figured vertically, so that the poor live on the streets, while the rich and powerful live and travel in the air. *Alien* similarly "trashed" the spaceship itself, the very emblem of scientific progress. The *Nostromo*, named after a dark novel by Joseph Conrad, is a vast, irregularly-shaped machine, that relies on the perception that future spacecraft may be built in space and thus not need to be aerodynamic in order to create a new paradigm for imagined space travel. The ship is damp, gloomy and forbidding, creating a space that is constructed as both feminine in its wet darkness and Oriental in its endless maze of storage holds, airways, and passages. The anxieties worked out in these films are domestic concerns of gender, class and identity, rather than the geopolitics of the Cold War era.

The old idea from *Invasion of the Body Snatchers* that the most frightening monster is the one that looks exactly like other humans was central to both films. In *Alien*, the replica human is almost as threatening as the extra- terrestrial itself. The plot turns on the discovery that science officer Ash is in fact an android dedicated to the survival of the alien. Not only was Ash programmed to defend the alien, he comes to admire its "purity" as a killing machine. For the alien was a distinctly new type of monster that continues to influence extraterrestial imagery today. Its body was a combination of insect, reptile, and shark. Unlike the lumbering monsters of the 1950s, it possessed great speed and powers of concealment and, unlike the harmless E.T., it was an effective and relentless killer. Above all, *Alien* gendered its monster female, rather than the masculine armored aliens of the 1950s, such as Gort in *The Day the Earth Stood Still* (1951) or Spielberg's childlike aliens. The second wave of feminism in the West had won reproductive rights, women's right to choose and was pressing for an Equal Rights Amendment in the United States. This context renders *Alien*'s obsession with the para-

sitical reproduction of the alien more than simply a textual device. The alien implants a fetus in a male human from a plant-like pod, evoking *Invasion of the Body Snatchers*. The infant alien subsequently explodes out of its victim's stomach, leading to his death, as if to warn of the consequences of disrupting "natural" reproductive processes. The alien's wet, dripping jaws were almost a parody of male fear of castration evoked by the sight of the female genitalia, a fear known to psychoanalysts as vagina dentata, the vagina with teeth (Creed 1990). At the same time, *Alien* created the character of Ripley, played by Sigourney Weaver, a palpably "strong woman," who is the only person able to defeat the alien over four encounters spanning several centuries of fictional time, culminating in *Alien Resurrection* (1997).

Bladerunner describes the tracking down and destruction of rebel replicants, androids with every human capacity except emotion. In its opening scene, a man is being questioned in apparently random fashion, designed to determine whether he can in fact feel emotion. The character turns out to be a replicant named Leon that kills the questioner. Although the replicants are the bad guys, we are also invited to feel sympathy for the "slavery" they experience, especially their short lifespan. The Tyrell Corporation even goes so far as to implant "memories" in the replicants that are reinforced by fake photographs. The status of photography as an index of truth is central to the film's plot as the replicants are tracked down using photographs. At the same time, *Bladerunner* calls attention to the falsifiability of photography in the electronic era, making it clear that seeing is no longer believing. The dark, diffracted visual style of the film emphasizes the unreliability of human senses to discriminate between real and replicant representations.

Furthermore, as Lee E. Heller points out, mass media characterizations of heterosexual relationships in the past fifteen years or so have concentrated on emphasizing the "insurmountable conflicts and irreconcilable differences" between the genders (Heller 1997). In books such as John Gray's significantly titled *Men are from Mars, Women are from Venus*, men and women are presented as seeing each other as alien species. A key complaint in this gender war is, to use a popular Oprah title, "Men Who Can't Be Intimate." From this point of view, all men are replicants. Harrison Ford's character Rick Deckard, the hero, is a bladerunner, whose task is to "retire" the replicants by killing them. But when Deckard ultimately elopes with the replicant Rachel, an advanced female model, it seems perfectly appropriate. Deckard can now have the perfect woman of male fantasies who will not make any irritating demands for emotional intimacy. On the other hand, the 1992 release of the director's cut hinted that Deckard himself might be a replicant, making Rachel and Deckard the perfect android couple. *Bladerunner* fused the narratives of race and gender put in play by *The Thing* into

the single person of the replicant. The unspoken worry is that all human bodies have already changed so much that there is hardly any way to tell the difference between human and machine. Tellingly, it takes over a hundred questions before even the veteran Deckard can detect that Rachel is a replicant.

The return of the empire

One of the acknowledged originators of science fiction writing was the French nineteenth-century novelist Jules Verne, an active member of the pro-colonial Geography Society of Paris, who believed that Africa's destiny was to be settled by whites. In the late nineteenth century, the French colonial enthusiast Hubert Lyautey set out his agenda for the colonization of Indochina to a government official. The latter replied: "But that is pure Jules Verne." Lyautey riposted: "Good Lord, yes sir, of course it is Jules Verne. For twenty years the people who march forward have been doing nothing else but Jules Verne." The connection between science fiction and colonialism has remained important in the era of science fiction films, many of which make references to European colonial expansion and exploration. In both the fictional film and the historical colony, distinction between types of humanity was the key to success. Indeed, the two models of extraterrestial alien that inhabit science-fiction films – the murderous monster and the replica human – are derived from the classifications created during the age of European expansion and imperialism. In the first years of the space race, director Byron Haskin made this connection explicit in his film *Robinson Crusoe on Mars* (1964), which has subsequently become a B-movie classic. Despite the labored special effects, *Time* called the picture "a modest yet provocative attempt to imagine what might happen . . . in the next decade or so." The plot involves Commander Kit Draper becoming stranded on Mars, only to discover that an alien is similarly adrift. The alien wears clothing and jewellery reminiscent of Aztec or Inca peoples and Kit names him Friday in allusion to Daniel Defoe's novel *Robinson Crusoe*. Friday is seeking to escape from another group of aliens, who have placed the bracelets on his arm as a form of identification and tracking device. Needless to say, the stranded duo evade the aliens and make it back to Earth – although it is unclear what Friday will do there. More recently, Ridley Scott indicated the source of much of his imagery in *Bladerunner* and *Alien* in his later film, the historical drama *1492: The Conquest of Paradise* (1992), in which Sigourney Weaver returned as Isabella of Castille. Gerard Depardieu, first introduced to American audiences as a penniless seeker of Resident Alien status, better known as the Green Card, now appeared with full immigration clearance as

Christopher Columbus (see Figure 6.4). But, like so much of the Quincen-
tennial "Celebration," the film flopped (Shohat and Stam 1994: 60–66).
Columbus' greatness no longer appeared secure in the face of hostile
criticism from Indian and Latino/a groups. Whereas the audience will
consistently identify with the "humans" over the "aliens," in the colonial
context the moral rectitude now appears to belong to "them" – that is to
say, the indigenous peoples who experienced the violence of colonial con-
quest.

The connection between 1492 and 2001 was tellingly evoked by the
anthropologist Claude Lévi-Strauss describing the encounter between
Europeans and indigenous Americans: "Never had humanity experienced
such a harrowing test, and it never will experience such another, unless,
some day, we discover some other globe inhabited by thinking beings" (Lévi-
Strauss 1976: 89). For Europeans immediately categorized the peoples of the
"New World" as fundamentally different. When Christopher Columbus
arrived at Cuba in 1492, he believed he had reached Cipango, or Japan,
in whose provinces "the people are born with tails." Soon afterwards, he
received confirmation that "far from there, there were one-eyed men, and
others with snouts of dogs who ate men, and that as soon as one was taken
they cut his throat and drank his blood and cut off his genitals" (Greenblatt

Figure 6.4 A still from *1492: The Conquest of Paradise*

1991: 73–4). It seemed a short step from the natural wonders that he did see, such as tropical fish and birds, to these human monsters that he did not.

From this first contact, a pattern was established whereby European travelers used the experience of natural wonders to confirm the existence of humanoid monsters. The British explorer Sir Walter Raleigh reached Guiana in the 1590s, where he told of peoples "reported to have their eyes on their shoulders, and their mouths in the middle of their breasts." While Raleigh was aware that these accounts sounded like fairy tales, he asserted that "I have seen things as fantastic and prodigious as any of those" (Greenblatt 1991: 21–2). In other words, Columbus and Raleigh suspended their disbelief in the accounts of monsters because the surrounding scenery was sufficiently fantastic to make such things seem believable. In similar fashion, science fiction film carefully establishes and normalizes its *mise-en-scène* before introducing its alien or monster so that it will seem appropriate in context. Further, it persuades its audiences to surrender to its illusions not because the monsters are real but because they are both like other monsters and other filmed images. The Europeans made a varied visual impression on native observers. Some were struck by the "ugliness" and "deformity," of their hairy faces and blue eyes (Takaki 1993: 24–5). Europeans were fond of reporting that they were considered to be gods by the people they met, a claim that is now the subject of considerable anthropological debate. On the other hand, it became almost routine for European explorers to claim that they had encountered different species of people on their travels. As late as the mid-nineteenth century, travelers like John Petherick reported that in Central Africa an old Dinka man had told him of "people possessed of four eyes – two in front and two behind – and consequently they could walk backwards as well as forwards" (Schildkrout 1993: 31). The credulity of the Europeans seems to have been matched only by the inventiveness of the Africans in creating monsters of the forest. Once printed, these writings became the primary source for anthropologists, most of whom, including Charles Darwin, did not do what we now call field work but relied on the reports of travelers, missionaries and other colonial officials for their data. These lurid accounts made it easy to demonstrate the "discrepancy between 'civilization' and 'Christianity' on the one hand, 'primitivism' and 'paganism' on the other, and the means of 'evolution' or 'conversion' from one stage to the other" (Mudimbe 1988: 20). That is to say, for example, that the Kongo peoples' repudiation of Christianity by the late nineteenth century was proof in itself of their primitiveness, confirmed by the bizarre varieties of human life reported from the region. From the Western point of view, in order to be fully evolved humans had to be civilized, which meant that they would be Christians. In the science fiction

context, the question of higher evolution is likewise paramount. The Alien, for example, is physically all but indestructible, while the replicants of *Bladerunner* can seem more "human" than the biological humans.

In the 1995 film of Michael Crichton's novel *Congo*, the themes of colonial settlement, evolution and space technology were formulated in ways that would not have seemed out of place in a nineteenth-century anthropology society. The opening sequence compresses the many travel narratives describing journeys into the Congo into a series of Western stereotypes of East and Central Africa. To the accompaniment of a suitably African sound-track, the camera takes us from dawn on the savannah via the wildlife of the Masai Mara to the highlands of Central Africa, following the route taken by Stanley in his exploration of the Congo. When the Travi Com expedition arrives at Mount Mukenko, Charles Travis sends a video message to company headquarters in Houston, Texas, via satellite reporting success in discovering the flawless diamonds required to create a new laser gun. The satellite that makes the action possible is shown in high orbit, sending real time images across the globe. His colleague Geoffrey then takes him to look at some nearby ruins, only to disappear. His eyeball drops from nowhere into Charles' horrified hands. When the video camera is activated by remote instruction from Houston, the camera presents a scene of widespread destruction and death before it too is destroyed by a blurry form that the technicians speculate might have been a "baboon" or one of the "locals." The contrast between the hi-tech Western expedition with its prosthetic eyes and the primitive but dangerous Congo, so threatening to the biological eyes but a vital source of raw materials, could scarcely be more luridly drawn. Further, *Congo* connects the nineteenth-century colonial project directly to contemporary science fiction with its careful evocation of Houston as the site of the company, reminding viewers of NASA's Mission Control in the same city.

Films like *Congo* undermine the comfortable presupposition that there is no longer an assumption that the West is more evolved than its Others. When the performance artists Coco Fusco and Guillermo Gómez-Peña devised their piece entitled "Two Undiscovered Amerindians," it was their intention to satirize colonial attitudes to indigenous peoples by presenting themselves as the representatives of a hitherto unknown people, the Guatinauis (Figure 6.5). By performing in a cage in "traditional" costume but with a variety of self-evidently modern props, like a television, books and a computer, Fusco and Peña intended "to create a satirical commentary on Western concepts of the exotic, primitive Other; yet, we had to confront two unexpected realities in the course of developing this piece: 1) a substantial portion of the public believed that our fictional identities were real

Figure 6.5 Two Undiscovered Amerindians Visit Buenos Aires

ones; and 2) a substantial number of intellectuals, artists and cultural bureaucrats sought to deflect attention from the substance of our experiment to the 'moral implications' of our dissimulation" (Fusco 1995: 37). Rather than provide an opportunity for reflection on the colonial past "Two Undiscovered Amerindians" became a means for sections of the audience to demonstrate how effectively they had internalized the colonial role.

This attitude is what Octave Mannoni called the Prospero complex, alluding to Prospero's domination of the indigenous character Caliban in Shakespeare's play *The Tempest*. Mannoni asserts that Western identity is now predicated on being able to claim such dominance of the Other. His idea was borne out by the audience reactions to Fusco and Peña's performance, which ranged from anger at the imprisonment of helpless aborigines to taunting and touching in explicitly sexual ways. Curators and critics responded by attacking the performers for their inauthenticity, as if it would somehow have been more appropriate to use "real" Amerindians in this context. On the other hand, the director of Native American programs for the Smithsonian Museum in Washington D.C. was troubled to see that audiences responded in exactly the same way to the satirical performance as they did to her carefully constructed events that were designed to be as "authentic" as

possible. Fusco concluded that "the cage became a blank screen onto which the audience projected their fantasies of who and what we are" (Fusco 1995: 47), fantasies that in good part have been sustained and enabled by popular visual culture like science fiction.

Aliens as evil

In 1996, the Prospero complex in science fiction once again became big box office with the success of *Independence Day (ID4)*, then the highest-ever grossing movie, by combining all the existing science fiction imagery available into a seemingly new whole (Figure 6.6). This combination was apparent from the opening scene in which a giant spacecraft flies over the moon and casts the Stars and Stripes into shadow. At once the audience is reminded of the 1960s space race that was widely held to be the key to winning the Cold War and America's success in "colonizing" the moon. The giant alien spacecraft evoked 1950s films like *The Day the Earth Stood Still* as well as the later space sublime of *2001: A Space Odyssey* (1968) and *Close Encounters*. The destructive yet unnamed alien species was visually derived from *Alien* (1979) and an adaptation of African sculptures such as the Akua'ba doll. There was no subtlety in the depiction of the alien. Lieutenant Steven Miller (Will Smith) sets the tone early on by declaring that he will "whup E.T.'s ass." Psychologically, the film was the child of the Cold War films such as *Earth vs The Flying Saucers* (1956) that first featured alien attacks on Washington monuments. Thus, when the aliens succeed in destroying global communications satellites – that symbol of the 1950s space race – the humans are forced to resort to Morse Code for communication, rather than using the Internet which was created with just such a crisis in mind. This feel

Figure 6.6 A still from *Independence Day*

of a first generation science fiction film remains in place throughout, despite its curious montage of cinematic styles. The first half of the film, in which the aliens mysteriously arrive in dazzling cloud formations drawing vast crowds of onlookers, is strongly reminiscent of *Close Encounters*, until the devastating attack begins, blending Cold War imagery with the ruthlessness of *Alien*. The second half, with its glorious human comeback, is all but pure *Star Wars* – especially in the heroic soundtrack music – right down to the central plot device involving the discovery of the single way to shoot down the alien space ship. Added into the mix was the crash of an alien spaceship at Roswell, New Mexico in 1947 that is a staple of TV shows like *The X-Files*, and defensive "shields" on the alien ships taken from *Star Trek*. *Independence Day* is quite brazen in its efforts to enlist the audience into its synthetic enterprise, seeming to acknowledge that its audience has gone far beyond the traditional fan base for science fiction. While Spielberg made oblique reference to cinematic convention in *Close Encounters* by including the great French director François Truffaut as an actor, he did not require the audience to understand the reference in order to follow the plot. On the other hand, *ID4* wears its postmodernism on its sleeve by simply making direct script references to *The War of the Worlds*, *E.T.*, *The X-Files* and *Close Encounters*. At a tense moment early in the film, one character is even watching *The Day the Earth Stood Still* (1951). Visually, *Independence Day* sought to reabsorb all previous modes of science fiction film into a new whole. Its cueing of the audience is both a symptom of visual sophistication in an audience nurtured on video rental and a means of supplying a short-hand visual history to its target young teenage audience.

In similar fashion, *Independence Day* sought to reconfigure the differing politics of science fiction films from the 1950s to 1996 into a new narrative of American triumphalism in keeping with the national mood after the victories in the Cold War and Gulf War. The critique of market economics implicit in 1980s science fiction was now displaced onto the aliens who seek to exploit the earth's raw materials themselves. The aliens were depicted as seeking to colonize Earth and then "consume every natural resource and move on" to another hapless planet. Now all humans become victims of colonialism and can unite against the alien oppressor under American leadership. The film reinvented the Clinton Presidency in these heroic terms, depicting the rehabilitation of the unpopular young President Thomas J. Whitmore (Bill Pullman), who redeems his early mistakes by learning to display true leadership. We see onscreen the commentators of CNN's McLaughlin Group, a right-wing political commentary show, attacking the President in the earlier moments of the film, only for his declaration of independence from the aliens to resound in the latter half. Here the film

displays a nostalgia for American (Cold War) leadership and authority, now desperately in search of an enemy and an issue. As the Americans broadcast their solution to attacking the aliens in morse code, a British army officer – located in the Iraqi desert to provide an echo of the Gulf War – mutters: "About bloody time." For the American audience and filmmakers, it is about time for the assertion of American global leadership. For other audiences, *Independence Day* might instead remind viewers that the United States continues to believe that it has a moral right to global leadership. Science fiction film, which has a hard time imagining anything other than repressive political regimes, is the ideal genre to spread this message. It was thus no surprise to see Bob Dole, the losing Republican candidate in 1996, allying himself with the film's message, despite his earlier critiques of Hollywood films. President Whitmore was nonetheless clearly modelled on Bill Clinton, but given a background as a fighter pilot like Kennedy. Just as the film jumbled the icons of the traditional left and right into a new format, so has contemporary American politics been reshaped around the fear of aliens. In order to promote his re-election chances, Clinton signed into law a raft of measures extremely hostile to immigrants and immigration that in effect shared the logic of *Independence Day* – assimilate or die. In a curious postmodern irony, Clinton found himself in the Rose Garden one month after the release of *Independence Day*, announcing that "we are not alone," a discovery derived not from gleaming spaceships but the traces of microbes on a fragment of Martian meteorite extracted from the Antarctic snow.

Yet for most viewers *Independence Day* was not a political film. The focus is instead on the regeneration of the "family of man," echoing the exhibition of that name from forty years ago. That is to say, both the earlier exhibition and contemporary film wanted to insist on the unity of humanity, rather than the differences of race, gender, class and sexuality that have preoccupied much of recent cultural and political debate. In his keynote Independence Day speech, President Whitmore reflects on "mankind – that word should have new meaning for all of us today. We can't be consumed by our petty differences any more." The plot of *Independence Day* resolves those differences within the different varieties of the American family, which is taken to be equivalent to mankind as a whole. Within this familiar viewpoint, what is unusual is that the film looks at the family from the child's point of view. The alien invasion is coordinated from the "Mothership," identifying the mother as the "problem" within familial structures. The "bad mother," represented by the President's wife in an unsubtle reference to Hillary Rodham Clinton, is killed in a helicopter crash, leaving their daughter in possession of her father. On the other hand, Miller is motivated by the crisis to marry his

long-term partner, much to the approval of her son Dylan (Dowell 1996). The scientist David Levinson (Jeff Goldblum), who cracks the alien code with his laptop computer, wins back his former wife and even more importantly makes his father admit that he is proud of him. Even the alcoholic father redeems himself by his suicide mission to destroy the alien battleship. The rest of humanity is reduced to cheering crowds as the spaceships come crashing down, featuring Egyptians by the pyramids and presumably African "tribes" waving spears.

It is perhaps fitting that the two heroes of *Independence Day* were respectively an assimilated Jew and a middle-class African-American. David Levinson's character is strongly contrasted with that of his nebbish father, Julius, played by Judd Hirsch just this side of Fagin. David's assimilation is marked by his marriage to a preppy Presidential aide. His partner Steven Miller is an African-American fighter pilot, carefully introduced to the audience as a respectable homeowner and father. By the movie's end, Levinson has acquired some grit and Miller has ascended to the marital state as the two combine to defeat the aliens. In short, *Independence Day* shows that immigrants who conform to the assimilation ideal can be fully American, that is to say human, while those who do not can expect only rejection. *Independence Day* offered a conservative view of American culture as a "given," established in the past by such icons as the battle for Iwo Jima and the moon landing, both carefully represented on screen. Just as the film begins with the American flag being threatened by aliens, it ends with the crashing wrecks of their spacecraft forming a triumphal Stars and Stripes in the sky, the ultimate Fourth of July fireworks. New arrivals are expected to assimilate to this culture and not attempt to influence or change it, let alone to try and dominate. *Independence Day* made great commercial play on the intense anxiety "white" Americans now feel as the demographics of the United States point toward a decisive change in the nature of "Americanness" in the twenty-first century.

Director Tim Burton discovered to his cost that audiences take such questions seriously when his spoof science fiction epic *Mars Attacks* (1996) failed at the box office, despite an array of leading stars. *Mars Attacks* portrays the Martians as duplicitous aggressors who are nonetheless more than capable of outwitting human politicians and military might alike until it is accidentally discovered that Hawaiian pop music from the 1950s causes their heads to explode. This comic book narrative undercut the new portentousness of science fiction without offering a substitute. On the other hand, *Men In Black* (1997) made the parallel between the fictional struggle with aliens and the actual politics of immigration into the United States quite explicit. Its opening scene is strongly imitative of Stephen Spielberg's visual style and

even seems to parody the content of the beginning of *Close Encounters*. For whereas Spielberg's film begins with a mysterious occurrence in the Mexican desert being investigated by a mostly American team, *Men In Black* opens with a group of Mexicans being chased by United States' border officials until the Men in Black, led by Tommy Lee Jones, intervene to show that the real issue is controlling the extraterrestials. Unlike the INS, which is widely felt to be both heavy-handed and inefficient, the Men In Black do an excellent job of supervising the resident extraterrestials in the United States, who in turn do not disrupt the American way of life. For all its cartoonish humor, *Men In Black* offered audiences the reassuring image of the United States in control of its borders that *Mars Attacks* neglected to create. It may be more than coincidence that *Men In Black* was a box office smash.

Trekking

In determining the influence of science fiction on contemporary identity, *Star Trek* is of particular importance because of its enormous popularity. By 1991, 53 percent of Americans said that they were *Star Trek* fans, giving considerable weight to its interpretation of the present-as-the-future. Further, its unique status as a long-running cluster of television series in eternal syndication, as well as two series of spin-off films, means that *Star Trek* is the only science fiction vehicle to have been in production both during and after the Cold War. For my generation, born in the 1960s, *Star Trek* has always been there, sometimes infuriating, sometimes exciting, but a part of what it means to be our kind of modern. Finally, its success has had a direct impact on the United States' space program, providing welcome support for NASA (Penley 1997). Although *Star Trek* is set in the distant future where our present-day dilemmas are held to have been resolved, they often reappear in different form. The crew members in *Star Trek* all belong to the United Federation of Planets, a transparent reference to the United States. All Federation members now can claim the status of being human, unmarked by race or ethnicity, that Richard Dyer has described as the peculiar characteristic of whiteness (Dyer 1997). With limited twentieth-century imaginations at work, contradictions often arise. In the original *Star Trek* series (1967–69), featuring Captain Kirk and Mr. Spock, the Klingons took the place of the Soviet Union as the implacable enemy of the United States/ Federation and hence were depicted as an inferior species. The only other regularly featured aliens were the Romulans, whose evasiness and secrecy clearly made them ciphers for the Chinese. In *Star Trek: The Next Generation* (1987–89) (hereafter TNG), a multi-cultural alien future had to be imagined. Thus, the Klingons were gradually reconceived in the fashion of

Western perceptions of Native Americans or Zulus – a proud, warlike race, eating "disgusting" food, and with a very direct sexuality. These characters were all played by African-Americans. The Enterprise now had a Klingon officer, Lieutenant Worf (Michael Dorn) who had been raised by humans but remained "essentially" Klingon. As Levar Burton, known to television viewers worldwide from *Roots*, played Chief Engineer Geordi La Forge, two African-American actors often interacted in roles where La Forge has the "white/normal" point of view and Worf that of the "black/exotic." In an episode entitled "The Icarus Factor," Worf needs to perform a Klingon ritual involving the endurance of repeated intense pain in the presence of his friends. La Forge agrees to participate but makes his repugnance clear, allowing *Star Trek* to depict racial difference while disavowing that it is doing so (Berg 1996). With the onset of *glasnost* the Klingons had to have a makeover, with the result that the Klingon General Chang in the film *Star Trek VI: The Undiscovered Country* (1991) pursued Kirk while quoting Shakespeare "in the original Klingon." Nonetheless, the Klingons were still racially differentiated from the "white" crew of the Enterprise. As Kirk invites the Klingon crew on board for a ceremonial banquet, Chekov mutters "Guess who's coming to dinner," alluding to the film starring Sidney Poitier in which a white couple confronts the trauma of their daughter's engagement to an African-American. When Worf arrives on the bridge of the Enterprise in *Star Trek: First Contact* (1996) Riker, the second-in command, teases him: "Still remember how to fire a phaser?" as if to remind the character and the audience of Worf's difference. For all the Star Trek sloganizing of "'Infinite Diversity in Infinite Combinations,'" it more closely follows the logic of cultural relativism – that all cultures certainly have value but must be related to the evident superiority of the (white) American way of life.

While race is referred to in such sub- and inter-textual fashion, gender and sexuality are explicit points of differentiation in *Star Trek*. In the first series, the roles played by women were often hollow clichés, epitomized by Lieutenant Uhura's signature line: "Hailing frequencies open, Captain." Although the Enterprise crew was explicitly multi-racial, featuring the African-American Uhura, the Russian Chekov and the Asian Sulu, gender roles seemed to have remained stuck in the 1950s. Captain Kirk frequently pursued various love interests, but these never came to anything as his "family" was the homosocial world of the Enterprise. Unsurprisingly then, there is a strand of homoeroticism running throughout *Star Trek*. This aspect of *Star Trek* has never been directly addressed by the program makers but has instead been given extended treatment by its legion of fans, who have reworked *Star Trek* themes in media ranging from "children's backyard

play to adult interaction games, from needlework to elaborate costumes, from private fantasies to computer programing and home video production" (Jenkins 1991: 175). The creation of a queer dimension to *Star Trek* is a striking example of the way in which mass media audiences seek their own meanings within the limited range of materials available to them and then find alternative outlets for those ideas. While the program and film makers now clearly seek to encourage this fandom, it was at first accidental, resulting from the endless opportunities to see popular shows offered by cable syndication and home videotaping. *Star Trek* has spawned an extensive network of conventions, fanclubs, newsletters and now websites that have vastly expanded upon the original series. Perhaps the best known example of this appropriation is the K/S fanzines, documented by Henry Jenkins and Constance Penley, in which mostly female writers create stories that often feature homosexual encounters between Captain Kirk and Mr. Spock from the first series (Jenkins 1991; Penley 1992). Fans expand upon the stories offered in the original series to fill in the gaps with their own versions of what might have happened.[1] The looseness of the *Star Trek* teleplays, which were never intended for close reading, in fact permits an extensive range of possible interpretations of the sexuality of the leading characters. For although Kirk appears to be the typical macho womanizer, he is also the emotional one of the two, compared to Spock's famous pursuit of logic. This polarity was itself reversed in a *Star Trek* episode – widely regarded by fans as a classic – entitled "Amok Time," during which the Vulcan Spock experiences *pon farr*, a biological desire to mate that can be summarized as being in heat. The Enterprise hastens to return Spock to Vulcan to fulfill his needs, but not until Kirk has had to fake his own death at the hands of Spock, courtesy of some medical wizardry from Dr. McCoy. When Spock sees the "resurrected" Kirk, his emotion is distinctly unVulcan and provides one of the key points of departure for a queer reading of *Star Trek*, as the normally masculine Spock becomes feminized, making Kirk in effect his husband. Fan writers have poured into the gaps left in this episode's account to create an extensive literature on Kirk/Spock encounters that has its own stars, bulletin boards, and conferences. *Star Trek* fans have continued to explore the possibilities of alternative readings in all the various versions of the series, from heterosexual S/M to all manner of alternative sexualities. In *The Next Generation* (TNG), the alien character Q, from a "superior" species of immortal omnipotent beings, causes havoc at his every appearance by throwing the Enterprise into unusual situations. Q has a pronounced affection for Captain Jean-Luc Picard that even finds them waking up in bed together in one episode, leading Henry Jenkins to ask: "Could Q, who minces and swishes his way through every episode, be a Queen? Was Q, the

outrageous shape shifter, Queer?" (Jenkins and Tulloch 1995: 261). For fans in the Gaylactic Network, an organization for gay, lesbian and bisexual science fiction fans, the answer is a resounding yes. With the arrival of the Internet, it is now possible to find adult-themed *Star Trek* stories involving characters from all the various series at the click of a mouse.

Increasingly *Star Trek* has come to displace these anxieties onto the Borg, an alien race featured in TNG. Indeed, the viciousness of the unnamed alien species in *Independence Day* clearly owed much to the Borg. The Borg – short for cyborg, a combination of cybernetic technology and organic matter – forcibly "assimilate" other species into the Borg while proclaiming their slogan: "Resistance is futile." This process of assimilation is the sole motivation of the Borg, who never cease their efforts to absorb all species into their collective. The Borg have injected new life into a series that had long been marked by nostalgia for the original 1960s television program and its ageing stars. The Borg are perhaps the only alien species created by *Star Trek* to be genuinely frightening. Descendants of the Cybermen from the cult British television show *Dr Who*, the Borg combine physical size, mechanical movement and metallic uniforms with laser eyes and unbreakable will. In a refinement on the soulless creatures of Cold War science fiction, the Borg are a collective, able to communicate with each other via the "hive mind" in which all Borg participate. The Borg thus combine the collectivization of Soviet communism with the aggressive acquisitiveness of Western capitalism into a new hybrid that is a worthy metaphor for global culture. As the *Star Trek* franchise is itself a remarkably successful aspect of global media marketing, it is unsurprising that it is extremely hostile to the Borg, who represent the alter ego of the friendly Federation. It is noticeable that this tension is figured in terms of gender. The Enterprise in its various forms has always been a very masculine space, a batchelor pad for the future with its black armchairs, matt grey surfaces, automatic cooking devices and almost total absence of interior decoration. It is always lit in a uniformly bright light that carefully avoids any shadows being cast, just as Star Fleet officers and crew rarely show any emotion, however drastic their circumstances. The Borg ships, on the other hand, are dark and gloomy places, often obscured by jets of gas. The collective establishes itself in a space that lacks the geometric perfection of the Enterprise and instead creates a womb-like cavern in a self-conscious evocation of the *mise-en-scène* of the *Alien* series. When individual Borg are not working, they insert themselves into the walls of the ship into niches that are provided with a curious circular electronic screen, across which sparks of electricity play, evoking at once Dr. Frankenstein's creation of his monster by electrification, the Cold War representations of crazed scientists and contemporary fears of the digitization of society. While

Independence Day offered a straightforward intergalatic war, *Star Trek*'s fascination with the Borg puts into play a more complex representation of contemporary society figured through gender.

The TNG crew first encountered the Borg during an episode of the television series called "Q Who?" Tellingly, the ambivalent figure of Q transports the Enterprise to a remote corner of the galaxy in order to set up an encounter between the Federation and the Borg, with the aim of lessening human arrogance. Given that Q seems to represent the indeterminacy of sexuality in *Star Trek*, he would be an unusual link to the war with the Borg, were they not so strongly gendered as feminine in opposition to the masculine Federation. The captain of the Enterprise, Jean-Luc Picard (Patrick Stewart), is able to learn about the Borg because Guinan, the wise barkeeper played by Whoopi Goldberg, has had experience with them before. She recounts how "my people encountered them a century ago . . . they destroyed our cities, scattered my people throughout the galaxy They swarmed through our system, and when they left, there was little or nothing left of my people." Given that Goldberg is African-American, this speech was clearly intended to evoke memories of slavery. The Borg embody a wide range of anxieties for late modern Western culture. They evoke the ghosts of slavery and colonization that haunt Western memory, while at the same time evoking fears that Western culture itself is now about to be "swamped," to use Margaret Thatcher's notorious term. Borg assimilation is the postmodern version of Communist domination that must be resisted "to the last ounce of my strength," to quote Picard. Furthermore, their androgynous bodies, asexual reproduction by assimilation and association with Q plays on the uncertainties of sexual identity and sexual reproduction in the age of genetic manipulation.

It was no surprise, then, that hard on the heels of *ID4* came the feature film *Star Trek: First Contact* (1996) centered around a conflict between the TNG crew and the Borg for possession of the planet Earth. The Borg declare that "your culture will adapt to service us," seemingly an ironic restatement of Star Trek's famous credo, "to seek out new life and civilizations." Much of the film is concerned with trying to differentiate the Federation's benign neo-colonialism from the aggressive imperialism of the Borg. This argument centers around the question as to which group is more evolved, a favorite *Star Trek* plot device that echoes nineteenth-century colonial assertions of a cultural hierarchy of evolution. Indeed, in a much-discussed TNG episode, "I, Hugh," the crew capture a Borg crewmember and assimilate him to the Federation's value-system. This adaptation is marked by the fact that the Borg learns to say "I am Hugh," the name he has been given by La Forge, rather than "We are Borg," as the collective consciousness articulates itself.

Figure 6.7 The crew from *Star Trek: The Next Generation*

However, the distinction is not as sharp as it first appears because the Borg is in effect saying "I am you." Like latter-day Robinson Crusoes, the crew have no qualms about renaming the Borg or about performing their own assimilation. In so doing, the crew violate the Federation's Prime Directive not to interfere in alien cultures. For the Borg's violent assimilation into a collective is so self-evidently bad within the *Star Trek* narrative that it necessitates the rational reassertion of bourgeois individualism.

In *Star Trek: First Contact*, two TNG characters, Captain Picard and the android Data (Brent Spiner) are used to try and establish a clear contrast with the Borg. In the film, the two characters are presented as buddies in the manner of Kirk and Spock, setting up the familiar binaries of male/female, human/non-human that the old characters represented. *Star Trek* fans are cued to make this comparison very early in the film. The Enterprise has been ordered away from the battle with the Borg, an order Picard intends to disobey. Data says he speaks for everyone in declaring "To hell with our orders," a direct echo of Spock's comment at the end of *Star Trek VI: The Undiscovered Country*, when the Enterprise is ordered to return for decommissioning: "If I were human, I believe my response would be 'Go to hell.'" Disobeying orders is *de rigueur* in *Star Trek* in order to "save the galaxy," as Kirk puts it in *Star Trek: Generations*.

For Picard, the encounter with the Borg gives him a chance to avenge his own previous assimilation by the Borg into their spokesperson, Locutus, a tension the viewer is expected to understand from an intertextual knowledge of the television series. Picard discovers that he is still able to understand the Borg's collective consciousness, giving the Enterprise a decisive advantage, but also showing that he is not entirely human. The character Locutus was created by the *Star Trek* team in response to the Alien Queen featured in the film *Aliens*, suggesting that assimilation in some way affects gender as well as species. As the Borg "reproduce" asexually by assimilating other species into their collective, the process would presumably entail becoming neuter or infertile. As one looks around the Enterprise crew, this difficulty of distinguishing between human and cyborg, or human and alien, becomes increasingly apparent. La Forge, whose blindness was formerly overcome by means of a visor that converted light into nerve impulses, now comes equipped with an "android" eye, capable of focusing on an object through tree cover at a distance of 500 meters. The new eye renders him at least partly cyborg and contradicts his repeated assertions during the television series that "I like who I am" as a blind person and that he did not wish to regain standard vision. The Klingon Worf and the empath Commander Troi are overtly non-human, while at the heart of the film is the android Data, who has long aspired to be more human, but is now given the opportunity to become a cyborg. Data's decision to reject the cyborg option allows the Federation to emerge victorious but also allows for a different reading of the film.

The (mostly) human characters rely on connections to the past in order to establish that they are in no way to be thought of as cyborgs. Of course, as the "past" within the film is still the future from the spectator's point of view, actual historical experience can still be safely ignored. By traveling back in time to the twenty-first century, the Borg endeavor to prevent the "first contact" between humans and aliens. If they are successful, the planet will be open to Borg assimilation. For first contact "unites humanity in a way no one ever thought possible," to quote Troi. The benign and progressive Federation depends on this unity, even though it is enabled only by the visitors from outer space. One testament to the progress thus achieved comes when Picard lectures Lily (Alfe Woodrard), a twenty-first century woman, on the abolition of the profit motive: "Money doesn't exist in the twenty-third century. The acquisition of wealth is no longer the driving force of society." He claims that capitalism has been replaced by the nonetheless rather Protestant moral earnestness of development and discovery, with the goal being to "better ourselves." However, as he pursues the Borg with utter disregard for loss of life amongst his own crew, Lily accuses him of acting like Captain Ahab in *Moby Dick*, obsessed with revenge at all costs. If Picard

is to be seen as Ahab, it opens an interesting ambiguity in the film. Ahab is understood in the sense given to him by the Caribbean critic C.L.R. James as the "totalitarian type" endemic to modern Western culture (James 1953: 6). Consequently, Picard loses his "normal" sense of strategy and even the value of his crew in his pursuit of the (white) Borg Queen. Picard refuses to accept that the best way to deal with the Borg at least cost to human life is to evacuate and destroy the Enterprise. His response to Lily's accusation is to claim angrily that he has "a more evolved sensibility," a phrase whose Social Darwinist overtones are made clear by the fact that Lily is an African-American woman. When Picard sees the strength of Lily's analogy by quoting Melville to himself, she admits that she has not read the book, a cue to the viewer that Picard is after all still superior. However, by renouncing his role as avenger, Picard also contradicts his high-minded stance. Destroying the ship cannot be assumed as inevitably destroying the Borg, for they have repeatedly escaped from such situations before. In *Moby Dick*, the crew are opposed to Ahab's strategy because it denies them the opportunity to make money in the usual way by hunting whatever whales they happen to find. For them, Ahab's madness lies in defying those very market rules that Picard has earlier described as irrational. As befits the multi-national franchise that *Star Trek* has become, the supremacy of capitalist values is asserted against the grain of the narrative itself.

Data is presented with a different dilemma that nonetheless leads to a similar normative conclusion. As an android, he is constantly striving to be more human, to reduce his difference and thus in effect to assimilate. The *Star Trek* narrative constantly reminds its audience that Data is not human. In the first regular season episode of TNG, "The Naked Now" (1987), Data adopts Shylock's speech from *The Merchant of Venice* to claim his similarity with humans: "We are more like than unalike. . . . I have pores; humans have pores. I have fingerprints; humans have fingerprints. My chemical nutrients are like your blood. If you prick me, do I not [pause] leak?" Data's assertion of sameness marks him as the Other, in this case as a Jew. (In passing, one might note that Jews had disappeared from *Star Trek*'s universe, until TNG introduced the Ferengi, a species who live for profit, are cowardly and highly sexual, and have prominent noses.) In later episodes, the Federation seek to repossess Data, or his android daughter Lal, forcing Picard to evoke the parallel of slavery and thus cast Data as African-American (Wilcox 1996). For all his efforts to "evolve," Data remains a machine, the Tin Man of the Enterprise.

The Borg Queen (Alice Krige) offers him a different choice – the chance to assimilate with cyborgs, rather than with humans. Her lure is not power but sex. For as the leader of the Borg, she is able to call herself "I" and thus

apparently is free of the constraint to reproduce by assimilation that is imposed on the "drone" Borg in the collective. Once Data has been captured by the Borg, they convert part of his arm to organic matter, making him into a cyborg. As he awakes, he informs the Borg that he will be able to resist them because he is "programed to evolve." The Borg Queen counters that the Borg also "want to evolve toward a state of perfection." "Forgive me," he replies, "Borg do not evolve. They conquer." Thus the Borg are directly compared to (human) imperialists whose rhetoric of higher evolution barely concealed their heart of darkness. By contrast, like Picard, Data claims a "genuinely" higher level of evolution because it is written into his programing and is thus inescapable. In this confrontation for superior evolutionary status, both contestants are non-human, at least part machine. They evolve either by programing or by forced assimilation rather than through historical experience or biological selection. They are both examples of what Richard Dyer has called "extreme white," skin that is not just white in hue but so exaggeratedly white that it is non-human, suggesting "the terror of whiteness of being without life, of causing death" (Dyer 1997: 210). Here Data, a machine, is without biological life, while the Borg's very existence brings death to others. The human Picard was unable to sustain his claim to be superior in evolutionary terms, leaving the cyborg and the android to debate the honor. This contest, like all such debates in science fiction films over human status, "may suggest that the suspicion of nothing-ness and the death of whiteness is, as far as white identity goes, the cultural dominant of our times, that we really do feel we're played out" (Dyer 1997: 217). In *Star Trek: First Contact*, the result was that non-humans took over the action, a drama very different from that of the swashbuckling Captain Kirk and his trusty sidekick Mr. Spock.

The Borg Queen turns from such electronically-generated argument over cultural evolution toward organic sensuality (see Figure 6.8). By manipulat-ing Data's electronic circuitry, she turns on his emotion chip, enabling him to feel sensations on his new organic skin and blows on it, causing Data to shudder orgasmically. In case we have missed the point, her next line is the classic: "Was that good for you?" At this point we recall that Picard has told Data earlier on that "touch can connect you to an object in a very personal way." As the two touch an historic spacecraft, Commander Troi asks: "Would you two like to be alone?" In the same way, the encounter between Data and the Borg Queen is presented to the audience as a traditional heterosexual seduction by a *femme fatale*, but appearances can be deceptive. Data is offered a choice that is not so much assimilation as homosexuality, cyborg with cyborg, not man with woman. Like all same-sex relationships, this sexual encounter is necessarily non-reproductive. Data is "fully

Figure 6.8 The Borg Queen and Picard in *Star Trek: First Contact*

functional" sexually and has had experience – but never with a cyborg, giving "First Contact" a rather different resonance. This device seems to evoke old heterosexist fears that people can be converted to homosexuality by contact with homosexuals, but Data's self-evident post-coital pleasure (in a very brief shot) can also be read against the grain as a validation of coming out. To borrow D.A. Miller's distinction, homosexuality exists within the film at the level of connotation, rather than that of denotation or literal depiction, but is nonetheless essential to the plot (Miller 1991). At the end of *First Contact*, Data inevitably opts for the normative heterosexuality of his human companions and the Borg are defeated. Nonetheless, he admits to Picard that he was tempted "for 0.68 seconds. For an android, that is near an eternity." That is to say, Data hesitated in a queer future long enough for an almost infinite number of sensations. However, once that brief instant is over, Data returns to the (human) fold. Data's desire to be human outweighs his attraction to his fellow cyborgs, like a latter-day Caliban. Although *First Contact* seems to contradict *Independence Day*'s celebration of assimilation by its defiance of the Borg's cybernetic assimilation, it in fact ends in the same way, with the minority choosing to belong with the mainstream and becoming heroic in consequence.

Yet, as so often in science fiction, the resolution is never quite perfect. If Data avoids the drastic choice of homosexuality, he nonetheless opts for

miscegenation with another species. Nor, unsurprisingly, has *Star Trek* ended its fascination with the Borg. The current series *Star Trek: Voyager* has featured several encounters with the Borg, culminating in the assimilation of a Borg into Voyager's crew. Seven-of-Nine was born human until she was captured by the Borg. Voyager's holographic doctor was able in turn to remove her cyborg implants and the series follows her attempts to return to human ways as a Federation crew member. For some on board, like Ensign Kim, the fact that she is a tall blonde, who appears to be allowed to wear high heels as part of her uniform, has helped ease the transition. But Seven-of-Nine's assimilation has not resolved *Star Trek*'s category crisis over the definition of humanity. In a 1997 episode called "The Raven," some very traditional colonial dilemmas over the assimilation of indigenous peoples were played out. In her attempt to assimilate, Seven takes a dining lesson from the ship's chef, who instructs her in eating while seated and the manipulation of silverware, evoking colonial efforts to assimilate their subject peoples to Victorian dining etiquette. At this moment, Seven reverts to being a Borg, as a homing signal from the Collective causes her Borg implants to regenerate themselves. The reborn cyborg embodies the old Western fear that the "primitive" biological essence of native peoples could never be truly effaced by cultural means. The episode ends with Seven returning to the Federation fold, but nonetheless it seems that *Star Trek*'s relentlessly positive and positivist portrayal of the future is unable to resolve the category crisis over the definition of humanity, even within its own framework. Indeed *Voyager*'s central drama in its 1997–8 series was the tension between the former Borg and the (human) Captain Janeway. As Seven became an established crew member, she increasingly used her Borg technical know-ledge and ability to adapt to new threats in the service of Star Fleet. Just as it is now unclear what difference there is between the Borg and the Federation in the fictional world of Star Trek, the definition of humanity is itself no longer as straightforward as it once appeared.

The contrast between *Independence Day* and *Star Trek* suggests that what is ultimately under discussion, and apparently under threat from within and without, is the hierarchical evolutionary cultural ladder inherited from colonialism. This long-lasting construct has placed the white heterosexual at the pinnacle of evolution and culture. Even at the final frontier of science fiction, the human can no longer be exclusively presented as white hetero-sexuals. For while the science fiction of the 1950s attempted to negotiate the fear of an external (Soviet) threat, contemporary science fiction finds itself seeking to justify historical disparities inherited from the long centuries of colonialism in the new circumstances of global culture. The suggestion is that if the cultural distinctions of the earlier period are abandoned, humans

will have become nothing more than cyborgs. The contradictions in such claims are clearly apparent. First, androids and cyborgs are often presented in the new science fiction as the carriers of cultural ideals. Second, if it is bad to be a cyborg because your individuality is crushed by the collective, it is certainly possible to read this as a critique of global capitalism rather than the now defunct Soviet communism. Finally, just as Darth Vader was the only compelling character in *Star Wars*, the Borg are fascinating in ways that the Federation's tired array of heroes are not.

TV past and present

It is in fact noticeable that contemporary American popular television has turned away from science fiction in favor of an opposition between a heroic past and a paranoid present. The notion of the future as a place in which contemporary dilemmas can be resolved has simply been dropped as no longer convincing to contemporary audiences. *Star Trek* was itself a reworking of the American frontier story – "space, the final frontier" – in a futuristic setting. American television has consistently used the United States' history as a source for uplifting stories, especially in the format of the Western. The last of these shows in syndication was *Dr. Quinn, Medicine Woman*, in which the Western is remade as a multi-cultural and emotionally sympathetic place, now that the routine massacre of Indians is no longer an acceptable plot device. A more dramatic solution to the problem of finding a convincing setting for heroic actions has been the creation of shows set in a wholly mythical past, such as *Hercules: The Legendary Journeys* and *Xena: Warrior Princess*. In this entirely fictional past, men and women alike have cartoon bodies of sculpted muscle. Although Xena is an Amazon she certainly has not followed the legendary Amazons in cutting off one breast to facilitate the use of bow and arrow. The short-lived Celtic televisual fantasy *Roar* (1997) was set in fourth-century Ireland, capitalizing on the vogue for heroic Celts established by Mel Gibson's Oscar-winning film *Braveheart*. *Roar*'s heroes are also fighting invaders, Romans, in a mediascape deliberately composed of elements taken from the dystopian fantasy *Mad Max*, punk fashion and elements of ancient costume. Unlike the science fiction reliance on technology to resolve situations, such as *Star Trek*'s warp drive and transporter beam, these new Romantic heroes rely on their own strength. But they do possess remarkable powers and are able to gain even greater abilities through the intercession of magical or divine agencies. In this respect, these series owe much to games like Magic and the MUD staple Dungeons and Dragons. At the same time, they represent a nostalgia for a fantasized past in which the human was truly

all-powerful, unthreatened by the cybernetic or the digital. Just as eighteenth-century Romantics fantasized about Celtic figures like the imaginary poet Ossian at the onset of industrialism, television's neo-Romantics have turned to an imaginary past to escape the dilemmas of the present and thereby create a humanity that is more powerful, wiser and fully self-defined.

This utopian fantasy is paralleled by series set in the present that play on the viewer's paranoia and anxiety. Shows like *Millennium* and *The X-Files* warn us respectively that "the time is near" and that "the truth is out there." The superpowers that Hercules and Xena enjoy as a matter of course have now been driven to the margins of postindustrial society but the crisis of the present (millennium) are about to make them apparent again. The FBI agents Scully and Mulder in *The X-Files* (see Figure 6.9) are Kirk and Spock for our times – her rational, skeptical and logical approach contrasting with his emotional belief in the "truth" of what he sees. In scenarios that blend the paranoia of left-wing conspiracy theorists and right-wing militia groups, the government has access to remarkable information about paranormal phenomena that are stowed away in classified X-files. As Scully and Mulder investigate the tangled web of conspiracy, fact and fiction created by the show, the sexual tension between the two characters is constantly displaced onto their differing views on the supernatural. For Mulder – and his fans – the 1947 events in Roswell, New Mexico, will always be proof of the presence of extraterrestials, no matter how much evidence to the contrary is offered by the government. Indeed, these efforts are simply a testament to the extent of the cover-up. For Scully, a weather balloon is just a balloon. The show's success depends on this representation of diametrically opposed views, even while its heart seems to belong to Mulder.

Both *Millennium* and *The X-Files* function around an always open plot structure, so that fans scarcely have to try to create extraneous narratives for the series – rather, watching them demands that spectators try and make sense of their inherently unintelligible narratives. The *Star Trek* fan network has always existed in tension with Paramount, who produce the series, with the latest of many tussles coming over Paramount's claiming the "right" to exclusive use of the *Star Trek* name on the Internet, which would render thousands of fan created websites illegal. On the other hand, the Fox network that airs both *The X-Files* and *Millennium* set out to create shows that would produce intense fan response. The director Chris Carter built on the cult success of his *Twin Peaks* and will frequently put provocative details into programs aimed at the fans. In the 1997 Halloween episode of *Millennium*, for example, the ghost is seen reading Jean-Paul Sartre's existential novel *The Age of Reason* in French, a detail that added nothing to the plot but

Figure 6.9 Mulder and Scully from *The X-Files*

gave new fodder to the fan speculation machine. Similarly, in a 1998 episode of *The X-Files*, a slightly worse for wear Mulder sings the soul classic *Shaft* to Scully, playing on the sexual tension between the two that is carefully not cultivated by the show itself but by the fans. Carter's shows do not even try to present dramatic resolutions. When one appears to approach, it simply opens the door onto another maze of plot and counter-plot, mirroring the conspiracy theories that flourish in modern American life. The media over-load of everyday life is deliberately played back to the televisual spectator of *The X-Files*, creating a series of mirrors that openly defy interpretation. In the now-classic episode of *The X-Files*, "Jose Chung's *From Outer Space*," a character known only as the Man in Black scorns the FBI agents' attempt to understand extraterrestial activity: "Your scientists have yet to discover how

neural networks create self-consciousness, let alone how the human brain processes two-dimensional retinal images into the three-dimensional phenomenon known as perception. Yet you somehow brazenly declare that seeing is believing" (Lavery, Hague and Cartwright 1996: 13). Feminist theorist Donna Haraway has issued another challenge to the scientific notion of observation, arguing that "vision is *always* a question of the power to see." Instead, she calls for the creation of "situated knowledges" that accept the inevitably partial viewpoint of such knowledges: "Vision requires instruments of vision; an optics is a politics of positioning. Instruments of vision mediate standpoints; there is no immediate vision from the standpoints of the subjugated" (Haraway 1991: 193).

Someone watching a movie or sitting in front of the television is at first in the position of the subjugated, bound to follow the plot as given by the film or program makers. Yet many fans refuse to be limited to the given point of view. They stretch the narrative, create alternative interpretations and re-imagine the endings. In a sense, they refuse to stay put in the body of the spectator as predicted by the film and television apparatus and become aliens, looking in ways that should not be possible. A number of early science fiction films like *It Came From Outer Space* and *The Fly* (1958) did in fact attempt to represent the alien way of seeing (Sobchak 1987: 93–4). Although *First Contact* does represent the Borg looking at Captain Picard, there is no sense in which the viewer is invited to identify with that point of view. An alien in *Independence Day* is shown looking at a missile countdown only to emphasize human superiority. The alien way of seeing is one that is excluded from modern power structures, just as colonial culture excised the point of view of the colonized. In terms of challenging geopolitical power structures, it is of course a weak point of view to adopt. Most *Star Trek* fans do not envisage overthrowing the United Federation of Planets. But in an everyday life where so many people are treated as aliens by their own societies, it can be very liberating to engage actively with the alien point of view, to boldly go where no one has gone before. In a time when there seems to be no politics in politics itself, the act of imagining a different future is a social practice that has extended but unpredictable cultural effects.

Note

1 However, the free play of fan writing is not always as free as some writers like to suggest. By way of comparison, Eric Michaels has described how Warlpiri viewing of Hollywood films concentrate on similar questions to fan discussion groups – such as the whereabouts of Rocky's grandmother – while maintaining a society in which "speech rights are highly regulated" (Michaels 1994: 2).

Bibliography

Baudrillard, Jean (1984), "The Precession of Simulacra," in Brian Wallis (ed.), *Art After Modernism*, New York, New Museum of Contemporary Art.

Berg, Leah R. Vande (1996), "Liminality: Worf as Metonymic Signifier of Racial, Cultural and National Differences," in Harrison *et al.* (1996).

Bhabha, Homi K. (1994), *The Location of Culture*, New York, Routledge.

Bukatman, Scott (1995), "The Artificial Infinite," in Lynne Cooke and Peter Wollen (eds), *Visual Display: Culture Beyond Appearances*, Seattle, WA, Bay Press.

Creed, Barbara (1990), "*Alien* and the Monstrous Feminine", in Annette Kuhn (ed.), *Alien Zone*, London, Verso.

Dowell, Pat (1996), "Independence Day," *Cineaste* XXII (3).

Dyer, Richard (1997), *White*, London, Routledge.

Fusco, Coco (1995), *English is Broken Here: Notes on Cultural Fusion in the Americas*, New York, New Press.

Greenblatt, Stephen (1991), *Marvelous Possessions: The Wonder of the New World*, Chicago, IL, University of Chicago Press.

Haraway, Donna (1985), "A Manifesto for Cyborgs: Science, Technology, and Socialist-feminism in the 1980s," *Socialist Review* (80).

Haraway, Donna (1991), *Simians, Cyborgs and Women*, New York, Routledge.

Harrison, Taylor et al. (1996), *Enterprise Zones: Critical Positions on Star Trek*, Boulder, CO, Westview Press.

Heller, Lee E. (1997), "The Persistence of Difference: Postfeminism, Popular Discourse, and Heterosexuality in *Star Trek: The Next Generation*," *Science Fiction Studies* 24 (2).

James, C.L.R. (1953), *Mariners, Renegades and Castaways: The Story of Herman Melville and the World We Live In*, New York.

Jenkins, Henry (1991), "*Star Trek* Rerun, Reread, Rewritten: Fan Writing as Textual Poaching," in Penley *et al.* (1991).

Jenkins, Henry and Tulloch, John (1995), *Science Fiction Audiences: Watching Doctor Who and Star Trek*, London, Routledge.

Lavery, David, Hague, Angela and Cartwright, Marla (1996), *Deny All Knowledge: Reading the X-Files*, Syracuse, NY, Syracuse University Press.

Lévi-Strauss, Claude (1976), *Triste Tropiques*, London, Penguin.

Michaels, Eric (1994), *Bad Aboriginal Art*, Minneapolis, University of Minnesota Press.

Miller, D.A. (1991), "Anal *Rope*," in Diana Fuss (ed.), *Inside/Out*, New York, Routledge.

Miller, Ivor (1995), "We the Colonized Ones: Kukuli Speaks," *Third Text* 32, Autumn: 95–102.

Mudimbe, V.Y. (1988), *The Invention of Africa: Gnosis, Philosophy and the Order of Knowledge*, Bloomington, Indiana University Press.

Penley, Constance (1992), "Feminism, Psychoanalysis and the Study of Popular Culture," in Lawrence Grossberg et al., *Cultural Studies*, New York, Routledge.

—— (1997), *NASA/Trek: Popular Science and Sex in America*, London, Verso.

Penley, Constance et al. (1991), *Close Encounters: Film, Feminism and Science Fiction*, Minneapolis, Minnesota University Press.

Schildkrout, Enid (1993), *African Reflections: Art from North-Eastern Zaire*, New York, American Museum of Natural History.

Shohat, Ella and Stam, Robert (1994), *Unthinking Eurocentrism: Multiculturalism and the Media*, London, Routledge.

Sobchak, Vivian (1987), *Screening Space: The American Science Fiction Film*, New Brunswick, NJ, Rutgers University Press.

Steichen, Edward (1986), *The Family of Man*, New York, Touchstone.

Takaki, Ronald (1993), *A Different Mirror: A History of Multicultural America*, Boston MA, and London, Little, Brown.

Telotte, J.P. (1995), *Replications: A Robotic History of the Science Fiction Film*, Urbana, University of Illinois Press.

Von Gunden, Kenneth and Stock, Stuart H. (1982), *Twenty All-Time Great Science Fiction Films*, New York, Arlington House.

Wilcox, Rhonda V. (1996), "Dating Data: Miscegenation in *Star Trek: The Next Generation*," in Harrison *et al.* (1996).

Global/Local

DIANA'S DEATH
Gender, photography and the inauguration of global visual culture

"**I**F WE REMOVE the image, not only Christ but the whole universe disappears," said Nicephorus, Patriarch of Constantinople, in response to the iconoclasts at the end of the first Christian millennium (Virilio 1994: 17). For all its drama, this comment almost seems like an understatement in the wake of the remarkable events following the tragic death of Diana, Princess of Wales, in a late-night car crash on August 31, 1997. Before her death, Diana was a combination of pop star, fashion model and royal figurehead, the most photographed person in the world. When she died, she unleashed a global mourning that was both intensely national and strikingly global. She at once attracted the attributes of a Latina saint, was given the oxymoronic title of the "People's Princess" by British Prime Minister Tony Blair and then commemorated as "England's rose" by Elton John. She joined the media necrocracy of Marilyn Monroe, James Dean and Elvis Presley and utterly eclipsed them all. A woman whose admirable charity work had never entailed the prospect of radical social change became the sign of a landmark shift in Britain's political culture. It was a truly millennial event, involving vast numbers of people, creating unforeseen consequences, and setting hitherto unimaginable precedents. One dramatic week later, Britain no longer looked like an old country and the world had its first insight into the ways that a global visual culture has the possibility to change everyday life in an instant. In this chapter, I shall not trace Diana's biography nor evaluate the consequences of her death for the British monarchy, tasks that have been amply undertaken elsewhere. Rather I shall

look at Diana's death as marking the end of photography and the inaugura-
tion of global visual culture.

Popularity and cultural studies

It must be admitted that this remarkable upsurge in popular sentiment was
scarcely anticipated by critics in visual and cultural studies. The Birmingham
Centre for Contemporary Cultural Studies had heralded the study of
"resistance through ritual," but they certainly did not mean the funeral
of a princess, the speech of an earl, or the songs of a staple performer from
Lite Radio. It seemed that eighteen years of Thatcherism had led many to
despair of the mainstream and instead to pursue their researches in minority
and marginalized groups. While that focus was both necessary and welcome,
it needs to be balanced with a greater understanding of the fissured and
fragmented body that Americans call the middle class and British political
culture now refers to as the vital center. Recent work on topics such as
whiteness (Dyer 1997) has already begun this task that appears all the more
necessary in the light of Diana's death. Darcus Howe saw the reaction to
Diana's death as a remarkable moment:

> It came like a thief in the night: unheralded and unannounced,
> united, disciplined and self-organized. The manner of its coming,
> the stoicism of this huge movement of British people suggests
> that it has been long, very long in its formation. Not simply a
> rush of blood with its accompanying hysteria, typical of vulgar
> spontaneity, but a measured entrance released by the death of its
> commander-in-chief, Diana Spencer. . . . Those of us who com-
> ment on social and political matters . . . did not have a clue
> about its existence, and along with so much else we have been
> exposed for a lack of careful observation and serious historical
> negligence.
>
> (Howe 1997)

In this carefully measured comment, there seems to be an echo of Stuart
Hall's admission that the arrival of feminism in cultural studies completely
transformed the project: "I use the metaphor deliberately: As the thief in the
night, it broke in; interrupted, made an unseemly noise, seized the time,
crapped on the table of cultural studies" (Hall 1990: 282). While the
metaphor seems to be the same allusion to the "thief in the night" made
by Howe, the scatological reference, which makes Hall rather more English
than he might like to admit, is what catches the eye. It seems that the trauma

of being challenged from within by feminism led Hall to express himself so pungently (Brunsdon 1996). It also betrays a concern that feminism and the feminine are in some way more vulgar and more physical than the serious enterprise of popular culture studies. Howe explicitly seeks to distance his account of Diana's death from vulgarity or, by extension, superficiality. On the other hand, as Billy Bragg and Linda Grant both highlighted, many commentators on the Left still found the events of her funerary week "mawkish" and "banal," even likening them to "the bayings of the mob," to quote Euan Ferguson. Several correspondents for the left-of-center *Guardian* referred in hostile fashion to the "mass hysteria" surrounding Diana's death (*Guardian* September 5, 1997). Hysteria is, of course, perceived to be a woman's disease and so the popular mourning becomes transformed into the feminization of the body politic.

For Linda Grant, such disdain was connected to "a sneering, Puritanical distaste for appearances, and an insistence that beauty must only come from within – any other kind can be nothing more than conniving artifice. It is the same as the assertion that football [soccer] is an honest, working-class game, while shopping and gossip are the insignificant, shallow activities of silly women who have nothing better to do with their time. And this disgust is another form of misogyny. . . . Here is the important and unavoidable truth about reality: that you can't have depth without surfaces" (Grant 1997). In this view, Diana was an emblem of visual culture, itself feminized in relation to the Word, a pop princess who liked Duran Duran, Wham! and John Travolta rather than more critically-approved music, in short someone who embodied what the British mean by the withering term "vulgar." Popular culture has been received into the academy on the basis that it "really" allows people to address serious issues behind the surface vulgarity. Diana's death forces us to realize that the distinction is, like all such distinctions, a form of élitism that wants to separate the serious wheat of popular experience from the chaff of its vulgarity. For the subcultures so celebrated in the cultural studies writings of the 1980s have given way first to fan cultures like those of science fiction and now to the mediatized world of post-fandom (Redhead 1997).

The British Left, from which cultural studies originated, was so badly wrong about the Diana phenomenon precisely because of its profound distrust for images and appearance. By the time of her death, Diana had become a global visual icon whose image was disseminated via all three varieties of modern visuality discussed in this book. Her image was so extraordinarily powerful because it incorporated the formal image of royalty, the popular photograph and the virtual image. In her passing, Diana caused this unlikely overlay to fall apart. Much of the general sense of

dislocation that followed her death can be attributed to this disruption of the symbolic order of everyday life. As a member of the British royal family, she benefited from the echo of power that adheres to the formal image of royalty. Indeed, her dramatic success in this role made it clear that the monarchy mattered in a way that most commentators had assumed it did not. As early as the 1950s, the popular press was criticizing Queen Elizabeth II for being aloof and rarely smiling, a perception that became widespread in the 1960s (Kelley 1997: 202). In 1969, the Queen had worn a simple dress and hat rather than robes and a diadem for the investiture of the Prince of Wales in response to pressure from Welsh nationalist sentiment. During the Queen's Silver Jubilee in 1977, Britain seemed divided over whether to celebrate or mourn the event. While many areas organized street parties and other celebrations, the Sex Pistols' ironically titled single "God Save the Queen" was at the top of the charts, despite being banned by the BBC. The *New Statesman* magazine, an influential center-left journal, published an Anti-Jubilee issue in which it recorded what some nine-year-olds in North London had written about the monarchy. One typical comment ran: "I don't like the Queen because she is too posh. She is too fussy. She looks like the Joker with her white face and red lipstick and she looks like a puff porcupine with those dresses and she thinks too much of herself and she doesn't care about the poor" (Fenton 1977). This critique concentrates on appearances. The Queen's clothes seem out of touch and her self-presentation makes her look like a comic-book villain rather than a hero. In the words of the Sex Pistols, "she ain't no human being." The former school-child would have been 29 at the time of Diana's death, typical of so many mourners in the streets of London. Yet in the same issue, the *New Statesman* had editorialized that "the monarchy is a dead hand, and that is bad enough: but it is a dead hand that could come dangerously alive . . . [given that] parliamentary democracy is extensively discredited in the popular mind and not entirely secure." The monarchy was discussed as if it was still central to issues of governance, even though the royals themselves did their best to stay out of party politics. In 1981, when Charles and Diana were married, feminists wore buttons saying "Don't Do it Di," while many others saw the spectacle as a crude attempt to distract attention from the problems of mass un-employment at the time. Indeed, the Queen and Prince Charles both distanced themselves from Mrs. Thatcher's policies, strengthening the peculiar alliance between the aristocratic British Left and the monarchy. Ironically, it was Diana herself who achieved what decades of leftist and republican comment had not, the thorough-going discrediting of the monarchy, working through the mass media. In such popular histories lies the movement noticed by Darcus Howe. For people like the North London

school-child, Diana was simply the last chance of the old system to put on a human face.

Photography and the Princess

Thus, photography was crucial to Diana's importance. She was not simply a symbol because the photographs that commanded so much attention were always of her as a person, rather than the abstract notion of monarchy that Queen Elizabeth II has tried so hard to represent. In the monarchical world-view, the person of the monarch is almost irrelevant, for the monarchy will always have a representative. One need only imagine the reactions to the death of a comparable figure like Hillary Rodham Clinton to see how much it mattered who Diana was. She was not simply another celebrity or beautiful woman, but a person who attained what now appears an un-precedented place in the global imagination through the medium of photo-graphy; a medium that was itself eclipsed during her moment of celebrity. In retrospect, it seems no coincidence that Diana's rise to stardom in the early 1980s accompanied the transformation of visual representation by electronic imaging. It mattered that she was imperfect, had off-days and, above all, that she was so very publicly unhappy because these things were visible in the photographs, attesting to reality in a virtual world. Photography created the fantasy of being a princess, and all the gender stereotypes associated with such a fantasy, and then literally dissolved it before our eyes. Diana said that the experience of being bulimic was the desire to vanish completely, like a soluble aspirin. Invisibility here was a fantasy not of power but escape, especially escape from photographers.

Diana's story was told in photographs. It has frequently been emphasized in the aftermath of her death that she was in some sense the creature of the media, or even that she manipulated photographs by posing for them, as if it was somehow possible to ignore the banks of cameras that attended her every move. More to the point, as Roland Barthes told us, "what founds the nature of photography is the pose" (Barthes 1981: 78). Like Madonna, Diana had raised the art of posing to new heights. But, as Madonna has often said, there is nothing inherently novel about such self-fashioning, which is typical of young women who follow fashion and popular music. Diana and Madonna were able to live out this fantasy on a global stage because of the new capacity of electronic communications to circulate images instantaneously around the world. For the tabloid journalist Harry Arnold, the conclusion was straightforward: "It was, to a certain extent, a marriage made by the media. She was created, if you like, as a bride for Charles." No doubt this was the royal intent. In 1977 it was said of Prince

Charles, quoting the usual "sources," that, "he will marry someone pretty and respectable quite soon and that she will then 'stay in the background as far as possible'." Diana's refusal to be the passive object of such media fashioning upset this simple plan. The various royal writers all agree that Diana's self-perception was transformed by her joining the media monarchy that the Windsors had become. Andrew Morton attributes the damage to Charles himself, who commented on her being "chubby" just before the wedding (Morton 1997: 128). Kitty Kelley asserts that in addition to Charles' comments, Diana was mortified by seeing herself appear "fat as a cow" on television (Kelley 1997: 276). Her physical appearance changed drastically so as to meet the media demand for slender, firm bodies, caused first by bulimia and later by her daily workouts at the gym. The media audience endlessly vetted every new look, so that in the end it can be said that we created the princess we wanted to see.

Whatever the first cause, Diana became involved in a complex exchange of image and gaze between herself and the mass media over her representation as soon as she became a public figure. As such, she was a classic example of Lacan's idea that the gaze is a two-way process, so that I see myself seeing myself, that is "I am photo-graphed" (Lacan 1977: 106). For Diana, it was almost literally impossible to see herself in any way without being photographed. Her real sense of being looked at exemplified what Coco Fusco has called the "sexual surveillance" of all women by men, of gay men and lesbians by heterosexuals, of transvestites by the conventionally clothed and so on. At the same time she provided a complex point of identification: for women, via another woman; for heterosexual men via a (heterosexual) woman and for gay men via the icon of femininity. In time, she was even able to represent racial difference from the point of view of Britain's minorities, something that would have been unimaginable to the rest of the royal family still steeped in imperial nostalgia. Filmmaker Lucy Pilkington commented after her death: "She was an outsider. That's why black people like her so much. We know what it's like to try to be as good as you can but never be accepted. Plus, she dated Dodi al-Fayed, an Egyptian. Black people liked that. You could say Diana was a black woman in many ways" (*Independent on Sunday* September 7, 1997). Remarkably, the daughter of an earl and wife of the heir to the throne was able to cross the ethnic divides of postcolonial Britain unlike any other white person.

People came to invest the still photographs of Diana with an astonishing range of meanings. One example is provided by the writer Blake Morrison:

> I met her once, at a Red Cross fund-raising event. "Met" is
> pushing it: I stood in line, along with various other writers,

and she shook my hand and passed along. But I have the photo-
graph. She has dipped her head to make her eyes bigger and is
giving me That Look, the look that said (slightly mischievously)
we're in this together, the look that made you think of Byron ("so
young, so beautiful,/So lonely, loving, helpless"), the look you
knew she'd given everyone else in the room but sent you away
feeling the charity work was worth it, that with a bit more effort
the world, in time, might be a kinder, better, more tolerant
place.

(Morrison 1997)

All that came not from the meeting itself, too transitory to generate any
memory or association, but from the photograph. Diana saw her charitable
work as "awaydays" to meet the "Tescos"; that is to say, one-day round trip
excursions to meet ordinary people. So the thoughts running through
Morrison's head were very unlikely to have originated with her. The
photograph, which comes to serve as his prosthetic memory for this briefest
of encounters, in fact creates a virtual meeting with "Diana" that never
happened but might have done. In the manner of fans everywhere, Morrison
finds his own range of meanings in the photograph, beginning, as for so
many others, with Diana's gaze, the upward look of her blue eyes from her
downcast head, creating a powerful sense of presence and need in men and
women alike. Her gaze leads Morrison, himself a poet, to think of Byron and
then to muse on the very Romantic goal of creating a better world. He is too
careful and intelligent a writer to say this without a hint of British irony but I
don't doubt that, at least for the instant of his encounter with Diana's
photograph, he meant it.

Pictures in India

Diana was not simply a cipher for other people's emotions. Her ability to
transform the banal photograph into an image laden with meaning was
perhaps achieved most strikingly on her visit to the Taj Mahal in 1992.
This monument to eternal love is a compulsory destination for all Western
tourists to India and Diana followed in the photographic footsteps of many
celebrities on her visit. The Queen and Prince Philip had visited it on their
tour in February 1961, but by moonlight so that there were no photographs.
Instead, the royal couple posed for pictures standing behind the corpse of a
$9^1/_2$ feet long tiger that Prince Philip had shot himself. The hunting party
are flanked by two elephants complete with howdahs, the traditional con-
veyance of the imperial élite. Indeed, such photographs of white hunters

with their tigers were staple features of Raj imagery (Thomas 1995: 4). The post-hunt photograph conveniently elided the fact that the hunter shot the animal from a raised platform after, in the words of the *Life* correspondent, "the tiger was brought into range by native beaters." In other words, Indians took the risks in order for white game hunters to enjoy an easy and risk-free kill. The Queen herself stands in the center of the group with her familiar austere expression, holding a home movie camera, indicating that she too has "shot" the tiger. Philip stands to the left, looking away from the camera altogether. The picture went down badly at home. The *Daily Mirror* complained that the Prince had "shot his tiger not fairly but from a 25-foot-high platform" and went on to draw an analogy with the gap between the "huntin' and shootin' royal family and the feelin' British people" (*Life* February 3, 1961). It would of course be Diana's role to expose that gap just by being herself. In the tiger hunt photograph, the royal couple appear as aloof imperialists out of touch with the modern world.

The same could not be said of the next famous visitor to the Taj Mahal, Jackie Kennedy. Although Mrs. Kennedy did visit the Taj Mahal by moonlight, she was careful to go also in daylight and be photographed. The resulting image was published in color on a full page by *Life*. Mrs. Kennedy poses for the classic tourist photo of the Taj, standing by the bench at the pool. The monument cannot quite be seen in entirety as the photographer has placed her slightly to the right of center. The result is a sense that Jackie commands the image and the building behind her, as Wayne Koestenbaum elegantly remarks: "Like Versailles, or the White House, the Taj Mahal is a monument that measures Mrs. Kennedy's scale and sublimity. Photographed in front of it, she seems tiny – but it's also as if the Taj Mahal has become her extension, proxy, and possession, and so she can absorb and claim its size" (Koestenbaum 1995: 102). The photograph is not about love or memory but about that air of authority and respect that Jackie Kennedy commanded so effortlessly. The picture shows that her blue and sea-green patterned dress beautifully picked out the colors in the Taj Mahal, so that even though the slightly fuzzy print obscures her face, the entire scene seems to belong to Jackie. While the British royal family struggled to find a way to represent themselves in the former British colony, *Life* reported that "days after she had gone people still called her *Ameriki Rani*, Queen of America" (*Life* March 30, 1962).

Thirty years later, it was Diana's turn to pose in front of the Taj Mahal, while on a state visit to India with Prince Charles. Like Jackie Kennedy, she visited the monument alone but created photographs with an entirely different resonance (Figure 7.1). She was photographed in the same classic spot but sitting on the bench, rather than standing. Further, the published

Figure 7.1 Princess Diana at the Taj Mahal

photographs used a wider angle for the shot and excluded the pool of water in front of the Princess from the picture. The result is that Diana seems overwhelmed by the monument, rather than in charge of it as Jackie had been. Her figure is almost a detail in the overall image but we can recognize the signature tilt of the head and upward gaze. Without the water in the image, the mass of white marble and cloudless sky give a sense of oppressive heat. Diana's clothing is unremarkable and with its red and pink accents certainly not in tone with the Taj Mahal, emphasizing her loneliness by its discordance. Television coverage of the event showed that there was in fact a veritable horde of camera people and photographers recording the Princess from the other side of the pool. Nonetheless, the resulting photographs became very evocative statements about lost love, all the more effective for their use of such a visual cliché as the Taj Mahal.

For the British public, to whom these photographs were primarily addressed, the Indian setting was highly appropriate to the theme of loss. What Salman Rushdie has called "imperial nostalgia" achieved very high profile in the 1980s with the popular television series "The Jewel in the Crown" and films like *A Passage to India* setting the nostalgic tone. These echoes of empire were of course the hallmark of the Thatcher government,

especially after its victory in the 1982 Falklands War. Ten years later, John Major's government had no dreams of glory and the royal family were beginning what the Queen was to call her "*annus horribilis*." The loss that Diana represented at the Taj was not just that of her dreams for her own marriage but the disillusionment of many Britons, especially those who had not benefited from the short-lived boom of the 1980s, with the neo-imperial dreams of modern Conservative politics. Diana's image was so effective because it was able to cross the gap from the personal to the political, in ways that academics, politicians and writers had not been able to emulate.

The celebrity *punctum*

Barthes called this ability of photography to summon unexpected and unintended meaning the *punctum*, which he opposed to the obvious and generally available meanings of the *studium* (see chapter 2). It is something that the viewer brings to the image regardless of the intent of the photographer, existing entirely at the level of connotation rather than denotation. Diana served as a *punctum* in herself for all kinds of meanings, just as many celebrities have done. Wayne Koestenbaum argues in his study of Jackie Onassis, for example, that for her fans: "In most photographs including Jackie, she is the punctum" (Koestenbaum 1995: 239). What is most striking about such photographs is that the *studium* and *punctum* in fact overlap in the person of the celebrity. The viewer scans the celebrity body and checks it against a wide range of remembered references to see if the star is looking "good" or "bad." The fetishistic viewing of celebrities creates a *punctum* effect of the first kind described by Barthes – a personal attraction to particular aspects of the image that is derived from whimsy, desire and memory. The second type of *punctum* is far more powerful: "this element which rises from the scene, shoots out of it like an arrow and pierces me" (Barthes 1981: 26). Diana, child of a broken home, bulimic, divorced, single mother and victim of a fatal accident, came to serve as a mass media *punctum* for personal loss. What made such effects possible in Diana's case was the sheer volume of her photographic image. Whether you were a fan or not, her face was unavoidable, a seeming constant in the ever-changing flow of global media. It was universally observed after Diana's death that she had been the most photographed person of modern times, that is to say the most photographed person ever. Yet in all the newspaper and television montages of these pictures it quickly became apparent that relatively few of these photographs were in any way memorable. For the most part, they consisted of grainy images of Diana going about her "private life" or photo opportunity shots of the Princess arriving or departing from

one function or another. In this way, the press photographs contrasted dramatically with the high gloss of official royal photographic portraits that were all instantly forgettable. The mass media images were memorable photographs only in that you remembered having seen them, for as Madonna said: "All of us, even myself, bought these magazines and read them" (Morton 1997: 278). It might be more accurate to say that we looked at these magazines in the supermarket checkout line, but nonetheless we had seen them. When she died, a small part of everyday life disappeared.

For the endeavors of the paparazzi to document every detail of celebrity were taken to extraordinary lengths in Diana's case. Diana lived at the very top of the pyramid constructed from celebrity, photography and the mass media. Such a convergence will inevitably self-destruct, as novelist Don DeLillo noted in an essay that ironically appeared on the very weekend of Diana's funeral, even though it must have been planned months in advance: "The fame-making apparatus confers celebrity on an individual in a conflagration so intense that he or she can't possibly survive. The quick and pitiless end of such a person's career is inherent in the first gathering glimmers of fame. And this is how the larger cultural drama of white-hot consumption and instant waste is performed in individualized terms, with actors playing themselves" (DeLillo 1997a: 62). Fame is the highpoint of a spectacularized consumer culture, in which the product becomes an image in order to attract the greatest possible attention and hence generate the highest possible return. In her interview on British television in 1995, Diana accurately diagnosed herself as a "product on the shelf." Her implied endorsement was capable of generating very significant revenues for companies. One survey estimated that she generated £14.5 million worth of free publicity that, for example, doubled the sales of her Audi 2.6E Cabriolet car in 1994, adding £10.2 million in revenue for the German company (*Guardian* September 2, 1997). Six months after Diana was photographed carrying a Lady Dior handbag costing $1100, given to her by Bernadette Chirac, wife of the French President, 200,000 similar bags had been sold, with an international waiting list. Inherent in the process of being a commodity is a necessary built-in obsolescence. In Diana's later interviews, she constantly commented that she "would not go quietly" and vowed to keep on fighting till the end. Given that she was only 35, it might seem odd that she would make such morbid remarks, unless you can imagine the way the world looks from inside the all-consuming blaze of the publicity machine. The madness of modern celebrity imaging – which is only the madness of consumer culture writ large – is that it demands such violent denouements, even as it denounces them. At the same time the wastefulness inherent in such conspicuous consumption appalls us all, even as we participate in it.

After Diana's death, supermodel Christy Brinkley voiced a widespread complaint of what was bizarrely termed the celebrity community when she asserted that no one should have the right "to photograph my image." By this she meant that no one should be able to photograph her without her explicit consent. In the case of models and film stars, whose primary commodity is their appearance, our desire to see them, and their desire to restrict our view, seems understandable. It is less obvious why there was such a strong desire to observe Diana going to the gym or shopping. Under the motto "Honesty, Quality, Excellence," the *Daily Mirror*, to take one example from thousands, filled its entire front page in January 1996 with a head-and-shoulders photo of Diana leaving her therapist's in tears, promising the "full dramatic story and photos" inside (*Daily Mirror* January 9, 1996). The photographers who took such images called taking her picture "whacking" or "hosing her down," metaphors that reveal the violence inherent in the process. As spectators, Diana's fans inevitably had contradictory attitudes to these photographs. One typical memento left outside Kensington Palace was constructed from a framed newspaper photograph of Diana over which the mourner had written "No More Photographs." The epitaph can be read in two ways. As a statement it simply suggests that now Diana has died, there will be no opportunity for further photographs, with the implication that photographers caused her death. As an imperative, it commands that there should be no more intrusive celebrity photography, a widespread sentiment in the aftermath of the disaster. Yet both meanings are contradicted by the very use of a mass circulation image of Diana in the votive icon. For some commentators, such paradoxes revealed the mourning to be nothing more than mass hypocrisy. More reasonably, it can be said that they are the very stuff of everyday life in the age of globalized virtual reality.

There was certainly an element of desire at play in the mass display of Diana's image. As Don DeLillo has pointed out, "fame and secrecy are the high and the low ends of the same fascination, the static crackle of some libidinous thing in the world" (DeLillo 1997b: 17). Part of our involvement with the famous is our desire to expose their secrets, to see what they do not want us to see. In Diana's case, this desire has usually been described as male sexual desire. Certainly such desire was an important element, especially in photographs of her sunbathing or exercising. Most Diana photographs did not have such obvious sexualized content, however, and were often published in media aimed primarily at women. *People* magazine ran Diana's picture on the cover no less than forty-one times in her lifetime, for example. Women's desire to see Diana was every bit as strong, perhaps stronger, than that of men. If there was an element of homoerotic desire in that looking, there was also identification with her as the leading example of

how difficult modern life can still be even for women who seem to have it all. Diana's ability to communicate her difficulties through photography was matched by the ability of her female audience to analyze and give meaning to fragmentary changes in appearance. As numerous commentators have argued, this skill in fragmented looking is learned from the same women's magazines that so frequently featured Diana's image. In Diana Fuss' view, the fragmented body parts seen in fashion photography are a visual reminder of the construction of female subjectivity in relation to the (m)other's *imago*, or image: "These images of the female body reenact, obsessively, the moment of the female subject's earliest self-awareness, as if to suggest the subject's profound uncertainty over whether her own subjectivity 'took.' This subject is compelled to verify herself endlessly, to identify all her bodily parts, and to fashion continually from this corporeal and psychical jigsaw puzzle a total picture, an imago of her own body" (Fuss 1995: 95). In looking at Diana, many women were reworking their own identities. Diana was the perfect subject for such identification both because of the frequency of her appearance in visual media and her own public struggles with identity.

In hindsight, this narrative may be seen to begin with the famous photograph of Charles and Diana kissing on the balcony of Buckingham Palace after their wedding ceremony on July 29, 1981. Diana's face is upturned, her neck fully extended as if she was putting her whole being into the kiss. Charles stands upright, his head barely inclined towards his new wife, with his lips slack. Even at the time his hesitation was apparent and it has now become known that he asked his mother's permission to make the kiss at all. The mythology of the young girl marrying a prince is of course sealed with a kiss. In re-enacting this role, Diana in effect made herself into a classic film star. She belonged here to the ranks of the old-fashioned stars in whose films the kiss comes to stand for the highest point of passion, that which Edgar Morin called the "eroticism of the face" (Dyer 1979: 52). Diana became the representative of a new generation of women, as Tina Brown pointed out in 1985: "[Diana is] one of the new school of born-again old fashioned girls who play it safe and breed early. Post-feminist, post-verbal, her femininity is modelled on a Fifties concept of passive power" (*Observer* September 6, 1997). Like the earlier film stars', Diana's face came to stand not only for her own subjectivity but also for that of the many women who identified with her.

Having created herself in the neo-Fifties mould of the Reagan–Thatcher era, Diana seemed to fast-forward through the different ages of modern women. After a certain point in her marriage, Diana refused to remain in the passive role assigned to her. From the royal point of view, one could apply the comment of *Hollywood and Great Fan Magazines* on the break-up of

Bette Davis' marriage to Harmon Nelson to that of Charles and Diana: "It's asking a lot of a man to expect him to be the lesser half of a marital partnership indefinitely" (Dyer 1979: 53). Diana became first the woman betrayed and then the single mother striking out on her own. As Ros Coward suggests, "many aspects of her life encapsulated the events which so many women now face as traditional expectations disappear" (*Guardian* September 2, 1997). Diana constantly reinvented her appearance, with assistance from leading designers and fashion moguls from *Vogue* magazine, to give visual expression to the challenges of the new era. Perhaps the best example of these reinventions was the dazzling Valentino off-the-shoulder black dress she wore to an opening at the Serpentine Gallery in June 1994 on the same night as Prince Charles announced on national British television that he had committed adultery with Camilla Parker-Bowles. Her confident, sexy image was the perfect counterpoint to the televised confession of a kilted Prince Charles. His awkwardness contrasted with her confidence, his anachronism with her modernity, above all her desirability with his ordinariness. The contrast was so powerful because Diana's image was so familiar and well known. Only through daily repetition in the media of her appearance could she make such a dramatic statement.

Flags and protocol: the devil in the detail

In the week following her death, Diana's British audience applied their skills in reading every detail of her image to the funerary arrangements and ceremonies. The neo-medievalism of the British monarchy as re-imagined by Lord Melbourne and Disraeli for Queen Victoria had made strikingly successful use of traditional monarchical symbolism. Diana's death brought the disjuncture between such feudal imagery and modern democratic society into full view. It was over the apparently incongruous detail of flags that this question emerged into public debate. Flags were an integral part of the apparatus of heraldry that have retained their significant emotive power in the modern world, as evidenced by Jasper Johns' *Flag* series of paintings and George Bush's divisive campaigning around the flag-burning issue. Around the time of Diana's death, Mrs. Thatcher made the British Union Jack a renewed subject of discussion by protesting the change of British Airways' livery from the flag to a series of multi-cultural designs. When the former Prime Minister saw models of the new planes, she immediately covered up the offending designs with her tissues, reminding everyone that in her day British meant white. The Union Jack had been adopted by white suprema- cists in the charged atmosphere of the late 1970s. Today, as Britain ponders its role in the European Union, national symbols like flags appear under

threat. All these issues came to a head in the question of the use of flags in commemorating Diana.

Although Diana had been officially stripped of the title Her Royal Highness as part of her divorce settlement with Prince Charles, the royal family rushed to wrap her, quite literally, in the flag symbolism of monarchy after her death. Prince Charles flew to Paris in order to reclaim her body and the coffin arrived back in Britain shrouded with the Royal Standard. Apparently satisfied that they had met popular demand for royal mourning, the royal family immediately retreated to Balmoral Castle in Scotland. But having initiated the symbolic use of the flag, the monarchy was unable to continue in this vein. While flags all over Great Britain, and indeed the world, were flown at half-mast in memory of Diana, the royal palaces continued to observe the absurdities of their imagined protocols. Despite having used the Royal Standard in Diana's homecoming, the ordinary rules were now enforced, as described by *The Times*: "The Royal Standard is . . . the only flag that flies above Buckingham Palace, and it flies only when the monarch is in residence there. . . . The Royal Standard is never lowered because the monarchy [always] continues." Buckingham Palace thus displayed the only bare flagpole in Britain, while Balmoral flew the Royal Standard at full-mast. The half-mast tradition is an adaptation of a seventeenth-century custom whereby ships dipped their flags as a mark of respect. Here the reinvention of tradition in the nineteenth century contradicted itself. The monarchy could not pursue its own symbolism and show respect to Diana at the same time. To do so would be to admit that the royal family are simply ordinary people like everyone else and challenge the unstated belief of royal ceremonials that, although political power has devolved to elected representatives, the monarchy still retains its aura of divine right. It later transpired that the flag question was the subject of controversy within the royal household, leading Prince Charles to tell the starchy Sir Robert Fellowes, the Queen's private secretary, to "impale himself on his own flagstaff" (*Guardian* September 10, 1997). Popular sentiment, which had long since ceased to view the royals as divine, was outraged (see Figure 7.2). On September 4, the *Sun* headline asked bluntly: "Where is our Queen? Where is our flag?," while even the sedate *Independent* read "No flag flying, a Family far away, and the people feel uneasy." By 3.30 that afternoon, it was announced that the Union Jack would fly at half-mast at Buckingham Palace during Diana's funeral for the first time ever. The strength of feeling forced Buckingham Palace to fly the half-mast Union Jack, not only on the day of Diana's funeral, but for the whole of the next day. The Queen may have felt that her bow to Diana's coffin was the ultimate mark of respect but the ground had already been conceded with the lowering of the flag. A monarchy

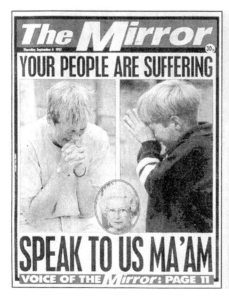

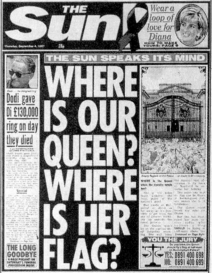

Figure 7.2 Tabloid covers dealing with the flag issue

that had set itself as the arbiter of protocol and social standards was hoist by its own petard. In what is widely referred to as New Britain, no one cares what the "done thing" is, only what it now seems right to do.

Death and the Maiden: the sign of New Britain

In her death Diana came to represent the wasted lives of the Conservative era in global politics. The astonishment that Britons felt at their own emotions during the funeral period was well characterized by Neal Ascherson as "a pent-up sense of moral failure" (*Independent on Sunday* September 7, 1997). These feelings had been building for a long time. On May 1, 1997 Britain elected its first Labour government in eighteen years with an overwhelming majority. After nearly two decades of free market economics combined with social authoritarianism, the voters turned instead to Tony Blair's New Labour and its message of rights with responsibilities. When the French elected a Socialist government in 1981, the streets were filled with celebrations all night. Despite many private parties, there were few mass demonstrations of popular jubilation after Labour's victory, for the mood was closer to a sense of failure and shame concerning the previous two decades than widespread confidence that Labour would transform the country. Diana's death provided the opportunity to vent the anger and grief that many felt with the state of the nation. When Tony Blair named Diana the "People's Princess," that most unlikely of titles, it bathed his government in the aura of the now divine princess. One immediate result might well have been the strength of the vote for Scottish devolution one week after Diana's funeral. Elsewhere, the Australian republican movement has gained greater impetus from the desire to avoid having Prince Charles open the 2000 Sydney Olympics that has resulted in a 1999 referendum on the monarchy.

The means by which Diana was mourned had been prepared by other disasters in the previous decade. What Martin Jacques dubbed the "floral revolution" that took place after her death had in fact become a British rite of passage since Hillsborough and Dunblane. After over eighty Liverpool football (soccer) fans were crushed to death at Hillsborough during a 1989 F.A. Cup semi-final, Liverpudlians carpeted the gates of Anfield, the club's home ground, with the sea of flowers that were to become the sign of British mourning. The flowers appeared again in 1996 after an unstable man shot and killed sixteen school-children in the village of Dunblane, Scotland. It was often said that Britain did not feel like itself during the dramatic first week of September in which the country was wreathed in flowers. More exactly, the sentiments that had previously been seen in the North and in

Scotland now came home to the metropolitan center as well. Further, in these mass displays of visible emotion, the English showed that for all the hostile Euroskepticism in the press, they were in fact very much Europeans. Diana's funeral was street activism similar to the French strike movement of 1995 and the Belgian protests against judicial and police corruption in 1996. In an era when the political party has begun to seem outdated as a means of effecting change, Europeans have returned to the mass street protest of years gone by. In France, the strikes were the forerunner of the surprise Socialist election victory of 1997, but in Belgium little lasting change yet seems to have resulted.

It can take years, however, for the effects of mourning as militancy to register in the traditional body politic. The emotiveness of Diana's funeral had long been foreshadowed by the political funerals protesting apartheid organized by the African National Congress in South Africa and by its supporters around the world. Since the 1980s, many have come to experience the anger and passion of funerals for people who have died from AIDS. It is no coincidence that AIDS and African suffering were causes that Diana publicly embraced. One woman brought a copy of Nelson Mandela's autobiography to read in the queue to sign the condolence books at St. James' Palace. Earlier in 1997, Diana had visited unfashionable Angola, spurned by many Western nations for its left-leaning politics, being photographed not at tourist sites but with landmine victims. The big hats and bigger hair of the 1980s had gone, to be replaced by short hair, casual khakis and shirts. These photographs put the issue of landmines on the global agenda and did more than anything to ensure the signing of a treaty outlawing the use of such munitions later that year. As Linda Grant observed, that in itself is far more than most commentators can dream of achieving. Certainly, Diana was no Nelson Mandela and her funeral may or may not be seen as a political turning point in years ahead. There is, however, no doubting its cultural significance and in the contemporary world of global culture, culture is politics.

Pixel planet

The reception of Diana's image was not, however, unambiguous. Rather it combined very traditional and conservative attitudes to women with a slow acceptance of the changes that are now taking place. It was perhaps her ability to speak to constituencies as diverse as traditional royalists, feminists, and gay men that made Diana such an effective icon. Her true potential to be such an icon was only fully revealed in her death, a necessarily ambivalent moment. In writing on Latin American women artists, Coco Fusco has

observed that "the very ambivalence towards ceding access to women in public life expresses itself perfectly in the sharp change in attitudes towards women artists before and after their death. It is almost as if a violent death makes them more acceptably feminine" (Fusco 1998) (see Figure 7.3). It was noticeable that Diana became a Latina saint almost as soon as she died, a British version of Our Lady with Flowers. Mourners waiting to sign the condolence books claimed to have seen visions of Diana that they described in suitably postmodern fashion as looking like the *Vogue* front cover of her with clasped hands taken by Lord Snowden. Rather than the endless comparisons to Marilyn Monroe, Diana's death would better be compared to that of Selena, a hugely popular Tejana singer, who challenged traditional gender roles and performed in both Spanish and English. Selena was killed by the president of her own fan club in 1996. The *People* magazine that led with this story sold more copies than any previous edition and Selena's story crossed over into the English-speaking world via a film biography and soundtrack album. Similarly, *People* had wondered on its front cover in August 1997 whether Dodi al Fayed was a "dreamboat or deadbeat," and then ran three adulatory post-mortem covers featuring Diana. It was left to Camille Paglia, who never passes up a chance to say the unspeakable, to refer to Dodi as a "scumbag" after his death (*Guardian* September 4, 1997). Doubts about Diana's liaison with Dodi are still sustained by the rumor

Figure 7.3 Coco Fusco, *Better Yet When Dead*

machine that circulates surrounding her death. In the Middle East, it is widely believed that Diana was assassinated to prevent her from marrying a Muslim (*Observer* December 28, 1997). The French government went so far as to issue a denial that the Princess had been pregnant when she died. The fear of miscegenation that was palpable in press coverage of her liaison with Dodi swirls even over her dead body.

The global media public found in Diana the first icon of the new age of the electronic image and the instantaneous distribution of images. One consequence was a certain flattening of perspective on the event, the homogenization that is one aspect of global culture. Newspapers around the world carried highly emotive stories taken directly from the British press rather than having their own journalists create accounts from local perspectives, even in countries that have good historical reason to resent British royalty like Zimbabwe. In Argentina, the last country to fight a war with Britain in 1981 and proud possessor of its own martyr heroine Eva Peron, journalists reported "an extraordinary intensity of grief" (*Independent on Sunday* September 7, 1997). Long queues formed at the British embassy to sign the books of condolence, while Argentine papers ran ten pages a day of news and comment. In the United States, coverage was at saturation levels as a younger generation that had got up early to watch Diana's wedding rose again to see her funeral. The media consistently emphasized, in the words of the *Chicago Tribune*, that "she was America's princess as much as she was Britain's princess." Given that the *Tribune* normally covers British politics only from a perspective highly sympathetic to Irish Republicanism, this appropriation was all the more remarkable. While Diana's death had striking local effects, it was in the end a global event that marked the coming of age of a globalized visual culture.

This compulsive, obsessive looking reminds us that there is a certain madness inherent in the photograph itself, as Barthes pointed out:

> The image, says phenomenology, is an object-as-nothing. Now, in the Photograph, what I posit is not only the absence of the object; it is also, by one and the same movement, on equal terms, the fact that this object has indeed existed and that it has been where I see it. Here is where the madness is, for until this day no representation could assure me of the past of a thing except by intermediaries; but with the Photograph, my certainty is immediate. . . . The Photograph then becomes a bizarre *medium*, a new form of hallucination: false on the level of perception, true on the level of time. . . . Society is concerned

> to tame the photograph, to temper the madness which keeps
> threatening to explode in the face of whoever looks at it.
>
> (Barthes 1981: 117)

Diana's death was in part the untaming of photography, a madness that generated the intensity of unleashed feeling so often recalled in words like "I never thought I would feel like this." In the endlessly repetitive sequence of Diana photographs, it now seems that what we were looking at was, in part, photography itself, checking on its now questioned capacity to report the "truth." The daily low quality newspaper image of Diana, combined with the glossy, posed magazine shoots, the televised appearances and the print media commentary on all these images combined to assert the continued power of representation to document everyday life.

While it is not yet possible to predict what the long-term political consequences of Diana's death may be, it has clearly changed the local and global culture. It might be more exact to say that it made certain changes apparent that have been a long time in the making and are now achieved. In Britain, the caste connotations of the class system have been decisively altered. It has long been possible for the British establishment to distinguish between itself and its others on the grounds of vulgarity. Vulgarity is immigrant, camp, Jewish, plebeian, modern. It took the daughter of a dozen earls to break through John Major's image of a Britain characterized by warm beer, spinsters cycling to church and deference to "betters." Julie Burchill called Diana "our pop Princess,"(*Observer* September 6, 1997) a person who participated in the mass culture of postmodern everyday life rather than maintaining a traditional royal distance. In her notes for her biographer Andrew Morton, Diana set out her pop culture strategy: "*Top of the Pops*, *Coronation Street*, all the soap operas. You name it, I've watched it. The reason why I watch it so much now is not so much out of interest but if I go out and about, whether it be to Birmingham, Liverpool or Dorset, I can always pick up on a TV programme and you are on the same level. That I decided for myself. It works so well" (Morton 1997: 66). Diana understood that in the era of mass visual culture, any sense of common identity now comes from shared viewing of television programs and films, rather from a local or national "culture." Diana was of course more than just another soap opera fan. She was the star in perhaps the most compelling *telenovela* of the decade.

It should not have been surprising, then, that so many were moved by her death, when we consider how the United States ground to a halt to find out who shot J.R. Ewing in the soap *Dallas*. What was perceived as unusual was that popular culture took center stage in Britain, a country that had long

been seen as trapped in an outdated class system. It was no surprise that the establishment newspaper, *The Times*, found that: "Many are bemused by this unprecedented outpouring of raw emotion: a few even sneer at it as alien or vulgar" (*The Times* September 4, 1997). The people being discussed here are those élite figures that feature in *The Times*' worldview. Tony Blair, on the other hand, said as soon as he heard of Diana's death that there would be grief on an unprecedented scale. Finally the "vulgar" label so condescendingly attached to popular culture had to be erased. No moment was more emblematic of this change than Elton John singing his new version of "Candle in the Wind" in Westminster Abbey. Here was an openly gay man, who was accompanied by his partner to the funeral, singing "pop" at the seat of British royal power. The singer Billy Bragg observed: "At last here was something that we knew, that we could hum, that offered a brief solace, the comfort of recognition that comes with hearing a cherished, half-forgotten song on the radio. Here was something of the culture that we and Diana grew up in, a sentimental Top 40 culture that nonetheless moves people much more than 'Nimrod'" (Bragg 1997). While the audience outside had mostly sat through the National Anthem, they all stood to watch Elton sing what was much closer to actually being a national anthem.

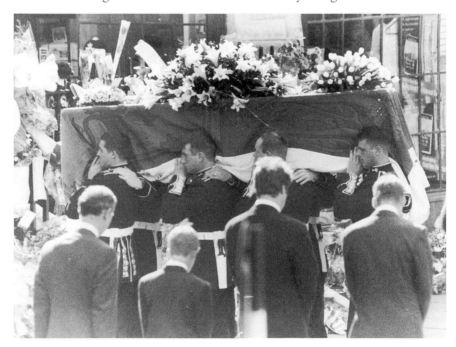

Figure 7.4 Princess Diana's funeral

It is hard to recall that moment in the aftermath of the deluge of Diana kitsch that has brought the world everything from Diana screensavers to replica Diana porcelain dolls. In the New Year's Honors List for 1998, Elton John was knighted under his original name, becoming Sir Reginald Dwight. Two years before its close, monarchical Britain officially joined the twentieth century.

For Diana's funeral was a global media event of astonishing proportions, entailing "the forging of a global icon" as Roy Greenslade termed it (*Guardian* September 8, 1997). It would be more exact to say that the extent to which Diana had become a global icon finally became apparent. The numbers involved tell the story most effectively. When Elton John's reworking of "Candle in the Wind" was released as a single it sold 31.8 million copies by the end of October 1997, surpassing in only 37 days the 30 million copies sold by Bing Crosby's "White Christmas," the former world-record for best-selling single. The single alone looks set to raise over £30 million for the Princess's charity, which was able to generate an endowment of £100 million in the space of a few months. The Princess's status as the commodity of all commodities in the postmodern era of visual culture was confirmed by these donations in which her attention-grabbing value was literally turned into cash.

Although Diana had lived her life in dialog with photography, her death was above all a televisual event. For all the countless websites that were created in her honor, none matched the creativity and spontaneity of what could be seen live on television. The Internet is an admirable information resource but does not yet have television's capacity for "live" reporting. This was an event where the world really was watching. While 750 million people had watched her marriage, and another 200 million her interview on British television in 1995, a staggering 2.5 billion people are estimated to have watched her funeral. If this figure is correct, it means that of the three-quarters of the world's population who have access to television, no less than 80 percent were watching. London police had expected a crowd of six million people but in the end most Britons experienced the funeral like the rest of the world on television. The largest portion of the London crowd gathered in Hyde Park to watch the event on giant television screens that had been specially flown over from Hong Kong, where they had been used during the ceremonies marking the return of the British colony to China. In two different ways, those screens registered the final death of the nineteenth-century imperial monarchy created by Queen Victoria. Diana's funeral was the inaugural of the pixelated planet.

Bibliography

Barthes, Roland (1981), *Camera Lucida*, New York, Noonday.

Bragg, Billy (1997), "After Diana," *New Statesman* September 12.

Brunsdon, Charlotte (1996), "A thief in the night: Stories of feminism in the '70s at CCCS," in David Morley and Kuan-Hsing Chen (eds), *Stuart Hall: Critical Dialogues in Cultural Studies*, London, Routledge.

DeLillo, Don (1997a), "The Power of History," *New York Times Magazine* September 7.

—— (1997b), *Underworld*, New York, Scribners.

Dyer, Richard (1979), *Stars*, London, British Film Institute.

—— (1997), *White*, London, Routledge.

Fenton, James (1977), "Why They Hate the Queen," *New Statesman* 93 (2411), June 3: 730.

Fusco, Coco (1998), http://www.favela.org/fusco

Fuss, Diana (1995), "Fashion and the Homospectatorial Look," in Kwame Anthony Appiah and Henry Louis Gates (eds), *Identities*, Chicago, IL, Chicago University Press.

Grant, Linda (1997), "Message from the Mall," *Guardian* September 9.

Hall, Stuart (1990), "Cultural Studies and its Legacies," in L. Grossberg et al. (eds), *Cultural Studies*, New York, Routledge.

Howe, Darcus (1997), "After Diana," *New Statesman* September 12.

Kelley, Kitty (1997), *The Royals*, New York, Warner.

Koestenbaum, Wayne (1995), *Jackie Under My Skin*, New York, Farrar, Strauss and Giroux.

Lacan, Jacques (1977), *The Four Fundamental Characteristics of Psychoanalysis*, New York, Norton.

Morrison, Blake (1997), "The People's Princess," *Independent on Sunday*, September 7: 4

Morton, Andrew (1997), *Diana: Her True Story*, New York, Simon and Schuster.

Redhead, Steve (1997), *Post-Fandom and the Millenial Blues*, London, Routledge.

Thomas, Nicholas (1995), *Colonialism and Culture*, Princeton, Princeton University Press.

Virilio, Paul (1994), *The Vision Machine*, Bloomington, Indiana University Press.

FIRE

DIANA'S DEATH SUDDENLY made it clear that the gap between the global and the local in the contemporary world is most effectively crossed by the visual image. The visual mediates modern life not in relation to some presumed economic base but in making connections possible both between individuals and *en masse*. In a world dominated by the search for what Geoff Mulgan has called "connexity", the role of the visual in everyday life seems set to increase still further (Mulgan 1998). Diana's image, in all the senses of that term, mobilized a new form of popularity that was both local and global. Its local resonances centered on the role of the monarchy and the imbrication of the royal family in the sexual politics of Britain (Campbell 1998). Global discussion was equally interested in the relationship between individuals and the media, the balance between privacy and surveillance and the role of celebrity in contemporary life. The mourning that accompanied her death was both unexpected and new, heralding a different relationship between the consumers and producers of the media. The very nature of popularity has changed so that studies of "popular culture" no longer need be simply another way of saying "non-élite culture."

For it is no longer possible to suggest that the mass audience will gullibly consume any product that is offered to it containing a simple formula of entertainment. Interestingly, of the mass media, television seems more at threat from these changes than cinema. The success of *Titanic* (1997) made film seem full of commercial possibilities. It is worth noting that this was a triumph created more by audiences than critics or other industry insiders, many of whom predicted failure. Even after its success, the Academy

pointedly gave *Titanic* no Oscars for acting or screenwriting, even though it was the story that made the film so popular, especially with young women. Highbrow critics in France and Germany perceived the film as an allegory for class division and the collapse of modernism, while the British Academy of Film and Television Arts found it unworthy to receive any of its annual awards. For all the colossal budget and special effects required to make *Titanic*, it was ultimately successful because audiences came to see it despite the media consensus in many countries that it was a poor film. Many American film critics felt the need to bemoan the fact that *L.A. Confidential*, an enjoyable *film noir* parody, had been passed over in favor of *Titanic* at both the box office and the Academy Awards. On the other hand, Egyptian and Indian audiences enjoyed *Titanic* while they had found *Independence Day* patronizing and narrowly focussed on American concerns. For all the weaknesses of the script, *Titanic* was open to a variety of interpretations and perspectives that spectators globally found appealing in different ways.

Television is both the dominant medium of our time and the one going through the most uncertainty. In the 1997–98 season, ABC Television responded to its falling ratings by launching a pro-television campaign, using such slogans as "We Love TV." Rather than promote individual programs, ABC is then trying to boost the activity of television watching itself in the face of constant criticism of television's content – much of which has, of course, aired on television. The knowing postmodern irony of this campaign barely conceals a panic that the era of network television, with its guaranteed audiences and profits, has passed. In the summer of 1998, the network share of the United States' television audience dipped below 50 percent for the first time. Both network and cable channels have been forced to adjust to the ongoing fragmentation of the audience by the seemingly endless proliferation of channels by taking note of viewer attitudes in a far more interactive manner than simply reading ratings data. Fox has started to show new episodes of popular programs like *Melrose Place* in the traditional repeat season of May to September, seeking to win viewers insulted by slogans like NBC's "It's New to You." Further, the by now commonplace strategy in television studies of concentrating on audience response to understand the medium has been adopted by the industry itself. As so often, MTV leads the way in this field. Its show *Twelve Angry Viewers* allows a jury of selected viewers to review and select the new music videos, while new VJs (Video Jockeys) are employed following a day-long exercise in viewer participation. Audience response now directs the future of MTV, which has in the past proved to be the future of television.

The relatively low cost of new media like Digital Audio Tape, Hi-8 video and the Internet allows many more people to be both producers and

consumers of visual and other media. Photographs can now be obtained in a variety of formats and then simply manipulated to enhance results. Local access stations on cable, such as that glorified by *Wayne's World*, provide an alternative to the cable and network stations alike for a young generation that seems increasingly resistant to the seductions of production values and actively engaged in a "do-it-yourself" aesthetic. While it is true that access stations never attained mass popularity, the production of visual imagery is by now so diversified that it collectively signifys a shift away from the passive consumer trying to invest consumption with meanings, towards a consumer–producer. Home videotapes are by now commonplace, with computer editing and digital tape available at low cost. With the development of video-player plug-ins, such videos can be posted on the Net or distributed both locally and globally by activist groups, charities and other small-scale organizations. These changes are partly generated by the corporate mantra of consumer choice. However, so rapid is the pace of change that increasingly sophisticated technology is becoming available to a mass-market audience. For example, as professional video production shifts to digital formats, analog video in all its forms can only survive as a consumer product, reducing prices and simplifying techniques. These brand-new yet obsolescent technologies are full of possibilities for challenging the corporate worldview. It is surely in making use of such technologies that any new revival of the visual arts will begin. In the narrower confines of the academic sector, this change implies that course work in visual culture should be devised in ways that bypass the traditional producer/critic divide, creating new forms of academic work that are more interactive with the wider culture.

For a new form of expression is coming into being that one might call the "visual-popular," based on Antonio Gramsci's notion of the national-popular that has dominated many previous analyzes of popular culture. The national-popular was a means of conceiving how the disparate groups that form a nation – classes, ethnicities, genders, subject peoples, immigrants and so on – can cohere into the national around certain key themes in popular culture from religion to sport and monarchy. It can equally be understood as the "common sense" of a time and place. In the contemporary moment, it has become common sense to understand the new configurations of the global and the local via images. However, these new visualizations are by no means simple or one-dimensional. Rather, as Gramsci noted of the national-popular, it is "an ambiguous, contradictory and multi-form concept" (Gramsci 1971: 421). As the nation state becomes increasingly subordinate to global forces from without, and subject to the centrifugal tendencies of

devolution and local autonomy from within, the national-popular is no longer the central arena of cultural and political contestation.

While no consistently global means of expressing this heterogeneous and constantly shifting image world yet exists – and perhaps cannot exist – the flows between the local and the global are fleetingly and transiently glimpsed in the visual-popular. Certain images stand out from the endlessly shifting media array and come to crystallize key moments and tensions. The visual-popular thus creates transnational popular groupings through the visual media in what has been termed the "transnational imaginary" (Wilson and Dissanayake 1996). It takes many different forms and has different political and cultural resonances. When Martin Scorcese and Richard Gere made Hollywood films to bring attention to the political crisis in Tibet, they used a global medium to call attention to a local problem. When a replica of the Tiananmen Square liberty emblem was displayed in Hong Kong during the 1998 anniversary commemoration of the massacre – after Hong Kong's reunification with China – the audience was both local and global. On the other hand, when differing factions of Iranians used the USA versus Iran soccer match in the 1998 World Cup to display their competing banners and emblems, the global media were used to circumvent local censorship. Yet again, the Taliban have been destroying television sets throughout Afghanistan as part of their effort to create an Islamic state. It is no coincidence that these examples all come from the interface between what are sometimes called the "developed" and "underdeveloped" worlds. The failure of cultural studies, in common with many other academic disciplines, to pay sufficient attention to Asia and Latin America has often been noted, faults perhaps shared by this book as well (Chen 1998). Yet the difficulty of acquiring the cultural, historical and linguistic expertise to create such genuinely global criticism should not be underestimated. The moments of cultural interface represented by the visual-popular may now allow a way for critics in cultural and visual studies to open a dialogue with area studies specialists. In so doing, it is possible that the often-wished for post-disciplinary academy might begin to create itself.

Even the most terrifyingly real of all human creations, the atomic bomb, is now being imagined in a visual context. When India detonated an atomic device in May 1998, her foreign minister laid down a challenge to Pakistan in words taken directly from Indian cinematic cliché: "All they have to do is tell us the time and the place." The weapon was named after Agni, the Hindu god of fire, also evoking such movie classics as Amitabh Bachchan's *Agnipath* (The Path of Fire) (Sardar 1998: 11). The Indian government, dominated by the Hindu BJP Party, has sought to transform the traditional Hindu ritual of purification by fire into a new cinematic context, at once

local and global, to which mostly Muslim Pakistan responded in kind. This standoff was a riposte to the West in several ways. First, it recast the Reaganite vocabulary of "Star Wars" in terms of Indian cinema. Second, by evoking the traditional energy of fire, it provided a counterpoint to the endless exaltation of electricity in current Western discourse. Finally, it challenged those who think that globalization is simply a euphemism for Americanization. None of these points is meant to condone or justify the expansion of nuclear weaponry, which is clearly a disaster for all concerned. Yet the incident shows the intricate ways in which the real and the virtual are now imbricated, mediated by the visual image. Fire has recurred as an image throughout this book, from the fire at the heart of Plato's cave to the fire-shaped pictorial design system invented by Michelangelo, the funeral pyres of the *sati*, and the multiple fires and weaponry of science-fiction film. In this way, the genealogy of visual culture outlined in this book could be told through the imagery of fire.

Fire is an image that is at once archaic, modern, and postmodern. It is at once a code, a symbol, an icon and a message without a code. That is to say, it is something that has material existence, that is both visible and interfaced with language. What is visual culture? Right now, it's on fire.

Bibliography

Campbell, Beatrix (1998), *Diana, Princess of Wales: How Sexual Politics Shook the Monarchy*, London, Women's Press.

Chen, Kuan-Hsing (1998), *Trajectories: Inter-Asia Cultural Studies*, London, Routledge.

Gramsci, Antonio (1971), *Selections from the Prison Notebooks*, London, Lawrence and Wishart.

Mulgan, Geoff (1998), *Connexity: Responsibility, Freedom, Business and Power in the New Century*, London, Vintage.

Sardar, Ziauddin (1998), "Two Asian Film Thugs Square Up," *New Statesman* June 5.

Wilson, Rob and Dissanayake, Wimal (eds) (1996), *Global/Local: Cultural Production and the Transnational Imaginary*, Durham, NC, Duke University Press.

INDEX